The Culture of Property

THE CULTURE OF PROPERTY

The Crisis of Liberalism in Modern Britain

Jordanna Bailkin

THE UNIVERSITY OF CHICAGO PRESS

CHICAGO AND LONDON

Jordanna Bailkin is assistant professor of history and women's studies at the University of Washington.

The University of Chicago Press gratefully acknowledges the support of the Graduate School Fund for Excellence and Innovation at the University of Washington in the publication of this book.

The University of Chicago Press, Chicago 60637
The University of Chicago Press, Ltd., London
© 2004 by The University of Chicago
All rights reserved. Published 2004
Printed in the United States of America

13 12 11 10 09 08 07 06 05 04 1 2 3 4 5

ISBN: 0-226-03550-6 (cloth)
ISBN: 0-226-03551-4 (paper)

Library of Congress Cataloging-in-Publication Data

Bailkin, Jordanna.
 The culture of property : the crisis of liberalism in modern Britain / Jordanna Bailkin.
 p. cm.
 Includes bibliographical references and index.
 ISBN 0-226-03550-6 (cloth : alk. paper)—ISBN 0-226-03551-4 (pbk. : alk. paper)
 1. Great Britain—Antiquities—Collection and preservation—History. 2. Cultural property—Protection—Great Britain. 3. Great Britain—Cultural policy. 4. Liberalism—Great Britain. 5. Museums—Great Britain—History. 6. Material culture—Great Britain—History. I. Title.
 DA655.B345 2004
 306.4'7'094109034—dc22
 2003027031

CONTENTS

ILLUSTRATIONS

―∞∞∞―

ACKNOWLEDGMENTS

For their financial assistance, I thank the Mellon Foundation, the Institute for Research on Women and Gender at Stanford University, the Yale Center for British Art, and the Junior Faculty Development Program at the University of Washington. During the final stages of editing and production, I benefited from the exceptional generosity of the Keller Fund and the Graduate School Fund for Excellence and Innovation at the University of Washington.

This project could not have been undertaken without the aid of many helpful librarians and archivists. I offer special thanks to Felicity Devlin, Raghnall O'Floinn, and Josephine McGlade at the National Museum of Ireland, Shauna Dunismere at the Kelvingrove Art Gallery in Glasgow, Rhys Griffiths at the London Metropolitan Archives, James Kilvington at the National Portrait Gallery, Deborah Hunter at the National Galleries of Scotland, David Allen at the Horniman Museum, Mike Miller at Royal Holloway College, and Martin Astell, David Carter, and Margaret Daly at the National Gallery in London.

When I was an undergraduate at Tufts University, my interests were encouraged by John Brooke, Steven Marrone, and Reed Ueda in the History Department, as well as Elizabeth Honig and Andrew McClellan in the Department of Art and Art History. Howard Malchow deserves a particular vote of thanks both for sparking my interest in British history and for bearing up through my exceptionally unwieldy senior thesis with equally exceptional patience.

I have learned and continue to learn much from my graduate advisers at Stanford. Paul Robinson was a terrific editor, and everything he has ever said about anything I have ever written has been absolutely true. Lou Roberts has been not only an outstanding reader but also a valued mentor who has always inspired me with her own work. Most of all, Peter Stansky has provided a particularly felicitous combination of direction and freedom. He told me once that all

the best work began with an episode of serendipity. It has indeed been serendipitous for me that he could bring his incomparable knowledge of British culture and politics to bear on this project in both obvious and mysterious ways.

At Stanford I was extremely lucky not only in my immediate advisers but in having a larger community of scholars interested in museum history. Jim Sheehan offered excellent advice at a very early stage in this project; Paula Findlen offered equally excellent counsel at a later one. The Stanford Comparative Gender/Women's History Workshop provided criticism and encouragement in just the right proportion.

I have benefited greatly from participation in a number of interdisciplinary institutes while completing this project, all of which have sharpened my thinking and enlivened the processes of research and writing. I thank in particular the Stanford Humanities Center Fellows of 1996–97 and all of my colleagues at the Columbia Society of Fellows in the Humanities in 1999–2001; special thanks are due to Karl Appuhn, Jonathan Gilmore, and Andrew Zimmerman for their valuable comments on various incarnations of this book. I was extremely fortunate to complete the proofs and indexing while I was in the early days of a fellowship at the National Humanities Center. Geoff Harpham, Kent Mullikin, the staff of the center, and the Fellows of 2003–4 all deserve great thanks for providing such an idyllic environment in which to put one project to rest and take up another. The center's incomparable library staff, Jean Houston, Eliza Robertson, and especially Betsy Dain provided invaluable assistance.

The Department of History at the University of Washington provided a stimulating and congenial environment in which to complete this project. As chairs of the department, Bob Stacey and John Findlay ensured that I had the time and financial support to undertake new research for this book; both were much appreciated. I have been fortunate to have colleagues in Seattle who have been willing to read a great many things, some of them more than once. I express my thanks to George Behlmer, Ben Schmidt, Lynn Thomas, and especially Sarah Stein for fruitful comments and careful criticism.

Many others have commented on different versions of this book, often at stages when I myself did not know precisely what I meant to do. Peter Mandler has always given me exceptionally useful feedback; his generosity in giving his time to this project at critical junctures has been much appreciated. For their constructive and often provocative comments, I thank Bruce Altshuler, David Armitage, Tim Barringer, Jane Caplan, Annie Coombes, Alison Matthews David, Andy Harris, Philippa Levine, Dianne Sachko Macleod, Lara Perry, Erika Rappaport, Marya Schock, Vanessa Schwartz, Randy Starn, Catherine Stimpson, Whitney Walton, Janet Watson, Jay Winter, and Kristin Zimmerman.

I also greatly appreciated David Wayne Thomas's generosity in sharing the page proofs for his forthcoming study from the University of Pennsylvania Press, *Cultivating Victorians: Liberal Culture and the Aesthetic*. Lara Kriegel has been a stellar fellow traveler. I express my gratitude to her for her helpful and numerous readings of this book.

In a time when it has become increasingly difficult for junior scholars to find support for their first books, Susan Bielstein at the University of Chicago Press has been unfailingly enthusiastic. Her initial suggestions helped me turn my dissertation into a book, and she has been patient with my own wild schemes. Her editorial assistant, Anthony Burton, has answered all of my many questions with fortitude, and Jane Zanichkowsky did much to improve my prose. Leslie Keros made several heroic interventions and took great care in shepherding the book through production. Seth Koven was an incredibly important reader for the press and for me. His extensive and generous comments have been of enormous value to me, and I hope he will see that I have tried to live up to his suggestions. Two other anonymous readers for the press offered thoughtful advice as well. Portions of chapter 3 appeared as "Picturing Feminism, Selling Liberalism: The Case of the Disappearing Holbein" in *Gender and History* 11 (1999): 145–63; a shorter version of chapter 4 appeared as "Radical Conservations: The Problem with the London Museum" in *Radical History Review* 84 (2002): 43–76.

I am pleased that my family and friends have had intense and sincere bouts of interest in this project but equally glad that these bouts were short-lived enough to keep me excited about doing something new. I especially thank Viviane, Rebekah, Molly, and Kate for all their love and humor. I am profoundly appreciative of the fact that we have all gone in different and interesting directions without growing apart. When I began thinking about this project years ago, I was an only child; I now thank Billie, Nicky, Cole, Alex, Chase (and Viviane again), as well as my grandparents, for enlarging my ideas of family. Most of all, I thank my parents for their faith in me and for their support in bringing this project to a close. I am very glad that my father, Michael, who is a vivid storyteller, told me elaborate bedtime tales about British military defeats. Although the stories themselves have not made it into the book, I hope that he will see some of his own spirit reflected here nonetheless. His great enthusiasm for urban spaces—grand and otherwise—has always been contagious. My mother, Shellie, perhaps did more than anyone to pique my interest in this topic by being genuinely reverent of all things artistic while profoundly irreverent of all else. For both of these qualities, I am thankful.

My final thanks must go to my husband, Christopher, who appeared in my life on the day that I wrote the first sentence of this book. I am happier than I can

say that he is still here. He has done all the things for which partners are typically thanked, including being an energetic and insightful reader, but he has done them in his own atypical and inimitable fashion. Although I have occasionally been surprised by some elements of our life together, I have never ever been bored. This book is dedicated to him.

INTRODUCTION

W hat kind of property is art? Is it a type of property at all? What rights and what duties are attached to it? Does art reinforce the inequities and hierarchies of other kinds of property, or can it revolutionize and transcend them? How did art ever come to be conceived as property in the first place? This book offers a new historical response to these questions. It explores the ways in which the terms "culture" and "property" have been constructed in relation to each other. My study has two major aims. The first is to provide a new frame of reference for understanding the ethics and politics of cultural property. The second is to illuminate the crisis of Liberal ideals and practices—the "strange death" of Liberalism—in Britain before World War I.[1] Here, debates about the possession of cultural objects were born of larger dilemmas: the struggle to define the relationship between property and political identity and the nature of property itself.

As many theorists have noted, property is not merely a relationship between a person and an object but a complex bundle of social relations. Fundamentally, the legal rights of property describe relations among individual people or groups, marking a decision to use the power of the state to allocate a given thing to an owner and prevent others from using that thing without the owner's consent.[2] There is no property without actors; as such, property can be a compelling expression of the human will.[3] Historically, property rights have been policed both by a fear of fetishism—hoarding, or "bad" object relations—and by the hazards of dependence that have been thought to characterize citizens without property. The great English legal scholar Sir William Blackstone defined "property" in the eighteenth century as a "sole and despotic" dominion that one person claims over the external things of the world, in total exclusion of the rights of any other individual.[4] This trait of exclusivity has long been taken as an ideal marker of property rights; it has, of course, been the most salient object of radical critiques of private property as well.

1

But not all types of property function in the same way. Legal scholars have been divided with regard to the question of whether cultural property can be regarded simply as a branch of property law (along with real property, personal property, and intellectual property) or whether it requires its own legal regime. As with laws of land and chattel, cultural property laws mark out relationships among individuals and groups. But unlike money or economic assets, works of art are indivisible. At least in physical terms, there is no possibility for a judgment of Solomon in the field of culture.[5] Furthermore, normal definitions of unqualified ownership are not adequate to describe cultural objects, because an entire community may have a stake in protecting these objects. It is for this reason that cultural objects have often been protected by a tradition of stewardship rather than a valorization of absolute ownership.[6] In this tradition, the public interest in works of genius is grounded in *duty*—that is, our collective responsibility to future generations to protect these works—rather than in the *rights* of ownership that characterize other types of property. As John Ruskin argued in the nineteenth century, the collective obligation to care for works of art is thus derived from the creators of the works themselves. Duty, not right, has therefore been a particularly powerful mode of interpreting the ownership of culture.

This study treats a series of disputes about the ownership of cultural objects in late nineteenth- and early twentieth-century Britain. I have called these objects "cultural" in order to indicate that they had undergone the mysterious process of being assigned value both by individuals and by institutions, an evolution that is itself a historical artifact.[7] My sense of "culture" is bounded by the fact that I have focused on objects that were institutionally laden with value, that is, they were enthusiastically trafficked by collectors and curators for public display. The manner in which they accrued value is part of my story as well. The key actors in these episodes were urban workers, women (mostly, but not exclusively, feminists), and Irish and Scottish nationalists. The objects of their desires ranged from a group of ancient gold ornaments dug up from a Northern Irish field to a portrait of a Danish duchess. These actors fought to return objects to their imagined points of origin; they fought to keep other objects at home. Sometimes, they fought to destroy the objects altogether. They wielded the conventional political weapons: the parliamentary debate, the pressure group, and the press. But at times these groups became anarchic, threatening to lay claim to Britain's artistic treasures by force. In so doing, they expanded the field of possibilities for enacting the uniquely British relationship between property and politics. Ultimately, their efforts to revolutionize the relationship between culture and property pointed to the new ways in which conceptions of gender, labor, and Celtic and colonial identity shaped and were shaped by late nineteenth- and early twentieth-century Liberalism.

The true Liberal—supported by Free Trade, a majority in Parliament, the Ten Commandments, and the illusion of Progress—vanished from Britain before the war ever began. This brand of Liberalism was killed, or killed itself, long before 1914. Or so claimed the historian George Dangerfield almost seventy years ago. In his classic text *The Strange Death of Liberal England,* he sketched a compelling vision of a nineteenth-century Liberal Party crushed between Capital and Labour, militant suffragettes and defiant Tory peers, Irish Home Rulers and unyielding Unionists. In Dangerfield's narrative, the world of culture (both high and low) was literally parenthetical to that of high politics.[8]

In contrast, one premise of the present book is that political history and cultural history are utterly inseparable in the history of Liberalism and its decline. It is, in fact, a particular path in the politicization of culture that forms the central axis of my study. As Matthew Arnold recognized long ago, Liberalism in Britain was in part an argument *about* the relationship between culture and politics, that is, how to implement models of education and cultural authority that would create rational citizens and stave off the forces of anarchy. This is precisely because the crisis of Liberalism evoked a cultural world of its own—its own states of mind.[9] What I wish to explore is the material culture of Liberalism. The debates treated in this book tell us something of what Liberals wanted their cities to look like, what kinds of objects they wanted to look at and own, and what kind of aesthetic (if any) they hoped to impose on their fellow citizens. Perhaps it is useful to stress that this was never a unitary vision. The history of "culture" in Britain has most often been narrated in terms of a complex set of responses to industrialization, democracy, and overseas expansion. But conceptions of "culture" were always responding to much else as well, including claims by feminists, Irish and Scottish nationalists, and urban radicals that they, too, were to be cultivated. Furthermore, the geographic sites at which "culture" and "property" were defined were not limited to England but extended across the United Kingdom and deep into the colonial world. Whereas the definition of "culture" in an Arnoldian framework is purposely expansive, I am focusing here on a particular stratum of debates that posit a less antithetical relationship between anarchy and culture. My primary concern is with the particular dilemmas confronting the Liberal Party in the late nineteenth and early twentieth centuries. But one important aspect of the history of cultural property is the way in which its traffic speaks to ongoing struggles of definition about the broader constellation of values denoted by the term "Liberalism." In this study, property—that central category of British history—is taken as the fulcrum of Liberal questions about the intersection of culture and politics.

The era spanned by this study (c. 1870–1914) was one of great experimentation and innovation in the rights of property, both in the extension of the

privileges and duties of possession to new players in British politics and in the articulation of new critiques of property itself.[10] One of the key shifts in Liberal theory and praxis in this period was in its vexed relationship to property rights. As the Liberal Party moved away from its longstanding defense of individual ownership, political theorists of all persuasions were obsessed by this reformulation of property as both a private and a social phenomenon.[11] Property, which in the English legal tradition was originally synonymous with land ownership, developed a more esoteric set of meanings during this period.[12] At its broadest level "property" not only referred to material goods but also was a shorthand reference to power. As such, property was therefore necessarily a dynamic concept, not a static one.

Like real property, or land, there is an implicit assumption regarding cultural property that the object itself is unique and not a fungible good for which proprietary rights might be easily exchanged for money. But cultural property also shares traits with intellectual property, in that both are infused with notions of human creativity and depend on the idea that creators have proprietary rights. One useful suggestion has been that cultural property is therefore a pastiche of all the other property regimes, copying aspects of the law of land, chattel, and intellectual property.[13] One of the aims of this study is to begin to disentangle the various historical elements of these regimes. In late nineteenth- and early twentieth-century Britain, debate about the ownership of cultural objects might be seen less as an imitation of existing property rights than a revolution in them. The rules that governed ownership of land and chattel were challenged by new efforts to reevaluate and regulate the ownership of art. Cultural objects—with their highly debatable traits of inalienability and nonexclusive ownership—provided fertile ground for rethinking the interdependence of property and political identity in Britain before World War I. As the property owner was joined in British political thought by the guardian, the steward, the trustee—that is, the nonexclusive owner—these efforts redounded on broader questions of citizenship and political participation. Fundamentally, British debates about culture and property spoke to the tensions and bonds between Liberalism's individualist past and its collectivist future.

The episodes of conflict explored in this book have a particular relevance to the distinctive British history of property and politics. As such, they serve as a point of entry into a new account of the dilemma of Liberalism in which the nexus between the ownership of cultural objects and the shifting ethics and laws of property illuminates the broader predicament of possession in Britain. But these debates also bear in significant ways on the legal and philosophical questions at the heart of cultural property law today. Out of the maelstrom of Liberal crisis in Britain—characterized by the rise of Labour, the radicalization

of feminist politics, and the acceleration of Irish and Scottish nationalisms—a new conceptualization of culture and property arose. British debates about the ownership of cultural objects played a pivotal role in shaping the relationship between culture and property, that is, in seeing these terms as mutually constitutive.

I have been using the phrases "cultural objects" and "cultural property" interchangeably, in part because it is anachronistic to describe objects as cultural property before the mid-twentieth century. The term "cultural property" was first used in English in a legal context in 1954, at the Hague Convention for the Protection of Cultural Property in the Event of Armed Conflict. The convention's definition of this phrase included any works of art and archaeological, historical, or ethnological objects that could be considered the material evidence of a particular stage of civilization. But as the pioneering legal scholar in this field, John Merryman, has noted, the phrase "cultural property" has been more expansively (or, one might say, liberally) defined since the convention to include almost anything made or changed by man.[14] Cultural property has several key traits: it is a finite, irreplaceable, depletable, scarce, and nonrenewable resource, like an endangered species.[15] More recently, the term has also come to encompass the less tangible realm of ritual practices, such as Maori initiation rites or the Japanese tea ceremony. As the anthropologist Annette Weiner has argued, "culture" has become an increasingly prized commodity; in the twenty-first century, culture itself is a form of property.[16]

If the legal definition of cultural property is relatively recent, the concept is ancient. The Greeks and the Romans both enacted prohibitions against plunder. The Greek historian Polybius, for example, called for the protection of art from foreign claim or seizure, and Cicero forced the praetor of Sicily to pay retribution to the Sicilians for plundering their art for his personal use.[17] In 1464, Pope Pius II prohibited the exportation of works of art from the papal states; this date has served as the inaugural point for cultural property law in at least one major study.[18] Historically, the looting or destruction of cultural property has been interpreted as a sign of deterioration in the codes of warfare. The modern idea that all cultural and artistic objects belong to humanity rather than to any particular nation—what has been termed the "internationalist" perspective on cultural property—has its roots in the customary international law that developed in the eighteenth and nineteenth centuries to restrict the plunder of cultural objects as war booty.[19] In 1758, the French writer Emberic de Vattel's *Law of Nations* declared that the destruction of cultural property was tantamount to an attack on humanity itself.[20] But de Vattel's principles were not sustained during the wars of the French Revolution, when the French imposed treaty provisions on the Italians and the Low Countries in order to legalize their acquisitions retroactively.

The Napoleonic campaign of conquest and looting across Europe prompted new restrictions against plunder at the Congress of Vienna, at which the nations allied against Napoleon demanded the return of the looted properties to their countries of origin. The guiding principle of all of these laws, which met with only limited success, was that a state's sovereignty over its cultural objects could not be disturbed by an occupying power. Because private property was ostensibly immune from confiscation or pillage during war, cultural artifacts were protected by the legal fiction that they were a special form of private property.

During the American Civil War, a professor at Columbia University, Francis Lieber, formulated the Lieber Code of 1863, which profoundly influenced international property law. The Lieber Code stated that an invading nation had the right to seize cultural objects but must hold these objects for safekeeping pending the resolution of their ownership in peacetime. The objects could not be sold, given away, privately appropriated, or wantonly destroyed. The premise of the code was that the destruction of cultural property due to military defeat furthered the annihilation of a community's sense of its own history. As such, this destruction was incompatible with just war. In 1907, the Hague Convention confirmed the illegality of military plunder. This convention marked the first time the international community had codified in writing the notion that each nation's cultural heritage was so valuable to humanity at large that it merited special protection during wartime. The 1907 convention was ratified by forty nations, including Germany, France, Britain, Russia, and the United States, although its terms would be routinely violated in both world wars. In Nazi Germany, Hitler's artistic irredentism—the quest to centralize all artworks created or owned by Germans—evolved into the megalomaniacal project of commanding all the artifacts of European culture. This appropriation of cultural property was part of a larger alienation of all property owned by groups targeted by the Nazis, establishing the Third Reich as a kleptocracy of unprecedented scope and scale.[21] In the aftermath of this large-scale wartime displacement of artistic goods, cultural property law has become a moral argument, just as provenance research has finally become a moral imperative.[22]

Historically, legal discussions of cultural property have focused on the issues of military seizure and destruction during times of war.[23] Indeed, cultural property laws would seem to have originated as a way of regulating warfare. In addition to international warfare, the other key point of reference for cultural property debates has been the ongoing legacy of colonial violence and dispossession. During the 1960s, the development of modern sovereignty in former colonial regions prompted an explosion of national cultural property laws aimed at regulating the traffic in cultural objects between Europe and its former colonies or between indigenous groups and museums. In Australia, Canada, and the

United States, cultural property rights have been linked to a host of other human rights issues, including indigenous land rights, civil rights, education, health, and social welfare.[24] As the chairman of UNESCO has said, cultural property and its return constitute one of the key problems of the Third World.[25] Debates about cultural property—focused on artifacts ranging from the Parthenon, or "Elgin," marbles to Kennewick Man to the *Enola Gay* to the German artworks looted by the Red Army Trophy Brigade—have thus become an important part both of restitutions made after 1945 (or the lack of them) and of postcolonial political life. The study of cultural property until now has been dominated by late twentieth-century concerns about the protection of artifacts during and after armed conflict and the cessation of an illicit market in cultural goods, focused primarily on power relations between Western and non-Western governments.

Cultural property law has inspired its own fruitful tradition of self-criticism, based primarily on the intricate and convoluted legacies of colonial legal relationships.[26] At stake is the broader question of whether law holds a redemptive status in postcolonial worlds. That is, considering that many of the objects now under contention were legally acquired, is law necessarily the best vehicle by which to negotiate their return? Critics have noted that the doctrines of utility and ownership invoked to reclaim indigenous objects are part of the same ideology that legally disenfranchised indigenous groups under colonial regimes.[27] In practical terms, the advent of stricter cultural property protection laws in non-Western nations has been accompanied by a rise in the illicit antiquities trade in those same nations.[28] Furthermore, the legal terminology of cultural property—which refers to artistic objects as things to be distributed, allocated, and apportioned—has been criticized for commodifying objects that would not otherwise undergo this process.[29] Rosemary Coombe has argued influentially that Western categories of intellectual and cultural property reflect and secure the logic of individualism and the cult of the "original" artwork, privileging a Lockean theory of equation between objects and identity—or having and being.[30] According to this view, the conceptual framework of cultural property is grounded in a reductionist Western legal philosophy of individual ownership that fails to recognize other forms of collective cultural knowledge.[31] The laws of cultural property therefore actually extend or enact the violence of colonization, tearing asunder what many indigenous groups view as integrally joined: spirit and matter, for example, or creator and community.

In effect, this book is a prehistory of cultural property, that is, of the legal category of cultural property that emerged at The Hague in 1954 and has shaped the rules of circulation and exchange ever since. The laws of cultural property have had many diverse antecedents and many national points of departure. Because the genealogy of these laws in fact extends back to the ancients, we might

reasonably plot the origins of cultural property anywhere on a line from Cicero's
Rome onwards. What is the rationale for privileging Britain in this particular
study? Is Britain just another point on this line, albeit one that has perhaps re-
ceived less attention than revolutionary France or post-Holocaust Germany?

My answer, of course, is no. This study makes the case that the history of
property and culture in late nineteenth- and early twentieth-century Britain re-
veals much about the politics of exchange that is fundamental to cultural prop-
erty laws today and is potentially disruptive to these same laws. I would not claim
that all ways of thinking about culture and property originated in Britain. Rather,
Britain in this period was an important site of an intense politicization of debates
about the ownership of cultural objects. Overwhelmingly, cultural property has
been understood in terms of international projects for regulating military con-
quest or postcolonial resistance. The dispossessions of colonial history are part
of the story I seek to tell. But British debates about the ownership of cultural ob-
jects were not chiefly about the restriction of plunder—at least, not by foreign
powers. Rather, the primary concern was the centrality of ownership within Brit-
ish political thought and the widely divergent relations to theories and practices
of ownership borne by women, workers, and Irish and Scottish nationalists. Per-
haps the key historical factor in forging British theories about culture and prop-
erty is not in the division between foreign war and domestic peace but in com-
plicating the parameters of "domestic" history itself. Anthropologists of art have
often taken as the starting point for their investigations the assumed conflict be-
tween Western and non-Western notions of value and preservation. One aim of
the present study is to investigate the visual anthropology of the British them-
selves: to make the circulation and exchange of artifacts in London, Dublin, and
Edinburgh as strange—and historically precise—to us as that which has taken
place in the context of overseas contact. The ways in which Britons thought
about cultural objects can never be separated from the broader history of ex-
propriation in which British art and ethnographic collections were formed. But
there is another history of material culture in Britain to be told, one in which the
status of such objects is of equal interest for feminists, for the Irish and the Scots,
and for urban radicals.

This history of debate about the relationship between culture and property
in Britain seeks to challenge and reorient the cycles of acquisition and return that
characterize contemporary museum culture. In mapping these histories, I intend
to illuminate the trajectories that European and American laws regulating the
traffic in cultural objects have taken in our own time, often in unanticipated
directions.[32] As *The Culture of Property* suggests, these paths were fashioned in
part by the torsions of British history—that is, by the fateful twists and turns of
the history of Liberal decline.

PRELUDE

On October 15, 1908, an Irish clerk and ex-soldier named Wallace Brandford Collins ordered a throng of unemployed men and women in Hyde Park to riot at the British Museum. Collins was described as a man of powerful physique who wore a dirty red rag and a war ribbon in his buttonhole. He exhorted the crowd, estimated by the police at four or five hundred people, to raid the public collections at Bloomsbury: "If you chaps go into the British Museum and see any art-pictures there, and it is not yours, well, you take it. It is worth taking it. If the police interfere with you, smash the frame on his head. It ought to be yours. We made all the art in this country. If you go to the British Museum, take all that is in it."[1] After this rousing speech, Collins gathered his followers at Marble Arch and set out to storm the British Museum. One hundred men followed him through the streets of London, waving their "Work or Riot!" banners high. The crowd was halted en route to Bloomsbury by a police inspector, who warned the marchers that the museum's iron gates would be closed against them. Collins bid the protestors to join him the next day at the House of Commons with bricks, iron bars, razors, and homemade bombs. He was promptly arrested for using language calculated to cause a breach of the peace and inciting the public to acts of violence.[2]

The Collins trial was a raucous affair, brought to a speedy conclusion by the defendant's own disruptive behavior. Collins shouted down the chief police witness's testimony, declaring that he would smash any work of art in his possession over the inspector's head. In the end, Collins was sentenced to three months in Pentonville, the infamously harsh model prison in north London where Oscar Wilde had been incarcerated ten years earlier.[3] There was great difficulty in getting Collins to leave the courtroom; he refused to make his exit until he had addressed the judge directly, declaring himself a martyr and a hero for world emancipation.

Anarchy and Culture in Britain

Collins's real and imagined path from Speaker's Corner in Hyde Park to the British Museum in Bloomsbury to the House of Commons in Westminster to the Pentonville Prison in Islington marks an important moment in the British invention of cultural property. This protest was noteworthy for the violence of Collins's rhetoric, for the particularly explicit connections he drew between the realms of culture, labor, and property—and also, of course, for the collective delusion of his audience that the artifacts at Bloomsbury represented the relics of alienated British labor rather than a storehouse of imperial booty. When Wallace Collins urged his followers to dismantle and take back these collections in 1908, he conveyed a vital sense of a museum under siege, that is, a museum in an age of protest politics.[4]

But the Collins rally was not the first or the largest episode of its kind. On April 30, 1876, a rainy Sunday afternoon, twenty thousand workers and artisans took to the streets and marched, first to the British Museum and then to the National Gallery.[5] Their demands were not for a wider franchise or higher wages but simply for the Sunday opening of all art institutions so that the workers might visit them more easily. The Sunday Society, the reformist pressure group that organized the march, represented the leading lights of Liberalism in its day; Henry Fawcett, Charles Dilke, Mary Carpenter, Joseph Chamberlain, Jesse Collings, Jane Cobden, and the earl of Rosebery all served on the society's executive committee, along with T. H. Huxley and Charles Darwin.[6] The marchers paused at the National Gallery, and the leaders soberly knocked three times on the locked doors for dramatic effect. The crowd then moved on to Hyde Park for a round of speeches and a rather dull rally about the value of mass education.[7]

These protests reflected two very different modes of political action: the uncontrollable ravings of Wallace Collins versus the orderly ranks of the Sunday Society. To put it another way, one protest embodied the very principles of Liberal reform, whereas the other rejected these principles for something more anarchic. But these episodes were linked in important ways as well. The Parliamentary and press debates about Sunday opening were couched in the language of ownership, albeit in less destructive terms than Collins would use in 1908.[8] The radical agrarian reformer Jesse Collings took up the cause of Sunday opening as an issue of proprietorship. In his view, the British Museum belonged to the nation's workers in the same way a private picture gallery might belong to a lord; the only difference was that the latter was the sole proprietor, whereas the former were proprietors in their corporate capacity as taxpayers.[9] On entering a museum, another Sunday opening advocate argued, one should have the notion that "he was going into his own house to see what was his."[10]

As the introduction to this book suggests, Britain has not been the sole point of origin for cultural property law. The concept of cultural property—and the development of laws intended to regulate the circulation and exchange of cultural objects—have had a long international history. For example, Dominique Poulot's analysis of the Louvre as a radical critique of royalist notions of patrimony is instructive in showing that the notion of property was absolutely central to the French art world in the eighteenth and nineteenth centuries.[11] The very flexibility of the concept of cultural property has contributed to its political importance in European historical contexts from Napoleonic France to Nazi Germany. But Britain's own complex history of property both marked it as a particularly productive site for the development of debates about the ownership of cultural objects and raised the stakes of these debates. Concepts of property remained vital to political identity in late nineteenth- and early twentieth-century Britain, just as they had been in the early modern period. But the 1870–1914 period marked a watershed of ideas about the relationship between property and citizenship in Britain.[12] The formation of widely divergent groups such as the Liberty and Property Defence League, the Central Land Association, the Commons Preservation Society, the Free Land League, the Land Law Reform League, the Metropolitan Public Gardens Association, the Land Nationalisation Society, the English Land Restoration League, the Land Union, and the Agricultural Organisation Society illustrated the changing and contentious value of land in the prewar balance of property, politics, and power.[13]

The driving question of property—how it was defined, owned, and exchanged—was linked to competing notions of British government as an individualist or collectivist endeavor.[14] Of course, as Jeremy Waldron has helpfully noted, concepts of private and collective property are ideal typic categories, never to be found in history in their pure forms. Nevertheless, the legal fiction that such categories existed purely was predominant in British thought on this subject.[15] For many eighteenth-century jurists—most famously, Blackstone—land had been the paradigm of property, and other concepts of property, such as literary property or copyright, were formulated on the basis of this model of landed estates.[16] But as the value of land in Britain shifted, so did its hold on the paradigm of property more generally. In Britain, theories of landed property rights before World War I rested on three intellectual pillars: natural right, the Benthamite theory of utility, and an aristocratic-legal tradition of land ownership that was being irrevocably altered by the expansion of towns, the growth of urban forms of landed property, and agricultural depression.[17] After the passage of the Married Women's Property Acts (first in 1870 and then, more significantly, in 1882) and the tentative resolution of the Irish land wars in the early 1900s, the circulation and redistribution of property along gender, class, and colonial lines

became a more general concern. Indeed, Oliver MacDonagh has suggested that the Irish Land Acts enacted at the end of the nineteenth century were perceived in England as a counterpart to the Married Women's Property Acts; this period therefore witnessed an analogous reformulation of property rights for women and the Irish.[18]

Within the Liberal Party, the traditional defense of individual ownership became more multifaceted. The Liberals developed their own land reform movement after a radicalized generation of M.P.s swept into Westminster in 1906.[19] The Edwardian "New Liberals" did not abandon individualism—in the realm of property or anywhere else—but rather reinterpreted it according to shifting boundaries between voluntarism and an enlarged view of the capacities of the state.[20] There was no such thing as a unified Liberal stance regarding property, beyond the fact that property rights played a vital role in Liberal thought and politics. The fault line of this issue ran within the party as well as between Liberals and Conservatives or Liberals and Radicals. In terms of reform, especially regarding the question of land, Liberals were divided about what they wished to achieve. Overwhelmingly, they wanted to eliminate the fiscal privileges of land ownership, a process that began with William Harcourt's Budget of 1894. But there was no consensus about whether land ownership should be diffused or abolished.[21] In short, property was one of the major political issues of the New Liberalism, defining its relationship to moral and material progress and generating new energies and sources of tension within the Liberal Party.[22]

In late nineteenth- and early twentieth-century Britain, modes of ownership were unusually varied and contradictory. As George Dangerfield had put it with regard to radical feminist attacks on shops and galleries, property was the question concerning which the Liberal government was most vulnerable: property, therefore, must be threatened by those who sought to challenge this government.[23] But property, as a tool of political protest or negotiation, was not only to be imperiled or destroyed. It was also circulated, redistributed, and preserved anew. During this period, different groups—namely, the same feminists, socialists, and Celtic nationalists long depicted as Liberalism's executioners—struggled to formulate institutional practices that would promote their political goals. In contending for the ownership of art, these groups were participating in a broader meditation on the dilemmas of property in Britain. Their efforts to reconstruct the relationship between culture and property addressed the status of individual and group rights of ownership at a moment of intense national preoccupation with this issue, focused on the bond between the privileges of ownership and the rights and duties of citizenship. Debates about the ownership of cultural objects both "high" and "low"—from a hoard of Celtic gold ornaments buried in an Irish field to a Holbein portrait at the National Gallery in London—

functioned as a form of dissent or self-criticism within Liberalism, especially as
the Liberal Party's attitudes toward property became increasingly complex.

Cultures of Property

Historians of property have not conventionally dealt in the realm of art and ar-
tifact, focusing instead on the links between economic, legal, and political sys-
tems.[24] The English conception of "property" had traditionally rested on the as-
sumption that ownership was a legally absolute condition, whether transfers of
property occurred within an individual family or between individuals and the
state.[25] Property, whether it was to be governed by authority or affirmed in lib-
erty, has often been taken as the foundation of personality itself.[26] As C. B. Mac-
pherson argues in his classic text *The Political Theory of Possessive Individualism*,
property in the bourgeois sense is not only a thing or a right to enjoy or use; it is
also a right to dispose of, to exchange, to alienate.[27] Indeed, the Anglo-American
approach to the alienability of property has been characterized as an inability to
imagine any form of possessive power that stops short of the power to bestow.[28]
By the mid-nineteenth century, the right to alienate one's property had become
the centerpiece of British proprietorial prerogative.

The question of whether art could be treated like any other form of prop-
erty was a vexed one in Britain and was directly engaged by a variety of schol-
ars and critics.[29] The two key issues were alienability and absolute ownership.
Was the ownership of art ever really absolute? If not, could cultural objects be
trafficked and bartered like any other form of property? Anxieties about the own-
ership of exhibited objects can be traced back at least to the Great Exhibition of
1851. The Protection of Inventions Act, passed nineteen days before the open-
ing of the Crystal Palace, reflected Henry Cole's desire to use the traditional lan-
guage of property rights in land and money to protect the rights of invention.[30]
Debates about artistic copyright prompted new efforts to define "art property"
in an institutional context as lawyers and politicians considered whether the ex-
hibition of an artwork in a public gallery constituted a form of publication. Dif-
ferent types of galleries engendered different modes of property law. For ex-
ample, a painting displayed at the National Gallery—where there were no rules
to prevent copying—must be considered a "published" painting. But the same
painting, if displayed at the Royal Academy, where copying was forbidden, could
not be said to have been "published."[31]

In part, the question of copyright rested on the moral qualities of the work;
as one legal scholar argued in 1881, copyright could not exist in immoral, irreli-
gious, seditious, or libelous works of art.[32] In 1879 the *Art Journal* stated unequi-
vocally that "the picture is a property [and] domestic life itself is sanctified by

the doctrine of exclusive right,"[33] but the Museums Association insisted equally strongly that "there is no private property in a work of genius."[34] The concept of individual possession, now a heated question of party politics, seemed particularly fluid within the realm of art.

An influential 1888 essay by W. H. Mallock referred to a man's pictures as his property, but only if he could sell them.[35] For Mallock, property in art was thus delimited by its alienability. Yet the concept of total alienability applied to art was clearly anathema to many British critics. Recently, Paul Barlow and Colin Trodd have argued that art "speaks the language" of property: indeed, art cannot be sustained *without* property.[36] Property, they contend, is both the condition and the corruption of the communal culture. That is, the audiences for art—the "promiscuous crowds" that cluster at public galleries and museums—are only the recipients of the bounty of prudent men. Other scholars have characterized the display of works of art in modern galleries as the "emancipation" of the artwork from the constraints of ownership.[37] As Marcia Pointon has suggested, an item separated from its owner (an artwork in a museum, for example) is no longer property, except in a strictly legal sense.[38] These artifacts thus constitute a form of "lost" or "ownerless" property.

We might say, then, that public art does speak the language of property, but it is often a language with an absent referent: the owner. And this language has developed alongside the institutionalization of objects in museums. In the sixteenth and seventeenth centuries—in Italy, for example—gift exchange played an important role in collecting, and artifacts were valued as tokens of the relationship they signified between the donor and the recipient.[39] In general, artifacts were not collected permanently but moved from hand to hand as part of a steady expansion of exchange networks. By the nineteenth century, the permanence of an artifact in a given locale was understood quite differently. In theory, the process of "collecting" had come to mean taking objects out of circulation by assigning them permanently to public collections.[40] This specter of permanence intensified discussions about the ambiguities of alienation and exchange in dealing with cultural objects. In late nineteenth- and early twentieth-century Britain, the question of how art might be owned generated a high volume of critical debate. Artists, individual buyers, and institutions asserted their different claims to the ownership of cultural objects in Britain, based on labor, consumption, and the power of preservation, respectively. These debates dealt both with the virtues of private collecting and with the special nature of property in art as it applied to public galleries. In *The Sport of Collecting*, Sir Martin Conway argued that ownership of a work of art bestowed an entirely different set of virtues than simple contemplation of the same work outside one's own home. He wrote,

"The glamour of possession is a reality. It enforces all beauties; it clouds over de-
fects. . . . It is at once stimulus and anesthetic."[41] For others, the experience of
ownership could serve as a pedagogical incentive, inspiring collectors to exam-
ine works in galleries more closely and lengthily to avoid making costly mis-
takes.[42] But who, if anyone, owned the works of art in the galleries themselves?
One fretful donor wrote to the distinguished collector Charles Fairfax Murray
that the notion of ceding a picture to a public gallery before her death made her
feel like a "socialist."[43] Public art institutions appeared to transform relations be-
tween owners and objects in ways that could provoke anxiety as well as national
pride.

The weak statist tradition of support for the arts in Britain was a political
maxim of the nineteenth century, just as it has become a scholarly truism.[44] The
public art collections of Britain were formed overwhelmingly by individual do-
nations rather than a systematized government policy of acquisitions. This fact
intensified the British sense of connectedness between private property and
collective heritage, especially as the number of private loans to public exhibitions
increased dramatically around the turn of the century.[45] The rise of private "art
rescue" services such as the National Art-Collections Fund, founded in 1903,
recast the terms of ownership between donors and institutions.[46] At the same
time, these new measures situated the public museum in the spheres of volun-
tarism and philanthropy. The democratization of art collecting—exemplified in
the *Times*'s aphorism that "we *all* care a little for art in these days; and we *all* col-
lect a little"—placed art proprietorship on a national scale.[47] In 1896 one Brit-
ish critic proposed a new labeling system in which the history of an object's own-
ership would be conveyed along with the name of the artist and the title of the
work.[48] The ethical meaning of the artifact was hidden in this story of private
property lost and gained, and it was the duty of the responsible curator to exca-
vate that story for the purposes of general education. This was, in the author's
opinion, the most "romantic" aspect of institutional pedagogy: the history of
property itself. Aesthetics and politics were united in a conceptual and legal ap-
paratus of property: the basis of British moral identity.[49]

The special status of art as a form of property fluctuated considerably dur-
ing the prewar period, particularly in terms of its relation to land.[50] As land was
increasingly equated with and supplanted by other kinds of capital,[51] political
theorists from all parties focused on artistic property as a potential means of in-
tervention in this shifting relationship between individual and collective owner-
ship. The word "culture" itself is derived from the Latin *colere*, meaning "to till
or to cultivate," drawing on an elaborate metaphor of ownership to link the ter-
minology of crop breeding and physical cultivation to a process of individual

refinement and domestication.[52] In more historical terms, Peter Mandler has shown that the 1880s marked a new era in the interaction between the art world and the fiscal world, as the agricultural depression necessitated asset sales by landowners and the prevalence of wealthy American buyers stimulated the market for Old Masters. Furthermore, low land valuations and high art valuations made the sale of artworks a first resort for financially strained landowners.[53] Although the antiquarian and Liberal M.P. Sir John Lubbock proposed a series of preservationist laws to protect British heritage, his bills were routinely scuttled as hazardous to private property rights.[54] The Settled Land Acts of 1882 allowed the sale of heirlooms to support ailing landed estates, which produced a stream of aristocratic art collections in British auctions. The founding of the National Trust in 1895 gave the state a way out of the potential conflict between public interest and private property; the Trust held property privately as a registered company but treated its holdings as inalienable. Although its preservationist aims were rarely fulfilled, the principles of property had been safely vindicated.[55]

Historically, disputes about property have been some of the most deadly to arise, particularly in colonial contexts.[56] Although the nature of property rights was central to nineteenth- and early twentieth-century British political discourse (best known, perhaps, for issues related to the "Irish Question" such as fair rents and fixity of tenure), the wider geographical dimension of debates about property extended to settler acts and efforts to elaborate or overturn the ownership rights of indigenous populations in Canada, Australia, and South Africa.[57] The dogma that colonized peoples had a "different" perception of property—namely, an undervaluation of it—eased the alienation of this property for colonial collectors of all kinds. In art historical terms, nineteenth-century artists used their canvases to illustrate the processes of colonial dispossession, idealizing the history of settlement and acquisition in faraway lands in the medium of landscape painting.[58] In 1892 Rudyard Kipling elaborated the terms of this debate, suggesting in a *Times* editorial that art owners should "spread [their] pictures over all earth, visiting them as Fate allows. . . . Nature is not altogether a bad frame-maker."[59] In Kipling's view the National Gallery could never be so English as the great museum of the countryside. The equation of land—British and otherwise—with the cultivated space of the gallery prompted an irate response from C. F. Dowsett, a land auctioneer. Dowsett argued that wealthy Britons should cultivate the land instead of buying paintings. This substitution of land for art within the market of luxury commodities would, Dowsett promised, benefit rural districts and ease agricultural distress.[60] By the following morning, the *Times* had taken up Dowsett's call for a National Gallery of Land and transformed Kipling's satire into a debate about the aesthetics of land ownership.

British buyers were faced with a choice between owning Constable's landscapes and owning the land itself. According to Dowsett, these two forms of property were both commensurable and incompatible. Britain would have to make a choice about what form of capital it wished to bank.

In 1909, Lloyd George's "People's Budget" further complicated the relationship between art, landed property, and British identity. The Budget entailed a new set of Radical taxes that financially strained the aristocracy and prompted the sale of many country-house art collections to continental and American buyers.[61] As Mandler notes, the top rate of the estate duty had gone up to 11 percent in 1907, after the Liberal victory in 1906, and up to 15 percent after the passing of the Budget two years later, triggering a new flood of art and land sales.[62] In July 1909, *Punch* published a satire titled "The Detachment of Prenderby: The Land Clauses of the Budget," which mocked the recasting of art as the "new land."[63] The narrator begins by finding the fictional Lord Prenderby seated in his exquisite Louis Quinze chair, absorbed in contemplation of the many masterpieces—particularly paintings by Old Masters—that adorn his chambers. Prenderby congratulates himself on having had the good sense to sell his land years ago and spend the proceeds on paintings, since Lloyd George appears less resentful toward paintings than toward real estate.[64] Prenderby also mentions that these works of art are exempt from taxation during his lifetime. If art were treated as land, Prenderby notes, he would have to pay taxes on the canvas, the oil paints, the foregrounds and backgrounds, the animal and human figures, and the wall space. The narrator is increasingly dejected about the declining status of land in Britain, but Prenderby debunks the national myth of land as the highest form of property.[65]

When the narrator continues to claim mournfully that "there's something peculiar about land" and chastises Prenderby for investing in pictures that yield no monetary interest, Prenderby responds that his art collection yields "at least five per cent in the form of luxury—the pure joy I get from regarding them."[66] More important, Prenderby concludes, land has become subject to all sorts of unfortunate intrusions from the municipality, which may destroy an individual estate with new streets or railroads. Art is the only form of property that has remained truly "private." Prenderby's multiple forms of "detachment"—his psychic state of ataraxia, his withdrawal from a national community, and his financial isolation—mobilize art as a line of defense against socialism: a final bastion of resistance to communalization.[67] Certainly Kipling and the creator of Prenderby are atypical in the directness of the satire with which they link the concepts of culture and property. But their narratives are nonetheless emblematic of a collective chain of associations between ownership and art in the Liberal crisis.

Liberal Arts: The Fall of the Gallery

Since the early decades of the nineteenth century, the public gallery had been viewed in Britain as a safeguard of Liberal principles: education, moral reform, and national cohesion.[68] The Crystal Palace, with its chaotic display of wares from a federation of nations, enshrined the principles of free trade and commerce, despite subsequent British dissatisfaction with native products.[69] More generally, international exhibitions were thought to reject the "mystery" of private guilds for the openness and transparency of the free market.[70] Henry Cole, the driving force behind the English Department of Science and Art, noted that his efforts to democratize art education in Britain were predicated on the Liberal extension of suffrage in the 1832 Reform Bill.[71] Cole was a close friend of several of the Philosophic Radicals. He also advised Treasury to follow the doctrines of Adam Smith in all its dealings with the department, suggesting that museum workers compete for portions of visitors' fees rather than receiving a fixed salary.[72] The establishment of the South Kensington Museum (later the Victoria and Albert Museum) in 1852, based on the art and design collections from the Great Exhibition of 1851, was thought to reflect a new utilitarian ethos in British educational institutions.[73] The British Museum might remain a haven for aristocratic dilettantes, but the South Kensington collections—gaslit at night and open free three days a week—were dedicated to the manufacturer and the workingman, in keeping with Cole's project of access and reform.[74] If French museums were all about 1789, the scholarly maxim goes, their British counterparts were all about 1832. By the 1860s, one writer happily credited Gladstonian Liberals with the lofty title "the party of art."[75] This is not to suggest that Britain's cultural history was exclusively the province of the Liberal Party—not at all. Tories, Liberals, and Radicals all participated in important preservationist schemes, and Conservative collectors such as Austen Henry Layard were vocal about the role their politics played in shaping their aesthetic concerns. But Tory art lovers aside, public galleries were closely associated with Liberal successes and failures. With its peculiar mixture of material progress, philanthropy, imperial values, and capital, the culture of the British gallery before 1914 has been described as "saturated" in Liberal ideology.[76]

But the question of what constituted Liberal ideology became increasingly elusive during the prewar period.[77] The crises brought on by the rise of Labour, the growth of radical feminism, and the acceleration of Irish and Scottish nationalism all undermined British confidence in the Liberal Party's principles of government. Ultimately, the legacy of the Great Exhibition was called into question as the audience for international exhibitions seemed finally to reach the point of satiety.[78] The surplus capital from 1851 was supposed to be dedicated to pro-

moting future exhibitions, but this goal seemed to lose its appeal toward the end of the century. Public proposals for using this fund ranged from the establishment of a free hospital for all nations to the alleviation of Irish and Highlands destitution and the purchase of an Irish estate for Prince Albert.[79] As the *Times* noted in 1879, the Great Exhibition had not in fact hastened the reign of universal free trade or extinguished national antagonisms. The "pretty dream" of universal aesthetic education and prosperity had "not exactly come true."[80] The Crystal Palace, the starting point of public institutional culture in Britain, was now perceived as the object of both misapplied eulogy and undeserved satire.[81] According to its critics, the Exhibition had not only marred public culture but also had a deleterious effect on domestic design. In her interior decorating guide of 1897 Rosamund Watson wrote, "[T]he great orgie of '51 has left almost indelible traces. . . . Ill weeds thrive apace, and the trail of the Great Exhibition, that very monster which gave birth to a longer-lived monstrosity, the Crystal Palace, is, decoratively speaking, over us all."[82] By 1909 *Punch* could suggest that the Crystal Palace be converted to a private residence for some "great hierophant" of Higher Political Criticism, indicating the failure of the palace as a barometer of public culture and education.[83]

The national sense of failure in artistic matters was overwhelming by the end of the nineteenth century.[84] British galleries were attacked at home and abroad for the poverty and eclecticism of their collections[85] and for their seeming inability to craft a recognizably "national" school of art.[86] Cole's South Kensington "gang"—periodically accused of nepotism—had "made the name of Art stink."[87] Professional groups such as the Museums Association, founded in 1889, were permeated by a sense of defeat almost from their inception. Henry Dawkins, the president of the Museums Association, described the typical British gallery as having "no more right to the name of a museum than a mob had to be called an army," an alarming turn of phrase.[88] One journalist described the management of the major public art galleries in London as "anarchic," comparing the relation of the National Gallery, the South Kensington Museum, and the British Museum to Homer's description of the Cyclops: "[T]hey have no city or common justice; each man does his own justice over his wife and children."[89] Far from upholding a Homeric ideal of nation-building, Britain's public galleries had come to embody the lawless spirit of the Cyclops. The scientist Francis Arthur Bather put the problem to his countrymen even more strongly in 1903: "Our museums," he said, "are a barbarism."[90]

William White, the curator of the Ruskin Museum, sadly confessed to his colleagues that the visitors to his galleries no longer seemed to believe that art could inspire civic virtue. He had once burst into an extemporaneous reading from *Stones of Venice*, John Ruskin's classic exposition of the moral value of art,

while leading a gallery tour, but he had been met with a stony silence and had vowed never to repeat the experiment.[91] Despite the extensive array of imperial booty located in British collections, the perils of institutional misinformation about these artifacts were ever present. One critic, J. G. Wood, published an exposé of the scandalous errors of ethnology that plagued British curators. He claimed that his survey of ethnographic, decorative arts, and science museums in London had identified figures of North American Indian warriors outfitted with beaded head-dresses intended for Bechuana women, various tribal groups indiscriminately armed with Zulu spears, and figures of Bushmen painted the wrong shade of black.[92]

The new exhibition spaces of the period—most notably the Tate Gallery, the Wallace Collection, and the Aestheticist "greenery-yallery" Grosvenor Gallery—posed further challenges to the Liberal educational ethos.[93] At the Tate, the conversion of a former penitentiary to a modern art gallery might have represented the high point of nineteenth-century ideals of public improvement. But the goal of "reforming" the prison into a bastion of civic order was never confident. Ultimately, the Tate project tended to reflect the exhaustion of Victorian ideals of art and moral redemption rather than their fruition.[94] Embedded in a *Punch* poem titled "English, You Know, Quite English," which insisted hopefully about the Tate, "When an Art-Collection's national / It is obviously rational," was a host of disclaimers about the personal failings of Henry Tate as a civic donor and the regrettable absence of moral didacticism in modern English painting.[95] At the same time, there were more material threats to Britain's public galleries. The police at Scotland Yard complained that the major collections, especially those in the Victoria and Albert, were costly and increasingly difficult to protect. In 1909 the police proposed reorganizing all of these collections by economic value rather than by period or type of object so that objects of high value would be grouped together and more easily guarded.[96] The staff at the Victoria and Albert repeatedly requested greater security forces in the early years of the twentieth century, although it is not clear whether their primary concern was theft or other disruptions from unruly suffragettes and political protestors such as Collins.

The nineteenth-century cliché that the public gallery should operate as a secular temple was countered by a wide variety of alternative tropes: the museum as a utopia of class relations,[97] a site of collective political life wherein a man might forget the "selfishness of self,"[98] a useless warehouse for discards from private collectors,[99] a shelter for unfortunate souls,[100] a sexualized space for illicit rendezvous,[101] and a public counterpart to the moral British home.[102] As aristocratic fortunes waned before World War I, Arthur Balfour described the public museum in Britain as the eternal ancestral manor: a home that may never

be broken up.[103] But despite the diversity of museum metaphors, British observers insisted on the uniqueness of their own art institutions, for better or for worse. As Sir James Yoxall, the art collector and trade unionist, recalled, "We travel and admire the galleries on the Continent, but they all either are or were the property of kings and Popes; *our* National Gallery did not begin like that."[104] For Yoxall, the distinctiveness of British galleries stemmed not from the quality of their collections (or the lack thereof) but from the particular set of property relations that had governed their origins and development. Elsewhere (in Napoleonic France, for example), cultural property laws were forged in the crucible of military conquest. Certainly, that aspect of history regulated the traffic in cultural objects to and from Britain as well. But British debates were always fundamentally about the peculiarity or puzzle of property itself.

Outside the Museum: Disciplinary Questions

What of Wallace Collins, the unruly Irish anarchist, and the orderly parade of the Sunday Society? The marchers in 1876 and 1908 were allied by the topography of London, following nearly identical paths through the urban spaces of art and politics. In both cases, the protestors circulated around the National Gallery and British Museum rather than within them.[105] The museum and the gallery—as well as conventional art historical concerns about objects and the methods of display—were more symbolically than practically central in these debates, superseded by the rallying cause of property.

In the final decades of the nineteenth century and the first decades of the twentieth, a series of disputes about the possession of cultural objects underscored the underlying tensions in British Liberalism. Each of these episodes illuminates a different element of Liberalism in crisis, illustrating the variety of ways in which this crisis played out for women, urban workers, and Irish and Scottish nationalists. These episodes took place both within and outside museums, as British art institutions increasingly crossed the boundaries of elite culture and occupied the riotous world of mass politics and the urban press. Whereas national heritage policies tended to aim at homogenous images of the nation, successfully or not, debates about who owned the stuff of which "heritage" was made pointed up the heterogeneous, the marginal, and the atypical within Britain's borders. In these disputes, accepted notions of individual and collective ownership were called into question. Fundamentally, these episodes were concerned with hammering out the definition of property as well as debating its circulation and redistribution. How did the participating groups and individuals define the key terms "culture" and "property"? Should national cultures be conceived of in terms of ownership at all? Would art institutions follow

Liberalism on its new path away from its legacy of laissez-faire and individual property rights? If not, what were the new political parameters of these institutions, defined by extra- or post-Liberal principles? This book offers a new view of the downfall of Liberalism, stressing the centrality of property in British debates about culture.

The history of cultural property thus intersects with but is not limited by the history of museums. My project is indebted to the explosion of museum studies scholarship, which in the past twenty years has located the history of art institutions firmly within the larger histories of state, nation, and empire. Initially, this body of scholarship focused overwhelmingly on France—in particular, on the postrevolutionary founding of the Louvre—as the prototype for the history of public museums.[106] Carol Duncan and Allan Wallach's classic study of power relations at the Louvre has produced a "social control" model of visitors and institutions that has directed museum history for the past twenty years;[107] as the Louvre curator Germain Bazin has argued, museums "suspend" time and place.[108] Chronologically, museum studies scholarship has favored the late eighteenth through the late nineteenth centuries—the period traditionally referred to as the great "museum age," or the heyday of the "exhibitionary complex."[109] The public museum in this era is pictured as an agent of subjugation that sought both to maintain the illusion of a pure Kantian aesthetic and to promote a pro-state agenda under the liberal guise of education.[110]

More recently, scholars have posed important challenges to this Foucauldian model, contending that institutional messages are never passively received.[111] The processes of commemoration, in which museums have played a central role, have been analyzed increasingly in terms of the production of social conflict and division rather than unitary exercises of representation.[112] Art collecting, for example, could function as an expression of desire for the legitimation of local élites, pointing to a range of motivations beyond the monolithic exercise of state power.[113] The intersection of the histories of museums and colonialism has proved especially fruitful, particularly in the case of Britain.[114] Annie Coombes and Tim Barringer, for example, have illustrated the myriad ways in which British art and ethnographic collections functioned as imperial sites of power striving to unite viewers in London and the provinces against the objects produced by "Other" cultures and establishing visual hierarchies of civilizations. But these authors also stress the role of variance and controversy in the creation of imperial museum cultures.[115] These histories of art and institutional power suggest that museums have encountered opposition from their inception and that they have been viewed as agents of social renewal at least as often as canonical fixtures of nostalgia or ossification.[116]

This book is intended neither to detail institutional histories nor to address

extensively issues of installation and display. Rather, its aim is to trace objects in motion. As my list of illustrations suggests, the images drawn upon here are not for the most part images of museums themselves—nor are they exclusively of the objects so carefully housed and guarded therein.[117] The images are of objects *and* their owners, offering programs of revolution and reform for visitors and donors as well as institutions. The illustrations, drawn chiefly from cartoons printed in the popular press, are intended to illuminate the ways in which Britons debated the conception of patrimony as a special form of property. Often, this conception of culture-as-property was itself an object of satire. The argument of the illustrations referenced in this book is therefore geared toward explicating the role of dissent in the ownership of cultural objects.

In recent years scholars have vigorously debated which element of what we now call cultural property—the "culture" or the "property"—has ethical and legal preeminence in making decisions about repatriation, deaccessioning, and other institutional practices.[118] These two key terms have often been understood as oppositional or conflicting, because the notion of "culture" applies primarily to groups and the notion of "property" is historically embedded in the rights of individuals.[119] Where did this conflation come from in the first place? I argue that the formulation of this relationship between culture and property is in many ways logically prior to the institutionalization of objects within the museum itself. If many scholars have come to see this relationship as antithetical, the aim of this project, in part, is to explore the historical context in which these terms became interdependent. My primary interest is in documenting the ways in which "culture" and "property" butt up against one another in British history: episodically, perhaps, but with force.

The history of culture and property in Britain does not offer a linear narrative of legislation and protest politics. Rather, debates about culture and property emerged at specific historical moments when the status of property in Britain was in question. That is, culture and property were conceptually interlinked throughout the period under discussion, from the 1870s through the Great War. But it was only in key isolated moments that this relationship prompted the mobilization of political resources and the formulation of new regulatory legal mechanisms. Much like the history of Liberal crisis, then, the history of cultural property is geographically and chronologically discontinuous.

Chapter 1 begins with an analysis of the historical origins of repatriation in late nineteenth- and early twentieth-century Ireland. It focuses on a battle for the return of a group of Celtic gold ornaments from the British Museum to Dublin. Today, repatriation is typically perceived as a critical response to colonial history, a method of postcolonial resistance. This chapter examines the ways in which the institutional practice of repatriation in fact originated as the prod-

uct of nineteenth- and twentieth-century colonial engagement. The very term "repatriation" is a deeply political one, because it assumes that artifacts have a *patria*—a national character and a homeland.[120] In this case, the problem of determining the political properties of cultural artifacts was complicated by a unique set of assumptions about the relations between the different constituent parts of Britain, all of which were ultimately challenged by the Irish campaign for Celtic gold.

This project is influenced by recent histories of British colonialism that seek to undermine the distinction between "Home" and "Away," considering Britain in this period as a site of colonial tensions rather than a focal point of uncontested power.[121] The fact that the Irish were both "native" and "white" constituted an affront to nineteenth-century colonial discourse. At the same time, the lack of historical closure in the relationship between England and Ireland makes it difficult to perceive Ireland's current situation as postcolonial.[122] The history of repatriation in Ireland functions as a forum for the evaluation and critique of categories of colonialism drawing on the growing historiography of Ireland's uneasy status as a past and present colony. In this sense, this study is both complementary and revisionist with respect to Coombes et al. Instead of focusing on the dispossession of colonized subjects overseas, this chapter considers the colonial elements of the culture of property for those who were identified, however unequally, as British. At its heart, then, are two major questions: First, what was Ireland's status as a colony, region, or nation in the late nineteenth and early twentieth centuries? And second, what is the political and ethical trajectory of repatriation in this particular historical situation? Or to put it another way, in what specific historical contexts have repatriation campaigns been successful, and how have the conditions of repatriation's emergence in law shaped its politics? Ultimately, these are questions about the impact and limits of law on the distribution of cultural objects that also drive chapter 2 and the comparative analysis of Irish and Scottish approaches to the problem of culture and property.

This study proceeds chronologically and thematically from the Irish repatriation controversy to the National Galleries of Scotland Bill (1901–1906), in which Unionists and Home Rulers struggled to define the relationship between state, nation, and culture by means of their reform of the National Gallery in Edinburgh. The Galleries Bill functioned as a legislative commentary on the problem of British identity, moving between Unionist and Home Rule visions of Scotland's position vis-à-vis both Ireland and England. The advocates and opponents of the bill focused less on the redistribution of artifacts than on the process of "reform," driven by competing notions of the prototypical Scot in Parliament as well as in the National Gallery of Scotland. Chapter 2 analyzes the ways in which the bill's supporters and detractors tried to conceive of Scottish

politics and culture beyond the existing terms of "Highland" mythology and the problems they faced in disrupting this invented tradition. The bill functioned as a forum for debating the power and validity of legislative change in the realm of culture, linking the public gallery in Scotland to a host of other Liberal Party causes, most notably land reform. This application of "law" to "culture" raised important questions about Scotland's status as a Liberal nation and the extent to which traditional Liberal narratives of progress and development would have to be reformulated at the National Gallery of Scotland.

In the historical relationship of property and personality, "property" can denote both real estate and liquid assets, on one hand, and inward though socially determined qualities, on the other.[123] Women have traditionally been identified with mobile property, highlighting a perceived division between masculine worth or permanence and feminine insubstantiality. In chapter 3, I focus on a controversy at the National Gallery in London involving an anonymous woman donor's gift of Hans Holbein's *Christina, Duchess of Milan*. The donor was suspected of being a suffragist, which sparked a public and professional furor about the feminization of patrimony, the redistribution of property to foreign (especially American) buyers in a post-Liberal era, and the gendered parameters of citizenship. In this episode, women art collectors took part in both the creation and the destabilization of a national canon of art. By means of the Holbein gift, a new tradition of feminist protest was integrated into the National Gallery—however contentiously—and it is this dual process of integration and contention that is examined here. This chapter investigates the application of gendered categories of property to the realm of art and artifact and considers the ways in which cultural property seemed to transcend other kinds of capital. It explores the ways in which anxieties about gender and feminism in the history of cultural property intersected with a uniquely British history of aristocratic decline and anti-Americanism before World War I.

Finally, I discuss the establishment and opening years of the London Museum, Britain's first "folk" museum and its first concerted effort to integrate New Liberalism into the realm of institutional culture. From its inception, the London Museum faced the problem of how to use objects to define the sociology of the "urban folk," a category that seemed in many ways to defy objectification. Existing models of folk history and culture were deemed inadequate to the special history of London as an imperial capital. The London Museum operated as a forum for debates about the changing relationship between collectivist politics and cultural objects, challenging the notion of culture-as-property within the context of radical feminist and Lib-Lab politics. Its valorization of domestic goods produced a new reliance on women donors, heightening anxieties about the feminization of British politics and culture. The conceptions of patrimony

and heritage that emerged from these debates reflected the particular circum-
stances of British Liberalism but also responded to an international set of con-
cerns about radical or revolutionary culture—specifically, in France.

The concept of cultural property developed unevenly in and across these
disputes.[124] In some chapters the key issue at stake is the status of law in the reg-
ulation of national cultures. Other chapters deal more directly with the evolution
of particular institutional practices such as repatriation and deaccessioning. At
the heart of each episode was a broader confusion or anxiety about the status of
property in British political life and a concerted effort to experiment with new
forms of ownership in the realm of culture. As the protests of Wallace Collins
suggest, sometimes these experiments were anarchic; more often, they were
geared toward legislative or institutional reform. These episodes reflect Liberal
crises of different kinds but also suggest the ways in which cultural responses to
these crises converged and required the mobilization of mass political resources:
the press, the Parliamentary debate, the making and breaking of laws. Each chap-
ter illuminates a different angle of the crisis of Liberalism and an independent
set of historiographical questions, illustrating the ways in which this crisis played
out differently for urban workers, women, and Irish and Scottish nationalists. In
debating the ownership of cultural objects, then, Britons confronted the dilem-
mas facing both the Liberal Party and Liberalism itself.

Recent studies of British identity suggest that postcolonial scholarship and
feminist scholarship have destabilized the historical concept of the British na-
tion-state, making it difficult to maintain a firm belief in the "nation" or in "na-
tional" history.[125] British debates about the relationship between culture and
property take us beyond, but not outside, the history of the nation-state.[126] The
groups contending for the ownership and redistribution of British patrimony
sought not only to be included in existing nationalist discourses but to transcend
them—drawing on radically different conceptualizations of British politics,
property, and culture beyond the bounds of "nationalism." In particular, Irish
demands for the return of cultural objects from England refused simply to reify
artifacts as parts of a "British," "English," or even an "Irish" culture but worked
against the idea of a unified national culture more generally. I have localized the
history of cultural property not only in England but also in the constituent na-
tions of Britain. My intention is to investigate the ways in which different prac-
tices of ownership in England, Ireland, and Scotland worked in tandem with the
fiction that Britain represented a unitary regime of property rights. This project
both draws on and moves away from the evolving "four nations" approach to
British studies, which has tended simply to incorporate Ireland, Scotland, and
Wales into prior models of English history instead of reconstituting those mod-
els.[127] The dominant terms of this study—culture, property, and Liberalism—

will be more than familiar to scholars of Britain. But the aim is to illustrate how these concepts must be reevaluated when they are first seen as related to each other and then inflected by the histories of the Celtic fringe, as well as feminism and radicalism.

This book offers a historically specific response to the following question: What kind of property is art? The history of cultural property has particular import for British history, in which theories of ownership have played such a critical role in the development of political rights. One premise of this book is that property is not a self-contained phenomenon. That is, the history of property incorporates the tensions and values of the social ether.[128] Art was not simply a subset of debates about the nature and limits of property in Britain; it was a critical, constitutive, and flexible component of these debates with particular relevance to questions of gender, labor, and colonization. In expanding the field of possibilities for enacting the relationship between property and politics—including theories of guardianship, trusteeship, and nonexclusive ownership—disputes about culture and property (or culture *as* property) contributed creatively and often subversively to British modes of citizenship.

Celtic Gold: The Irish Invention of Repatriation

Think of the old days when invading bands
Came like a deluge, swamping men and lands;
How natural it was that many should
Hide their best valuables where they could.
'Twas so in times of the old Roman sway;
So yesterday—and so it is to-day;—
And all lies dead and buried in the soil,
The soil is Caesar's—his the splendid soil.

—Goethe, *Faust II* (1832)

I asked Nanny yesterday what people do
When they find some WONDERFUL thing;
And she said—and I think she was speaking true—
That treasure belongs to the KING . . .
If I felt certain the KING would say,
"Oh, Tony, just keep two or three!"
I'd not mind him taking the others away—
But would he leave any for me?

—Enid Blyton, "Treasure Trove" (1926)

On June 11, 1903, Sir Robert Bannatyne Finlay, attorney general for Ireland, entered London's High Court and brought suit against the trustees of the British Museum.[1] His actions, which galvanized the English and Irish press into a new phase of mutual rancor, represented the culmination of nearly a decade of struggle between English institutions and Irish academics, individual property rights and communalism, and culture and agriculture. The origins of his case were on a middling-sized farm in Derry, in the north of Ireland. In 1896, a farm laborer named Thomas Nicholl had turned up a hoard of ancient Celtic gold ornaments with his brand-new American plough.[2] Because the farm was located

in the townland of Broighter, these ornaments came to be known as the Broighter Hoard. The group included a solid gold torque, two necklaces with plaited chains, a hemispherical bowl, a striking hollow collar with elaborate *repoussé* decoration, and a model boat complete with mast, rudder, seats, and fifteen oars (figs. 1 and 2).

The farm belonged to Joseph L. Gibson, who would later be described by the trustees of the British Museum as a "shrewd, hard-headed Presbyterian" on whose word one could rely: the very prototype of an Ulsterman.[3] Gibson purchased the ornaments from Nicholl for £5 and brought them to a Belfast jeweler for appraisal. The details of what happened next are unclear, but somehow the ornaments ended up in the hands of an Irish antiquarian from Cork named Robert Day—a personal acquaintance of Joseph Gibson's—who offered and sold the collection to the British Museum for £600. Day had been a member of the Royal Irish Academy, a group devoted to antiquarian research in Ireland, and of the Royal Society of Antiquaries in London.[4] But on this occasion, his colleagues in the Irish Academy grew suspicious of his transactions and began an unofficial investigation.[5] Day was not able to explain how he had originally obtained the ornaments from Nicholl, nor could he account for his failure to offer the hoard to an Irish authority, as he was bound to do by law. The academy determined that the ornaments had been illegally exported and should be returned—not to Day, Gibson, or Nicholl but to the Dublin Museum of Science and Art, where the academy housed its collection of Celtic antiquities.[6] The British Museum refused to cede the objects, and after an extensive press and Parliamentary campaign, the academy engaged Finlay to win the ornaments back for Ireland.

The Gold Ornaments trial, as antiquaries and archaeologists have termed it, certainly did not "invent" the concept of repatriation as it is currently used by museum professionals. The term "repatriation" is derived from *patria*, Latin for "fatherland," and has historically referred to the organized return of people, especially prisoners of war, to their country of origin, birth, or citizenship.[7] Within the museums profession, repatriation has been defined as the return of heritage objects to their places of origin.[8] But as early as 1903, the Gold Ornaments trial underscored two points. First, places of origin cannot always be easily or conclusively determined for artifacts. Second, and perhaps more important, colonial histories are themselves often disruptive to notions of origin.

Many scholars date the birth of state intervention in repatriation from the 1970 UNESCO Convention on the Means of Prohibiting and Preventing the Illicit Import, Export, and Transfer of Ownership of Cultural Property, which elaborated a legal framework for negotiating the return of artifacts.[9] The convention has been seen as a pivotal moment in linking cultural rights to human rights

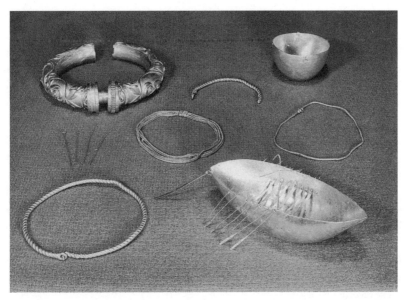

1. Broighter Hoard ornaments. Courtesy of the National Museum of Ireland, Dublin.

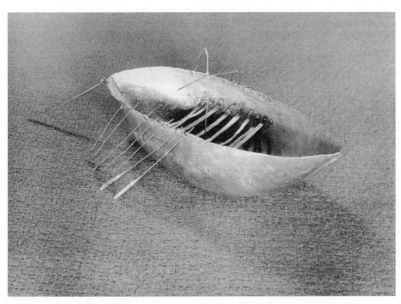

2. Gold boat from the Broighter Hoard. Courtesy of the
National Museum of Ireland, Dublin.

and defining cultural property as an essential element in the personality of the peoples of the world. Here, UNESCO sought to define the right that emergent nations should have over their self-definition and to connect this right to control over prescribed sites and objects.[10] Critics of UNESCO have noted that the 1970 convention established the legal regulation of cultural property in terms of a series of unnecessarily or unwisely oppositional relationships: source nation–market nation, Third World–First World, and Eastern Bloc–Western Bloc.[11]

As the introduction suggests, however, the history of intra- and international cultural property law clearly predates the founding of the United Nations. In 1662, England had benefited from the Treaty of Whitehall, concluded with the Netherlands, under which it received back items taken from the Stuart art collections. Later, the Treaty of Vienna of 1815 included a special clause devised by Lord Castlereagh to ensure that the art objects looted by Napoleon were returned, although this policy was not strictly enforced.[12] It is important to stress that these objects were returned *not* to the source nations that had originally produced them but to the European museums from which they had been looted most recently.[13]

One truism of existing scholarship concerning repatriation has been that although objects may have been removed from their points of origin in earlier times, the emergence of claims by states and peoples for their return is very recent.[14] Contemporary studies often link repatriation with the civil rights and decolonization movements of the late twentieth century, interpreting the process of repatriation as a "spontaneous outgrowth" of postcolonial politics.[15] Although scholars cite the Treaty of Vienna and the Hague Conventions as isolated historical precedents for cultural return, their accounts have treated repatriation claims primarily as a human rights issue that gained moral and legal precedence in the 1960s.[16] There are earlier precedents for repatriation in international law. For example, Francisco de Vitoria developed arguments against depriving South American indigenous populations of their cultural treasures in the sixteenth century.[17] But modern claims (that is, those made after World War II) have distinctive features, namely, the awareness that claims for repatriation to autochthonous peoples may be connected within one legal system or may be claims against another state. The recognition that cultures are not necessarily coextensive with nations is taken as a new development in the international laws of repatriation.

In the United States, repatriation debates have been described as rooted in the rise of Native American political pressure lobbies and culminating in the adoption of NAGPRA (Native American Graves Protection and Repatriation Act) in 1990.[18] From a global perspective, there has been an explosion of protective cultural property legislation following the termination of colonial status

and the inauguration of modern sovereignty in Africa, Southeast Asia, South America, and the Pacific.[19] Recent claims to restitution of cultural property define its removal from a country or ethnic group as a highly particular form of theft in which the removal constitutes not only a denial of the originators' right to enjoy the objects in question but a fundamental attack on the integrity of the group itself.[20]

In Great Britain, repatriation debates have focused primarily on two groups of artifacts: the Benin bronzes, seized from what is now southern Nigeria on a punitive British expedition in 1897,[21] and the Parthenon, or "Elgin," marbles, which one critic has referred to as the urtext of cultural return.[22] Parliamentary debates about the Parthenon marbles date back to 1832,[23] but both sets of artifacts continue to function as *causes célèbres* among supporters and opponents of repatriation. More recently, appeals by the Africa Reparations Movement for the return of the Benin bronzes to Nigeria have been accompanied by demands for an apology for Britain's role in the slave trade and cancellation of Third World debt.[24]

The Gold Ornaments trial is a unique episode in the history of repatriation. The timing of the case, from 1896 to 1903, tends to disrupt the current association between repatriation and postcolonial activism.[25] The location of the case in Ireland poses a further conceptual problem. The Celtic gold controversy occurred in a framework of two culturally distinct nations—England and Ireland—contained within the political state of Britain. Scholars of repatriation have recently begun to evince an interest in the history of objects displaced during peacetime, because the history of cultural property has been focused so overwhelmingly on the dispossessions of war. But it is worth asking whether the process of English occupation in Ireland should more appropriately be considered war or peace. The curator of social anthropology at the South Australian Museum in Adelaide, Christopher Anderson, has aptly described the process of repatriation in terms that curators have used since the 1960s. Returning objects, he suggests, is a social act, but one that takes place between two societies that do not really know each other.[26] One might reasonably argue that the problem with England and Ireland is that they have known each other all too well.[27] Although many scholars would make the case that repatriation represents a healing of the wounds of history,[28] this chapter proposes the counterargument that repatriation can reify and reinforce historical traumas of its own.

At the heart of this chapter, then, lies the vexed historiographical question of Ireland's colonial status.[29] The participants in the Celtic gold case were preoccupied primarily by the ties between Ireland and England, but their concerns extended to the broader relationship between domestic and overseas colonies as

well.[30] Celtic participation in the overseas empire has been well documented in sources from Kipling to Colley.[31] Recently, historians have begun to investigate the ways in which English policy in Ireland functioned as a prototype for its actions in India throughout the nineteenth and early twentieth centuries, stressing analogies and affinities between the Irish and Indian colonial experiences.[32] For example, one study of the English reform of property laws in Ireland and India argues that both sites posed important challenges to an Anglocentric model of political economy.[33] George Bernard Shaw's 1904 play *John Bull's Other Island* captures the peculiar role of Ireland in the broader colonial world. Tom Broadbent, the quintessential Englishman, is musing on why he so adores all things Celtic. He has difficulty explaining himself to his disaffected Irish pal Doyle, who detests his homeland and lives as a happy Anglophile in London. Tom vows to focus his political ambitions on the Irish town of Rosscullen, concluding, "I am an Englishman and a Liberal; and now that South Africa has been enslaved and destroyed, there is no country left to me to take an interest in but Ireland."[34] Furthermore, Tom points to Ireland as the only remaining site of "pure" British citizens. England is monopolized by unpleasant hybrids: "Germans, Jews, Yankees, foreigners, Park Laners, cosmopolitan riffraff."[35] This chapter explores the terms of this Shavian exchange and considers the diverse colonial hierarchies that informed the Gold Ornaments case.

In 1902, the junior whip for the Liberal Unionists, Austen Chamberlain, described the Gold Ornaments case as "very peculiar"; the case, he said, was entirely without precedent in the history of national collections.[36] But what made it so peculiar? Earlier claims for the return of cultural objects had hinged on the international codes and procedures of warfare, whereas the Gold Ornaments case rested on the vagaries of a highly particular colonial history. The participants in this case rarely spoke of historical precedents for repatriation claims such as the the Napoleonic restitutions—nor did they refer consistently to the Parthenon marbles. From both the English and the Irish points of view, the Gold Ornaments trial was *sui generis*. This chapter explores what this case tells us about the history of repatriation and about cycles of acquisition and loss in colonial history. In particular, debates about the status of Celtic gold illuminated what was anomalous or peripheral—"peculiar," as Chamberlain had put it—about Ireland and what was absolutely central to British ideologies of colonization.

How does the model of culture-as-property, exemplified by the Gold Ornaments trial, function in societies with different conceptions of possession, community, and political selfhood? Steven Ellis has argued that the model of the nation-state has always been invalidly deployed for Ireland, because Gaelic

Ireland was never a unitary sovereign state. He suggests that a more appropriate model for Irish history would be that of a borderland within the British archipelago, because Ireland shared its Gaelic culture with Scotland.[37] The divergence of myths about property and authority in England and Ireland dates back to the Gaelic dispossession in the sixteenth and seventeenth centuries, which became in turn the basis of Irish nationism from the eighteenth century onward. In this framework, the Enlightenment notion of a contract between state and society is dissolved in Ireland because the state is perceived only as a foreign yoke rather than as the protector of domestic property rights.[38]

The fact that the Celtic gold ornaments were discovered in Ulster poses an interesting set of challenges to Irish nationalist geography, which has tended to position Ulster as an alien aberration.[39] David Brett's study of the Irish heritage industry argues that Ireland has traditionally operated as the locus of the unspoiled and the authentic within Britain, producing higher stakes in debates about commemorating Irish heritage for all British citizens.[40] But Tunbridge and Ashworth have also targeted Ireland as one of the most fertile sites of "heritage dissonance" in modern Europe, suggesting that differing interpretations of Irish authenticity have given rise to competing nationalisms within Ireland as well as between Ireland and England.[41] As this chapter will suggest, the notion of authenticity is not only a by-product of colonialism but also is central to its ethics.[42]

Furthermore, the Gold Ornaments trial occurred in the post-Parnellite context of what Ray Foster has termed a "vacuum in politics: political 'energy' being diverted mystically (and mechanically) into the channels of 'culture,'"[43] and in particular the surrogate politics of the Celtic Revival—that "quaint little offshoot of English Pre-Raphaelitism," as Shaw called it.[44] Foster equates this period of cultural revival not only with political inaction but also with political unionism. The public works improvements of these years in Ireland have been described as an effort to "kill Home Rule with kindness."[45] But recent research concerning Irish land agitation and labor unrest from the 1890s to the 1920s has suggested that the older historiographical model of cultural activity as a response to the "loss of politics" is in need of revision;[46] the precise nature of the relation between cultural activity and political nationalism in Ireland is still hotly contested by scholars of this period.[47] Terry Eagleton has proposed that cultural nationalism in fact served as a *source* of political nationalism in nineteenth-century Ireland. The Yeatsian view that politics yielded to culture after the fall of Parnell betrays both a narrowly parliamentarian view of politics and a curiously depoliticized view of culture. What is at stake in Irish nationalism's encounter with British sovereignty is not simply a political conflict but the clash of two opposed conceptions of the political.[48]

The Gold Ornaments trial functions as a useful point of entry into this historiographical debate because it spanned all shades of political opinion in Ireland and England. The controversy was "cultural," but it represented a different form of culture than the language leagues, theatrical productions, and athletic associations that have formed the mainstay of Irish cultural history thus far. The connection between nationalism and art institutions is more complicated in Ireland than in the rest of Britain. Since the early nineteenth century, Irish museums and galleries have been associated with the Anglo-Irish Protestant ascendancy rather than with the Gaelic Catholic population. They were symbols of the eradication rather than the preservation of Irish Ireland.[49] Institutional education, perceived in England as the route to a stronger national character, was feared and mistrusted by Irish cultural nationalists as a threat to the innocent peasant soul of Gaelic Ireland.[50]

The roots of Irish institutional culture were in the Irish Industrial Exhibition of 1853, a self-conscious effort to reinforce indigenous industry after the devastation of the Great Famine.[51] The Irish exhibition took place only two years after the Great Exhibition in London, but the English display of surplus capital could not be easily replicated in Dublin. There was no nationalist "founding moment" in Irish museum culture, no starting point for a vitally regenerative culture of display. As a result, the study of cultural nationalism in Ireland has been overwhelmingly focused on literature and drama;[52] the public museums supported by Anglo-Irish patrons and Treasury funds have never taken their place in Irish nationalist narratives. Contemporary efforts to preserve and memorialize Irish folk culture focused on "lifestyle" changes such as the revitalization of the Irish language, the banning of English games in Ireland, and the revival of traditional Irish dress—a tendency within Irish cultural nationalism that reinforced the English depiction of the Irish peasantry as a living museum.[53]

The Gold Ornaments trial and surrounding controversy offer a different vision of the interaction between Irish nationalism and "high" and "low" culture. The battle for Celtic gold raised compelling questions about the relationship between politics and culture expressed in the life of material artifacts. The Dublin Museum, whose administration shifted during the Gold Ornaments debates from England's Science and Art Department to Ireland's Department of Agriculture and Technical Instruction (DATI), represented the meeting point of Anglo-Irish and Gaelic Catholic perceptions of the Irish past, of political and cultural nationalisms, of the Irish public—however that public was understood—and of the British nation-state. The development of the institutional practices of repatriation thus occurred within a specific set of historical debates about the various meanings of property, agriculture, and "traditional" and "modern" culture within Ireland and England.

But the reform of the Dublin Museum was a contentious process that revealed the ways in which repatriation could act as a conservative or a regressive force as well as an anticolonial one. The trial and its preceding controversy represented an important step in the development of postcolonial culture in Ireland, positioning the Celtic gold campaign as part of a strategy of resistance to English rule. But the trial also revealed the ways in which concepts such as repatriation and deaccessioning were embedded in colonial models of culture as a form of property. The participants in this contest for Celtic gold engaged with a variety of British mythologies about the status of the Celt in Ireland and in England, about the role of agriculture and labor within institutional culture, and about the national characteristics of property and patronage—English or Irish. Irish history has often been written as a morality tale, with a pre-formulated structure and established patterns of triumph and travail.[54] Certainly, the history of the Gold Ornaments case could be written entirely as a nationalist narrative in this genre, and this case is clearly concerned with the articulation of Irish nationalism at many key moments. But the trial also offers an opportunity for exploring another kind of narrative, in which we see both the English and the Irish participants struggling against the confines of national history.

The Dublin Museum and the Crafting of Irish Aesthetics

The Dublin Science and Art Museum Act was passed in August 1877, and the museum opened to the public on August 29, 1890. The collections—which ranged from Irish glass, silver, and textiles to Burmese and Japanese coins and medals, as well as mineralogical and botanical displays—were drawn primarily from the donations of the Royal Irish Academy and the Royal Dublin Society: legacies of the collecting impulses of the Anglo-Irish élite.[55] But as early as 1867, popular agitation for a museum of science and art in Dublin had been framed in terms of colonial relations and surrogate politics. The *Irish Times* reported that "even the eloquence of O'Connell never made so strong a case for the Repeal of the Union as . . . the Duke of Leinster did for the forming of a Central Museum of Art and Industry in Ireland."[56] From the Anglo-Irish point of view, the new museum provided an opportunity for conciliation, a chance to show Irish visitors that a progressive policy toward them had been adopted.[57]

The Dublin Museum had not been planned as a specifically Irish institution. The building was designed for classical and neoclassical collections, with a Victorian Palladian exterior and an interior featuring motifs from ancient Greece and Rome and the signs of the zodiac.[58] The entrance hall housed a group of bronze cannons that had been captured in Punjab in the early nineteenth century, evoking memories of a different colonial enterprise.[59] Irish architects ex-

pressed great disappointment that the chief architect—Thomas Newenham
Deane, who was ultimately knighted for his work at the Dublin Museum—was
an Englishman.[60] The *Weekly Irish Times* published a spoof of this agitation
about the architectural design in which an angry Irishman termed the South
Kensington complex in London a "heathen department," with "every hair on
[its] head a Saxon bristle. No Irish need apply."[61] The speaker went on to de-
mand a national museum constructed "in our own way, by our own people, of
Galway marble and Killiney sand . . . built in the architectural form of a sham-
rock, and crowned by a wolf-dog."[62]

The Dublin Museum's relationship to the South Kensington complex in
London was never precisely defined. The former was managed by the Irish
Board of Visitors, which reported to the Department of Science and Art in Lon-
don, but the respective powers of these two bodies were never clearly fixed. The
Freeman's Journal noted that a Conservative government had originally sanc-
tioned an independent institution for Dublin, rather than a subordinate branch
of South Kensington.[63] According to the *Journal*, the Conservatives had sought
to rescue Ireland from "the blighting influence of English officialism." Instead,
they were compelled to strive to "mould Irish genius to an English pattern,"
which would do more harm than good. As one Irish citizen put it, Ireland had
neither the freewheeling independence of the English provinces nor the close su-
pervision of the overseas colonies such as India. As always, Ireland was both too
near to and too far from England.[64]

These complaints about the tentacle-like ambitions of South Kensington
were not limited to Ireland. South Kensington organizers were under constant
scrutiny during this period for their efforts to centralize British art education;
many critics feared that the complex exerted too much control over provincial
schools of design and that this system would stamp out individuality in artistic
production.[65] But Ireland's position was unique, marking as it did the limits of
South Kensington's aesthetic imperialism. Even Henry Cole, the director of the
South Kensington complex and a notorious advocate of artistic centralization,
acknowledged that the Dublin Museum must "manage Irish affairs according
to Irish ideas."[66] Cole recognized that his system of branch administration, in
which artworks, personnel, and instructions for display were transferred whole-
sale from London to the English provinces, would fail in Ireland. As he sug-
gested, all the things that came from South Kensington—the principles of artis-
tic education as well as the art objects themselves—were inevitably tainted with
Englishness and thus disdained by Irish nationalists. But at the same time, the
impetus for a central Irish museum of science and art derived from South Ken-
sington's example. Cole proposed that the museum in Dublin eventually be ad-
ministered by a new Irish Department, which would satisfy the "intensely na-

tional" spirit in Ireland. The nationalization of the Dublin Museum would be accomplished by a process of Anglo-Irish negotiation.

Long before the Celtic gold suit, then, the curators and trustees at the Dublin Museum were faced with a series of controversies about their relative loyalties to Ireland and England. Was the new museum simply an outpost of the South Kensington "monster"? Or was it intended to produce an independent system of art education for Ireland? To what extent might it represent the politically disempowered but culturally vibrant Gaelic Irish population? Indeed, Irish journals questioned whether the museum could retain any native Irish identity under South Kensington's reign.[67] Its tradition of centralization and uniformity in artistic matters raised hackles in the Irish context.[68] The *Irish Builder* likened South Kensington's dominion over the new museum to the social and economic practices of absentee landlordism, invoking centuries of oppression under English rule. Irish art and design, like the Irish economy, would inevitably decline and die under such a system as "the indigenous creation is replaced by a changeling."[69] The *Builder* concluded, "This country has already experienced the evil effects of centralization carried to extreme limits. . . . We are not clannish, but at the same time we desire to see our institutions 'racy of the soil.'"[70]

But what did it mean to make an Irish institution "racy of the soil"? The emphasis in the Irish press was not exclusively on visual matters such as enriching the indigenous crafts collection but on a particular conception of the educational needs of the Irish audience. Irish curators criticized the Dublin Museum's privileging of art rather than industry, noting that the collectors' curios that might be appropriate for English audiences were useless for Irish visitors; "the interior of a Dutch peasant's cottage would be more instructive in an Art they could imitate to those whom the State should try to reach than Burmese Idols or Mexican Monoliths."[71] While Irish nationalists blamed South Kensington's stranglehold on the Dublin Museum for the continued failure of art and industry in Ireland, English observers criticized Irish artists for catering to the corrupting influences of nationalist sentiment. The Celtic Renaissance was understood in England primarily as a literary and dramatic phenomenon with limited corollaries in the visual arts.[72] Irish workmanship, particularly in lace-making, received much praise from English art critics, but Irish principles of design were characterized in England as "a distorted harp, [and] a few caricatured shamrocks."[73] English art journals constructed a model of "degenerate" Irish aesthetics—either slavishly imitative of English traditions or nationalistic to the point of visual and moral tedium.[74]

Of course, there were important exceptions. The naturalist and art critic Grant Allen published an article called "The Celt in English Art" in the *Fortnightly Review* in 1891. Allen was the Canadian-born son of an Irish Protestant

clergyman; he had been educated in France and America and lived in Jamaica before emigrating to England.[75] He argued that the major aesthetic developments of his day—namely, the rise of the Pre-Raphaelite Brotherhood and the improvement of the decorative arts in England—were due to Celtic influence in London, by which he meant the presence of Irish and Welsh emigrés.[76] His claims were supported by two developments in British social and intellectual history: the high visibility of the Irish poor in Victorian Liberal consciousness, due in part to the reformist efforts of Henry Mayhew and Friedrich Engels,[77] and the concentration of Irish cultural revivalists established in London at the turn of the century, such as D. P. Moran and W. B. Yeats.[78] In Allen's view, the pre-Raphaelites were both distinctly Celtic in spirit and essentially democratic in their politics, led by a coalition of Welshmen, Highlanders, Irishmen, Radicals, Socialists, Home Rulers, and Secularists.[79] Further, he argued that the "New Radicalism" in Britain (by which he seemed to mean New Liberalism) was a fundamentally Celtic product, from the new London County Council to the workingmen's education movement.[80] He diverged from Matthew Arnold's brand of romanticized pan-Celticism to begin a concrete discussion of Irish and Welsh artists and their influence on English painting.[81] Before this recent influx of Celtic influence in England, Allen argued, English aesthetics had been predominantly Teutonic—by which he meant both pictorial and aristocratic. Art in England had been "a special aristocratic exotic; a luxury for the rich, like champagne and orchids." In Allen's analysis, the Celt linked the aesthetic and the political, bringing his English brothers "decorative skill, artistic handicraft; free land, free speech, human equality, human brotherhood." This was not art criticism, he assured his readers, but merely a study of "ethnical" characteristics. Whereas in non-Western nations the tribe or race would tend to move exclusively in one aesthetic direction, civilized nations could accommodate more than one set of aesthetic principles. In Britain, the Celtic and the English spirits could—in Allen's vivid terminology—"interosculate."[82]

Allen's vision of "interosculation" eluded the South Kensington organizers.[83] Irish art critics chid them for removing the extensive collection of Irish relics at its London museum to a dusty corner while Indian undergarments and tea trays usurped the central display cases.[84] Instead of paying homage to ancient and modern Irish culture, South Kensington had offered "indignities" to the collection by foregrounding the artifacts of empire rather than "native" products. The visual hierarchies of India and Ireland at South Kensington heightened anxieties at the Dublin Museum that Cole and his followers perceived Ireland as just another outpost of empire.[85] Also, the South Kensington Museum contained no examples of ancient Irish stone-carving such as the internationally acclaimed Celtic crosses, and its specimens of Irish lace were considered to be poorly dis-

played.[86] This tension between South Kensington's treatment of the Dublin Museum as a signpost of Ireland's colonial status and the Dublin Museum's own vision of Irish identity formed the background for the Gold Ornaments controversy, prefiguring the ways in which the Irish supporters of repatriation would reject an empire-centered vision of British identity.

In 1898 the Science and Art Department published a report on the first twenty years of the Dublin Museum. The Select Committee Report recommended an increased salary for the Keeper of Celtic Antiquities and closer ties between the museum in Dublin and other educational bodies in Ireland.[87] Further, the report proposed that the Board of Visitors, an auxiliary body of leading lights from Dublin's artistic and scientific societies, take more initiative in determining museum policy. According to the Science and Art Museum (Ireland) Act of 1877, South Kensington was legally bound to seek the advice of the Irish Board of Visitors, but board members had repeatedly complained that their suggestions were overlooked or ignored by English administrators.

The minutes of the report proceeded to a more general discussion of the principles of artistic devolution, revealing the extent to which competing visions of Ireland complicated the administration of the Dublin Museum. The Select Committee wanted this museum to reflect their own English interpretation of Irish economic and social life as predominantly rural. One of the witnesses to appear before the committee, Arnold Graves, argued that this English presentation of Irish art and science would hamper public interest in the museum and limit its usefulness for the development of Irish industry. Graves suggested that the Dublin Museum present its audience with a wider range of industrial exhibits to reflect the variety of trades actually practiced in Ireland, such as carriage-building, stone-carving, silversmithing, bookbinding, saddlery, and tanning. The existing industrial exhibits were almost entirely based on looms, which, Graves argued, were obsolete.[88] The institutional presentation of these newer trades would not only offer practical education for future Irish industrialists but would also symbolically counter South Kensington's marginalization of Ireland as a purely rural nation.

According to Graves, the Dublin Museum could serve either the retarding influences of South Kensington or the modernizing influences of new industry. The latter course would be possible only if this museum were managed by an exclusively Irish board. Graves further argued that local control of the Dublin Museum would be a popular reform measure with implications for the contentious question of self-government, which led one committee member to dismiss Graves as a Home Ruler.[89] The Select Committee responded unfavorably to Graves's proposals, arguing that an Irish-administered museum would lose touch with the wider industries of Great Britain. The Dublin Museum would

therefore produce economic stagnation and parochialism by emphasizing its Irishness at the expense of a larger British industrial and economic identity.

The struggle for Celtic gold began against this backdrop of ambivalence about the administration of the Dublin Museum and the future of what Allen had called a "Celtic spirit" in both English and Irish art. The curators in Dublin were plagued by a sense of doubt about Ireland's debt to English patronage, even as the focal point of their institutional concerns shifted from South Kensington to the British Museum in Bloomsbury. With this shift, the Dublin Museum's relationship to agriculture, industry, and craft invoked a larger set of questions about the national properties of artifacts in Britain. Both sides confronted the underlying dilemma of repatriation. Although the return of the ornaments might give greater credence to the Dublin Museum as a "national" institution, the proposed deaccessioning of the British Museum posed a greater challenge to the notion of a national museum itself.

The Celtic Ornaments Commission and the Problem of National Museums

In 1898 Treasury appointed a special commission to investigate the legal status of the gold ornaments. As much as the future of Irish independence—cultural or political—the question of whether the British Museum could continue to function as the central imperial institution of art and science was at the heart of the Celtic ornaments controversy.[90] Furthermore, the commission sought to define the parameters of repatriation, asking whether the civil ownership of objects was defined by country of origin, mode of acquisition, or the intangible but powerful claim of "national character." They made no reference to international precedents for repatriation claims but treated the Celtic gold investigation as a unique moment in European history. The commission, composed of Lord Rathmore, John Morley, Sir John Lubbock, Sir John Evans, Sir Herbert Maxwell, and Sir Thomas Esmonde[91]—a predominantly Liberal and Anglo-Irish group—set about the formidable task of assessing the Britishness of the British Museum.

The commission's investigation of the Gold Ornaments case was fundamentally linked to a broader question about the interaction between cultural pluralism and political hierarchy in Britain. The British Museum's director, Edward Maunde Thompson, aroused hostility from the commission when he referred to Scottish and Irish museums as "provincial."[92] He was asked several times whether he fully understood that the collections in Dublin and Edinburgh had been acknowledged as national institutions *for those countries* by Parliament. Lord Dillon, another British Museum trustee, suggested that the right of acqui-

sition for Irish and Scottish artifacts should always go to his own institution. When he was asked whether he credited the national feeling that gave Irish and Scottish citizens pride in these objects, he responded, "I attach the greatest importance to it, but . . . I look upon the three peoples as one nation."[93] The commission immediately branded Dillon an extreme advocate of centralization and pressured him into conceding that objects pertaining directly to Irish and Scottish history should remain in their own countries.

As Dillon attempted to establish the boundaries of repatriation within Great Britain, the mutability of national identity in the realm of art and artifact came to the forefront of the ornaments controversy. He maintained that although objects related to important events in Scottish and Irish history should be returned to their native lands, artifacts linked to the "Celtic fringe" only by style or design should remain in the British Museum. But the process of distinguishing national histories from art histories proved elusive, and Dillon soon realized that the commission made no such distinction in its own investigation. The gold ornaments were integrated into a larger framework of Irish national history because of their value and import in the history of Celtic design, regardless of their relation to specific political events. From the commission's point of view, the national histories of Ireland and Scotland had been narrated primarily *through* the production of art objects, since there were few official or political outlets for these histories. The commissioners, rejecting Dillon's atomization of history into political action and visual artifacts, maintained that Irish cultural history and colonial history were inextricably intertwined. In effect, the commission argued, the history of Ireland *was* cultural history. Once again, the idea that Ireland required its own museology—both in terms of the objects displayed and in the vision of history informing these objects—came to the forefront of the larger debate about repatriation.[94] For Ireland, though not for England, culture and politics were collapsed—much to Dillon's dismay. Dillon's division between the stuff of art and history was deemed irrelevant to Ireland.

When Dillon was pressed to reveal his method for separating objects of historical interest from "purely aesthetic" objects, he responded by questioning whether Ireland had a national history at all. His reluctance to acknowledge the ongoing history of Irish nationalism culminated in his denial that the Irish claim for repatriation was motivated by "national feeling":

> I should hardly call it a national feeling, if I may say so. It is the feeling of what must be a limited number, according to the population, of educated people. It is not what I may call a national grievance . . . particularly as, after all, Ireland is part of England.[95]

John Charles Robinson, the queen's surveyor of pictures, testified that Manchester and Birmingham had the same pride of place as Ireland and Scotland. Terming the Irish museums "national," he said, was purely a matter of sentiment. The commission as a whole was quite agitated by Robinson's dismissal of national cultures and asked, "But you do not want to obliterate the old national boundaries or to ignore them?" Robinson, unfazed, replied, "I do not think I do, but I do not care about keeping them up unduly either."[96]

This casual dismissal of pre-Union Irish and Scottish cultural identities shocked the commissioners and challenged two of the fundamental tenets of British institutional culture: the presumed connection between public museums and national pride, and the assumption of disparate national cultures within a political union. George Coffey, the keeper of Irish antiquities at the Dublin Museum, suggested that his museum halt negotiations concerning the Celtic gold ornaments until it was recognized in England as a national institution.[97] In the meantime, the Dublin Museum and the British Museum would have to enter the international art market as competitors, a situation described by the *Daily Express* as "a strange and absurd state of affairs . . . [in which] we will find the State virtually bidding against itself."[98] The myth that the British Museum represented all four nations of Great Britain had begun to unravel. The Celtic ornaments controversy was reconstituted as a satire of Union, producing a new vision of mutual destruction and competition instead of harmonized national cultures.

Coffey and others challenged the British Museum's representation of history as a fundamentally imperial endeavor.[99] More damningly, Coffey argued that the British Museum had never fulfilled the conditions of a national museum in the sense that the collections at Copenhagen, Berlin, Paris, and, of course, Dublin were "national"—that is, they illustrated the combined local histories and archaeologies of the domestic population as well as the empire. In Coffey's view, the British Museum was concerned with empire at the expense of nation; national museology was ultimately the province of the Celtic fringe. In a 1901 memorandum, Coffey objected to the British Museum's efforts to map Unionist politics onto museum scholarship. "The United Kingdom is a political division whose boundaries have no necessary relation to archaeological provinces."[100] Coffey's rejection of the British Museum's equation of the empire with the nation raised larger questions about the relative status of domestic and imperial identities in British self-perception.

As George Noble Plunkett, the director of the Dublin Museum, told the commission, the idea of a national museum for Britain had "hardly existed" when the British Museum was founded in 1753.[101] In Plunkett's view, the British Museum had predated the development of nationalism and national museol-

ogy. The link between national collections and national pride, Plunkett claimed, was a nineteenth-century Irish invention. Irish advocates of repatriation argued that the Celtic gold ornaments were "lost," "out of place," or deprived of their national character in the imperial setting of the British Museum,[102] because Irish artifacts were displayed at Bloomsbury only as the products of a colony or dependency. The *Freeman's Journal* reported that the British Museum had never even catalogued the gold ornaments, which were therefore deprived of any educational function.[103] Irish nationalists were further infuriated when a British Museum trustee characterized the Dublin Museum a "local academy" while referring to the British Museum as the institutional representative of "the nation."[104] One commissioner, Sir Thomas Esmonde, responded angrily, "It is not a question between your 'nation' and a mere Irish 'local academy' . . . it is a case of the right of the nation of Ireland against the power and influence of the British Museum."[105] Esmonde sought both to dissociate Ireland from other components of the empire and to prove that Irish cultural identity could not survive in an imperial context such as the British Museum by establishing a series of oppositions between Irish and imperial culture.

Esmonde's characterization of the un- or anti-Britishness of the British Museum provoked an impassioned response from the museum's director, Edward Maunde Thompson. Predicting that Irish nationalists would seek to retract every object of Celtic make or design from the British Museum, Thompson implored the commission to protect his institution from Irish acquisitiveness. He claimed that Irish and Scottish artifacts formed important points of reference and comparison for the English collections at the British Museum; English archaeology could not survive in isolation. As an added disincentive to repatriation, Thompson argued that depriving the museum in Bloomsbury of its Irish collections—what one M.P. referred to as making the museum "un-Irish"— would only skew the public perception of British identity further toward England.[106] If Irish nationalists wished to strengthen Ireland's role in the definition of British public culture, Thompson insisted, the British Museum's retention of the Celtic gold was the only sure route to this goal.

When William Atkinson, the secretary of the Royal Irish Academy, confirmed that he sought the return of every gold ornament found in Ireland from British institutions, even the most sympathetic members of the commission seemed perturbed. Although the commission was clearly willing to consider the transfer of this particular group of ornaments, Atkinson's call for a more extensive revaluation of the Irish collections in the British Museum and the formulation of a general Anglo-Irish repatriations policy went unheeded. The commission asked Atkinson whether he found it curious that the Irish Office had so little information about the original sale of the ornaments, and he replied, "In Ireland

things go on so very differently from the way they go on in England. We are very independent people, and do not like to inform."[107] The expectation that Irish citizens should report any private finds of treasure to an Ascendancy body such as the Royal Irish Academy or a South Kensington subordinate such as the Dublin Museum was unrealistic, Atkinson suggested. The more surprising development was that they ever reported them at all.

In 1900 the new Department of Agriculture and Technical Instruction for Ireland took over the administration of the Dublin Museum, shifting the seat of Irish artistic and scientific education from London to Dublin. The department, the product of the 1895 Recess Committee on Irish agricultural and industrial welfare, was heralded as a radical innovation both in Irish political practice and in British political thought more generally: a new framework of relations between governors and the governed. Modeled on the Danish system of voluntary associations, the department emphasized the interaction of state aid and private effort in introducing agricultural cooperation and economic improvement to Ireland.

The department thus stood as an important collectivist alternative to the valorization of individual ownership that characterized Irish politics after the land wars: an effort to reconstitute individual farms as communal property.[108] Sir Horace Curzon Plunkett, the Conservative Unionist who guided the department from 1900 to 1907,[109] predicted that it would usher in a new era of cooperative government for Europe and America as well as Ireland. Plunkett hoped that his program of agrarian reform would subvert the broader Irish demand for self-government, but he also promoted the idea that the department would provide essential preparation for Home Rule if it came: equipping the Irish character for political responsibility.[110] Although the department was primarily concerned with the rehabilitation of Irish rural life, it was also intended to achieve a more effective liaison between government and the Irish people, providing a working model for a devolved government to develop Irish resources. Plunkett's rural cooperatives, though modest, stood as experiments in participatory democracy that resisted the centralizing tendencies of both British imperialism and Home Rule nationalism.[111]

The department established elective councils from the working and agricultural classes, forming what Plunkett referred to as the first British occasion of "people's government." Plunkett also stressed that the department was adapted from non-English models and constituted a major departure from traditional English laissez-faire.[112] Against serious Unionist opposition, he elected a Catholic Home Ruler to the secretaryship of the new department so that it would "never get out of touch with the thought and feeling of the people."[113] Irish nationalists ultimately called for Plunkett's resignation, linking the department to

the much-hated Dublin Castle administration and characterizing its reforms as "benevolent assimilation."[114] But the department's political legacy of partial economic, social, and institutional devolution was more complex than this attack on Plunkett suggests.

The transfer of power from South Kensington to Ireland's Department of Agriculture provoked a flurry of retracted loans and exchanges, although none of these attracted the same level of publicity as the Celtic gold campaign. South Kensington responded to the inauguration of DATI by stripping the Dublin Museum of all pieces nominally on loan from London. The *Freeman's Journal* promptly urged the Dublin Museum and DATI to sue South Kensington for this "high handed impertinence."[115] While the Dublin Museum was embroiled in its legal and public battle with the British Museum for the return of the Celtic gold ornaments, South Kensington's forcible retrieval of its artworks from Dublin was described by the Irish press as "wholesale barbarism . . . prompted solely by motives of petty jealousy and revenge."[116] Comparing the English representatives of South Kensington to French revolutionary armies that sacked European capitals to enrich Paris, the *Daily Nation* reinvoked the question of whether England and Ireland could be considered part of the same nation. The *Daily Express* promptly demanded the return of a coach housed at South Kensington with painted shamrocks on its side that was supposedly owned by the earl of Clare.[117] The coach was returned to Dublin, although with little fanfare; experts could no longer agree about whether the earl had actually used the coach or not.[118] This series of exchanges pointed both to the variety of repatriation debates within Britain and to the diversity of their receptions in the English and Irish press. The disputes with South Kensington were of a different order than those at the British Museum, because South Kensington had so recently served as Dublin's "parent" institution. But they did provide an important context for the British Museum's defense of its Celtic gold artifacts, offering evidence for Thompson's claim that the Irish sought to dismantle all of London's treasure houses.[119]

The department's takeover of the Dublin Museum also provoked criticism and satire from a variety of Irish sources. The *Irish Figaro* claimed that DATI "would be a very wonderful Board indeed, if it can do everything people expect, from improving the pigs and potatoes to collecting curiosities for [the Museum at] Kildare Street."[120] Plunkett himself complained frequently about the poor condition of the arts in Ireland[121] and suggested that the burden of artistic education fell more properly on the Anglo-Irish gentry than on his department, proposing cultural philanthropy as a remedy for older landlord-tenant tensions.[122]

Yet art and institutions were at the heart of the new department's project,

and the department consistently demonstrated serious concern about the model of "culture" it should embrace. For DATI, Irish "culture" involved a complex of practices including new modes of agriculture, the revival of old crafts, and the promotion of new industries. Art, craft, and history were conflated and incorporated into a larger narrative of modernization in which the preservation of ancient artifacts was valued primarily as a lesson for modern craftsmen. In an interesting juxtaposition of class and colonialism, Plunkett's officials sought advice from English and continental professionals who had dealt specifically with museums for the poor and solicited information from Canon Samuel Barnett about his Whitechapel Picture Gallery in London's East End.[123] The department also took a prominent role in the Cork Exhibition of 1902,[124] at which Plunkett advocated the revival of Irish crafts and industries and coined his ditty: "What applied science or applied art meant / I first learned at Cork from our peep-show Department."[125]

By 1900, the Irish campaign for Celtic gold had been taken over from the Royal Irish Academy by a department fundamentally opposed to antiquarian pursuits. The cultural policies of DATI were never coherent, in part because its officials were never sure how far they might intrude into the mysterious realms of art, aesthetics, and the acquisition of artifacts.[126] The department continued to press the British Museum to relinquish the Celtic ornaments. But in many respects, the return of the ornaments would seem to be at odds with DATI's vision of Irish development. What role could ancient Celtic gold play within this new image of a modernized, collectivized agricultural Irish economy? Luke Gibbons's analysis of rural mythology in modern Ireland is particularly instructive. As Gibbons has noted, these myths—created overwhelmingly by an *urban* leadership—constituted a break with the past, not continuity with it.[127] As such, Irish rural nostalgia actually represented the first phase of post-Famine modernization. At the Dublin Museum, the tension between modernization and tradition intensified as the department sought to update the museum's archaic industrial and agricultural exhibits.[128] Repeatedly, the Dublin Museum's inability to represent a modern industrial society with up-to-date machinery frustrated DATI officials and the Irish press. Both wondered whether the Dublin Museum's popular but obsolete industrial exhibits might hamper economic progress in Ireland.[129] Graves's earlier concern that the collections in Dublin only reinforced English visions of Ireland as a living museum—an economically and politically backwards society that preserved artifacts of visual interest even as it oversaw the degeneration and disappearance of its industries—resurfaced as part of the department's emphasis on Irish economic dynamism and revitalization. At the same time, Plunkett's administration provided a new institutional context for the Celtic gold ornaments controversy: a collection of modern arti-

facts aimed at constructive unionism. The transfer of power from South Kensington to DATI necessitated a different set of arguments about repatriation that were fundamentally concerned with the relationship between individual and institutional property. These arguments would resonate not only in Dublin or at the British Museum in London but wherever the conception of self and property was called into question.

Preservation, Property, and Patrimony: Owning Irish Artifacts

The Celtic Ornaments Commission posed a major challenge to the national standing of the British Museum. But the commissioners were wary of making any specific recommendations about the fate of the ornaments themselves, and the case was still unresolved when the commission broke up. The case now entered a new phase of intense campaigning in the English and the Irish press. If the British Museum's imperial vision of artifacts was rejected or under attack, what alternate model of object-centered history could Ireland propose? The Gold Ornaments controversy crafted a new vision of Irish populism that challenged prior notions of Irish culture as antipreservationist, anti-institutional, and ultimately, antimuseological. The struggle to return this group of gold ornaments to Ireland was grounded in a particular historical dynamic of English and Irish traditions of ownership, preservation, and political authority.

The trustees and supporters of the British Museum initially claimed that they had rescued the objects in question from an unsafe and uncaring native environment. Whereas the "Elgin" Marbles were reputedly endangered by the Turkish invasion of Greece, the perceived threat to Irish gold antiquities was even more insidious: not the hazards of war but the deliberate greed of the "melting-pot."[130] As early as 1869, the English art critic R. H. Soden-Smith expressed his fear that Irish peasants—who regularly turned up ancient artifacts in their ploughing and farming—were imperiling British patrimony by melting down gold ornaments for bullion.[131] The *Freeman's Journal* issued an admonitory reminder to its Irish readers that the full market price offered by the Royal Irish Academy for any objects of artistic or archaeological interest would be much higher than the bullion value and urged the Irish peasantry to resist their indigenous impulse toward vandalism.[132] The same journal estimated that at least £10,000 worth of ancient ornaments had been melted down in Ireland during the past century.[133]

Another scholar, George Vere Irving, complained that peasant finders often refused to divulge the location of their discoveries in order to protect their future financial gains.[134] The "finder," according to Irving, was almost invariably a laborer or small cottar in an out-of-the-way district. The finder's primary fear was

that his landlord might wrest his possession from him, and thus he had the "nat-
ural" feeling not to publicize his good fortune "any more than he would pro-
claim the amount of his deposit in the Savings' Bank, or of the little hoard in the
corner of his chest."[135] Even if his finds were turned over to the proper author-
ities, their utility to archaeological science was limited without full details of their
discovery. Prior to the mid-nineteenth century, the scholarly interest in antiqui-
ties had focused on individual objects. But the later decades of the century wit-
nessed a new interest in the constitution of hoards and the necessity of studying
antiquarian objects in relation to one another.[136] Without complete information
about the circumstances of the find, the artifacts would "sink" to the level of
bric-a-brac and be suitable only for a museum of design. The peasant was there-
fore a threat to history, both in consigning valuable artifacts to the melting pot
and in intentionally obscuring the locality and origins of the objects he was all
too willing to forfeit.[137] The destructive peasant was a common motif in the le-
gal and academic texts concerning antiquarian research, and the Irish peasant
was typically characterized as the worst of the lot.

According to the British Museum's trustees, the Irish were a nomadic, dis-
possessed population: a people who had never benefited from the political rights
derived from property nor understood the basic principles of individual owner-
ship. The much-vaunted Celtic love of the poetic and the beautiful was per-
ceived simply as a passion for the ephemeral and the immaterial, a collective aes-
thetic imagination that was both distinct from and opposed to the institutional
preservation of culture. In the trustees' rhetoric, the entire Irish political nation
was collapsed into the peasantry.

Furthermore, the British Museum claimed that it had retrieved the Celtic
gold ornaments not only from a destructive and mercenary peasantry but also
from an inactive and unprofessional educated class. Thompson criticized the
keepers of Scottish and Irish museums for "not looking out quite sharp enough"
for their own antiquities. Antipreservationism, then, extended beyond the Irish
countryside to the Dublin Museum itself.[138] Lord Balcarres, the future founder
of the National Art-Collections Fund, narrated the history of the ornaments for
his fellow M.P.s as one of Irish passivity and English action: the ornaments had
"passed from hand to hand of many peasants, until they came into the posses-
sion of a dealer, and finally found their resting place in the British Museum."[139]
English patriotism, Balcarres suggested, had protected Britain's patrimony from
Irish incompetence. If the ornaments had been lost to Ireland, they had at least
been saved for Britain instead of sacrificed to Paris or Berlin.[140]

During the same debate, one English politician suggested that the orna-
ments had originally been acquired by an Irish king during a raid on England,
and "if it was a case of spoiling the Saxon they [the ornaments] were not Irish at

all."[141] The Irish relationship to cultural objects was categorized in terms of loot-
ing, destruction, and material gain; museology and preservation were character-
ized as fundamentally English. The British Museum's claim to retain the orna-
ments was cast in terms of moral authority: a legitimate response to Ireland's
long history of thievery. To this end, the trustees offered Dublin a set of facsim-
iles of the Celtic artifacts. This offer, which was promptly rejected, implied that
Ireland was unworthy of the original artifacts. But at the same time, such a pro-
posal complicated the idea of origins for objects within the British Isles. As Colin
Graham has argued, the provenance of debates about authenticity and original-
ity is less apparent in Ireland than elsewhere in the British colonies because dis-
courses of authenticity have been derived from across the political spectrum of
England and Ireland. In Ireland, he suggests, the doctrine of authenticity has
combind a prioritization of origins with the pathos of incessant change.[142] As the
Celtic gold trial would demonstrate, the trustees' intention in holding out these
facsimiles or "fakes" to Dublin was to suggest that the "origins" of an object en-
compassed more than the moment or location of its material creation. The mo-
ment of preservation—the creation of value—was originary as well.

An anonymous satirical poem titled "To the Commissioners on the Keltic
Gild Ornaments found in—the British Museum!" juxtaposed Saxon "guilt"
with an image of Irish ignorance and carelessness that stretched back to the an-
cients and the original concealment of the ornaments in Limavady:

> By yer lave—if I'm not interferin'—
> Sure our claim on sound basis is built,
> When on our side are Virtue an' Erin,
> And the Saxon has grabbed all the 'gilt.'
>
> Faix! we'll raise yiz all statues by Farrell
> If ye help us to get back our own—
> Them thrifles in wearin' apparel
> That we dhropt in a bog in Tyrone.[143]

The ancient Celt who abandoned his valuable gold treasures—or "thrifles," as
he perceived them—in a bog was linked through history and character to the
modern Irish supporters of repatriation, who sought redemption for their own
foibles from a Treasury-appointed commission. The ornaments were twice lost
by the Irish: first by the original owner, and then by the art dealer who willingly
sacrificed the gold to English hands. Celtic gold was only truly discovered or
"found" at the British Museum, where cultural objects were valued and pre-
served instead of literally and figuratively dropped.

The British Museum's case for retaining the Celtic gold ornaments invoked this older English tradition of representing the "nomadic" Irish as the destroyers of British patrimony.[144] These accusations of Irish fecklessness were of course nothing new, but in this case the Irish press successfully turned the stereotypes on their head. The Irish press conceived of the Celtic ornaments controversy and trial in terms of property rights, referring to the British Museum authorities as "the receivers of stolen property"[145] and titling articles about the Celtic ornaments "Burglary at the British Museum."[146] Similarly, two Irish legal scholars argued that this case set a precedent for the British Museum's holding stolen goods.[147] The *Evening Herald* condemned the trustees' actions as "a piece of spoilation," directly countering the trustees' claim that the ornaments were acquired during an Irish raid of an English king.[148] Ireland was reconfigured as the defender of property rights against unlawful English acquisitiveness. The demands of archaeology, history, education, and even moral right were all subordinated to the principle of property: The ornaments were Irish property, whether ownership was determined by the location of their discovery or by their intrinsic "national character."[149]

The irony and political significance of the Irish having to explain to the English that "possession was the whole thing in the case" was lost on neither party.[150] The *Irish Figaro* caricatured the British Museum trustees for taking English tenets of property ownership to absurd extremes: "[A]ll is coloured with the tenacity of John Bull in holding on to anything he regards as his property, and his amazingly liberal estimate of what is his rightful property."[151] The English opinion, expressed in the House of Commons by Lord Balcarres and at the British Museum by Thompson and others, that the Irish were incapable of taking adequate care of their patrimony—or indeed that such a concept as Irish patrimony existed—was challenged in a parody of English possessiveness. The rhetoric of the Celtic gold case was aimed at reconstituting the Irish as a body of property owners and caretakers according to Liberal definitions of citizenship: literally, repatriating Ireland in English terms.[152]

The proposal to return the Celtic gold ornaments to Dublin was received ambivalently throughout the museums profession, underscoring the extent to which these institutions depended on a particular framework of property relations. Lord Dillon of the British Museum suggested that exporting the ornaments to the Dublin Museum would be "reverting to the state of things at the Creation."[153] This motif of returning to Genesis, an age before the practices of permanent acquisition and exchange that undergirded both the institutionalization of art and civilized property relations, plagued Irish and English curators throughout the campaign. But the president of the Museums Association, Francis Arthur Bather, questioned whether museums ultimately preserved

cultures or destroyed them. He referred to public collectors as "modern Vandals" and lamented that artistic and archaeological objects were robbed of all their glory and significance by the "garish monotony" of the museum setting.[154] For Frederic Harrison, the leading positivist and art critic, repatriation claims were far more compelling to Britons at the end of the nineteenth century than at the beginning. Foreign marauders might invade the Parthenon, but the National Gallery and British Museum could just as easily be destroyed by domestic "political or riotous commotions." Modern London, he pointed out, was not necessarily safer than Athens.[155]

The *Freeman's Journal* suggested that British curators were already starting to consider the political responsibilities of museums in new ways, departing from the blithely imperial excavations of the early nineteenth century. In an atypical reference to the Parthenon marbles, the editors of the *Journal* wrote:

> In the old times it was thought the right thing to tear the column from its base or the inscription from the rock in some distant clime and bury it away to the dusty cases at Bloomsbury. No one can look without shame at the shattered fragments in the Elgin Room and remember that they were the most glorious statues in the world, torn by an impious Scotchman from the facade of the Parthenon they had adorned for twenty centuries. The modern feeling is that objects of art should remain in their native land, and, if in museums, with cognate and appropriate surroundings.[156]

This editorial denounced the Celtic history of participation in imperial expansion—Lord Elgin, after all, was the impious Scot in question—and exhorted Ireland and Scotland to reclaim their property from the British Museum. Museums, it seemed, could unmake colonial object relations just as they had buttressed them in the past. Repatriation was the right choice of "modern" curators. But what was so modern about repatriation or about techniques of display that placed captured objects in "cognate" surroundings? Should we read "modern" in this context as "anticolonial"? Not uniformly, certainly.[157] There is an ideological gulf between the stance of the *Freeman's Journal,* which was unfailingly critical of English colonial pursuits, and that of Francis Bather, who was decidedly not. For Bather, the goal of repatriation was to improve the curator's ability to contextualize the objects that remained. His project was the rationalization of curatorship rather than a critique of colonial relations.

The *Journal*'s advocacy of repatriation was particular to Anglo-Irish history. The *Journal* concluded that the Celtic gold ornaments should be returned to Ireland not only because this transfer would be in keeping with modern museolog-

ical movements but also to prove "what a glorious dawn of art it was that the En-
glish invasion forever darkened."[158] The ornaments inverted traditional stereo-
types of property and destruction in English and Irish culture. But they also now
stood symbolically for three separate phases of Anglo-Irish relations. First, there
was the pre-invasion utopia of independent Irish art and culture. This phase was
followed by a period of war and English domination culminating in the "cap-
ture" or "filching" of the ornaments themselves. Finally, there was the planned
return of the ornaments, which would inaugurate a new era of development for
Ireland. Within the *Journal*'s account of Irish history via Celtic ornaments, re-
patriation would bring a museum age to Ireland—complete with the revival of
industry, agriculture, and the arts—as well as an anticolonial age of political de-
volution. The Irish political future, and the Celtic artistic past, were narrated via
this Parliamentary, legal, and public battle for gold.

 The controversy about the gold ornaments contributed to a larger debate
both within and outside the museums profession about the appropriate methods
for determining the national character of art. One Conservative English M.P.,
Sir George Bartley,[159] argued that Irish nationalists needed to clarify the grounds
on which they sought repatriation. He supported the return of the gold orna-
ments to Dublin because of their Celtic character and their significance for Irish
archaeology but objected to repatriation claims based solely on location. If the
ornaments were returned to Ireland simply because they were discovered in
Derry, Bartley feared, this mode of repatriation would produce a "very awkward"
situation in which museums would consist only of articles belonging to that par-
ticular nation, "and that would be a great disaster."[160] The Irish campaign for
Celtic gold had produced a disturbing new vision of the anti-imperial national
museum: a post-repatriation institution of repetition, isolation, and stagnation.

The Gold Ornaments Trial and the Legalization of Celtic Culture

The Gold Ornaments trial was presided over by Sir George Farwell, with
Richard Burdon Haldane—the future lord chancellor—representing the British
Museum and Sir Robert Bannatyne Finlay taking the Irish side.[161] The trial be-
gan with a courtroom exhibition of the ornaments, presumably so that Farwell
might be impressed by the beauty and historical significance of the artifacts. The
judge eyed the collection warily and commented only that "[W]e do not seem to
advance very much, even at the present day."[162] With Farwell at the helm, tele-
ological arguments about material and artistic progress—which had been at the
center of the Victorian museum project—would clearly be difficult to main-
tain.[163] Whereas the Irish press had concentrated its claims for repatriation on

the location of discovery and on the changing norms of curatorship, the court case focused primarily on the original character and function of the ornaments in ancient Irish society. As the case moved from Treasury Commission to High Court, its participants came to focus less on the institutional rights of museums and more on the status of Ireland within colonial history. Ultimately, the themes of the trial ranged widely from the evolution of Celtic design to the preservation of the Ulster landscape and the vagaries of monarchical authority in Anglo-Irish history.

The Irish attorneys argued that the original owner had deliberately hidden the ornaments with the intention of recovering them at a later time. Thus, the ornaments came under the legal definition of *trover*: treasure trove, or Crown property.[164] Arguments about treasure trove are of particular interest here, because they required the participants in the Gold Ornaments case to reevaluate the precise legal relationship between culture and property. That is, what legal notions of ownership were at play in the Irish demand for the return of Celtic gold? Which particular aspects of property law governed institutions of art and history? How did the laws of property apply or extend to cultural objects, and how might these laws fail to encompass or address the special nature of the same? In Farwell's courtroom, as Irish claims for repatriation came to focus on the history and scope of treasure trove law, these questions all received special attention.

According to legal scholars, no doctrine of laws protecting Britain's past has attracted greater disquiet than that of treasure trove.[165] One critic has recently called it "the most problematic category of personal property,"[166] and it was described in the early twentieth century as a "hopeless muddle" of a law.[167] The cardinal elements of treasure trove were that the cache or object must be gold or silver,[168] the original owner or his heirs must be unknown, and the object must have been concealed for the purpose of safekeeping.[169] According to Blackstone's authoritative *Commentaries on the Laws of England*, a man who hid his treasure in a secret place did not mean to relinquish his property, and if he died, the law gave this property to the sovereign as part of the royal revenue. But if he scattered his treasure upon the sea or upon the public surface of the earth, he abandoned his property absolutely and returned it upon his death to the common stock where it belonged to the first claimant, as in a state of nature.[170] An additional provision in practice, if not in law, was that the objects must be grouped together in such a way as to suggest that they had not merely been lost or dropped. For example, if a ploughman turned up a single gold ring in a field, the ring probably would not be designated as treasure trove but would be assumed to be lost property instead. As such, it would belong to the finder rather

than to the Crown.[171] The modern (that is, post-Blackstone) law of *trover* in Britain thus hinged in part on the manifest intentions of the original owner.[172] This last point was almost invariably established by circumstantial rather than direct evidence and required a certain degree of historical speculation or imagination.

There are two key sources of treasure trove law: Roman and Teutonic, or feudal.[173] As one English commentator wrote in 1903, the law of *trover* was "a tie that bound us [modern Britons] with the thought of the Middle Ages, and a chain that links us to the life and law of the Roman Empire."[174] Under the Roman law, the state had no particular right to found treasure, which was defined as all things of value that had been hoarded up as opposed to things of value that were in use. Hadrian gave the finder the rights of ownership for treasure discovered in his own land. If the finder were a stranger, half the treasure went to the finder and the other half to the owner of the land, whether a private person or the state.[175] Sir George Hill of the British Museum speculated that the legal definition of treasure arose in the period immediately following the fall of the Republic. The crisis had destroyed many owners of landed property and caused widespread emigration on the part of the landed classes; Hill said that this process, which must have sounded all too familiar to British collectors in the early twentieth century, had caused many hoards to be forgotten. When tranquility returned, the scope of ownerless treasure discovered on land possessed by new proprietors was sufficiently broad to inspire lawmakers to define the rules of treasure more carefully.[176]

Legal historians disagreed in the nineteenth and early twentieth centuries as to whether the British law had an exclusively Roman origin. Indeed, they have continued to differ concerning this point. The connection between the Roman and the British law of *trover* was not always easy to trace. Blackstone's theory, which was invoked throughout the Gold Ornaments trial, was that English laws of treasure trove originated when the Romans were driven from the British Isles.[177] The Romans had planned to hide their caches of gold and silver only temporarily, anticipating a brief period of turmoil after which they would return to Britain and reclaim their treasure. After the Romans were exiled, the British framed laws based on the Roman system to establish title to the treasure left behind.[178] If correct, this theory would suggest that the laws of *trover* in Britain were rooted in an early imperial disaster. But British legal historians in the nineteenth and twentieth centuries were more interested in the second potential source of British treasure trove law: the Teutonic, or feudal, law.

Legal scholars traced the sovereign's exclusive claim to treasure to the increasing power of the Teutonic chieftain as he developed into a feudal overlord.[179] The Crown's privilege in the realm of treasure trove thus derived from the feudal doctrine of the ultimate ownership of land being vested in the Lord

Paramount.[180] The king's right to claim treasure trove was primarily a means of increasing his revenue in times of domestic insecurity.[181] Like mining rights, the law of *trover* was exercised for the benefit of the exchequer, not for the private advantage of the ruler.[182] But it was also a mechanism of power used to illustrate that the king would prevail in any conflict with his subjects.[183] Here, the Crown combined the rights of the finder and the owner of the land where the find was made. As such, the feudal principle of treasure trove would seem to subvert the Roman property rights of the individual finder. Sir Walter Scott's famous tenet "Nae halvers nor quarters. Hale of mine ain, and nane o'my neighbours" failed under the feudal derivation of *trover*.[184] Scholars of treasure trove law stressed that the "finders keepers" rule was firmly entrenched in the British popular imagination. The law of *trover* thwarted this rule and thus stood as one of the most striking legal exceptions to the protection of individual property rights in Britain.

This law was not a limitless mechanism of monarchical rights, however. The general rule of feudal Europe was that all ownerless property belonged to the king. But in England, where the feudal system was imperfectly developed, this kingly power of ownership was always restricted to gold and silver objects that were intentionally hidden and did not apply to all abandoned or ownerless property.[185] The English law, which originally gave title to treasure trove to the finder, was elaborated in the twelfth century to specify the Crown's prerogative. The first evidence of an English king exercising the right of *trover* in Ireland dates from 1208; legal scholars have speculated that King John was trying to bring about uniformity of law and custom between England and Ireland.[186] The most expansive form of *trover* existed in Scotland, where the king could lay claim to all types of ownerless antiquities: bone, bronze, and copper, as well as more precious metals.[187] The law of treasure trove was therefore unevenly developed throughout the British Isles, and the king's right to claim this category of property varied by region. During the nineteenth century, many colonial outposts also adopted the rule that treasure trove belonged absolutely to the Crown,[188] in part to combat the endemic looting of archaeological antiquities in India, Ceylon, and elsewhere.[189] The Gold Ornaments case provided contemporary scholars with an opportunity to reassess the law of *trover*, revaluating its connection to modern and archaic systems of authority.

In response to the Irish claim that the ornaments were treasure trove, the trustees of the British Museum countered that Gibson's field had at one time been part of a seabed. According to their geologists, this tract of land had only been reclaimed in the past sixty years by the construction of an embankment.[190] Thus, the Celtic ornaments could not have been hidden there with a view to recovery. The trustees argued that the ornaments had been scattered on the water as a votive offering to an ancient sea god and were never meant to be reclaimed.[191]

As further proof of the votive offering thesis, the trustees suggested that the objects had been "mutilated" to release their spirit in some sort of profane ritual, although the torque and chains were actually in perfect condition. George Coffey of the Dublin Museum said that the fact that one torque was cut in half in no way suggested that the objects had been used as part of a pagan religious practice; rather, this fact provided more evidence for the Irish claim that the ornaments had been raided and hastily concealed with an eye to recovery. The cutting off of one half of the torque would have been common practice at a time when ornaments of this kind were used as currency for payments. According to Coffey, half of the torque might have been cut off in a division of spoils or for a payment when the raider carried them around, a practice that he said persisted in India in their own time.[192] What the English chose to see as a remnant of a pagan votive offering was in fact a personal hoard.[193] The Irish attorneys tried to resolve the geological question before the trial, interviewing old men from the locality who claimed that Gibson's land had not been under water in the 1840s.[194] Furthermore, the fact that Nicholl had discovered the ornaments all in one area, clustered together in a spot approximately nine inches square, tended to undermine the British Museum's claims that these objects had been tossed into the Sea.[195]

The question of how the ornaments were originally used produced a lengthy debate about the academic status of ancient Irish history. Celtic antiquarianism, the longstanding obsession of the Anglo-Irish élite, became an object of litigation.[196] If the Celtic gold ornaments could be proved to fall under the legal definition of treasure trove, Finlay suggested, then the British Museum would stand in the same relation to the Crown as the purchaser of stolen property, especially because museum officers were expected to be conversant with the laws of *trover*.[197] The penalties for concealing treasure trove had undergone several alterations in the development of English law. In the fourteenth century, under Edward III, the penalty was changed from death to fine and imprisonment. In 1903, the willful concealment of treasure from the Crown was still an indictable offense. At that time it was punishable by unlimited imprisonment without hard labor (although the ordinary statutory term was two years) and fines without statutory limit.[198]

Although the disposal of treasure trove was at the discretion of Treasury, acting on behalf of the Crown, Treasury had had virtually no direct dealings with the law of *trover* in Ireland for many years and had delegated this responsibility to the Royal Irish Academy. The academy received £100 annually from Parliament to reward discoverers of treasure trove and posted notices in the constabulary barracks and similar venues throughout Ireland, informing the public that the academy's remuneration for gold or silver would be higher than that of private dealers and explaining the substance of the law. Furthermore, the enforce-

ment of *trover* was intended to relieve tension between tenants and landlords such as Nicholl and Gibson as to who owned found objects, a topic of particular interest in Ireland. The problem of determining the "owner of the soil," as the legal terminology would have it, was more pronounced in Ireland than elsewhere.[199] As one legal scholar had written in 1865, the abdication of *trover* would only work if all landlords were popular, resident, and antiquarian—an entirely utopian and fantastic proposition when speaking of Ireland.[200]

Because no history of early Ireland was available, the British Museum's contention that the Ulster chiefs had been sea kings could be neither proved nor disproved. Even the periodization of "Celtic history" was unclear; neither side could produce a scholar who would fix the so-called Celtic period within several thousand years. The British Museum's attorneys tended to extrapolate both from modern Irish practices and from ancient histories extending back to Herodotus; R. B. Haldane argued that the Irish still made votive offerings, but he was quickly rebuked by the Irish attorney general for equating the modern Catholic practice of dropping objects into holy wells with a "pagan" ritual.[201] This confusion of Celtic history and contemporary Catholic custom was a frequent cause of complaint against the British Museum, particularly after one expert witness acknowledged that he had never studied the history or archaeology of the north of Ireland.[202] Another witness suggested that the hoard might be explicitly tied to a Christian history rather than a pagan one. His deposition stated that the golden boat might have represented an offering to the shrine of Saint Columba to protect the owner from shipwreck.[203] According to this account, the boat was a Christian votive offering. Therefore, the ornaments could not fall under the law of *trover* because to reclaim an offering—pagan or Christian—would be sacrilegious. But from the Irish point of view, the pre-Christian hoard represented Ireland *before* its colonial rupture into sectarian denominations. The national value of the collection depended in part on its contribution to a common currency in the holy and the sacred, and the English misalliance of the Celtic and the Catholic was therefore particularly disturbing.

The apparent impenetrability of ancient as well as modern Irish culture was exemplified by the fact that one of the key witnesses for Ireland—the farmer, Thomas Nicholl, who had originally discovered the ornaments—could not be understood by the English judge or attorneys because of his dialect.[204] The Irish attorney general feared that his other witnesses would "scarcely be able to find their way to London unless they are placed in charge of some person," and he engaged several policemen to accompany the Irish participants—who could not read a map—to court.[205] The fact that Nicholl was from Ulster had given him a higher status in London, since Ulster was perceived as an outpost of agricultural and political security even during the land wars.[206] Nicholl was clearly neither an

agitator nor a radical. Indeed, the case put the Irish attorneys from Dublin in the atypical position of defending Ulster as their own. But ultimately the "foreign-ness" of the Irish, both in the fanciful history of the ornaments and in the living witnesses, underscored the problem of Anglo-Irish cultural exchange, past and present, and emphasized the gap between Irish and English identities within the British legal system. Nicholl could not function as a witness for either side in the London courts, and Farwell's assistant requested that they not interview any more "ancient inhabitants" after Nicholl's deposition.[207] Indeed, one legal commentator accused Nicholl and his sister of melting down at least one fragment of gold from the Derry site and thus consigning their history to the melting pot.[208] Nicholl, Gibson, and Day all receded into historical obscurity,[209] and institutional property rights supplanted the rights of both the individual Ulster farmer and the collective Irish peasantry.

The Dublin Museum devoted increased resources and energy to their Celtic antiquities department during the trial, perhaps hoping to prove that the ornaments would be suitably housed if they were returned to Ireland. This new emphasis on Celtic antiquities within the Dublin Museum also countered DATI's future-oriented vision of Irish museology, demonstrating that the curators maintained an antiquarian interest despite DATI's innovations.[210] The legal battle for the gold ornaments functioned as part of this larger struggle to balance the Dublin Museum between history and the future, satisfying both the antiquarian scholar and DATI. But as English and Irish representatives contended for the ownership of Celtic cuture, definitions of Celtic art and design were no less problematic than Celtic history. The British Museum was unwilling to recognize Celtic art as a uniquely Irish product and argued that the proposed link between Irishness and Celtic gold was an invention or construct of the Dublin Museum itself. Several of the British Museum's trustees testified that "the form of art known as Late Celtic is . . . pre-eminently English,"[211] and one trustee referred to the ornaments' connection to Ireland as "purely accidental."[212] As C. H. Read, another British Museum trustee, asserted, the Celts of Caesar's time had camped out on English shores, and the Thames had itself been a prolific field for the discovery of Celtic antiquities.[213]

The witnesses at the trial ranged from experts in ploughing to those in conchology and geography as the participants argued about the degree to which the Irish coastline had shifted since the ornaments were deposited.[214] The mythology of Irish sea kings was based on the notion that these kings had escaped the peril of the waves on a rocky coast liable to shipwreck; the Irish attorneys countered with extensive cartographical evidence to show that the coastline was not in fact rocky. George Plunkett commissioned a set of photographs to show the depth to which the bog had been cut away at Gibson's farm, proving that the

land had never been under water and thus that the original owner had not flung the ornaments into the sea.[215] To their original interviews with the older residents of Derry the Irish attorneys now added distinguished geologists, who testified with maps to show that this particular tract of land had been elevated above sea level long before the Christian era.[216]

Like Matthew Arnold, the English participants in this trial presented the Celtic sensibility as a conceptual knot buried within the English soul.[217] But increasingly, the Irish case rested on an empirical and evidentiary challenge to Celtic mythology. In fact, the Gold Ornaments case was striking for the extent to which the key Irish proponents of the Celtic Revival did *not* involve themselves with the repatriation campaign; this particular initiative was not solely a function of the Anglo-Irish élitist doctrines of W. B. Yeats and Lady Gregory. Yeats himself does not seem to have commented publicly on the case until the 1920s, when he noted that the ancient Irish ornaments were the only visible evidence that Ireland had ever had a civilization.[218]

During the trial, the British Museum's trustees suggested again that the ornaments had been brought to Ireland as part of an ancient piratical foray. Their "recovery" of the Anglicized Celtic gold thus constituted its own form of legitimate repatriation, while the Irish movement to return the ornaments to Dublin was characterized as a reenactment of the original piracy. At the same time, Irish advocates for repatriation argued that the Roman conquest of England had diverted all early Christian British art production to Ireland and Scotland. Any traces of Celtic design in England had been "obliterated by the all-devouring uniformity that the Roman World stamped upon the regions it subdued."[219] From the Irish point of view, early English craft was neither Celtic nor British but merely Romanized and corrupted. The Irish claim to ownership of Celtic culture, as well as this particular group of gold ornaments, was bolstered by this denial that there had been an early English school of art and by the historical depiction of England as a conquered colony. The trial provided an opportunity for the Irish attorneys to depict England, at least in the realm of design, as another helpless victim of colonial history.

As the trial progressed, the attorneys for both sides brought new historical moments into play. Depending on whether one emphasized the original use, the hiding, or the survival of the ornaments, they could function either as a physical symbol of a recuperated pre-colonial past or as the very inauguration of occupation itself. Whereas some scholars stressed the possibility that the ornaments had been hidden during the invasion of ancient Norsemen in A.D. 850, the legal discussions focused on a rather more recent phase of Irish subjugation: that is, Tudor history.[220] The British Museum's attorneys argued that if the ornaments had been buried with the intention of recovery, their existence would have been

recorded during the Tudor inquisitions. Justice Farwell acknowledged that "one's recollections of Irish history before Elizabeth . . . are very scanty," but he dismissed the claim that the Tudors would necessarily have known about and catalogued these ornaments. He repeatedly reminded both sets of attorneys that Northern Ireland had been an exceptionally dangerous place in the days of Elizabeth and that the English had made life and property markedly insecure for the Irish inhabitants of this region. As Farwell described it, the Broighter Hoard reflected a historically specific response to the English destruction of property in Ireland. The original owner was not simply hiding his precious gold from anonymous "raiders" but was responding to an immediate English threat.[221] From Farwell's point of view, the key point was not whether the owners had been good Christians or good pagans but how the particular history of English colonization in Ireland had disrupted the normal circulation of property.

More generally, Farwell asserted the principle of Irish independence even within the context of Tudor and pre-Tudor rule; he said, "King John, I suppose, would practically call himself the King of the whole of Ireland, but I do not know that he was *de facto.*"[222] The British Museum's attorneys had steered the ornaments case toward an Anglocentric discussion of Tudor colonialism, for which Farwell reproached them. Integral to this case was a larger question about the impact of colonization on property rights. To what extent, if at all, did conquest of a particular region or state establish ownership of the objects within it?[223] In Farwell's court, the history of English conquest did not establish rights of ownership in Ireland per se. He suggested that this discussion of Tudor rule could undermine English claims to moral authority, asking another museum attorney, Viscount Warmington, "Perhaps you are not very disposed to enter into Irish history?" Warmington hastily retreated, conceding, "No, my Lord."[224] The artifacts were, to borrow a phrase from Luke Gibbons, part of the debris of the history of invasion.[225] Rather than focusing on the glories of ancient Celtic civilization and craft or on the virtues that this collection would inculcate in the Irish public, Farwell suggested that the artifacts had made the process of colonization all too visible.

Ultimately, the Gold Ornaments trial provided a panoramic tour of Anglo-Irish history. The scope and limits of Tudor control functioned as a key point of contention in the trial. Was it possible that the Irish had hoarded valuable goods without English permission or knowledge? From different points of view, the ornaments narrated the history of colonial oppression, the history of English redemption from Irish immorality, or, finally, the history of Irish opposition to colonial incursions. The meaning and value of this history would be fixed by the ultimate destination of the ornaments. At the British Museum, the ornaments referred to a British imperial past—a narrative in which Ireland functioned only as a conquered colony and England as the true inventor of Celtic art and design.

But the proposal to repatriate the ornaments to the Dublin Museum pointed to a new historical context or trajectory for the collection. In this Irish location, Celtic gold would pose a challenge not only to contemporary colonial practices but also to a longer tradition of Whig historiography that pictured the conquest of Ireland as a fait accompli. The Irish struggle to return the ornaments to Dublin thus reimagined the history of colonial relations and pointed to the survival of the ornaments throughout the Tudor period as proof of an alternative historiography of Irish resistance and defiance.

While the Irish and English lawyers struggled to define the national parameters of "the Celtic" within British culture, the press noted that the trial itself was imbued with an unmistakably Celtic sense of mystery, mysticism, and romance.[226] As one observer commented nearly fifty years later,

> We heard a mass of interesting information . . . the period ranged
> from the time of Xerxes to modern days, the *locus* from Finland to
> the Malay archipelago. Mananaan MacLir was dragged in as an
> Irish sea god, and Fraser's *Golden Bough* was well to the fore. The
> judge got restive over this wealth of folk-lore and legend, and
> protested once or twice.[227]

The Gold Ornaments trial ended after only four days on June 15, 1903, with Justice Farwell finding "hands down" for Ireland. The total costs of litigation were £3,113, with Treasury defraying the British Museum's taxed costs of £1,486.[228] According to Farwell, the British Museum's case had rested on an unlikely invention of Celtic culture that asked his court to believe in ancient sea gods and ritual practices without substantial archaeological or anthropological evidence.[229] The far more likely conclusion, Farwell added, was that the artifacts had been a hoard hidden for safety in a land disturbed by frequent raids and forgotten by reason of the death or enslavement of the depositor. His final address to the court stated that the British Museum's testimony had been "more suited to the poem of a Celtic bard than the prose of an English law court."[230]

At the heart of the trial was a larger question of how to talk about Irishness within the context of British legal culture: how, in other words, to debate Celtic art and history without inevitably drifting into the arena of fantasy, myth, and legend. According to Farwell, the British Museum had fabricated both Irish history and its own relationship to the Celtic past to the point that it could no longer be entrusted with the material preservation of this history. The trustees of the British Museum, rather than the Irish supporters of repatriation, had become the fanciful "Celtic bards" who circumvented English law and reason. The negative ramifications of Celtic culture had shifted from the Irish onto the English, although the status of the Celtic—an outpost of romance, poetry, and imagination

within a larger British framework of legality, rationality, and property—remained essentially unchanged.

The ornaments were displayed briefly in the tearooms of the Houses of Parliament[231] and returned to King Edward under the law of treasure trove. Significantly, the Irish victory depended on this archaic notion of monarchical property rights and royal authority. Legal scholars had long argued that the preservation of *trover* was the only way to militate against the peasantry's tendency to conceal and destroy valuable artifacts, especially in Ireland. The modernization of Crown privileges was impossible owing to the failings of the Irish peasant; the continuation of *trover* was thus the only way to maintain British patrimony.[232] Ultimately, the property rights that were valorized in this case were neither institutional nor collective but the anachronistically absolute rights of the king who ruled over England *and* Ireland.

Edward made a free gift of the ornaments to the Royal Irish Academy in November 1903, with what one observer called "that tact and fine sense of justice for which he is so deservedly famed."[233] He stated in a public address to the academy that he hoped the return of the Celtic gold would usher in a new era of peace, commercial prosperity, and industrial progress throughout Ireland. The hoard was placed in the Irish antiquities section of the Dublin Museum, to be exhibited "in a most admirable and beautiful manner . . . a source of great attraction" both to the museum and to Ireland more generally.[234] With the British Museum temporarily in defeat, the Irish press called for greater recognition of the Dublin Museum as Britain's new "national" institution of art, science, and archaeology. In 1908, the Dublin Museum was officially renamed the National Museum of Ireland.[235] Ireland had successfully reclaimed "the Celtic" from England—both materially and spiritually—but the Irish public's interest had shifted from the distant Celtic past to living industry and agriculture, taking the Dublin Museum's cultural policy in a new direction. Irish museology, formerly suspect because of its associations with the Protestant élite and its tendency to glorify the more obsolete aspects of Irish economic life, was recrafted as a dynamic force in Irish politics and culture.

This process of repatriation was in turn informed by new developments in the Irish land rights struggle, culminating in the Irish Land Act (Wyndham Act) of 1903. Beginning with the Land Act of 1870, the long process of transferring ownership of land to those who cultivated it had started to erode the economic base of the Anglo-Irish gentry.[236] The Celtic gold controversy was in fact neatly framed by two pieces of Irish land reform legislation: the Land Law (Ireland) Act of 1896, which provided changes in the determination of fair rents and provisions for land purchase, as well as the reinstatement of evicted tenants, and the Wyndham Act.[237] The Wyndham Act decisively loosened the grip of the Anglo-

Irish ascendancy on Irish estates, establishing provisions for the purchase and re-
sale of estates to occupying tenants.[238] As a result of the act, Treasury invested
more than £70 million in Irish land purchases; two hundred thousand Irish farm-
ers became owner-occupiers.[239] The conventional analogue of England with in-
dividual property rights and Ireland with communalism was breaking down as
the notion of absolute ownership eroded in England as well. In an age of exper-
imentation with ideologies of property, Ireland became an atavistic site of indi-
vidual ownership, a surprising outpost of secular, liberal, and, historically speak-
ing, unmistakably English norms.[240] After 1903, the notion that Irish agriculture
depended on an unwritten, custom-bound sense of land that was fundamentally
at odds with British contractualist ideology could no longer be sustained, and
what Terry Eagleton has termed one of the critical cultural divides of nineteenth-
century Britain was diminished.[241]

The Gold Ornaments case was linked to the land issue not only by its co-
incidence with the Wyndham Act but also by the shadowy figure of Thomas
Nicholl, the Ulster farmer whose labor had produced the fruits of culture.
Nicholl's "disappearance" in this case is fascinating, particularly given the val-
orization of pastoral farming and tillage that took place in Ireland after the land
wars.[242] Nicholl would seem to represent the ideal in Irish land reform—magi-
cally excavating Celtic civilization with his plough—except for his regional iden-
tity as an Ulsterman.[243] Even more complete was the disappearance of Joseph
Gibson, the original owner of the farm where the ornaments were discovered.
The DATI takeover of the Dublin Museum had crystallized the tension between
agriculture and industry in the existing collections. But the convergence of the
Wyndham Act and the Celtic gold trial produced a new vision of agriculture in
Ireland as a Catholic and propertied endeavor. Framed by the recent and on-
going land rights struggle, the Irish use of the Celtic ornaments controversy to
incorporate the Liberal tenets of property into their own cultural history was an
important political maneuver.[244] But whose property was upheld? Ireland had a
new national museum, but the British parameters of property rights were in dis-
array. The ornaments had followed a tortuous path from Irish individuals in Ul-
ster (Nicholl, Gibson, and Day) to English institution (British Museum) to Brit-
ish king (Edward) to Irish institutions in Dublin (Royal Irish Academy and the
Dublin Museum). Institutional property was clearly valorized instead of indi-
vidual ownership, but the only absolute owner of the artifacts seemed to be the
king himself.

After the Celtic gold ornaments were repatriated, the trial served as a focal
point for scholars continuing to debate the value of the law of *trover*. By 1903,
when the case came to trial, a major disconnect had developed between the orig-
inal purpose of the law—namely, to accrue income and symbolic power for the

Crown—and its more recent use, which seemed to be aimed at the preservation of antiquities for public benefit. The law of monarchical authority had devolved into a historicist protective measure, an aim "diametrically opposed" to the law's intended purpose.[245] The *Juridical Review* demanded that the law be recast to reflect its "real" function in modern days: the safeguarding of artifacts, rather than the veneration of kingly power.[246] As it stood, the law was an inadequate preservationist measure because it failed to extend protection to the full range of antiquities. A Celtic gold torque was treasure trove if it was accidentally discovered hidden in the ground. But if the same torque were to be found on the surface of the land, it belonged absolutely to the finder and could be melted down or sold out of the country at will.

According to its critics, the law of *trover* was arbitrary in the worst sense. It usurped the rights of the individual finder, but did so under such narrowly defined conditions as to make the cause of historic preservation impossible. Another objection was that the Crown abstracted relics from their locality and aided in the process of centralization.[247] In ignoring the rights of the finder, the law embraced an outdated or stagnant notion of monarchical authority that one scholar deemed "barbarous."[248] Other critics advocated the abandonment of the law of treasure trove altogether, suggesting that *trover* be relegated to the shelf of bygones along with trials by battle and the law of deodand.[249] One widespread suggestion was that the English law of *trover* be modified along the lines of the Indian Treasure-Trove Act of 1878, in which finders of all objects (gold, silver, or otherwise) worth more than ten rupees were compelled to write to a collector to mediate between owner, finder, and government.[250] In this instance, the overseas colony functioned as a model of preservationist lawmaking for the metropole.

Even those who defended the English law recommended that Treasury take a more active role in informing citizens that individuals who lawfully reported their find would be rewarded.[251] Most British finders were "ignorant" both of the law of treasure trove and of the "liberal manner" in which they could expect to be treated on the voluntary surrender of their finds to the Crown.[252] Indeed, Thomas Nicholl might have received as much as £80 for the bullion value of the Celtic gold ornaments if he had handed them over to the police immediately, instead of the £5 offered by Gibson.[253] William Martin acknowledged that the whole process of enforcement struck some critics as "savor[ing] of confiscation"—even when the finders were amply rewarded—because the law failed to acknowledge attachments or claims to property that went beyond the financial.[254] That is, finders might value objects more than cash, but the law treated the two as interchangeable. One scholar suggested that the law of *trover* might be aided by reducing the role of the police, who typically acted as the Crown

agents in cases of treasure trove. In this system, it was easy for the finder—often a rural villager—to get the impression that he was being bullied by the police or cheated by the authorities.[255] The police, who tended to treat the finders as potential criminals, could be replaced in such cases by parish councils or civil servants.[256] In particular, Martin and others suggested making use of the Board of Education or the county councils.[257] The law could thus be brought into keeping with the preservationist instincts of an enlightened age, rather than treating finders as the "besotted tavern-hunters" contemplated by the feudal kings.[258] Complaints about the archaic and haphazard nature of treasure trove law continued through the 1930s, as critics lambasted the British courts' inability to clarify the conflicting rights and duties of the state, the finder, and the landowner.[259]

Clearly, the contradictory status of the Celtic past in both stultifying and revitalizing Irish culture was unresolved even after the ornaments returned to Dublin. Following the success of the Gold Ornaments trial, a number of Irish nationalists issued the call for aesthetic home rule. These critics held that English norms in the fine and applied arts were antithetical to Irish ways of life; English suburban domestic design failed to accommodate the needs of the Irish household such as spaces for Catholic mourning rituals, shrines, and *ceilidhs*, informal evening sessions of storytelling, traditional music, and dancing.[260] Developing an independent Irish school, however, would require a break not only with English artistic principles but also with the antiquarian impulses of contemporary Irish art and design. The journalist Robert Elliott warned against using Irish nationalist emblems as the sole route to independence from England, arguing that the resulting school of art would be depressingly uniform. Elliott also described the experience of living under British rule as being subject to "brain-sucking octopi" and blamed English influence for the corruption of Irish taste and manufacturing he witnessed in Dublin. Striking at perhaps the most prized artifact in Irish possession, the Book of Kells, he wrote,

> Freedom of thought in design is the solution and the only solution.
> Perish the Book of Kells and Durrow rather than they should ster-
> eotypedly spread themselves into every parish church in the land. . . .
> Perish Puginism, perish so-called Celticism, if it here means Book
> of Kellsism, but live the art of design and a man's own masculine
> original thought as long as the universe holds together and Ireland
> along with it.[261]

Further, Elliott argued that the development of an independent Irish style would obviate the need for future repatriation campaigns. Pictures might be stolen by English or French invaders or sold to American millionaires, but the spirit of art

that produced them could never be alienated or repossessed.[262] Finally, he characterized the gold boat of the Broighter Hoard—the object of so much adulation during the Gold Ornaments trial—as an ugly and contemptible artifact. More particularly, he condemned the Irish impulse for "antiquarian eulogy" that supported such collections. The aftermath of the trial pointed to a serious rethinking of the role of the Celtic in Irish cultural politics. In Elliott's view, the Celtic obsession was purely degenerative.

The Gold Ornaments trial also prompted a general reevaluation of the function of repatriation in Britain. George Noble Plunkett, the director of the National Museum of Ireland, noted in 1911 that the Irish had once been entirely unsuccessful in preserving material evidence of their past industries, some of which had "disappeared without a trace."[263] From Plunkett's point of view, the successful bid for repatriation of the gold ornaments had left Ireland free both to incorporate her Celtic past into the Irish present and to leave that past behind. The reclamation of the gold ornaments should revitalize Ireland's commitment to participating in a diverse European economy, bringing Ireland's struggle to memorialize Celtic history to a satisfying conclusion. This broadening of the National Museum's aims was exemplified in Plunkett's new universalist philosophy that "while they desired the Museum to be Irish, they also desired it to be representative of humanity at large"; in this respect, Plunkett had come to sound much like the curators at the British Museum.[264] In 1912 the National Museum of Ireland instituted a "purely industrial" annex, and the Irish press predicted great advances in industry under the museum's auspices.[265]

In 1913, the Museums Association met in Dublin, providing Irish curators with an opportunity to present their vision of local institutions to a broader British public.[266] Plunkett began his address to the association by outlining the particular problems of curatorship and preservation in Ireland, namely, the loss of tradition in Irish arts and the "historical difficulty" that English occupation of Ireland had led to the wholesale destruction of artifacts from the thirteenth century onward. He concluded that despite the efforts of the Department of Agriculture, the collections at the National Museum of Ireland were still strongest in ancient Irish artifacts, rather than in modern aids to industry or farming. The purpose of the Irish antiquities collection, as Plunkett perceived it, was to prevent skeptics from treating the Celtic past as pure myth; the National Museum functioned both as a shrine and as a counterbalance to outsiders who characterized the Irish saints and sages as "fantastic fables."[267] He suggested that Irish and foreign visitors to the museum carry with them a copy of the *Tain bó Cúalnge,* or better yet, Mrs. Hutton's splendid English translation, *The Cattle Raid of Cooley,* so that they might see the "truth" of the old romance brought to

life through the collections in Dublin.[268] Plunkett's literary recommendation was particularly striking given the regionalist aspect of the Celtic gold debates; the *Tain* stood as the centerpiece of Ulster mythology. It narrated the epic hero Cuch-ulan's single-handed defense of Ulster and his chieftain's famous bull against the invasion of Queen Maeve of Connaught. Plunkett's vision of the post-repatriation museum served in part to undermine his audience's sense of regional division between what seemed like a homogenous South and an alien North.

The issues of authenticity and truth-telling, always at the heart of the mu-seums profession, forged an important connection between the repatriation of the Celtic gold ornaments and the revamping of the Irish past in the new Na-tional Museum. The ornaments, now at the center of the Celtic antiquities col-lection, ultimately provided a material basis for the factualization of mythology about the Celtic past, despite Irish efforts during the trial to steer away from the Celtic storytelling tradition. Throughout the trial and surrounding debates, the supporters of repatriation promoted a new vision of Irish culture as both propertied and preservationist. After the trial was over, the Celtic vision of Irish history reasserted itself within a professional curatorial context, and the gap be-tween living Ireland and Celtic history reemerged. Making the museum Irish seemed to mean making it antiquarian, while efforts to memorialize contempo-rary Irish history and culture fell flat. As Plunkett himself lamented, "[I]f we have so many things that are ancient, we have very little indeed that can be called modern."[269] Again, the tension between modernity and the museum illustrated the ambivalent legacy of repatriation. From Plunkett's point of view, the re-turn of the Celtic gold represented the valorization of a past no longer useful to the Irish in either political or economic terms. His critique of the National Museum stressed that colonial history was unfortunately absent from the new collections. The period of English occupation, he noted, was represented little or not at all.[270]

In the aftermath of repatriation, Ireland pledged itself anew to the culture of preservation, reinventing itself as a museological nation. The loss and subse-quent return of the Celtic ornaments had presumably revitalized Ireland's desire for a national museum; repatriation was an integral part of remaking the Dublin Museum as the National Museum of Ireland. At the same time, profound anxi-ety about the political ramifications of preservation—namely, that it would in-terfere with Ireland's delayed progress toward economic, social, and political modernization—persisted. Sir Horace Plunkett, who had seen Dublin through its victory over the British Museum, still characterized Irish history as "a thing for Englishmen to remember and Irishmen to forget."[271] His description of Irish history and British memory was quoted in Francis Hackett's 1918 study of Irish

nationalism, and Hackett followed Plunkett's epigram with his own set of questions
about the complex interplay of memorialization and modernity in Ireland. He
asked, "Why is it that the past, the musty past is a living reality for Ireland, a mem-
ory with a sabre tooth? Is it Celtic contrariness, or Celtic mystery, or Celtic twi-
light?"[272] The post-repatriation Celtic character emerged as obsessively preserva-
tionist, museological to the point of political pathology. Having proved itself
worthy to curate its own past, Ireland now feared this role as a barrier to progress,
a delimiting of the role Ireland could play in the future of modern Britain.

The repatriation of Celtic gold was plagued by new mythologies through
the mid-twentieth century; Robert Lloyd Praeger, who had investigated the orig-
inal site of the hoard in 1902, presented fantastic theories about the ornaments
as late as 1947. In particular, Praeger reported a recent claim that the hoard had
been discovered in an old umbrella lying in a ditch and that it was in fact a nine-
teenth-century hoard rather than an ancient one.[273] Although Praeger dismissed
this rumor as "the tale of a modern wag," he did note that it was a pity that the
alleged umbrella could not be displayed alongside the returned gold ornaments
at the National Museum, in order to "link the steel and calico art of the present
with the golden art of the past."[274] In Praeger's framework, the proposed union
of Celtic gold and steel umbrella recast the ornaments as industrial prototypes.
The agricultural origins of the collection were effectively obscured, along with
Thomas Nicholl and the Irish farm. The ornaments were reconceived in DATI's
own terms, incorporating the Celtic and the antique into the modern and the in-
dustrial. Ancient and contemporary Irish artifacts were linked on a continuum
of Irish making and mythmaking.

The complex relationship between culture and politics in Irish artistic and
scientific institutions preoccupied Irish professionals through the establishment
of the Free State and the Dáil Éireann. In 1949, the art critic Thomas Bodkin is-
sued a report on the history of relations between the state and the arts in Ireland,
culminating with the Free State and the establishment of a Ministry of Fine Arts
as part of the Ministry of Education.[275] Bodkin focused his report on the devel-
opment of the National Museum of Ireland, formerly the Dublin Museum, as a
metaphor for the Irish treatment of national art and history. In particular, he at-
tacked the historical collections at the National Museum as a testament to "mis-
conceived sentimentality," likening the museum in Dublin to the Fascist Mu-
seum in Rome because of its use of "mock relics."[276] Bodkin noted approvingly
that certain objects of Irish sentiment such as Eamon de Valera's boots and the
birette of the late bishop of Limerick had lately disappeared from the museum,
but he criticized the curators for allowing the mythology of Pearse to persist
in their display of "an unsightly umbrella presented by the boys of St. Enda to
Patrick Pearse on his birthday, the necktie worn by William Pearse, and a couple

of delft cups from which they drank tea."[277] The worst offense, according to Bodkin, was the room commemorating the rising of 1916, which consisted "largely of trash."

Concluding that there had never been a sustained alliance between the arts and industry in Ireland, and exposing DATI's failed project of re-creating the Dublin Museum as the helping hand of industry, Bodkin ended his report by suggesting that the Irish were still resistant to any central authority in education, including a national museum.[278] Although the return of the Celtic gold nearly half a century earlier had supposedly created a national museum for Ireland, the question of what history, culture, and politics this museum should embrace persisted. The dreaded association of Irish museology and Celtic sentiment also remained intact, a seemingly inevitable by-product of memorializing Irish national history.

Conclusion: The Colonial Invention of Repatriation

The Gold Ornaments trial functions as an atypical success story in the history of repatriation. During the era of imperial acquisitions, the case was an unusual—if not a unique—episode of cultural return. The fact that this case has gone largely unnoticed within the broader field of scholarship on repatriation speaks to the power of existing interpretations of cultural return, which see this practice as taking place beyond the bounds of colonial history. Why was the Irish campaign for the return of Celtic gold successful? Why, in this instance alone, was the British Museum legally compelled to abandon its traditional position as the citadel of colonial expropriation, its objects in circulation rather than locked in place? What did the Irish victory signify about the ongoing drama of Anglo-Irish relations?

The Celtic gold controversy initially seemed to make Irish museology and Irish nationalism compatible, positioning the new National Museum and its expanded collection of Celtic antiquities as an emblem of repossessed Ireland. At the same time, the Gold Ornaments trial invented repatriation for a colonial context, illustrating the ways in which the idea of culture-as-property was itself embedded in the history of dispossession—especially given the centrality of the king and the law of *trover* to Irish "success" in this case. We might assume that the Irish victory in the struggle for Celtic gold was due to the English perception that Celtic antiquarianism promoted the Union by keeping Irish energies focused on the distant past.[279] To this extent, repatriation would function as a barrier to or a diversion from nationalist (especially Home Rule) politics rather than an impetus to it.

The evolution of the trial would seem to support this interpretation. The

strategies of repatriation within the genre of law differed profoundly from those in the press. The Irish press sought to infuse the case with Home Rule energies. But what happened when the case entered the courts? The legal case for return rested with Sir Robert Finlay. And Finlay was no Home Ruler. He broke with the Liberals regarding Gladstone's Home Rule Bill in 1886, though he still briefly styled himself a Liberal Unionist. By the time he undertook the Gold Ornaments case for the Royal Irish Academy in 1903, he was already contemplating his future as a Conservative M.P. What were his motives in securing the return of the Celtic gold? The moral and historical validity of repatriation had been widely debated in the Treasury Commission, in the English and the Irish press, and in the trial itself. But it was Finlay the Unionist who emerged triumphant. The project of justice for Ireland had long dramatized the tensions between coercion and reform within liberal political theory and within the Liberal Party.[280] The Celtic gold case was, in certain respects, another Liberal failure in Ireland. The Treasury Commission, an overwhelmingly Liberal group, inaugurated the process of repatriation in 1898. But, characteristically for the Liberal Party in Ireland, the commission could not reconcile its desire for Irish popular support with the need to maintain Anglo-Irish authority. When "justice" came, it was credited to the Conservatives.

As the trial made clear, the Irish use of Celtic culture and history had changed during the late nineteenth century into a considerably less benign project. Furthermore, regardless of the value of Celtic gold in either spurring on or deterring Irish nationalist politics, the trial raised troubling questions about the future of the British Museum and its ability to dictate the terms of the relationship between English, Irish, and Celtic cultures. The return of Celtic gold to Ireland ensured that the ornaments were positioned as part of a national history rather than a provincial one. As the hoard traveled from private farm to public museum, Ireland understood its own trajectory into the realm of institutions, in which culture could purify and modernize agriculture. But, as Elliott and Bodkin would suggest, repatriation had also turned the National Museum into a site of eulogy rather than modern nationhood, demonstrating the ways in which the redistribution of cultural objects could strengthen colonial frameworks as well as challenging them. Despite Farwell's admonitions, the key question of the trial was not whether the trustees of the British Museum had obtained the ornaments legally. Rather, the case revolved around the broader question of where, when, and how Ireland's engagement with England began. Although the testimony by no means revealed a unified vision of colonial history—nor did it yield any consensus as to whether this history was analogous to that of the overseas colonies— the Irish victory depended on the supposition that this particular form of colo-

nial attachment had not yet come to an end; the king of England was still the king of Ireland. Ultimately, the return of Celtic gold was derived from the joint affirmation of kingly power and colonial kinship.

The conceptual and practical problem of repatriation within Britain has persisted to the present day. A 1984 appeal by Scottish Nationalists for the return of the Stone of Destiny from Westminster Abbey was rejected by UNESCO on the ground that the disagreement was within a single "national entity," that is, within the geopolitical unit of Great Britain.[281] The stone was ultimately returned to Scotland in 1996. As in 1903, the return took place under Conservative sponsorship. This act of repatriation was immediately preceded by Labour's proposals for partial devolution in Scotland and Wales. Like the Celtic gold case, the return of the Stone of Destiny raises important questions about the nature of radicalism and conservatism in the realm of cultural property. What can properly be considered a "liberal" action in this sphere? One might also ask what imagined future Conservatives have sought to forestall with these offerings—the gleaming heap of gold, the sacred stone. More than one scholar has suggested that the advent of Scottish and Welsh devolution will have a domino effect on repatriation campaigns. These scholars envisage regional assemblies within England demanding the return of their artifacts from London and a renewed set of petitions for disaggregating the British Museum.[282] Although UNESCO has established a policy against illicit trafficking in antiquities, there is still no single legislative model that is internationally recognized for repatriation, and the United Kingdom and the United States are not parties to the UNESCO treaties. In terms of domestic class politics, Elspeth King of the People's Palace in Glasgow has compared the treatment of workers' artifacts in twentieth-century labor history museums to the "imperialist trophies" of the nineteenth century. She proposes that the Labour Party join in the queue for the restitution of its cultural property— by which she means the material culture of British workers—from provincial history museums throughout the British Isles and Europe, likening this putative workers' campaign to the Greek demand for the return of the "Elgin" Marbles.[283]

In terms of former colonies, repatriation campaigns have been most successful with human remains; the Pitt Rivers Museum in Oxford and the Glasgow Museum have both returned skeletal remains to Australia, and the Manchester Museum and the Ulster Museum have returned tattooed Maori heads to New Zealand.[284] The Glasgow Museum has also returned some of the Benin bronzes and has been publicly acclaimed for its efforts to formulate a clear repatriation policy.[285] Several curators and art historians, appealing to the notion of a shared Western and non-Western heritage, have proposed digital museums as an alternative to repatriation.[286] Moira Simpson's discussion of African demands

for repatriation from British ethnographic collections offers three key questions
for European curators: How was the artifact under dispute originally acquired?
What was the power relationship between the two parties? Was the artifact com-
munally owned in its place of origin? [287] Similarly, when the Glasgow Museum
opted recently to return a Native American ghost dance shirt to the Lakota, they
set out five issues to be considered in any future repatriation claims: [288] first, the
right of those making the request for repatriation to represent the community to
which the artifact originally belonged; second, the historical continuity between
the community that created the object and the community requesting its return;
third, the cultural and religious significance of the object; fourth, the process by
which the object was acquired by the British institution and the subsequent and
intended use of the object within the institution; and fifth, the likely fate of the
object if returned. [289] The continued centrality of property rights in these cases
is striking, especially since most of the artifacts in question were legally acquired
in the eighteenth and nineteenth centuries.

Today, the gold antiquities section remains the most popular exhibit at the
National Museum of Ireland, with the Broighter Hoard as one of its key attrac-
tions. But the cultural significance of the repatriated hoard extends beyond the
museum itself. The National Millennium Committee, chaired by Minister Sea-
mus Brennan, recently selected an image of the Broighter boat—nestled under
two stars—to serve as the primary design for Ireland's £1 millennium coin
(fig. 3). The coin was intended to mark the millennium in Ireland, and each baby
born there on January 1, 2000, received one of the coins as a gift. The Central
Bank produced a commemorative edition of the coin but also released five mil-
lion coins for general circulation. The winning design team, the jeweler Alan
Ardiff and the designer Garrett Stokes, chose the image of the Broighter boat in
order to depict Ireland's history as an island nation as well as its history of crafts-
manship. The boat, a common symbol in European currency, was also intended
to link the creative spirit of exploration and navigation of an older age with mil-
lennial technology. At that time, Ireland had become the second largest exporter
of computer software in the world. Although it is too soon to judge whether this
moment too has passed into history, the boat was meant to evoke a new sense of
"navigation" in which Ireland's geographic peripherality had become irrelevant
to its economic development. Furthermore, the boat was perceived by the coin's
design team at the end of the twentieth century as a final spiritual offering from
the beginning of the Christian period, an appropriate celebratory symbol for the
millennium. [290]

The coin was launched from the National Museum by the Taoiseach Bertie
Ahern. The governor of the Central Bank, Maurice O'Connell, addressed the

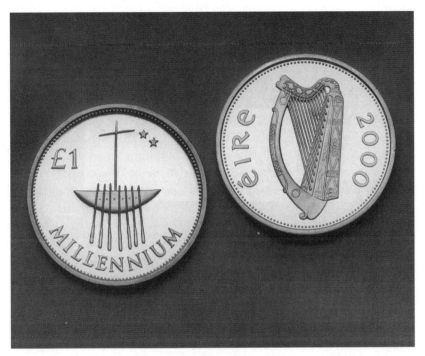

3. Millennium Coin. Courtesy of the Minister for Finance of Ireland.

audience from the museum's antiquities section, the original Broighter Hoard boat shining behind him.[291] His speech began with a progressive history of Irish coinage in which he praised the distinctiveness of Irish design. Whereas other nations imprinted their gold and silver currency with portraits of important personages, Irish coins had a much loftier history. The first Irish coin, minted in 1928 and based on indigenous animals and birds, was a product of W. B. Yeats's own design committee. According to O'Connell, this new millennial coin was linked both to Yeats's legacy and to a history of uniquely Irish aesthetics, with which no other European nation could compete.

Thus far, both the design and the launch of the new coin had seemed unreservedly forward-looking. But the minting of the coin also marked a key moment of tension between progress and nostalgia in Ireland's new economy. As O'Connell acknowledged, all of these unique Irish coins would shortly disappear from circulation as Ireland entered the age of the euro in 2002. He noted that euro coins were already being produced at the rate of more than two thousand per minute, and bank notes would follow soon after. The Broighter coin thus represented the end of seventy years of Irish coinage: it was the last uniquely

Irish coin. And, despite the fact that O'Connell invited the public to use these coins in their everyday transactions, he also expected that many people would want to hold on to the coin as a memento. Ultimately, the Broighter coin would function as a keepsake, not a viable part of the Irish or international economy. The Broighter Hoard's connection to nostalgia has been reaffirmed in this millennial memento. But nostalgia for what, exactly? The coin was meant to signal a hopeful transition from the cultural and political nationalism of the nineteenth century to the global economy of the late twentieth century, a process David Lloyd has described as a celebration of Ireland's passage from domination by British colonial capital to its participation in neocolonial circuits of global capitalism.[292] The repatriated Broighter Hoard boat seems like an especially apt marker of these shifts between different phases of colonial endeavor.

In the end, the question of precisely what Ireland had won and what had been returned in the Celtic gold controversy remained unresolved. One way to look at the case would be to say, in effect, that the principles of property had trumped colonialism—that is, that the claims of rightful ownership could not be resisted or denied even as property became an increasingly vexed category of British politics. But at the same time, the invention of repatriation in an Anglo-Irish context in the early twentieth century underscored the extent to which property rights were themselves embedded in colonial histories. Repatriation was part of the inexorable logic of salvage that characterized the extension of colonial rule.

It is very difficult to undo or reverse history, even the history of artifacts.[293] One might suppose that the materiality and portability of most artifacts would make them especially amenable to such reversals. An object moves "home" and, with a relative ease that could never be contemplated in redressing the violent displacement of peoples, historical imbalances are corrected and restored to something like justice. But is the responsibility of either party really severed upon the return of the contested objects?[294] If objects are, as theorists of material culture would argue, "traces" of the often unequal relationships between individuals and nations, does the return of an object imply that these inequities have been satisfactorily resolved?

In the case of Celtic gold, the ornaments served as traces of a historical relationship between England and Ireland at every point in their existence: creation, burial, discovery, sale, and return. But now that they are in Dublin, quite far from where they began, is that relationship still visible? Is there a material acknowledgment that this relationship is ongoing? Or has the link between Celtic gold and English history been obscured by the return to Ireland? The ornaments never went back to where they came from in any real sense. As the shift from Derry to Dublin suggests, circles of return are never perfect in the life of cultural

objects. When the ornaments finally cycled back to Ireland, they were displayed as part of an Irish antiquities section with a sign that read, "Irish Antiquities— principally collected by the Royal Irish Academy to illustrate the ancient history of the people who have inhabited Ireland from the earliest time in which men have lived in this country and left traces of their existence."[295] The ornaments and other antiquities are still prized as traces of history, but the geographic borders of that history have narrowed. The hoard speaks neither to a relationship between nations, nor to one between nation and colony, but only to a single continuous strand of national history.

The point of locating this act of repatriation within Anglo-Irish history and within colonial history more broadly is not to devalue the practice but rather to expand its aims. The failure of existing repatriation policies is that they purport to bring to an end relationships that never can or should be ended. When repatriation occurs, it must serve as a starting point for a new kind of engagement— for renegotiating the economic, political, social, and technological relations that were implicit in the objects themselves. If the path of the objects were effectively outlined as an integral part of their exhibition, then repatriation might begin to function not only as an effort to right the dispossessions of colonial history but also as a critical reflection on that history. Otherwise, as in the story of the Gold Ornaments trial, the practice of return may easily become stagnant or barren. The future of repatriation need not be dictated by its past. It may yet become a powerful method of intervention in the status quo. But looking at the case of Celtic gold, it seems that repatriation, historically speaking, has been one way of keeping things very much the same.

T W O

The Art of the Stateless Nation:
The National Galleries of Scotland Bill

When John Douglas Sutherland Campbell, the ninth duke of Argyll and the marquess of Lorne, surveyed the National Gallery of Scotland, he saw great cause for concern. In 1901, while Ireland was stepping up its campaign for the repatriation of Celtic gold, the duke was engaged in writing the preface for his *Portfolio of the National Gallery of Scotland*. Above all, this catalogue pressed the cause of reform on its Scottish and English readers. The duke's credentials for this undertaking were not impressive. He was the dashing if not terribly ambitious son of George Campbell, the great Scottish landowner, Liberal grandee, and champion of individual property rights. From 1878 to 1883, he served as the governor-general of Canada and aided in the selection of a few paintings for the National Gallery in Ottawa. After this stint in the northern provinces, he returned to England with his wife—Princess Louise, Victoria's daughter—and resided at Kensington Palace until his death. Undoubtedly, he was an outsider in Scotland. But the circumstances at the National Gallery of Scotland had drawn him home again. The gallery, the duke warned with uncharacteristic urgency, must be reformed with all due haste.[1]

The gallery in Edinburgh should have had much to recommend it. The location was extremely attractive, with excellent views of the city from the Mound. The white neoclassical edifice (fig. 4) was much admired in England and elsewhere, aiding in Edinburgh's reputation as the "Athens of the North."[2] The small but prized collection of Scottish paintings was also internationally acclaimed. The gallery's Gainsborough, *Mrs. Graham*, was acknowledged to be one of the finest anywhere in the world—including the National Gallery in London.[3] Yet despite the many charms of the Scottish Gallery, the duke of Argyll was discouraged. Certainly, the National Gallery in Trafalgar Square was plagued by a crisis of faith in the late nineteenth century, comparing itself unfavorably with its counterparts in France, Germany, and Italy.[4] But even given the

4. National Gallery of Scotland, Edinburgh. Courtesy of the National Galleries of Scotland.

pervasive sense of failure in British art institutions, the National Gallery of Scotland presented unique problems. It suffered from inadequate funds, the absence of a clear purchasing policy, and mysterious financial arrangements with the Imperial Parliament. More important, the duke wondered whether this Edinburgh institution could ever fulfill the conditions of a national gallery. Contemporary definitions of national galleries demanded a broad range of works for mass aesthetic education—a universal survey of art history, triumphantly guiding the visitor to his own national school of painting and sculpture.[5] The National Gallery of Scotland, long described by disillusioned patriots as a purely local "student's cabinet," offered no such art historical overview.[6] In terms of representing continental schools, the gallery possessed only a small number of early French portraits, several Claude and Poussin landscapes, and a few works by Chardin and Fragonard. The visitor had no way to comprehend the special contributions of Scottish painting to the history of art, and any sense of autonomous national progress was therefore noticeably absent.[7]

Even the chronology of Scottish history, interrupted by the external intervention of the Union with England in 1707, seemed to undermine the kinds of progressive whiggish plots that characterized national galleries elsewhere. As Colin Kidd has argued, the deus ex machina of 1707 had undercut any possi-

bility of a gloriously unfolding history of indigenous development.[8] The history of Scotland is in itself disruptive to a Whig history of the nation-state.[9] Furthermore, nineteenth-century Scottish historiography had experienced what Kidd calls a "failure of nerve," deriving all its tales of liberty and modernity from post-Union history and stressing the backwardness of the pre-Union past.[10] For the duke of Argyll, the solution to this Scottish crisis of historical thought was art historical. He urged his Scottish readers to draw on their "northern patriotism" to make their national collection more universally representative. The duke's selection of images for his *Portfolio* avoided an undue emphasis on Scottish artists, carefully including works by Hals, Greuze, Boucher, Watteau, and Rembrandt. The duke promised that the integrity and status of the Scottish paintings would be upheld if the collections were expanded, pledging, "[W]e shall not be lost by comparison. Raeburn and Wilkie may speak to our rivals in the gate."[11] Ultimately, the duke sketched out a formulation for Scottish identity as well as the reform of the National Gallery of Scotland. By knowing others, he promised, the Scots would learn to know themselves.

This frustration with the state of the arts in Scotland found its legislative voice in the National Galleries of Scotland Bill, debated in Parliament from 1901 to 1906.[12] The galleries bill, sponsored by the Conservative Unionist John Stirling-Maxwell, demanded increased funding from Parliamentary sources and a new, skilled Board of Trustees. Given the limited nature of Scottish business in Parliament during this period, perhaps one pertinent question is how the galleries bill managed to take up five full years of Parliamentary energy. The participants in these debates were concerned not only with the reform of the National Gallery of Scotland but also with the intersection of art and law more broadly. What were the powers and limits of the law—or the medium of Parliamentary debate—when dealing with issues of national culture?

The galleries bill debates served as a meditation on the broader process of Parliamentary reform in Scotland. The protracted process of drafting, debating, and amending the bill raised important questions about the viability of national galleries in the multinational state of Britain. What sort of national gallery could a "stateless nation" like Scotland hope to produce?[13] Was the National Gallery of Scotland to function simply as a representative of the British state in Edinburgh, a physical emblem of the rightness of union? Or might this gallery reify Scotland's cultural difference and autonomy, perhaps ushering in an era of Scottish state-building as well as artistic independence?

These questions were explicitly engaged with the trajectory of Liberalism in Scotland, because they seemed to depend on Liberal doctrines of "unity in diversity," or a celebration of the role of Celtic ethnicity within the state of Britain.[14] The bill was neatly framed by the phases of Liberal crisis and resurgence,

marked by the sharp Liberal setback in 1900 and major victory in 1906. Initially, Scottish discussions of the galleries bill were limited to the *Scotsman*, the major organ of the Liberal press in Edinburgh.[15] By 1906, the galleries bill debates had spread to a host of regional and Radical papers, many of which were deeply critical of Liberal Reform. The bill had many incarnations: first, as a critique of English injustice and a meditation on Unionist versus Home Rule interpretations of Scottish identity; then, as a turning inward to reflect on the problem of regional and party fissures; and, finally, as a relegitimation of the Union. The effort to remake the gallery in Edinburgh as a uniquely Scottish institution produced a host of controversies about the value and power of the new Scottish Office, regional identities within Scotland, and the relationship between Scottish and English Liberals.[16]

More generally, the galleries debates in Scotland challenged the post-Enlightenment assumption of British political theory that state, nation, and society should be in symmetrical alignment, raising larger questions about the status of the categories of nationhood and statehood within Scotland and Britain. Brown et al. have argued that Scotland's status as a non-nation-state that nonetheless has an independent political history has posed a theoretical problem for British political thought since 1707.[17] Certainly, the viability of Britishness seemed less secure at the end of the galleries bill process than at the beginning. At the same time, these debates raised larger questions about the seeming impossibility of fixing Scottish nationalism as a wholly Unionist or Home Rule endeavor and revealed the limitations of existing categories of Scottish political action and identity.

The National Galleries of Scotland Bill is particularly striking for its simultaneous engagement with and suppression of Highlandism.[18] In recent years, Scotland has had more museums per capita than any other part of the United Kingdom.[19] But many of these institutions have drawn disproportionate criticism for their promotion of the "Highlands Myth," that is, the notion that modern Scottish identity can be reduced to the invented traditions of the Highlands.[20] The struggle to depict Scottish history beyond the romanticized image of tartanry and kailyard—what Fiona Watson has referred to as the twee and the tweed—has extended to institutions in all regions of Scotland.[21] The galleries bill provides an early focal point for these concerns. It drew on a wide range of existing conceptions of Scottish "types" from the hapless crofter to the Enlightenment rationalist to the Glaswegian industrialist.[22] These varying models of the ideal Scot were alternately promoted and rejected during the galleries bill debates, illustrating the ideological versatility of the bill in Scotland. Which regional vision of Scotland would be embodied in this particular national gallery? Furthermore, was there any possibility of transcending regionalist interpretations of

Scottish identity altogether, from enlightened Edinburgh to the romanticized Highlands?

As with the Irish debates about Celtic gold, the galleries bill was linked to the ongoing issue of land reform—specifically, to the economic crisis in the Highlands. The plight of the crofters, the impoverished joint tenant farmers who resided in Scotland from Shetland in the north to Argyll in the south, was frequently invoked during the galleries debates along with the problem of rural depopulation. In 1886 the Crofters Holdings (Scotland) Act had provided security of tenure for crofting tenants in the Highlands and the Islands, as well as fair rents and the right to assign crofts. The Congested Districts Board Act of 1897 provided for the creation of new croft holdings, but the measure was only a limited success, and no significant new measures were introduced until 1911.[23] During the years of the galleries bill debates, then, the Highlands crisis was in legislative abeyance. But the crofter was nonetheless symbolically central to the bill as the participants considered the relationship between rural and urban identities in Scotland. As John Shaw has noted, the legal debates about crofters' rights in the 1880s placed a new value on the communitarian, the customary, and the collective in British political discourse, fusing land and nation in the rural mythology of the Celtic fringe.[24] The crofters themselves were envisioned as "splendid specimens of humanity" to be preserved as both the economic crisis and the artificial industry of Highlands tourism threatened to alter the crofter beyond repair.[25] The classic Scottish theme of conflict between peasant traditionalism and agrarian rationalism carried with it the cultural weight of dispossession and alienation.[26] The fate of the crofter—both as economic individual and as living artifact—remained a preoccupation for both the sponsors and the opponents of the galleries bill.

The legislative measures concerning Highlands land reform enacted before the galleries bill expressed two distinct visions of property and ownership in Scotland. The 1886 act rested on a Liberal policy of dual ownership intended to reduce the influence of landowners over the crofters; the 1897 act expressed a Conservative concept of land purchase and owner occupation.[27] Both measures were inspired by earlier efforts in Ireland, but the application of Irish models to Scotland proved inadequate; the Scottish crofter did not want to own his land.[28] According to George Campbell, the eighth duke of Argyll, a benighted loyalty to Celtic traditions of communal ownership was impeding progress in Ireland. Scotland's economic success depended on its defense of individualism in the realm of property, its willingness to abandon these "barbaric" Celtic customs and to debunk the mythology of pre-1745 Arcadian bliss.[29] The connection between land, ownership, and art was formulated very differently in Scotland and in Ireland, pointing to important ideological divergences within the British cul-

ture of property. The land issue was distinguished in the nineteenth-century Highlands by the persistence of the widespread belief in the ancient "right to land" in exchange for military service, which stirred deeper passions in Gaeldom than anywhere else in Britain.[30] British debates about the nature of property rights thus had a distinctive Scottish strand, characterized by a preoccupation with the plight of the crofters, tied cottages, and, ultimately, the condition of miners' and urban housing in the early twentieth century. At the same time, Edinburgh fulfilled a special role in the reconstruction of Scottish property relations. Home ownership in Edinburgh skyrocketed from the 1890s onward, owing in part to the efforts of mutual aid societies such as the Edinburgh Co-operative Building Company.[31] As Richard Rodger has suggested, the company aimed at a "moral sequence" of ownership and self-government within the capital city.[32] Ownership, replicated from the individual to the social level, provided a mechanism for the empowerment of a property-owning democracy.[33] The galleries bill offered a forum for Irish, Scottish, and English politicians to consider the different trajectories of property rights throughout the three kingdoms, charting the paths of reform in land and art.

As the preceding chapter suggests, the relationship between political and cultural nationalisms has been a driving concern in the history of the Celtic fringe. Historical narratives of Scottish nationalism, noting the centrality of education in Scotland's sense of itself as an independent nation, have focused on three key institutions of civil society: the kirk, the university, and the law.[34] The historiography of prewar Scotland has traditionally divided Scottish nationalism into two mutually exclusive categories. The first is a Gaelic patriotism that emasculated political independence movements by means of cultural sublimation. The second is a legislative nationalism that draws attention primarily by its absence or ineffectuality.[35] Colin Kidd has argued that nineteenth-century Scotland was awash with a variety of sentimental substitutes for nationalism proper and missed out on the real thing.[36] Scholars have characterized the mindset of prewar Scotland as the "ideology of noisy inaction," which spent its energies on the lionization of Scott and Burns and the cult of tartanry rather than devolution.[37]

The National Gallery of Scotland sits uncomfortably in this framework of opposed cultural and political nationalisms. This gallery was self-consciously devoted to the promotion of Scottish art and artists—what contemporary critics termed a "Home Rule" aesthetic. But it was also funded in part by annuities paid to Scotland in compensation for the Union of 1707, the "ur-event of the British Empire."[38] This economic arrangement was a source of much controversy in the galleries bill. The effort to remake the National Gallery of Scotland extended far beyond the nature and organization of the collections or the acqui-

sition or presentation of objects. The gallery was assessed with regard not only
to its paintings and sculptures but also to its complex administrative relation to
the British state. This gallery therefore holds a unique position within the histo-
riography of Scottish and British institutions, functioning as a point of contact
between Unionist and Home Rule politics as well as between cultural and po-
litical nationalist movements. The movement to wean the National Gallery of
Scotland away from its Unionist origins served as testimony to the incomplete-
ness of the Union from the Scottish point of view.[39] Furthermore, the galleries
bill revealed the disjunction between cultural separateness and political unity—
or between the Scottish nation and the British state. The bill disrupted the narra-
tive of British unity based on the central tenets of Protestantism and anti-French
feeling, revealing the extent to which such narratives needed to be reformulated
at every point of economic, cultural, political, and technological change.[40]

The political concerns of the galleries bill encompassed a variety of admin-
istrative structures, highlighting the complex relationship between state and na-
tion in Scotland. The Scottish Office, founded in 1885, secured a ministerial
presence for Scotland in Westminster and Whitehall. The creation of the Scot-
tish Office had long been resisted by Gladstone and was in part urged along by
the land wars that made Scottish affairs a matter of acute imperial concern.[41]
Many scholars have taken the establishment of the office and its key post, that of
the secretary for Scotland, as the starting point for political history in Scot-
land, although the office was largely ceremonial and clearly did not entail any
measure of legislative devolution.[42] Centralized political development in Scot-
land, it seemed, could take place only in pro-Union terms.[43] The secretary was
a working minister of relatively low official rank; he was expected to be as much
grandee as cabinet minister.[44] Even though the office was founded at a time of
considerable demand for distinctive Scottish legislation—Highlands discontent
and university reform are examples—the secretary tended to focus on minor ad-
ministrative reforms.[45] The potential and limits of this first post-Union structure
of the Scottish state became a major concern in the galleries bill.

What has it meant for Scotland to have a political history? The galleries
bill debates were profoundly concerned with this question, as well as with the
broader issue of the intersection of law, culture, and reform. Recently, historians
such as R. J. Morris and Graeme Morton have formulated a new narrative of
Scottish political development that focuses on the city and the burgh as key
sources of national identity rather than becoming mired in the nonappearance
of a centralized state.[46] In this framework, Scottish nationalism was expressed in
the bourgeois governance of civil society—philanthropic organizations, schools,
and local institutions—rather than in Parliamentary movements.[47] That is, Scot-
land's nationalism was *not* absent in the nineteenth century; its expression was

civic rather than ethnic or "high" political. But this model of self-government was placed in jeopardy by the expansion of the state in the late nineteenth and early twentieth centuries.[48] In many respects the galleries bill reflected this transition. Further, the bill spoke to ongoing debates about whether Scottish nationalism more aptly expressed itself in cultural terms or political terms and whether this division was false or real. The architects of the bill proceeded on two key assumptions: first, that law had a pivotal role to play in the development of national cultures, and second, that it was possible to legislate cultural change. By the end of the galleries debates, all of the participants had begun to question whether law posed a viable solution to Scotland's particular dilemmas.

Art, Fishes, and Union: The Background of the Galleries Bill

From its inception in 1850, the National Gallery of Scotland was shaped by Scotland's history of political incorporation and was structurally dependent on the Union. The gallery was opened to the public on March 22, 1859, nine years after Prince Albert had laid the foundation stone. The Scottish system of patronage, fragmented and incomplete, was heavily dependent on a landed faction that was even less focused on artistic matters than was its English counterpart.[49] The gallery was administered by the Board of Manufactures, an office established after the Union to oversee Scottish manufacturing and fisheries. The board, a body that described itself as "nebulous,"was thus in no sense devoted solely to the gallery.[50] As Stirling-Maxwell, the sponsor of the galleries bill, noted when he introduced his plan for reform, the National Gallery of Scotland had been handicapped throughout its career by being tied up in the Board of Manufactures with a bundle of other institutions. The gallery should be allowed to "stand on its own legs."[51] Derision of the board was strongest within the incipient Scottish administration. The secretary for Scotland outlined the genesis of the Board of Manufactures to the House of Commons: "Originally they had something to do with manufactures; then they became a Fishery Board, and finally, they took to art."[52]

From the English point of view, the connection between the National Gallery of Scotland and the Board of Manufactures represented the happy final product of the Union: proof that the Union had strengthened Scottish industry to the point at which it could support the "weaker," or fine, arts.[53] The board was legislatively rooted in the gallery. The connection between art and manufacture was thus indissoluble in Scotland. But by the turn of the century, the Scottish art world had come to find this connection embarrassing. There were a number of reasons for this shift. For example, the growth of art historical scholarship concerning Scottish artists such as Wilkie and Raeburn produced new

frameworks for interpreting the gallery's collections. Sir James Caw's overview
of Scottish art dated the "Scottish school" of painting from the second half of
the nineteenth century and characterized this school by its naturalistic pictorial-
ism, its "full and fine" use of color, and its tendency to graft Scottish perception
and feeling onto old masterly traditions.[54] He was careful to clarify that this Scot-
tish school was more than a mere branch of English art—it had merits and de-
fects of its own. At its best, Scottish painting possessed a "masculine quality of
handling, a grim, hard sense of fact and character . . . and a touch of poetic glam-
our, mayhap of Celtic origin."[55] Caw noted that any distinctive Scottish traits in
painting were unconnected with either church or state patronage; they were the
result of a "spontaneous" expression of national feeling.

Caw also argued that the development of the Scottish school of painting was
a markedly post-Union phenomenon. For him, the independent Scottish tra-
dition in art began when Scotland ceased to struggle against its "'auld enemy
o' England.'"[56] He also described the development of the Glasgow Boys, a
loosely knit group of West Coast painters who rose to international prominence
in the 1880s. The Boys' domestic landscapes were strongly influenced by Whist-
ler, as well as by Japanese painters. Caw acknowledged that the Boys were often
treated with suspicion in Scotland and resented for promoting an "alien" style.[57]
But in the artistic centers of Europe, the Boys were hailed as an embodiment of
the Scottish temperament, and their success made it possible for living Scottish
artists to identify themselves with a "national" school.[58] One of the Boys' key art-
ists, Sir James Guthrie, would play a major role in supporting the National Gal-
leries of Scotland Bill.[59]

That the gallery was administered by a board originally responsible for fish-
eries and woolens had been a point of English if not Scottish pride. By the turn
of the century, this system of gallery management was perceived as an unwel-
come Unionist intrusion into what might have been an independent sphere of
Scottish creativity.[60] The close connection between the board and the National
Gallery of Scotland also angered Scottish manufacturers, who complained that
the gallery diverted energy from industrial expansion. Because the Scottish Gal-
lery did not actually house objects of industrial design, the elision of art and in-
dustry within its administration seemed illogical.[61] But when the Department of
Science and Art at South Kensington proposed taking over the Board of Manu-
factures, placing the responsibility for Scottish art education in English hands,
this project was characterized as the "disestablishment" of the board, evoking
the heated controversy about disestablishment of the beloved Scottish kirk.[62] In
1901 the Edinburgh Museum of Science and Art, formerly the "South Ken-
sington of Scotland," moved from the trusteeship of the Board of Education in

London to the independent Scotch Education Department.[63] Although this shift did not affect loans from South Kensington to Scotland, Cole's English vision of a universal program of art education had clearly miscarried.[64]

The principle of "Home Rule" in art could also function as a displacement or obviation of Home Rule in its more specific political meanings. William Muir's 1886 address to the Edinburgh School of Art focused on the dangers of allowing the South Kensington Museum to establish a universal "taste dictatorship" by means of its overcentralized system of art education. "Of 'Home rule' he would not say what he thought—good or bad; but certainly in that matter of design let them seek by all possible means to have Home Rule acknowledged."[65] Muir's equivocation on the issue of political Home Rule was as significant as his casual application of Home Rule terminology to the realm of aesthetics.[66] While South Kensington was doing its best to produce a highly standardized "national" school of art, the independent Scottish aesthetic upheld by Muir and others worked against such a unified British school.

In political circles, Scottish dissatisfaction with the National Gallery in Edinburgh focused on the arcane funding arrangements in force between the Board of Manufactures and the Imperial Parliament.[67] For Stirling-Maxwell, the key objection was not the amount of the grant but its character. At the Union of 1707, England had undertaken to pay Scotland approximately £398,095 for taking on a proportionate share of the national debt. In 1901, the remainder of this sum was still being paid out in annual £2,000 "grants" to the National Gallery of Scotland. The galleries bill debates initially focused on this historical anomaly. English M.P.s argued that the Union annuity should be considered a regular grant to the gallery rather than a simple repayment of debts from 1707.[68] But according to many Scots, the balance of art and money had been improperly conceived. As Sir Robert Reid, the M.P. for Dumfries Burgh, claimed, the so-called grant was "merely a payment in discharge of an obligation two hundred years old. It was no present to Scotland at all."[69] Stirling-Maxwell, the sponsor of the bill, argued that any money diverted from Union funds was Scottish money and put the gallery under no obligation to Parliament. The £2,000 "grant" was not drawn from Imperial funds, and thus the Scottish Gallery could not hold the same relationship to Parliament as did the national galleries in London and Dublin.[70] The National Gallery of Scotland was repeatedly described as an institution that the British state was "bound to foster and preserve,"[71] but Parliament took no responsibility for it beyond this yearly reenactment of Unionist history. The existing settlement underscored this gallery's complex ties to the Union and signaled the high stakes of the galleries bill debates. The National Gallery of Scotland was itself an artifact of a Unionist economy, a sign of a Parlia-

mentary commitment to pay off historical debts rather than invest in Scotland's future. The Parliamentary controversy concerning the galleries bill turned on the question of whether the Union had ultimately benefited or impeded Scotland.

The peculiar situation of Scotland was emphasized by the fact that the national galleries in London and Dublin both received purchase grants, whereas the gallery in Edinburgh depended solely on the Union repayments. Scottish critics were particularly outraged that only the curators at London and Dublin had received special grants to bid on the Hamilton collection, which had originated in Scotland; the National Gallery of Scotland was shut out of bidding on a tremendously valuable Scottish collection.[72] The *Scotsman* published an angry letter about the Hamilton sale that pictured Irish and English curators raiding the spoils of Scotland's lairds. The collection had been "made by a Scottish nobleman and stripped from a Scottish palace, [but] came to the hammer without the Scottish Gallery being able to spend a sixpence. . . . Can absurdity go further?"[73] The possibility of repatriating the Hamilton collection to Scotland was never raised.[74] But whereas the primary threat to British patrimony was from continental and American buyers, this perceived danger from English and Irish buyers heightened concerns about the gallery's funding arrangements in Scotland.[75]

The National Gallery of Scotland had come to symbolize both the costs and the benefits of the Union: a reminder not only of what Scotland had gained in commercial terms, which allowed it to support a national gallery of art, but also of the state and Parliament it had lost. The exchange of a state for a gallery raised the question of synchronicity between the state and nation in Scotland as well as in Britain more generally. Certainly, criticism of the gallery did not in itself constitute a rejection of the Union. It was plausible for Unionists to call for gallery reform as a means of purifying the Union rather than negating it, holding the English to the terms of union as it ought to be. But despite the fact that the galleries bill had been sponsored by a Conservative Unionist, the financial question also brought Home Rulers into the galleries debates. Home Rule publications praised the defunct National Association for the Vindication of Scottish Rights—that "eccentric grandparent" of the modern nationalist movement in Scotland—for targeting museums and galleries as a focal point of Home Rule energies.[76] For Home Rulers, the early gallery debates functioned as a basis for criticizing the ideology of union as well as its practical implementation: What exactly had the Union wrought, in both political and in cultural terms? The Home Rule interpretation of the galleries debates focused on the perceived disjunction between the gallery—as an administrative institution—and its collections. Within its walls lay the aesthetic objects of Home Rule: the paintings

and sculpture that constituted the Scottish school. But at an institutional level, the National Gallery of Scotland still represented the economic legacies of the Union. In other words, the gallery's art might be "national," but the gallery itself was not.

As the Scottish Home Rule movement developed during the prewar period, the National Gallery of Scotland occupied an increasingly central role in Scotland's vision of its future. By 1893, the gallery cause had been taken up by the Scottish Home Rule Association, one of the major organizations for the expression of political nationalism in Scotland. The association cited the expatriation of artistic talent in its formal list of wrongs done to Scotland by the British state.[77] The path of redress clearly lay in the National Gallery of Scotland, whose plight bridged the issues of the "brain drain" and the unequal distribution of material resources between Scotland and England. The association also argued that an improved gallery in Edinburgh would help keep Scottish artists and intelligentsia north of the Tweed.

The Scottish Home Rule Association was joined in its project of linking the gallery debates to Home Rule politics by a variety of nationalist newspapers and journals. The polemical *Fiery Cross* took up the question of financing the National Gallery of Scotland as proof that the Union was antipatriotic. The journal advocated reform of the National Gallery along with the reclamation of Lia Fail (the Stone of Destiny), the return to a clan system, the expurgation of the term "English" with regard to Scottish or British matters, and the restoration of the royal Stuart family. As John Wilson wrote, this gallery was being "defrauded" yearly of a large sum; Scotland would never have an equal partnership in art until she had an equal representation in the British Parliament or a Parliament in Edinburgh to attend strictly to Scottish business.[78] Wilson thus elided the causes of political and artistic Home Rule, although his directness in addressing this question was unusual. The Board of Manufacture's utopian vision of a Gallery of Union had degenerated into accusations of fraud and defalcation. Wilson acknowledged that a perfect, federated Union might eventually replace the current corrupted system. But he also maintained that the flawed nature of the existing Union was best exemplified in the impoverished and parochial National Gallery of Scotland. The gallery was a testimony to the weaknesses of the Union in practice, or of a Union that had proved to be incorporationist rather than federationist. The Unionist bill, therefore, had constantly to confront the objections and challenges of Home Rulers who sought to reform this gallery on their own terms. Their focus was not on methods of installation or display but on banishing the economic legacy of 1707 from the process of acquiring artistic patrimony in Scotland.

Making a Scottish State: Bringing in the Galleries Bill, 1901–1903

When Stirling-Maxwell brought in the National Galleries of Scotland Bill in June 1901, he was careful to stress the imperial dimension of the debate. He described the current poverty of the gallery as "a discredit—he would not say to Scotland, but to the Empire, of which Scotland formed a part."[79] But he also acknowledged the particular needs of a Scottish gallery and the impact that the process of reform might have on Scottish politicians. Just as the officers of state could bring about a new national gallery, the National Gallery of Scotland—if properly altered—could produce a new vision and reality of statehood, bridging the gulf between civil society and state that had existed since the Union. At the institutional level, Stirling-Maxwell's bill aimed at professionalizing gallery administration, increasing Parliamentary funds and replacing the outmoded Board of Manufactures with an expert Board of Trustees. But more abstractly, the bill functioned as a treatise on the idea of Scottish statehood—within and outside the Union.

In particular, Stirling-Maxwell focused on the new post of the secretary for Scotland. The claims for a newly "nationalized" gallery were consistently intertwined with demands for an increased role for the new Scottish minister. Even before the introduction of the galleries bill, the two causes were linked; in 1881, William M'Kay asked the readers of the *Scotsman* how they thought a national gallery could exist without the apparatus of state officials.[80] With the creation of the Scottish Office in 1885, Scottish commentators hoped that Parliamentary neglect of the National Gallery of Scotland would necessarily cease. But the direction of progress was not always clear. Would the new Scottish secretary produce a reformed gallery, or would Scottish agitation about the galleries bill aid in the cause of the secretary? The *Scotsman* published an article in January 1885 noting that the Scottish art world had long delayed pressing its claims for the reform of the gallery until the Scottish minister was appointed; finally, the critics had realized that the gallery could not wait, and they would have to hope that their agitation in the artistic realm produced a minister instead.[81] The first secretary for Scotland was the duke of Richmond and Gordon, an experienced Tory politician and the owner of the two best salmon rivers in Scotland.[82] His first act of office was to take a guided tour of the National Gallery of Scotland, "inspecting with much interest the works of art exhibited on the walls."[83]

The bill was at least as much an exhortative narrative about Scottishness within the larger realm of British government as it was a cautionary tale about Scottish art. Optimism about the secretary's power to secure justice for the National Gallery of Scotland had taken a sharp downturn by the time the galleries bill was debated in Parliament. Stirling-Maxwell was quick to criticize the Scot-

tish Office for failing to promote gallery reform in Parliament. Overall, the bill reflected a deep sense of dissatisfaction with the secretary as cultural benefactor. Stirling-Maxwell described his bill as an experimental measure to put "some backbone into the Department [the Scottish Office]," treating the gallery as a testing ground for Scottish statehood.[84] Beneath this criticism of an impoverished gallery in Edinburgh was a deeper antipathy toward the secretary and toward Scottish M.P.s, who seemed unable to prioritize their claims as Scotsmen in the face of English opposition. Underlying the galleries bill was the hope that the concentric loyalties of Scottish politicians could be realigned so that state and nation might be brought back together.[85]

At the same time, the bill's supporters were anxious to muster up some evidence of independent national action in favor of the bill. By the time Stirling-Maxwell brought in his bill, the popularity of the National Gallery of Scotland was clearly on the wane. The attendance figures had peaked in 1874 with 133,399 visitors.[86] Attendance actually worsened between 1901 and 1906, ranging between 62,974 and 70,537 visitors per annum.[87] Of course, Stirling-Maxwell might argue that the declining attendance statistics proved how urgent the need for gallery reform really was. But the Royal Scottish Academy urged him not to limit his cause to Parliamentary supporters: "There could be nothing more helpful to the S[cottish] members than some concrete action by this Community itself. The *dead* lift for the Treasury is the trouble."[88] Without any proof that the galleries bill represented the collective will of Scotland's museum-going public, Treasury's responsibilities toward the gallery were difficult to substantiate.

The galleries bill was portrayed in the press as an educational experience for Scottish M.P.s, who seemed to have forgotten how to engage in effective Parliamentary debate. Indeed, the *Scotsman* reported that the bill had provided "the liveliest hour Scottish business has furnished for some sessions."[89] The Speaker of the House was constantly called upon to instruct members to address themselves directly to the galleries bill and not to the hazier problem of Anglo-Scottish relations. According to the editors of the *Scotsman*, the real lesson of the bill was that if the Scottish members acted more frequently "in concert . . . Scotland would be less scurvily treated than it often is." Acting in concert was not what Scottish M.P.s had done best in the past. Stirling-Maxwell spent much of his speaking time in the galleries bill debates urging the Scottish members to form a special interest coalition in Parliament. If the Scots were not yet a state, they could at least be a party.[90]

But what kind of party could they be? And of what political denomination? As the galleries debates moved into their second year and the bill took on various new sponsors, the divisive effects of the bill on Scottish party politics became

apparent. In particular, the galleries bill revealed an ideological rift within Scottish Liberalism, dividing Home Rule and Unionist Liberals according to their vision of a new gallery. Bonar Law, the prominent Tory member for Glasgow (Blackfriars), sought to neutralize the role of party in the galleries bill. He noted that "it would be an unfortunate thing if the idea were to get abroad in Scotland that Scottish interests were better looked after on the Opposition side of the House."[91] An Englishman, Captain C. B. Balfour of Middlesex, Hornsey, quickly countered that national galleries in Britain must be beyond the taint of party politics. Where they required reform, they should be institutions of coalition. As Balfour spoke in support of the galleries bill, he caused an outburst of laughter by reminding his fellow M.P.s that owing to the recent Liberal defeat, this was the first Parliament in which they had a Unionist majority in Scotland. Because the Liberal side had enjoyed predominance for so many years, the success of the galleries bill was still their responsibility. But, Balfour admonished the Scottish members, it was the Unionists who would bring about legislative reform in the gallery and elsewhere, not radical nationalists. Stressing the unfeasibility of Scottish nationalism *without* the Union, Balfour ensured that the galleries bill maintained its Unionist origins. His speech encapsulated the English vision of the National Gallery of Scotland, affirming the Unionist character of the gallery itself.

Radical nationalist dissatisfaction had been provisionally shelved by Balfour's speech, but the threat of a Home Rule galleries bill had not been completely overcome. The tension between the ostensibly Unionist character of the bill and the specter of Home Rule was exacerbated by constant comparison between the Scottish and the Irish National Galleries, as well as between Scottish and Irish models of political action. Under the guidance of the former director, Henry Doyle, the National Gallery of Ireland had become an undisputed success, with a small but choice collection. In a crucial set of Parliamentary speeches in 1902, the chancellor of the Exchequer, Michael Hicks-Beach, lambasted the Scottish Board of Manufactures for falling short of Irish standards. He argued that Treasury had contributed to the public galleries in Dublin and Edinburgh on the principle of a joint venture between private generosity and government assistance. The government could not be expected to compensate for the "niggardliness" of individual Scottish art collectors when Ireland had done so well.[92]

The *Scotsman* leapt to the defense of the Board of Manufactures—not as an appropriate arbiter of taste but as an institutional embodiment of the Scottish character. Hicks-Beach was a Disraeli protégé and a quintessential English country gentleman, personally impoverished by the late nineteenth-century agricultural depression.[93] In 1902, he was desperate to increase revenue and was unlikely to be friendly to any claims for more funding for the Celtic fringe. But the

complaints against him were more specific; Hicks-Beach had failed to acknowl-
edge the uniquely Scottish office that oversaw the Board of Manufactures. In
short, he had treated Scotland as a nation without state representation. His as-
sault on the board, therefore, amounted to more than an insult to Scottish artis-
tic self-determination: it was a denial of Scottish statehood. When Hicks-Beach
threatened that Treasury might co-opt the power to purchase art objects for
Scotland, the *Scotsman* countered that the chancellor had overstepped his pow-
ers. The Board of Manufactures might be "mysterious" and "unwieldy," but it
was nonetheless a "distinctively Scottish" institution.[94] If the board were indeed
incompetent to manage the National Gallery of Scotland, the task of reform lay
properly with the Scottish Office, not the aggressive English chancellor.[95] Even
the *Scotsman* could admit to the flawed nature of the board *qua* arts administra-
tor. But the board was nevertheless the basis for the gallery's claim to Scottish-
ness—not only in its collections but also in its institutional life. No collection of
Raeburns and Wilkies would be able to rescue the Scottish Gallery from the in-
tractable Englishness of Treasury.

Whereas Home Rulers had seen the Board of Manufactures and, by logical
extension, the National Gallery of Scotland as painful reminders of a bad-faith
Union, the *Scotsman* recast the board as a key carrier of Scottish political and
cultural identity. Behind the question of the board's competence was the broader
question of the control of Scottish affairs. With reference to the National Gallery
and National Portrait Gallery in Edinburgh, the *Scotsman* warned, "The Board
of Manufactures may mismanage these institutions; English control would de-
stroy them altogether. They would lose their national character, and become
mere branch agencies of a central institution in London."[96] Maladminstration,
then, was preferable to denationalization. If revamping this gallery involved dis-
mantling the Board of Manufactures, then how was the gallery to maintain its
Scottish integrity? Was its Scottish character simply a function of being admin-
istered by a Scottish board, or did Scottishness inhere in the paintings and sculp-
tures of the gallery itself? The Board of Manufactures had clearly produced an
institutional and artistic disaster, but the proposed rejection of the board threat-
ened to forfeit the principles that had made this gallery meaningful to Scottish
citizens. The path of reform was now suspect. "Reform," if it meant overhaul-
ing the board, was synonymous with Anglicization.

The funding of the Irish and Scottish national galleries became one means
of discerning the hierarchy of the constituent elements of the Celtic fringe within
the British state. Scotland had a stronger historical tradition of "civility," espe-
cially in Edinburgh, which one might expect to have facilitated Parliamentary
funding for its artistic endeavors. But Ireland had a more organized nationalist
lobby. Despite Hicks-Beach's claims of parity, Irish art institutions in fact re-

ceived approximately one-third more in aid from Treasury, despite the fact that the total revenue derived from Scotland was far greater than that from Ireland.[97] A 1905 diagram graphing the line space—the square footage available for hanging pictures—in British galleries demonstrated that the National Gallery in Edinburgh was, at 573 feet, more than 1,000 feet behind its counterpart in Dublin (fig. 5). The *Scotsman* attributed this inequality to the fact that the Scottish people had not made equal distribution of the grants a Parliamentary question as the Irish would have done; "[I]t is the willing horse that always gets the burden."[98] Irish M.P.s often turned up at sessions concerning the galleries bill to pledge their support, pointing to a potential Irish-Scottish nationalist alliance. But the Scottish response was competitive and resentful. As T. H. Cochrane, the M.P. for Ayrshire North, commented after an Irish nationalist endorsement of the galleries bill, "The treatment of the two nations had never been the same, and

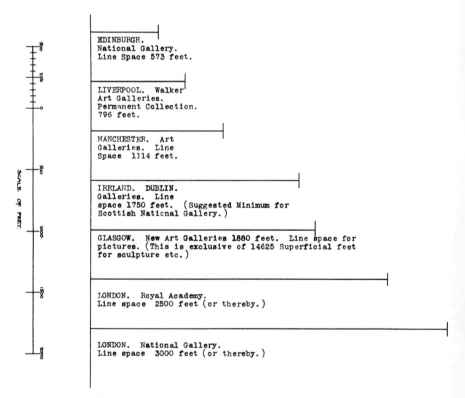

5. Diagram of line space in the National Gallery of Scotland in relation to
that in other galleries, Edinburgh, May 9, 1905

Ireland had always been the spoiled child whilst Scotland was the snubbed child of the Government."[99] Similarly, Henry Campbell-Bannerman, a leading Liberal M.P. and a Scot, confessed that he was "not very fond of these comparisons between Ireland and Scotland!"[100] The comparison was problematic both because it associated the galleries bill with the contentious politics of Home Rule and because it undermined the uniqueness of Scottish claims.[101] The solidarity of Scottish and Irish nationalist M.P.s, strong in the early months of the bill, evaporated—no doubt to the satisfaction of Hicks-Beach.

Hicks-Beach's attack on the Scottish Board of Manufactures was sufficiently vicious that one member of the board resigned in protest.[102] The *Scotsman* lambasted Scottish M.P.s for failing to exonerate their compatriots, suggesting that they had submitted too meekly to the chancellor.[103] Supporters of the galleries bill seemed to have bungled the larger political aim of uniting the Scottish M.P.s in a spirited defense of the gallery. Sir Joseph Dobbie, the Liberal member for Ayr Burghs, made a statement of collective guilt in which all the blame for England's poor treatment of Scotland was borne by the Scottish members of Parliament.[104] The perceived unity of Irish M.P.s as political actors was an embarrassing counterexample, along with the purported superiority of the National Gallery of Ireland.[105] In the Parliamentary realm of the galleries bill, the Irish colony seemed to trump the Scottish dependency. The bill—and Hicks-Beach's vitriolic response to it—functioned in part as a meditation on the problem of being a Scottish M.P. The Scottish members readily acknowledged that they were less prone to legislate en masse than were the Irish. They were able to represent Scotland only as a diverse group of economic and commercial interests, whereas the galleries bill called for a more culturally motivated show of unity.

Hicks-Beach's stance concerning the galleries bill became a focal point of resentment against him in Scotland, where it was grouped together with his stance concerning the coal tax and the corn duty as well as his general ignorance regarding Scottish customs and institutions.[106] In particular, Scottish M.P.s responded bitterly to Hicks-Beach's demand that the National Gallery of Scotland draw its funds from private resources; Londoners were required to make no such gestures toward proving their love of art.[107] James Weir, the Liberal M.P. for Ross and Cromarty, reminded the chancellor that the National Gallery of Scotland was far less costly than the broadly imperialist endeavors of, for example, the British Museum. He asked,

> Had any of the members of their [Scottish] Board of Manufactures
> ever ventured to go to Japan in quest of curios or antiquities from

Shinto or Buddha temples? Had they ever sought antiquities in
Egypt, India, or Greece? What did the right honorable Gentleman
expect in the way of pictures worth placing in a National gallery, for
£1000 a year?[108]

Weir was reinvoking Stirling-Maxwell's original claim that the shame of the Na-
tional Gallery of Scotland was an imperial concern. He also expressed the col-
lective Scottish anxiety that national museums—as defined in the British Parlia-
ment—were de facto imperial museums. If Scotland could not compete in the
realm of imperial acquisitions, the galleries bill might not be considered a truly
"national" legislative reform. But at the same time, Weir reproached his fellow
M.P.s for limiting their conception of national galleries to imperial or ethno-
graphic collections. As in the Irish Gold Ornaments campaign, the Scottish sup-
porters of the galleries bill strove to shift the focus of national collections to do-
mestic artifacts.[109]

The bill initially asked for an extra £1,000 per annum. According to Stir-
ling-Maxwell, this reform would place the National Gallery of Scotland on an
equal footing with its counterpart in Ireland. But parity with Ireland was not all
that many Scots hoped for. The Irish struggle to regain its Celtic gold ornaments
from the British Museum was invoked several times in the galleries bill debates,
most often as a point of contention between Scottish and Irish M.P.s. One Scot-
tish speaker asserted that Ireland, unlike Scotland, had no national school of
art—a particularly divisive statement in light of the ongoing repatriation con-
troversy in Ireland. William Redmond, the Irish M.P. for Clare East, responded
angrily that there had been schools of art of the highest possible merit in Ireland
before Scotland was thrown up by "some volcanic disturbance."[110] Again, the
possibility of a coalition between Ireland and Scotland had foundered, owing in
part to Irish frustration that the Scottish members would not support a pan-
Celtic repatriation movement.

Whereas Irish agitators focused on the repatriation of artifacts, the galleries
bill emphasized the reconstitution of the National Gallery of Scotland—a new
recognition that it was a national institution protected by a strong Scottish Of-
fice. Scottish reformers sought a gallery equal in status to London's, not the pop-
ular but clearly "regional" National Gallery of Ireland.[111] From the Unionist
point of view, the preferential treatment of Ireland in the realm of art was com-
mercially unsound. Because Treasury received more income from the Union
with Scotland than from the conquest of Ireland, Scotland should receive ade-
quate cultural compensation for being a productive part of the kingdom. At the
same time, the Irish example—even when rejected outright by Scottish Union-

ists—ensured that the voice of Home Rule was never completely eradicated from the galleries bill.

By the autumn of 1902, a Parliamentary investigation into the National Gallery of Scotland was under way, along with an ancillary investigation into the Board of Manufactures. The committee included Stirling-Maxwell, the original sponsor of the galleries bill, Sir Walter Armstrong, now the director of the National Gallery of Ireland, and Thomas Ryham Buchanan, a Liberal M.P. from Glasgow who had also represented Edinburgh and Aberdeenshire. Treasury and the Scottish Office were also represented on the committee, and Treasury decided that it would make any increased grants to the gallery contingent on the committee's reforms.[112] The structure of the committee reflected the complexities of dealing with the Scottish Gallery as a regional, national, and imperial institution. All of these different constituents, including Treasury and the Scottish Office, were to have a voice in the galleries bill.

What had begun as an investigation of English mistreatment ended in the report (published in November 1903) as a forum for self-criticism in Scotland. Here, Scotland's historical failings as a nation-state were revealed. The 1903 report found that the curator at the Scottish Gallery had no initiative for purchase and that the men on the board were not qualified for the duties they had to perform. Also, the absence of a permanent chairman for the board led to a want of system and continuity in accessions policies.[113] The Board of Manufactures was cited for a general dereliction of duties. The committee suggested that it be replaced with a smaller body of fifteen members: three representatives from the Royal Scottish Academy, four members nominated by the Royal Society of Edinburgh, the Society of Antiquaries, the Town Council of Edinburgh, and the University of Edinburgh, and the remainder appointed by the secretary for Scotland. The report further recommended a substantial increase in the Parliamentary subsidy to the gallery, ensuring that the fiscal responsibility for these improvements would be shared between England and Scotland.

As the *Glasgow Herald* warily noted, the reconstituted board—to be called the Board of Trustees for the National Galleries of Scotland—would give a small majority to government nominees, increasing state control over the gallery.[114] The town council of Edinburgh would also provide a site for the reformed gallery. The new governing board would cease to have direct responsibility for art education in Scotland, but it would retain wide discretionary powers for using large sums of national money, including the Union annuity, for the general encouragement of art. But the report's most significant conclusion was that the Union annuity should be kept separate and distinct from ordinary grants. The

annuity would be governed by the principle that it was "Scottish" money. In this way, the reformed gallery was to embody a perfected legacy of 1707.

The report, and in particular the point about gallery finance, attracted a considerable amount of attention from the Scottish art world. James Guthrie, now the president of the Royal Scottish Academy, described these reforms as "plucky . . . straightforward and thorough." He characterized the report as a whole as a "deliverance" from English opposition and wrote to Stirling-Maxwell that he hoped the other Scottish members would back him solidly when the matter came to Parliament again.[115] The adoption of the Report on the National Galleries of Scotland constituted, in effect, Scotland's first Parliamentary victory and, at least in theory, welded the Scottish M.P.s together. The *Scotsman* suggested that Scottish artists form a vigilance committee to appeal to Scottish M.P.s individually and that the Scottish members vow to meet before each Parliamentary session to consider their claims on Treasury as a group.[116] The remaking of the National Gallery of Scotland was thus equated with the making of a distinctly Scottish "party," neither Liberal nor Conservative.

Expectations for reform rose in the Scottish art world when Henry Campbell-Bannerman became the prime minister in 1905. In an article about the galleries bill, the *Scotsman* reminded Campbell-Bannerman that he was never more appealing to Englishmen than when he played the "perfervid Scot." The bill seemed to be an ideal proving ground for the enactment of Scottish identity in Parliament. Guthrie's presidential address to the Royal Scottish Academy in 1906 urged Campbell-Bannerman to take up the cause of the National Gallery of Scotland. Guthrie drew enthusiastic applause from the crowd when he announced, "We claim the redress of forty years in the wilderness. . . . We claim on this side of the national life something that has a new sound, but an old and growing meaning. We claim justice for Scotland."[117] For Guthrie, the galleries bill spoke to the larger historical problem of being Scottish citizens in a British political milieu.

The *Scotsman* sketched out an elaborate fantasy of Campbell-Bannerman's enthusiastic support of the galleries bill, concluding that the English members would inevitably be "relegated by his exultant patriotism to a lower plane of nationality, [and] listen with chastened temper when he describes England as the knuckle end of Scotland."[118] Optimism about the bill was at its peak. If the secretary for Scotland had failed to defend the Scottish Board of Manufactures and its gallery, a Scottish prime minister represented a new coalescence between the Scottish nation and the British state. The success of the galleries bill seemed to depend on its authors' ability to catapult Scottish nationalism beyond English limits.

Radicalism and Regionalism: Amending the Galleries Bill

The galleries bill was initially passed by Unionists and Radicals on its first read-
ing in April 1906. But a series of amendments introduced that summer pointed
to the problem of regional identities and the reemergence of party interests en-
tailed in reforming the Scottish Gallery. Whereas the bill had been introduced
by Stirling-Maxwell, a Conservative Unionist, the amendments were the prod-
uct of a fractured Liberalism both within and outside Scotland. This examina-
tion of the galleries bill and its amendments thus serves in part as a case study of
Scottish party politics in the early twentieth century, while also illustrating the
particular dilemma of legislating culture in the non-nation-state. The 1903 re-
port had been predicated on an understanding of Scottishness that cut across
socioeconomic and regional variations. The process of amending the galleries
bill produced a growing anxiety that the National Gallery of Scotland embodied
the nation's rifts as much as its bonds. Competing visions of Scottishness—from
the mythmaking Highlands to industrial Glasgow to Liberal Edinburgh—were
integrated into the bill's amendments, much to the detriment of the bill itself.

The Highlands, the key source of mythologizing about the Scottish past,
had long been a source of dissent regarding the galleries bill. When Hicks-Beach
attacked the Board of Manufactures for its inability to garner public support in
Scotland, the Scottish M.P.s defended themselves with an appeal to recent High-
lands history. The remaking of the National Gallery of Scotland, they claimed,
had long been postponed because of the economic crisis in the Highlands. The
progression of art and culture could take place only now that internal problems
had been provisionally resolved and Scotland was ready to take its place in
the British system of national galleries—a system that presupposed the appear-
ance of collective prosperity and unity, if not the reality. As Sir Michael Shaw-
Stewart, the M.P. for Renfrewshire, said in support of the galleries bill, this
gallery could never have been allowed to take precedence over their needy com-
patriots in the Highlands.[119] The argument was not that the Scottish members
had been delinquent in pursuing money for their national gallery but rather that
they had purposely delayed requests for these funds until they had crafted a na-
tion worthy of having its own gallery. But now that the crisis was provisionally,
though unsatisfactorily, resolved by the acts of 1886 and 1897, this same gallery
could be the perfect symbol of reconciliation between Highlands and Lowlands
culture.

The bill also represented a concerted institutional effort to move beyond the
protracted dominance of the Highlands in British perceptions of Scottish iden-
tity. There was nothing of "jacobitical kitsch" in the National Gallery of Scot-

land, either in its original collections or in the plans for reform.[120] One 1905
Glasgow News article about the popularization of art in Scotland, referring to the
Scottish Ethnographical Section at the Kelvingrove Gallery in Glasgow, asked
whether the artifacts there "could be made to live again[.] What a chance there
is for a Gallery of the Clans!"[121] This article never mentioned the National Gal-
lery of Scotland in Edinburgh and confined its proposal for a "Clan Gallery" to
Glasgow. The desire to make the National Gallery of Scotland more "Scottish"
clearly did not involve subscribing to this particular romanticized cult of the
Celt, at least within the confines of the galleries bill.

But if the Highlander was not the key cultural prototype of the National
Gallery of Scotland, who was? The proposed abdication of the Scottish Board
of Manufactures from the management of the gallery meant that the tangible
signs of Union had disappeared from gallery administration. The challenge of
reimagining the gallery as an explicitly non- or post-Unionist venture loomed
large. The fiction that Scotland itself was a unified nation, central to the early
years of the galleries bill, began to disintegrate. Although the common tendency
to equate all of Scotland with a Highlands ideal was resisted in the galleries bill,
the question of which new vision of Scotland should be promoted by the gallery
remained divisive. The unforeseen effect of the bill was to challenge the idea of
Scotland itself—to acknowledge that the universalizing Highlands myth was in-
sufficiently representative, but also to suggest that the very nation embodied by
the National Gallery of Scotland was a phantasm. The sponsors and amenders
of the bill thus faced the question of the Highlands myth directly, but as the
amendments process would reflect, the problem of Highlandism was intrac-
table—in part because alternative mythologies of national history seemed so
elusive.

The two key amendments to the galleries bill were proposed in July 1906.
The sponsors were the Liberal M.P.s Donald Smeaton (Stirlingshire) and John
Gulland (Dumfries Burghs).[122] Smeaton and Gulland argued that Glasgow,
which had "done so much for art," should be represented on the new Board of
Trustees. Further, this board should be popularly elected rather than nominated
by the secretary for Scotland. Gulland also threatened to prevent the second
reading of the bill if the issue of regional diversity was not addressed. Even if the
gallery were to remain in Edinburgh, which was not a foregone conclusion, Gul-
land and Smeaton wanted the new Board of Trustees to reflect a broader spirit
of reform and national representation. Scottish sponsorship of the bill was po-
larized between Edinburgh and Glasgow, and the bill was "apt to be swamped
by parochialism on the one side and cosmopolitanism on the other."[123] James
Bryce, the major Liberal statesman, worried that the people of Edinburgh were
"a little too apt to mistake themselves for Scotland."[124] The Edinburgh-Glasgow

axis, which has often been taken as the distinguishing feature of nineteenth-century Scottish politics, had become a major point of contention in Scotland's main cultural institution.

In effect, the bill represented a Unionist effort to produce a gallery of regional and party unity. But the amendments, which were supported by a vocal Radical minority, testified to the impossibility of this project. The amendments thus provided an important forum for alternative conceptions of the National Gallery of Scotland but placed the bill itself in jeopardy. The bill was swallowed up in amendments, each embracing its own vision of the ideal relationship between art and democracy. The question of British injustice toward Scotland continued to recede, while the problem of Scottish regional identity came to the fore. Ultimately, the introduction of regionalism into the galleries bill debates would bring in the key figure Stirling-Maxwell had tried to avoid: the romantic Highlander. In this respect, the amendments testified to two major problems in nineteenth-century Scottish nationalism. What happened when the Highlands were left behind? Could the competing visions of Scotland beyond the Highlands—namely, those that revolved around Edinburgh and Glasgow—be reconciled?

The resistance to the amendments pointed to a deeper division concerning the image Scotland wished to present to Britain and Europe. Within the parameters of the galleries bill debates, Glasgow had a unique set of associations.[125] It was undoubtedly the city of industry, machinery, and commerce. In this respect, it was not a typically Scottish city; Glasgow had more in common with Manchester than with Edinburgh.[126] But at the same time, Glaswegians benefited from the city's extensive provision of social and cultural services, ranging from public health care to Scotland's finest municipal art galleries.[127] Starting in the mid-nineteenth century, Glaswegian patriotism was fueled by faith in urban regeneration, with potent symbols of renewal and intervention derived from evangelical Presbyterianism.[128] In contrast to Edinburgh's fractiousness, Glasgow represented a spirit of civic unity, enterprise, and education—the Scottish citadel of modern municipal cooperation.[129] In Glasgow, as Garret Fisher put it in 1895, municipal collectivism had achieved great things but Glaswegian councilors had been collectivists "without knowing it, or at least without caring about it."[130] Collectivism, then, was clearly distinguished in Glasgow from the dangers of socialism; Glaswegian socialism was presented by its proponents as a particularly safe and responsible form of the beast.[131] Whereas municipal socialism was expected to be profitable in Birmingham and other English cities, Glasgow's councilors resisted economic imperatives in their social improvement projects.[132] Furthermore, the Glasgow art galleries appeared to have a more cooperative relationship with the Imperial Parliament than did those in Edinburgh. Their curators expressed a strong belief in their civic uniqueness but also an equally

strong sense of collaboration with the Exchequer.[133] Glasgow could thus prom-
ise a greater tradition of local aid to the arts, as well as a less combative approach
to English institutions.

Early agitation for gallery reform had been concentrated almost exclusively
in Edinburgh, a fact noted in Glasgow with some condescension. Although
the Royal Scottish Academy was located in Edinburgh, the Glasgow Boys had
earned a far greater international reputation for Scottish artists. As James Guth-
rie wrote to a friend in 1904, "In the north my work seems to be quite well
known! A lady from Edinburgh said today that she wished I would go up there
and start something *national*—printings would be the thing."[134] In Edinburgh,
the National Gallery was inevitably associated with Scotland's own inglorious art
history, in which native productions were either academic or overly localized.
In a satirical editorial, the *Glasgow Herald* suggested that the "unreformed" Na-
tional Gallery of Scotland be moved to Glasgow as the cure for its ills. The *Her-
ald* further compared the proposed relocation to the "harmless" removal of the
papacy to Avignon, suggesting that the ongoing Parliamentary focus on this gal-
lery's Scottish collections could only damage its reputation in the international
art world.[135] The path of reform planned in Glasgow was framed in entirely
different terms: "Glasgow will do its best for the national good in the circum-
stances—as it always does—though it does not label its enterprises 'Scottish.'"
In the more cosmopolitan and specifically Francophile city of Glasgow, the *Her-
ald* argued, the National Gallery of Scotland might take its place with the greater
galleries of Paris, Berlin, and even London.

The question of regional unity had clearly posed problems even before the
amendments had been introduced, in part because of the changing landscape of
Edinburgh itself. The National Gallery of Scotland was situated in a new urban
setting, constructed between 1850 and 1914, in which a series of civic, govern-
mental, and ecclesiastical buildings in Edinburgh converted the city's prior
informality and accessibility into an impenetrable scheme of regulated spaces.[136]
In a 1904 debate about the galleries bill, James Caldwell—previously the Liberal
M.P. for Glasgow and now for Lanarkshire—argued that the potential reloca-
tion of this gallery might necessitate rethinking the location of the Scottish capi-
tal as well. Caldwell proposed an overhaul of the geographical markers of na-
tional sentiment by means of the gallery reforms: "In the past Edinburgh was the
capital of Scotland, but why should they look at the site of the National Gallery
from the point of view of sentiment?"[137] The *Scottish Patriot* condemned Cald-
well's proposal as positively un-Scottish, lampooning the M.P. whose "patriot-
ism seemed to ooze out at his finger ends."[138] The notion that "smoky, dirty"
Glasgow would be a superior site for the National Gallery of Scotland than "ro-
mantic" Edinburgh was dismissed as a philistine maneuver to taint the gallery

with industrial interests. Any evocation of a union between art and industry was too reminiscent of the recently deconstructed Board of Manufactures and was quickly quashed in Parliamentary debate.

Once Smeaton and Gulland introduced their amendment in the summer of 1906, the claims for regional representation began to multiply. Another amendment introduced by Charles Price, the Liberal M.P. for Central Edinburgh, proposed that the board members be appointed by the five city councils: Glasgow, Dundee, Aberdeen, Perth, and Edinburgh. Although public opinion in Glasgow did not unanimously favor these amendments, the *Herald* stated that Price's measure would at least create politically beneficent bonds between the municipalities—regardless of whether these bonds would aid the gallery.[139] The *Scotsman* responded that a nationally representative board would be cumbersome and impractical. More important, the *Scotsman* dismissed the regionalist amendments as "mere party cant," associating the new bill with Radical notions of representation.[140] The National Gallery of Scotland was an inappropriate testing ground for Radical democracy. The *Scotsman*'s view was followed elsewhere; the nationalist journal *Scottish Review and Christian Leader* printed an editorial arguing that the principles of representative democracy applied poorly to art.[141] Stirling-Maxwell's Unionist vision was under attack, but the Radical alternative of the superdemocratic gallery and art curatorship by electorate found few supporters.

The appearance of party unity with respect to the galleries bill disintegrated as supporters of the original bill strengthened their ties to Unionism and the amenders theirs to Radical dissent. Gulland's amendment pictured Stirling-Maxwell's bill as a "miserable" piece of legislation that sought to manage the National Gallery of Scotland through a London "clique."[142] In particular, he urged Scottish Liberals to resist this effort to set up an artistic autocracy in which the Scottish Gallery would be the creature of Dover House.[143] Smeaton further characterized the bill as being "saturated with the essence of centralisation, officialism, and red tape." With this bill the gallery would remain the property of Edinburgh, rather than Scotland as a whole. Most significantly, because of the nominative principle proposed for the Board of Trustees, "they would not be able to call their soul their own. They were tied, hand and foot, slaves to the will of the Secretary for Scotland."[144] Ironically, the amenders perceived the greatest threat to the National Gallery of Scotland to be from the secretary himself. Once again, the processes of improvement and reform carried with them the prospect of denationalization, potentially from within the Scottish Office.

The debate about whether the board should be nominated or elected raised important questions about the National Gallery of Scotland as a symbol of the country's liberal, democratic status.[145] The amendment process therefore en-

couraged Parliamentary and public discussion not only about regional identities
in Scotland but also about Scotland's adherence to an enlightened code of lib-
eral political theory. How "democratic" was the nation whose gallery had not an
elected board? Again, Glasgow was invoked as a critical site of contrast. In 1905,
the Glasgow Town Council had held a postcard plebiscite on the Sunday open-
ing of museums, demonstrating the new spirit of mass politics at work in public
art. Legislation allowing Sunday opening in England was passed in 1896, but
the strong Sabbatarian lobby in Scotland prevented the enactment of similar
laws until this plebiscite was held. The Scottish plebiscite makes an interesting
contrast with the 1876 workers' march for Sunday opening in London discussed
in the prelude. In the Scottish case, the mechanisms of mass voting were de-
ployed rather than protest politics. The plebiscite, which attracted approxi-
mately 140,000 respondents, resulted in the first Sunday opening north of the
Tweed. The process of reform in Glasgow was depicted in two cartoons in the
Glasgow News (figs. 6 and 7). The first, "The Question of the Moment," depicts
a sober Scotsman contemplating his vote over his morning meal. Six days later,
the results of the public vote were tallied, and the newspaper published a far
more fanciful sketch titled "The Open Sesame." In it, a beautiful fairy with a
gauzy dress emblazoned with the word "Yes!" waved her magic wand at a gal-
lery's door, proffering the magic of art to Glasgow's citizens.

The *Bailie* referred to the plebiscite as a "bloodless revolution," although
the *Glasgow Times* insisted that the measure had been pushed through by "alien"
elements in their city.[146] The galleries bill amenders invoked this history of pop-
ular reform to show that Glasgow had embraced a more egalitarian vision of art
and culture than had Edinburgh. A Scottish Gallery hampered by Edinburghian
parochialism and Sabbatarianism could never be fully national. The press in Ed-
inburgh warned that Radicals would wreck the galleries bill "on the democratic
principle," just as the intrusion of mass politics had proved morally destructive
in Glasgow. Again, the east-west divide of Scottish politics was central to the fate
of the bill. From the amenders' perspective, the secular spirit of legislative reform
and popular rationality was properly located in the west.

The perceived limitations of the Scottish Office were driving the amend-
ment process. Gulland described his ideal gallery board as an "independent"
body, which, "if necessary, would agitate even over the head of the Scottish Of-
fice."[147] The original Board of Manufactures he characterized as a local House
of Lords in Edinburgh, further radicalizing the demand for an elected board.[148]
The secretary for Scotland was too closely tied to Parliament to represent au-
tonomous Scottish initiatives; the new galleries board must take over this func-
tion instead. Gulland objected to the original bill on the ground that it deprived
the gallery of its national character. Nominated boards might be good enough

6. "The Question of the Moment," *Glasgow News*, May 10, 1905

for England, but "surely what was needed was not that Scotland should follow the English practice, but that they should level up England to Scottish practice. They had in Scotland some ideas of nationality, and they were quite capable of managing their own affairs."[149] For Gulland, Scottish nationalism rested on the principles of representative democracy in cultural institutions as well as in political theory. Without this fundamental code of enlightened democracy in the administration of the National Gallery of Scotland, no valorization of Scottish art could save the gallery from moral degeneration.

Gulland and Smeaton also argued that national galleries must take local political systems into account. The National Gallery in London might have a nominated board because England had a state to nominate it. Scotland had only the Scottish Office and the secretary for Scotland, neither of which could be depended upon for an accurate expression of the national will. There was no official connection between the Scottish Office, which one M.P. described as a

7. "The Open Sesame,"
Glasgow News, May 16, 1905

"benevolent despot," and the canvassing of public opinion regarding artistic matters. Indeed, the danger that a nominated board would simply replicate the problems of the earlier Board of Manufactures was striking. According to the *Glasgow Herald*, the Board of Manufactures had never properly fulfilled their duties at the National Gallery of Scotland after 1885 because they were afraid of offending the new Scottish Office.[150] If the office controlled the gallery, as would be the case with a nominated board, harmonious relations with the Parliament in London would always be valued above the needs of the Scottish Gallery itself.

Gulland continually stressed the deficiencies of the Scottish Office vis-à-vis the National Gallery of Scotland.[151] The reformed gallery would be unpopular as well as antinational; as Gulland argued, "The Board had not only to buy pictures, but it had to induce people to see them."[152] What made a gallery popular? In Gulland's terms, popularity had less to do with attendance figures and the educational value of the collections than with the gallery's infrastructure. For him, this infrastructure must be Scottish (by which he meant regionally inclusive) and democratic in its principles and execution. Gulland's proposal that the galleries bill go to a Scottish Grand Committee rather than continue in open debate in Commons was characterized by an Edinburgh M.P. as "entirely subversive of Parliamentary control."[153] Scottish politicians were divided about referring the bill to a Scottish committee, because treating the gallery as a purely

Scottish problem might detract from hard-won British interest in this matter. For the most part, the M.P.s who supported greater regional diversity on the galleries board also favored referring the whole question to a Scottish committee. The *Scotsman* referred to this part of Gulland's scheme as "a deliberate step to Home Rule all round," [154] or—as the *Glasgow Herald* called it—"dragging in the Home Rule fetish." [155] The *Herald* even suggested that sending the bill to a Scottish committee might obviate the need for representative boards in Scotland, a recent innovation in partial devolution. [156] Once again, the specter of Home Rule loomed over the Unionist bill, underscoring the difficulties of reconciling opposed—but equally Scottish—ideologies within the National Gallery of Scotland.

A debate about Gulland's amendment in the Edinburgh Town Council began with Lord Provost Macpherson's expression of dissatisfaction with Scottish M.P.s. Macpherson noted that the council was willing to expend considerable funds to "put some steam into the Scottish members of Parliament," so that they might all enjoy a National Gallery worthy of Scotland. He also asked Gulland, who was present at the meeting, to withdraw his amendment. Gulland refused. This gallery had come to function as an institutional embodiment of the failings of the incipient Scottish state, both in the hopes for an organized Scottish party in Parliament and in the Scottish Office itself. The laborious process of remaking the gallery administration highlighted the more general difficulty of enacting political change in Scotland, although Macpherson stressed that cultural dynamism was the weak point of Scottish politicians; "he was not talking about political matters." [157] This separation of the galleries bill from strictly "political" matters was a significant one. In terms of economic prosperity and even political stability, the Union might be considered a success. In terms of institutional expressions of national culture, it was doomed. The National Gallery of Scotland was a constant reminder of the sticking points of the Union.

In December, John Sinclair, who had become the secretary for Scotland in 1905, announced that he would not meet again with Radical representatives; he would try to push the original bill through without its amendments. Sinclair was singularly unpopular with the Scottish M.P.s in Commons. He was an unmistakable grandee who was at best unenthusiastic about Home Rule. During his tenure he gained a reputation for inaccessibility and ineffectiveness, pushing hopes for the Scottish Office to a new low. [158] Radical opposition to Sinclair's announcement was vitriolic. Smeaton described Stirling-Maxwell's bill as "against the spirit of the people" and argued that it defied every precept of national feeling. He further predicted that the term "National Gallery" would be a misnomer for the Edinburgh collections, because "for a thing to be national in Scotland you must take the nation with you from the start and keep it with you." [159] If the

reformed gallery board did not represent the entire nation of Scotland—by means of the inclusion of a wider variety of regions and the democratic nature of the electoral rather than the nominative process—the development of a "national school" of Scottish painting and sculpture was meaningless. The Radical view was that Stirling-Maxwell would create a gallery of the state—an institution administered primarily by the secretary for Scotland—rather than a national gallery. In the specific context of a stateless nation, the debate about nominated as opposed to elected boards was disproportionately central. For England and Ireland as well as for Scotland, national galleries were an important institutional mechanism of identity. But the effort to re-create an ideally democratic state structure within the gallery administration was uniquely Scottish, signaling the additional political weight the National Gallery of Scotland must bear.

The galleries bill adopted new political languages during the amendment controversy, culminating in Glaswegian John Honeyman's radical proposal to federate the three national galleries of Britain. Honeyman suggested that the artworks at all three institutions—Dublin, Edinburgh, and London—be amalgamated. The National Gallery of Scotland would be transformed into a municipal institution and would cease to compete with London and Dublin for artworks and funding. Britain would then have only one national gallery, with parts of its collections dispersed to Ireland and Scotland. As Honeyman wrote to the *Glasgow Herald,*

> By some, this might be regarded as an encroachment on "Scottish
> rights," but I am disposed to take a broader view of the subject.
> Every Scotsman will continue to admire and venerate Edinburgh . . .
> but in a United Kingdom there can be only one King and one capi-
> tal and—strictly speaking—one National Gallery. It would be a
> great mistake—indeed, altogether wrong—were we to despise the
> privileges we may claim or disregard the duties and responsibilities
> which devolve upon us as subjects of the wider realm.[160]

Honeyman's scheme revealed the extent to which the galleries bill and all its amendments had challenged previous conceptions of national galleries in a British context. His own project represented an effort to recapture the notion of centralization; it was an acknowledgment that the very existence of a National Gallery of Scotland posed a threat to the cultural unity of Britain. Devolution, Honeyman reminded his audience, was a matter of duties as well as rights. Scotland had an obligation to recognize the political primacy of Great Britain by ceding its own national gallery and receiving in return a superior variety of artistic collections.

Practically speaking, Honeyman's proposal had little effect on the galleries debates. Artistic amalgamation was an expensive prospect. But the principle of federation, introduced by Honeyman just before the passing of the galleries bill, indicated the extent to which the idea of a single national gallery for Britain was unable to find an audience. The network of competing national galleries in London, Edinburgh, and Dublin served as a visual expression of disjunction between the British state and its component nations. These galleries were supposed to promote cultural autonomy just as they contained it, functioning as state-sanctioned outlets for Scottishness, Irishness, and even Englishness. After a flurry of amendments that had endeavored to divide Scotland by party and region, Honeyman reminded his readers that the concept of Britishness was no more stable than Scottishness.

Although Honeyman's project of artistic federation was ideologically significant, the public's attention was focused on the continued demands of the Scottish Radicals. The *Scottish Review* referred to the galleries bill as the "ewe lamb" of Scottish legislation, arguing that the Radical amendments had permanently obstructed the process of institutional reform.[161] By December 14, Sinclair had agreed to meet with the Radicals after all and agreed to incorporate a limited version of their collective proposals. Three of the seven members of the new Board of Trustees would be drawn from the town councils, but the board would be nominated rather than elected. The question of how to integrate regional feeling into the National Gallery of Scotland without forfeiting connoisseurial standards in Edinburgh was provisionally shelved.

The insistence on a regionally diverse board again called attention to the Scottish region best known in Britain and Europe: the Highlands. In the last days of the galleries bill debates, the bill vied for Parliamentary time with legislation regarding the crofters and the Scottish agrarian revolutions, underscoring the implications of a reformed gallery for Radical notions of property, ownership, and land in Scotland. The M.P. for Sutherland, A. C. Morton, a Radical defender of the crofters, made the conceptual leap from a Radicalized National Gallery of Scotland to land reform, stressing the apparent incompatibility of these two focal points of Scottish discontent in Parliament:

> He contended that before they spent money on bricks and mortar in
> Edinburgh, something should be done for the crofting counties. . . .
> In respect of the promises which had been made of legislation for
> Scotland, it was understood that she would have to wait, which was
> very hard, seeing that Scotland had consistently supported the Lib-
> eral Government. The latter, however, offered them this little Bill
> [the galleries bill] instead of doing something to assist the people.[162]

The crofter, the embodiment of agrarian Scotland, intruded into the final moments of the galleries debates with an alternative conception of region, nation, politics, and property. The *Scotsman* reported that Morton was determined to wreck the galleries bill, which had become a focal point for his critique of the Liberal Party. In Morton's view, the Liberals had sold out Scotland—in particular, the Highlands—when they sacrificed the Scottish Landholder's Bill. Interestingly, Morton described the galleries bill as a "Liberal sop," although it had a Conservative sponsor. What struck him as uniquely Liberal about the current debates was the false or disingenuous analogy of cultural amenities and economic change. For Morton, the beguiling equation of a new gallery in Edinburgh with a broader national policy of economic reform was unmistakably Liberal, regardless of the origins of this particular bill. The crofters were to be sacrificed to the gallery.[163] For Morton, the moral museum-goer in Edinburgh came at the direct expense of the hapless crofter, compelling Scottish M.P.s to choose which region and which vision of progress they wished to embrace. The incorporation of the rural into the realm of urban, institutional culture proved just as complex in Scotland as in Ireland, and considerably more contentious in terms of party politics.

The revised galleries bill passed on December 15, 1906. The *Scotsman* described the final reading of the bill as a "purely Caledonian" affair; attendance was limited to forty or fifty Scottish members and a few stray Scotsmen who sat for English constituencies.[164] Morton was censured by the Speaker of the House for his sarcastic comment that "this having been described as a 'Caledonian' day it was surprising that the Prime Minister did not arrange to have the bagpipes."[165] His comments revealed the contemporary difficulty of discussing Scottishness beyond the prevailing terms of Highlands tartan, kilt, and pipes, which Stirling-Maxwell and his supporters in Edinburgh had so strenuously avoided until the regional amendments were introduced. With the National Gallery of Scotland supplanting the cause of land reform, at least in Morton's mind, the Scottish politicians were back to the bagpipes again. If the larger aim of the galleries bill had been to renegotiate the loyalties of the Scottish M.P.s and give them a new political language in which to couch Scottish business in Parliament, the passing of the bill represented a very limited victory.

The lengthy process of drafting and amending the bill had given rise to a reformed gallery, but along what lines? What was the new curatorial vision of Scotland? How would the ideologies of Union and Home Rule be reconciled in this new gallery? In the end, would the gallery be reformed along the lines suggested by Stirling-Maxwell, Gulland, or Morton? The mood in 1906 was one of anticlimax. The nationalist coalition with the Irish had fallen apart in the early years

of the galleries bill debates, and the interminable series of amendments had pro-gressively narrowed the audience for the bill in England. The incompatibility be-tween accepted models of Scottish identity and the National Gallery of Scotland lay at the heart of the amended bill, speaking to the problem of national cultures in the non-nation-state.

Reconstructing Caledonia: The Aftermath of the Galleries Bill

Ultimately, the National Galleries of Scotland Bill satisfied very few. The post-mortem on the bill was less than wholeheartedly enthusiastic. In making the board regionally representative, many feared, they had ruined the gallery. The bill itself was characterized as an unsatisfying balance between the Radical de-mand for "local sentiment" and the apparently sacred principle of nomina-tion.[166] Stirling-Maxwell's private correspondence reflects the widespread belief that Asquith had intimidated Sinclair, the Scottish secretary, out of any but the most Unionist of bills. As Sir James Guthrie, now a member of the new gallery board, had put it earlier, "It would almost seem as if the Scottish Office were 'bogged' by the whole question."[167] In Sinclair's concluding speech about the National Galleries of Scotland Bill, he offered thanks to Asquith, as chancellor of the Exchequer, and to Treasury—omitting the Scottish M.P.s entirely. But according to the *Scotsman*, Sinclair had also bowed to the forces of regional rep-resentation and had allowed a serious encroachment on his new ministerial re-sponsibility and Parliamentary initiative.[168] Whether Sinclair's greatest fault was his susceptibility to Asquith or his vacillation regarding the regionalist question, the possibility of a Radicalized Scottish Office had clearly diminished.

Within the limited context of Parliamentary legislation, the question of Home Rule for the National Gallery of Scotland had vanished from public de-bate. But an alternative vision of Scottish art and nationalism persisted beyond the passage of the galleries bill. The Edinburgh Exhibition of 1907, for example, became a battleground for the same issues that had been at the heart of the bill. The nationalist journal *Fiery Cross* repeatedly protested the plan to hold this ex-hibition of art and industry in the bicentennial of the Union, arguing that such a visual celebration of 1707 would only induce exhibition visitors to perceive the Union as a hopeful spectacle or a work of art. The editors of the *Fiery Cross* had been at the forefront of nationalist efforts to reform and, as they put it, re-Scottify the National Gallery of Scotland. In the aftermath of the galleries bill, they carried these efforts into other areas of exhibition culture, trying to sever the connection between art and Union.

Other nationalist publications joined in this project of integrating Home

Rule principles into the theory and practice of institutional culture. The *Scottish Patriot* reported that many members of the Edinburgh Merchants' Association opposed the 1907 Exhibition and quoted one merchant as saying,

> A Scots National Exhibition had not claims to an International Exhibition. He did not think that they should pride themselves on the Union of Scotland and England. They should rather regret it. It was not at all flattering to Scotland that they should look back on the time when they became absorbed as a nation and lost their identity and distinctiveness simply because they became allied to England. There was no occasion for rejoicing.[169]

According to the *Patriot*, an exhibition celebrating the Union was no national exhibition at all. The objection was not only to the commemoration of the Union but also to the fact that the processes of commemoration were—at least in Edinburgh after the passage of the galleries bill—themselves inherently Unionist.[170] The Home Rule side in the galleries debates had never found an institutional voice, and this 1907 effort to recast Scottish visual culture in Home Rule terms reflected the ongoing problems of promoting a national gallery in a country divided about the focus of its nationalist energies: Britain, or Scotland alone.

It is difficult to escape the conclusion that the National Gallery of Scotland *looked* very much the same after the passage of the galleries bill as before it. The offices of the curator for the National Gallery and the National Portrait Gallery were amalgamated, and the post of Keeper of the Gallery was instituted. The Board of Trustees was instructed to define its own functions as including a wide responsibility for the promotion of art, and funds designated specifically for the purchase of new works were increased.[171] The former Union annuity was put to the broader purpose of the encouragement of art in Scotland. But in terms of buying Old Masters, Scotland had waited too long. The new curator's list of *desiderata*, which highlighted the gallery's deficiencies in the Italian and Dutch schools—particularly Rubens—served only to demonstrate that Scotland would never have the universal art survey institution the duke of Argyll had wanted. The board was advised by the new curator to aim at collecting examples of individual painters or characteristic phases from the important schools rather than a general collection illustrating the international history of art. Sir James Guthrie noted that the prices for Italian paintings had soared so high since the gallery's founding in 1850 that he would have to rely entirely on private collectors to obtain these works.[172] The National Gallery of Scotland was no closer to the continental model of a national gallery now than it had been in 1901, and Guthrie

acknowledged that prior ambitions for a universal survey collection would have to be abandoned for good.

The Scottish collection in the Edinburgh gallery, although excellent in quality, was still insufficiently representative for general education purposes. The curator expressed his hope that this section of the gallery might eventually be turned into a comprehensive survey collection, because private donors were most likely to be helpful with Scottish works. The establishment of the Scottish Modern Arts Association (SMAA), founded in 1908 to acquire works by contemporary Scottish artists, also worked to convince other British galleries that Scottish paintings were important to all national collections. The SMAA focused less on the National Gallery of Scotland than on improving the status of Scottish works at the Tate Gallery and the National Gallery in London, arguing that these institutions were necessarily British rather than English.[173] The SMAA appears to have been resented in London because it was perceived as an unnecessary corollary to the National Art-Collections Fund.[174] Guthrie drew further criticism from the fund when he suggested that Scotland should have its own "art rescue" organization, raising the possibility of internal competition for British artworks.[175] Now that the reform of the National Gallery of Scotland had been partially accomplished, the SMAA instituted the call for representation of modern Scottish artists throughout the British gallery system. But at the same time, in the aftermath of the predominantly Unionist galleries bill, the status of a Scottish school of painting and sculpture seemed elusive. One 1908 editorial suggested that national artistic styles were difficult to identify in England or Scotland; although a "distinguishable something" did bind together the works of Scottish artists, "it might not be easy to make out a case for a British, far less a Scottish school."[176]

In this climate of reluctant and half-hearted compromise, the new Board of Trustees remained cautious about continued Radical discontent. They made considerable efforts to solicit Radical opinion of the newly reformed gallery, and when Treasury failed to provide promised funds for new pictures, the board brought the Radicals back into the fold of gallery politics. In March 1909, James Guthrie attended a meeting of Scottish Radicals and presented them with a synopsis of Treasury delays, adding that the deficit of funds received for the arts in Scotland as compared to Ireland now amounted to £120,000.[177] At about the same time, the *Thistle* published an article titled "How Scotland Is Done by the Treasury" that showed the total expenditure on national museums for the previous decade to be £550,597 for England and Wales, £7,837 for Ireland, and £1,274 for Scotland.[178] The Radicals agreed to support Guthrie in his quest for justice from Treasury and appointed a deputation to interview the chancellor of

the Exchequer, Lloyd George, about this matter. They also consented to include two Unionists in this deputation, now that Stirling-Maxwell was also a member of the Board of Trustees. Lloyd George proved relatively amenable to the gallery coalition's proposals and agreed to consider a demand for £20,000.[179]

The epilogue to the galleries bill, then, was one of party reunification. With critical attention refocused on Treasury rather than regional demands in Scotland, Radicals and Unionists could convene in the gallery once more. Although the Radical voice had been effectively quelled within the bill itself, particularly with regard to the question of an elected board, Radical support was called upon to enforce the bill. The first act of the new Board of Trustees was to institute Sunday opening for the National Gallery of Scotland, bringing it into line with the public galleries of England and Ireland. If the Radicals had been disappointed with the final version of the galleries bill, they could at least ensure the appearance of democratic access within the new gallery itself.

To the *Scotsman*, the passage of the bill marked a moment of transition from Parliamentary niggardliness to fair dealing with Scotland.[180] The gallery board described the new condition of the National Gallery of Scotland as a beneficent "revolution" in the relations between the imperial Parliament and artistic interests in Scotland—and between Scotland and Parliament more generally.[181] But in terms of redefining the Scottish Office as a cultural patron, even the *Scotsman* admitted that the galleries bill had failed. A 1912 motion in Commons for increased funding to support lectures about art history at the National Gallery of Scotland met with a very cold response from the Scottish Office. The secretary for Scotland responded publicly that there was no demand for artistic scholarship from the Scottish people.[182] The connection between the Scottish Office and the gallery was weaker than ever.

The central struggle of the galleries bill—the battle between the Unionists and the Radicals to define the cultural and political center of Scotland—had resolved with no clear victor. The *Thistle*, dissatisfied with the reformed National Gallery of Scotland, continued to publish suggestions for making Scottish art institutions more "patriotic." The editors of the *Thistle* found the 1911 Exhibition in Edinburgh "disgusting" because its organizers failed to treat relics pertaining to William Wallace as "the shrine of the Exhibition, the first and last object to which all patriots should turn their step."[183] For the *Thistle*, Scottish patriots would have to turn away from Edinburgh in order to find an appropriate institutional outlet for their political program. Again, nationalist definitions of Scottish patriotism ran up against the gallery's own vision of Scottish pride, a complex amalgam of Unionist administration and Radical dissent.[184] William Thomson's 1911 letter to the *Thistle* cited the Liberals' "abuse" of the gallery as

an impetus to the formation of a separate Scottish National Party, asking, "Is this the Party [i.e., the Liberals] which granted thousands of pounds to purchase masterpieces for the National Gallery in London, but which doles out petty sums to the National Gallery in Edinburgh?"[185] As the Home Rule question became increasingly divisive within the Liberal Party, the history of Liberal neglect of the National Gallery of Scotland served as a focal point for criticism of Liberalism's past and present relation to Scottish nationalism. Right before World War I, this gallery had come to symbolize the failure of Liberalism to represent national cultures within Britain and thus embodied the institutional limits of Britishness instead of its potential for expansion.

The Highlander in the Gallery: An Epilogue

After the gallery reopened in 1912, the *Dispatch* published a long article called "Beauty's Shrine: A Visit to the Scottish National Gallery" as a coda to the galleries bill and its controversies.[186] The gallery had been, as one journal put it "rehabilitated." The process of rehabilitation was made visible by the addition of new treasures, most notably, a portrait of James III of Scotland and his wife, a gift from George V.[187] The travelogue in the *Dispatch* revealed the ways in which the Scottish press reimagined the gallery after 1906 in terms of at least two "invented" Scottish cultures: not only the ancient Highlands, but also the eighteenth-century neoclassical Enlightenment. The *Dispatch* editors likened their own annual visits to the Scottish Gallery to pilgrimages made by pagan Greeks to Mount Olympus: paying homage to the power of beauty in a Grecianized Edinburgh. The Scottish reader was invited to

> [c]ome for a moment from the defences of your shores and your
> building of battleships and strengthen at this quiet shrine the battle
> of your soul. Step out from the clank and rattle of your industrial
> machinery, and listen here to the unheard melodies of the children
> of the spirit. Steal from the throbbing stones that pave the streets
> and enter the quietude of this fairy grotto.

This depiction of the ideal Scot as the laborer in service of modern industry, in particular the industries of war, was repeated throughout the article. The imagined visitor was called upon to reenact Scotland's history of conflict with the British military state, certainly something very far from what John Stirling-Maxwell had in mind. The prose grew increasingly purple as the anonymous author concluded with an exhortation to examine the Scottish paintings and

> [i]dentify yourself with the grim Highlanders, who are grouped
> about a wounded comrade, living in the grip of death—"after the
> battle." Disturb not the awed silence in a home too soon to be deso-
> lated by the pride of kings. See the wean sleeping snugly in his
> cradle, bend in spirit with that lonely female figure lavishing the last
> tendernesses of unavailing love upon a stricken manhood; then,
> Scotsman if you are, and with memories of the tartan thrilling
> through the veins, seize pikestaff or matchlock and prepare, like
> those figures in the doorway, to give a bloody welcome to the first
> redcoat that dares to cross the threshold.

Now that the period of Parliamentary negotiations concerning the bill had
ended, the tartan, the kilt, and the grim Highlander encroached upon the Na-
tional Gallery of Scotland, which was depicted as the site of a violent struggle in
the name of the Highlander, spurred on by the Scottish paintings of the gallery.
If the bill had once aimed to evade or escape the Highlander myth, this part of
the experiment was clearly over.

 "*Comment peut-on être Écossais?*" [188] At several points during the galleries bill
debates, the field of possibilities for responding to this question had seemed par-
ticularly rich. In certain respects, this emergence of tartan imagery and fictive as-
sociation with Highlandism foretold the death of the bill's legislative import. The
debates had treated the National Gallery of Scotland as a potential site of leg-
islative and political nationalism and offered a variety of options for conceptual-
izing Scottishness outside of the romanticized, backward-looking terms of the
Highlands. But after the bill had passed, the gallery was disengaged from the
struggles of Union and Home Rule that had involved the past two generations of
Scots. Instead, this new vision of the National Gallery of Scotland as a point of
entry into Highlands history confirmed the end of the gallery's experimental rule
as an institution that incorporated a diversity of Scottish political opinion. The
amenders' project of a Radical gallery had been overcome by the time "Beauty's
Shrine" was published. But at the same time, the existence of such a project
is in itself a challenge to a historiography that separates political and cultural
nationalisms.

 The galleries bill addressed the status of law in regulating national cultures.
The reform of the National Gallery of Scotland was linked to a host of other con-
cerns about ownership in Britain: most strikingly, to the crofters and the ques-
tion of Scottish land reform. The apparent incompatibility of these two different
kinds of "improvement" raised important questions about the process of Liberal
reform. In Scotland, this process was always modulated by regionalism and rad-
icalism. For the participants in the galleries bill debates, the future of the gallery

depended on which vision of Scottish Liberalism won out and on elaborating the relationship between Scottish Liberalism and its English counterparts. At the heart of the galleries bill was a broader meditation on the processes and limits of reform that had characterized politics in the nineteenth century both within and beyond the borders of Scotland.

Chapter 3 analyzes the changing status and politics of the culture of property in Britain through the lens of gender. It focuses on the intersection of radical feminist politics and the National Gallery in London. The question of whether national galleries could withstand the Liberal crisis of faith, ideology, and practice—and what new forms they might need to take to do so—was a major concern in thought about British patrimony before World War I. Again, the status of law in the production of culture was at the heart of the debates: This time, they were geared toward the emergence of a traffic in objects rather than the reform of institutions.

THREE

Picturing Feminism, Selling Liberalism:
The Case of the Disappearing Holbein

In the early spring of 1909, the duke of Norfolk announced that he was putting Hans Holbein's *Christina of Denmark, Duchess of Milan* (fig. 8)—displayed at the National Gallery in London since 1880—up for sale in the international open market.[1] The painting was a portrait of Christina, the young Danish widow whom Henry VIII had cursorily wooed while Holbein painted in Henry's court; the curators therefore classified the work as part of the "British school," although neither the painter nor the sitter was British.[2] The public response to the duke's announcement was immediate and dramatic. The potential loss of the Holbein portrait—most likely to an American millionaire—produced what one newspaper termed a collective "condition of mourning" in Britain, with aesthetes holding daily vigils in the gallery halls.[3] Charles Holroyd, the director of the National Gallery, swore that if Mary Tudor had Calais written on her heart, he had Holbein written on his.[4]

British art lovers promptly began a campaign to "save the Duchess" by meeting the duke's sale price of £72,000,[5] with women and noted feminists playing a particularly important role in the subscriptions drive. At the same time, the press debated the *Duchess*'s patrimonial value. Could female portraiture be considered a truly "national" form of art as long as British women lacked full political rights?[6] Did the duke, a property-owning male subject, have the authority to sell and export his *Duchess* despite its special merits in the British art historical canon? Should the salvation of the painting be an endeavour for men, following the Victorian convention of characterizing the public gallery as a "boy's pocket," or individual male property writ large?[7] Or was the National Gallery being reinvented as a feminine, even a feminist space? At a broader level, what did the sexual and class politics of the Holbein campaign signify about feminism's relationship to the larger political nation?

The Holbein debates raised important questions about the connection be-

118

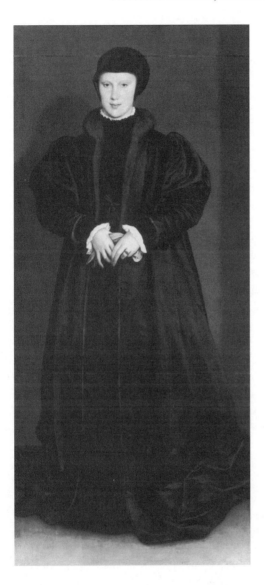

8. Hans Holbein, *Christina of
Denmark, Duchess of Milan,*
1538. Courtesy of the National
Gallery, London.

tween gender, property, and patriotism and reflected changing relationships be-
tween women and property and between Liberal and Radical frameworks of
property in prewar Britain. This chapter treats "the case of the disappearing
Holbein" as a focal point in the history of art, gender, and citizenship. Feminist
scholarship has tended to treat art institutions primarily as agents of exclusion.[8]
Although biographies of individual women art patrons and critics proliferate,[9]
the historical relationship between feminism and the museum has not been a ma-

jor concern of museum studies thus far.[10] The history of gender relations and the protection of cultural heritage, as Rudy Koshar suggested nearly a decade ago, has yet to be written.[11] Studies of gender and art institutions have tended to posit the museum as a mirror of political society, overlooking the ways in which the institutional context refracts historical situations.[12] Campaigns by the Guerrilla Girls and the Women's Action Coalition have allied the question of representing women artists in public institutions with broader feminist agendas of social, political, and economic opportunity.[13] Studies of early suffragettes' attacks on art have also pointed to a feminist narrative of antimuseology, positioning the history of radical feminism outside or against the museum.[14] According to this brand of scholarship and activism, feminism exists in relation to the museum only as an ideology of opposition: a reminder of what the museum is not.[15]

Although these contemporary movements are grounded in a late twentieth-century model of feminism, their notion of the museum is based on the nineteenth-century universal survey institution with its grand art historical narratives and cults of individual genius.[16] For many Victorians, this type of institution was necessarily grounded in men's property.[17] Patrick Geddes's comment that "no great museum was but once a boy's pocket!" was echoed in William Henry Flower's description of his curatorial work at the British Museum as a natural extension of his earlier "boy's collecting" practices. Flower argued that British adolescent males had a passion for the organization and display of their own possessions that led them naturally to museum work.[18] Even Ethel Deane, whose advice tracts about collecting were aimed primarily at a female audience, described the collecting spirit as fundamentally male. "In boyhood," she wrote, the desire to collect "finds expression in the amassing of hoards of countless marbles, pen-nibs, stamps and what not."[19] The systematization of property was thus natural to men, evident from earliest boyhood. Deane offered no corollary for girls, who had to be taught to categorize their possessions. Furthermore, the rights of property were habit-forming. Individual boys' pockets found their ul timate collective expression in the institutional culture of the museum. Within this Victorian model, museums were generated by the naturally preservationist instincts of men, combined with a male love of system and the legal rights that enabled men to cede their property at will. But this model met constant challenges throughout the Edwardian period. The museum was constituted not only as a microcosm of gender relations in the larger social and political world but also as a site for remaking these relations.[20] This chapter investigates the historical relationship between British women and art institutions from the early nineteenth century to World War I. What, precisely, was the gender politics of the museum, and how might this politics be incorporated into the world outside its walls?

After the passage of the Married Women's Property Act in 1882, which purported to allow married women to hold property and enter into contracts as if they were *feme sole*,[21] women had begun to play an important role in the donation of art to public institutions.[22] These changes crystallized anxieties about the status of private property in public galleries and about the capacities of women as civic-minded property-holders. The question of what it meant to be a female citizen was at the heart of the case of the disappearing Holbein and of the debates that preceded and shaped this controversy. For my purposes, "feminism" refers primarily to nineteenth-century Liberal feminism, based on a Lockean conception of the rational, rights-bearing individual and focused on a progressive program of education for women.[23] But since this chapter spans a relatively long time period, from the 1820s to the 1920s, its flash points for defining feminism necessarily shift as well. Many feminists who campaigned for women's property rights in the nineteenth century also took a critical view of the "overarching sanctity" of property in British political life, pointing to the connections between men's reverence of property and their abusive treatment of women.[24] This chapter focuses on the role of gender in debates about the ownership of cultural objects in order to illuminate the evolution of British feminist thought—and feminist ambivalence—about property itself.

The history of feminism in Britain has situated itself in a number of institutions, for example, Parliament and town councils, universities, philanthropic organizations, and the press.[25] My intention is not simply to add museums to the list of institutions to which British women have gained access, nor to rehabilitate the museum as a proto-feminist institution. Indeed, although nineteenth-century models of the feminist museum may have been rooted in a liberal conception of individual enlightenment, the Holbein controversy prompted a new series of disjunctions between Liberalism and feminism, calling the ideological underpinnings of feminism itself into question. Would feminism remain outside or at the periphery of the museum, which itself had begun to lose its Liberal bearings? What was the appropriate relationship between (Liberal) institution and (feminist) critique?[26]

This chapter examines a range of individual and collective efforts to articulate a feminist museology—a set of institutional practices that would promote the political ideology of feminism. Clearly, not all of the contemporary efforts to include British women in the practices of collecting and curatorship could be properly classified as feminist. And when reformers did intend for women to receive political benefits from their participation in the realm of high culture, their aims and methods were not always well defined or well received. But whether these projects focused on changing the visual presentation of women in public galleries or increasing the role of women as donors and curators in public art in-

stitutions, feminism was one mode of responding to the changing parameters of culture and property in prewar Britain. What different kinds of public culture did British femnists wish to create? What relationship, if any, did the Holbein portrait of a Danish duchess—and the getting, keeping, or loss of this portrait— bear to the project of making a feminist museum?

This chapter begins with the works of Anna Jameson, one of Britain's first feminist art historians. With the term "feminist art historian," I wish to indicate that Jameson intended women to gain political benefits from the acquisition of art historical knowledge. She criticized Harriet Martineau for neglecting the question of women's aesthetic education and considered training in "the delight in beauty" essential to women's social and political development.[27] More broadly, Jameson was an important proponent of Liberal feminist thought in the 1850s who helped initiate the Married Women's Property Bill in 1857, an effort to abolish the common law of spousal unity with respect to married women's prop- erty.[28] She also presided over a salon that included some of the leading lights of Victorian feminism, such as Bessie Parkes, Barbara Leigh Smith, and Emily Faithfull.[29] Jameson's project for improving the condition of womanhood predi- cated social progress on individual education, particularly in the fields of art and aesthetics.[30] Recent scholarship has identified a range of Victorian women art historians, such as Emilia Dilke and Vernon Lee, who engaged critically and productively with issues of gender in their work.[31] But Jameson's critique of ex- isting institutions and her projects of institutional reform are of particular rele- vance for the Holbein debates at the National Gallery, because they demonstrate the ways in which feminism, public art, and British identity were already linked when the duke of Norfolk threatened to sell the Holbein in 1909. Jameson wrote about art galleries as important institutions for the elaboration of feminist prin- ciples: laboratories for feminism as well as potential havens of sexual equality and independent judgment for women. In her fictionalization of anticonnois- seurship, her gallery guides for women, and her Liberal tracts concerning wom- en's rights, Jameson raised important questions about the museum as a point of contact between cultural life and political life for British women.

Jameson's conjunction of art and feminism was only one of many com- peting strategies for defining the museum's gender politics. The culture of prop- erty played a complex role in the development of British feminist thought and practices. Contemporary debates about the feminization of museum work—in particular, curatorship—recast gendered perceptions of labor, leisure, and pro- fessional identity. At the same time, rising numbers of donations from British women to public galleries and museums challenged existing national stereo- types of patrimony, public-spiritedness, and patriotism. The project of crafting a feminist museology had revealed a series of disjunctions among British women

of different socioeconomic levels and between curators and their increasingly discontented audiences. As with the earlier workers' march on the National Gallery, the campaign to save the Holbein took place both within and outside the gallery, raising questions about the circulation of artifacts in an international market as well as in domestic institutions. The participants in the Holbein debates met with a host of collective anxieties about the purity of British art, the role of feminism in an institutionalized national culture, the influence of American philistinism on British economic and cultural life, and the changing status of property for women and aristocrats. The case of the disappearing Holbein is a particularly fruitful episode in the British history of culture and property, linked to broader and increasingly pessimistic predictions about the fate of Liberal culture in Britain. Ultimately, the Holbein controversy was as much about the National Gallery's memorialization of feminism as it was about its effort to contain radical feminist discourse; the two processes were wholly interdependent.

Anna Jameson's *Ennuyée:*
Nationalist Fictions of the Feminist Museum

Anna Brownwell Murphy was born in 1794 in Dublin, the daughter of an Irish miniature painter. In 1798 her family moved to England, where Anna was educated until she reached the age of sixteen. At that point, she secured a position as a governess in the family of the marquess of Winchester. She was apparently overjoyed at the prospect of taking a "Grand Tour" of the Continent in her capacity as governess.[32] But Anna's engagement with the Winchester family was mysteriously terminated before the promised trip to Europe took place, and she became deeply depressed. Fleeing the attentions of her future husband, a barrister named Robert Jameson, Anna immediately sought another position as governess and went off to France and Italy with her pupil. She stayed in Europe for one year, during which she kept a journal of her impressions of Continental life. She then returned to England and married Jameson, although they were soon estranged and rarely lived together.

According to the *Dictionary of National Biography* and Jameson herself, she never intended to publish her journal. Nonetheless, in 1825, just after the founding of the National Gallery in London, a version of the journal, glossed by more overtly "fictional" fragments, was anonymously published under the title *A Lady's Diary*. Throughout the 1820s and 1830s, Jameson claimed that an unscrupulous bookseller named Thomas was responsible for the publication; she had agreed to the printing only on the condition that he buy her a Spanish guitar if there were any profits beyond the cost of publication. "Thomas" sold the

copyright of *A Lady's Diary* to the bookseller Richard Colburn, who changed the title of the volume to *Diary of an Ennuyée*. The identity of the narrator was thus implicitly shifted from "lady" to psychological "type." But Jameson's own use of the term extended beyond the literal meaning of "the bored one"; her *ennuyée* was characterized by inertia and depression but also by great, though misdirected, talents—a symbol for the ways in which social conditions such as the inadequacy of women's education compelled individual women to unfeminine behavior. Having no outlet for her artistic observations, Jameson's *ennuyée* is of questionable sexual morality and ultimately self-destructive despite her redemptive interest in art. With this new title, Colburn republished the volume, and it became a tremendous popular success.

The *Diary* provoked an intensely hostile reaction among the British intelligentsia in the 1830s, in part because of the problem of a little too much verisimilitude. The *Diary* was initially presented as the nonfictional journal of a governess who committed suicide at the age of twenty-six. This information was conveyed via an editorial "note" on the last page, and other interpolations such as "rest of page illegible" or "lines crossed out" were scattered throughout the text. When Jameson revealed that the creator of the *Diary* was not in fact buried in an unmarked French grave but was alive in London and profiting well from the *Diary*'s publication, contemporary reactions were extremely unfavorable. After Fanny Kemble, a celebrated English actress, was introduced to Jameson, she commented that "the Ennuyée, one is given to understand, dies, and it was a little vexatious to behold her sitting on a sofa in a very becoming state of blooming *plumpitude*." [33] The *Diary* went through several printings, and the 1856 and 1885 editions appeared with an apologetic preface. Jameson denied that she had intentionally deceived her audience and asserted that the underlying truth of the *Diary* was in its accuracy as a "picture of mind" or a "true picture of natural and feminine feeling." [34] Many of her acquaintances were unconvinced by this explanation, and her works about connoisseurship were therefore grounded in this public controversy about personal character, narrative ethics, and authenticity.

The nameless narrator of the *Diary*, a laudanum-addicted governess recovering from a broken heart, travels to Continental museums and galleries mocking the aesthetic and sexual vagaries of men. In one particularly damning passage, Jameson describes the male connoisseur gazing at an unspecified artwork

> as never gazed the moon upon the waters, or love-sick maiden upon
> the moon! We take him perhaps for another Pygmalion? We imag-
> ine that it is those parted and half-breathing lips, those eyes that
> *seem* to float in the light; the pictured majesty of suffering virtue, or

the tears of repenting loveliness; the divinity of beauty, or *"the beauty of holiness,"* which have transfixed him? No such thing, it is the *fleshiness* of the tints, the *vaghezza* of the coloring, the brilliance of the carnations, the fold of the robe, or the foreshortening of a little finger. O! whip me such connoisseurs! the critic's stopwatch was nothing to this.[35]

The connoisseur of Jameson's satirical fantasy dissects art according to technical criteria alone. He is touched only by the physical or the visual aspects of the work, not by its underlying ethical principles. Male connoisseurship, she suggests, is of uncertain morality and banal eye.[36] To the narrator's amusement, the connoisseur turns out to be an anti-Pygmalion. Instead of breathing life into the object of his analysis, he murders art with his overly mechanical analysis and emasculates himself in the process.

Crucially, Jameson's narrator distinguishes herself not only from male connoisseurs but also from "women of fashion," who have the consumer power to buy art but lack the critical power to judge it.[37] The narrator's class position as a governess functions as an asset to her ability to judge art purely and well. "Taste," within the realm of public art, is literally re-classed as the province of viewers who are out of the art market's bounds. The combination of a female body and a working-class or lower-middle-class economic position defines the narrator as the ideal critic within Jameson's philosophy of art. The narrator of the *Diary* is contrasted with the ordinary male tourist as well as with the "professional" connoisseur. The requisite "ugly American," who demonstrates no interest in art, is a young and sexually predatory businessman. When the narrator tries to introduce him to the artistic riches of Venice, he replies that "he knew nothing of *them* things." Again, the financial power to consume art has destroyed aesthetic perception.[38] Disinterestedness, the quality prized above all others by contemporary art critics,[39] is defined as the province of women—at least, women of requisite poverty.

Despite the narrator's strengths as an anticonnoisseurial critic, she eventually implodes; her rejection of male taste and tutelage result in an untimely death. Jameson promptly distanced herself from this work and turned to more "scholarly" volumes of art and literary criticism.[40] In the 1840s she embarked on a series of gallery guides for British women. She acknowledged that works such as her *Handbook to the Public Galleries of Art in and near London* (1842) and *Companion to the Private Galleries* (1844) might strike Continental women as simplistic; German galleries, for example, were so well-organized and accessible that no intermediary between visitor and institution was required. But as Jameson wrote to her friend Ottilie von Goethe, "What do I care of that? I write for En-

glish women, to tell them some things they do not know."[41] Originally, Jameson had planned a history of women artists, but she decided that gallery guides were ultimately more useful in the mass inculcation of feminism. Knowledge of women's role in making art was useless without a broader framework for understanding the institutional conditions of artistic production. Her *Handbook* offered detailed information about the provenance of individual paintings and sculptures and carefully distinguished between artworks owned by the government and those donated by private collectors. Most of all, the *Handbook* exposed the shortcomings of the galleries themselves.

Jameson's vision of Liberal citizenship was based on the qualities of individual judgment and discernment—traits that were developed by the study of art. Whereas men could participate in the closed circle of amateur connoisseurs' clubs, women were thrown upon the mercy of public collections for their artistic and civic education.[42] Jameson's analysis of the National Gallery in London, the future site of the Holbein controversy, illustrated the failings of existing institutions. She attacked this gallery's corrupted vision of femininity, which warped public taste with its promotion of "those meagre, wiry ringleted, meretricious, French-figurante things, miscalled women, with which we are innundated in Books of Beauty, Flowers of Loveliness, and such trivialities."[43] Interestingly, her target here is not the artist but the National Gallery itself. Rather than developing the qualities of moral citizenship that should transform female audiences into moral voters, male patrons and curators had failed to create a gallery worthy of Liberal womanhood. The problem of women's education was made manifest in the nation's most prized exhibition space, where feminists had nothing to see. The source of British women's ignorance and political impotence, even of their occasional pathology or ennui, had shifted from the individual to the institutional psyche. Where, and at what, was the worthy feminist supposed to look?

Jameson's project to reform the National Gallery was only obliquely stated in her *Companion*; her vision of a feminist gallery was couched largely in negative terms. The feminist would remake the National Gallery by encouraging the deaccessioning of inferior or morally suspect works, redeeming both the institution and the larger political nation from the miscalculations of male connoisseurship. Jameson wrote, "There should be no deception permitted in a gallery intended for the pleasure and instruction of the people."[44] The existing National Gallery and its "lies" of taste were opposed to a future gallery of truth, justice, and faith, one that would uplift British citizens instead of demeaning them. The *Handbook* stood as a corrective to the National Gallery, offering readers a very different brand of aesthetic, moral, and political education than they would find within the gallery's walls.

But Jameson was also resolutely nationalistic. In her *Sketches of Germany*, the protagonist, Alda—again, an emphatic anticonnoisseur—praises German women's education but stresses that higher knowledge is meaningful only within the context of British Liberal feminism.[45] An Englishwoman need not tolerate the circumstances Alda describes as prevalent in Germany, where "the wife of a state minister excused herself from going with me to a picture gallery, because on that day she was obliged to reckon up the household linen."[46] Continental art institutions might trump the National Gallery in terms of wealth, educational value, and even images of women, but the conjunction of art, feminism, and Liberal personhood was, for Jameson, fundamentally and uniquely British.[47] Ultimately, her project was to return the *ennuyée* to native soil to live out the joint promises of British feminism and a reformed National Gallery. Indeed, the British Museum and the National Gallery both functioned as important meeting placs for urban feminist activists such as Jameson in the nineteenth century as signatories for various feminist petitions gathered in these sites.[48]

Jameson's project of a feminist museology was based on her understanding of the museum as a significant institution for the formation of political identity. But the museum was a space of work as well as a site of civic education, and the question of whether women could fulfill the highest functions of museum work—namely, the acquisition and preservation of British art and culture—called prior definitions of women's work, heritage, and patriotism into question. The curator was perceived not merely as the caretaker of objects but also as the guardian of the principles and practices of citizenship: literally, one who has charge of the nation's soul. The rise of professional debates about the "woman curator" throughout the prewar period challenged the notion of institutional patrimony as an exclusively masculine property.

Curators and Collectors: Keeping House in the Prewar Museum

For John Ruskin, museums were sites of nostalgia for former standards of female behavior. Ruskin's description of an ideal public gallery suggested that the entrance room should depict the history of needlework as a testimony to the female artisanship of the past. He lamented the fact that women had been distracted from salubrious pursuits such as needlecraft, but public galleries might be the means of their reeducation.[49] Ruskin's archetypal museum was imagined both as a monument to lost womanhood and as an institutional critique of changing roles for women: a joint project of conservatorship and conservatism.[50] But the Ruskinian model of curatorship, in which a masculine institution preserved and regenerated a pre-feminist culture, met constant challenges from within and out-

side the museums profession. By 1911, Lady Dorothy Nevill, an art collector and political hostess, had located the origins of British art institutions in women's property and taste. She argued that Victorian museums had grown out of the eighteenth-century culture of temporary exhibitions and that the most important of these was "Miss Linwood's exhibition of needlework pictures," open to the public from 1787 to 1846. Nevill described Linwood's pictures as "skilfully worked . . . copies after famous masters."[51] She offered a new account of women's exhibitionary projects in place of the Geddesian "boy's pocket."[52]

Nevill eventually donated her own collection of ironwork to the South Kensington Museum,[53] a gift that was noteworthy in part for having been personally amassed during Nevill's visits to private farmhouses in East Sussex rather than bought from art dealers.[54] She did want to "popularize" the South Kensington Museum and the National Gallery, but in a very different sense than that intended by Ruskin or Jameson. Nevill, a staunch Conservative who once sighed to her friend Elizabeth Haldane, "Oh what weather—even worse than the liberal party,"[55] often expressed great disappointment that the London galleries were not better attended by upper-class women like herself.[56] The project of feminizing the gallery, then, was not exclusively a Liberal or a feminist concern. But during the Holbein debates, the question of party politics—specifically, categories of Liberalism—would become far more central. In particular, the issue of women's relationship to the culture of property came to highlight the ongoing problem of Liberalism's relationship to feminism.

Discussions of women's work in museums initially focused on the Victorian trope of the museum as a philanthropic institution and as a site of female philanthropy in particular.[57] For example, the Turkish Compassionate Fund, established in 1877 to aid distressed Turkish refugees, conjoined philanthropy and aesthetic reform in its efforts to sell Turkish women's embroidery to a British consumer audience.[58] The organization was originally intended to find employment for Turkish women and children, and one member suggested that the refugees might be paid to sew hospital clothing. But the women founders of the fund included some of Britain's most important art collectors, such as Lady Charlotte Schreiber and Angela Burdett-Coutts.[59] The possibilities for administering an overseas, female-managed and -staffed "design firm" were immediately attractive to these women. Another fund member, Lady Enid Layard,[60] suggested that the female refugees could earn their livelihood by copying patterns and colors from their "exquisite old designs," and the women of the fund contributed money for materials and weaving frames. Lady Charlotte introduced samples of the embroidery to the famed department store, Liberty, where they were offered for sale. In five years the employees of the fund produced al-

most seventy thousand yards of material, which was sold at Liberty for more than £8,000, and the Turkish sultan founded the Order of Shefket (Mercy) in honor of the women of the fund.[61]

The fund's literature emphasized the projects of artistic preservation and regeneration. One history of the fund concluded that a visit to Liberty would reveal the artistic and intrinsic value of the embroidery and show "how great a debt of gratitude is due to those who have rescued from absolute extinction an industry in which excellence of workmanship is allied to beauty of design, with a result which may be pronounced to be almost unique."[62] The terms of this exchange of art and philanthropy were those of institutionalized connoisseurship: uniqueness, originality, and purity of design. Here, Liberty was described as an exhibition site as well as a source of goods for sale. The British women who organized the fund, though not necessarily the Turkish women embroiderers, were reinvented as curators, that is, carriers of national (albeit foreign) patrimony who revived dying art forms even as they memorialized and trafficked in them. The dominant descriptive frame for artistic production and conservation in the fund's own literature was philanthropy, not commodification, despite the fact that the embroidery was to be exhibited at Liberty.[63]

The gendered union of philanthropy and the museum occurred in a variety of institutional settings.[64] The *Nineteenth Century* published an article in 1905 called "Parish School Dinners and Museums" that suggested that school refectories be converted into art exhibition spaces in order to keep the children busier and their mothers better-rested,[65] and throughout the 1880s and 1890s the Manchester Art Museum offered facilities for meetings of the local ladies' branch of the Sanitary Association. The association hosted a series of mother's meetings—designed to instruct working-class women in proper maternal functions—at the museum and also gave twenty-four lectures there on topics ranging from temperance to the care of flowers and a comparison of English and French home life. Alice Compton, the head of the Women's House of the University Settlement in Manchester, was elected honorary secretary of the Manchester Art Museum because of her philanthropic endeavors there.[66] In 1901, this museum was amalgamated with the Manchester University Settlement, and it served thereafter as the site for the Women's House. Previously, Manchester's working-class women had been believed to be so ignorant of the natural world that they mistook squirrels for birds or red berries for roses.[67] Now, with the opportunity to study the collections at the art museum more carefully, they could correct their educational deficits with regard to both fine art and nature. The philanthropic women of the Sanitary Association noted that their cause had been greatly aided by the beautiful setting for their meetings. The Manchester Art

Museum hosted a "Poor Man's Lawyer," who attended fortnightly to give free legal advice, and the association planned to offer cookery lessons in the museum kitchen.[68]

Thomas Horsfall, a Manchester philanthropist and gallery founder, staffed the Manchester Art Museum with women in a variety of professional roles and encouraged his "museum ladies" to dress in clothes that might be readily copied in cheaper materials.[69] He hoped that poorer women visitors would then learn to emulate the "Museum fashion."[70] The female guide to art and fashion, positioned in the borderland between amateur philanthropy and professional curatorship, recrafted the museum as a site of domestic instruction as well as masculinized political education. This trope of the woman guide was echoed in different ways in the writings of Henrietta Barnett and Vernon Lee,[71] as well as in Mrs. E. T. Cook's *Highways and Byways in London.* Cook's discussion of "lady-lecturers"at the British Museum reported the pleasing sight of a "charming, Hypatia-like lady, tall and fair, gray-eyed and gray-robed, holding thus her little court, by the lovely figure of Demeter."[72] Cook concluded that she was glad that the study of art had not led this young lady to neglect her clothing or appearance, as so often happened with aesthetically minded women.[73]

These debates about the role of women in museums took place in a climate of increased professionalization. The Museums Association was founded in 1889 to standardize curatorial work throughout Britain and provide communication between British art and science institutions. Its annual publication, *Museums Journal,* was a key forum for debate about the desired function of artistic and scientific institutions in Britain. Within the Museums Association, debates about women's work focused on the problem of female curatorship. In 1903, the association had acknowledged the rights of women to be paid for their labor in museums.[74] But one of the association's goals was to raise the status of curatorial work in middle-class professional society, and the inclusion of women as paid museum workers threatened this objective. For Geddes and Flower, the curator was simply a professional surrogate for the "boy" collectors who originated the great public collections. But could museums really continue to function as an institution of collective masculine property and political rights if they were organized and safeguarded by women? To what extent could British artifacts operate as part of a national "patrimony" if they never passed through the hands of men?

In 1896 the association hosted a special panel to discuss women's participation in museum work. Clara Nordlinger, a museum worker from Owens College in Manchester, prepared a paper on the paid employment of women in art and science institutions.[75] She focused on her recent visit to the Schleswig-Holstein Museum in Kiel and her meeting with the curator, Miss Mestorf. Nordlinger re-

ported that much to her surprise, Miss Mestorf did not believe in women's rights, and women were forbidden to attend lectures at the Kiel museum. Implicit in Nordlinger's consternation was the assumption that women's participation in curatorship in Britain would be part of a larger feminist political project. Once again, as in Jameson's *Sketches*, German institutions seemed to be wasted on the Germans.

The panel started a lively discussion about the professional role of women. Several members of the audience offered examples of successful women museum workers, but the association concluded that it could not expect scientific work from women without scientific training—an ironic caveat given that so few standards for professional training existed for male curators. One trustee of the British Museum noted that women were well suited to cleaning fossils because they were particularly capable of doing "very fine and delicate work," and a curator from the Kelvingrove Gallery in Glasgow confessed that he had employed very satisfactory women workers in his gallery for half the wages of men—an important advantage in the financially straitened world of the public arts and sciences.[76] In suggesting that women might not meet the criteria so recently established for museum work, the association assured itself that a recognizable set of national norms for public museums did indeed exist. Despite regional variations, the association was committed to a uniform educational program for all British curators. If women were allowed to participate in curatorial work without standardized university training, then museums lost their meaning as tools of cohesion and unification in national culture.

In 1898 Nordlinger published another paper concerning women and museum work, a paper deceptively titled "The Cleaning of Museums." This time, she focused not on a female curator or museum director but on the humbler sphere of the charwoman, suggesting that the charwomen employed in museums should form an all-female auxiliary staff headed by the "oldest and ablest of their number." This feminization of "housekeeping" in museums reflected a particular vision of museology as a cluster of domestic virtues in which men had little place and appropriated museums to the sphere of the charwoman rather than that of the male citizen:

> The utilisation of female labour in museums . . . is a question on
> which the greatest museum authorities hold the most widely diver-
> gent opinions; but wherever the charwoman reigns supreme, it
> seems to me reasonable to consider her work from the feminine,
> and not from the masculine point of view. . . . Why not place this
> essentially feminine department of our museums in the hands of a

woman? Why should not lady inspectors, voluntary or professional,
include museums in their rounds?[77]

Instead of bringing women into museum curatorship, Nordlinger had brought
the museum into the female-dominated world of home visiting and inspection,
philanthropy, and the regimentation of hygiene. Institutions of high art and cul-
ture were amalgamated to the homely, the humble, and the womanly. The *en-
nuyée*, within the professional context of the Museums Association, was refig-
ured as the charwoman, reflecting the extent to which the museum's gender
politics was always shaped by class. Women—sometimes the lowest of their
number—would remake museums as good "homes" for artifacts, policing the
museum environment for signs of dust and degeneration.

Domestic and fine arts often were elided within public museums; home-
making was incorporated into cultural patriotism. The principal journal for am-
ateur collectors, *Connoisseur*, published a series of articles between 1900 and
1910 about women's collections that were donated to public institutions, most
often by women writers such as Julia Frankau, Louise Gordon-Staples, and
Lady Victoria Manners. Lady Harriet Wantage's collection, for example, was
"toured" in a five-part article that cited Anna Jameson's scholarship on early
Flemish painting.[78] In 1896 the sisters Gertrude and Lily Baber set up a tea shop
in the Manchester Art Gallery, and the considerable press surrounding their
business venture focused on the feminization of the exhibition space. One ar-
ticle, titled "Inspired Art with a Kettle," reported that plush divans and copper-
topped tables accomplished the Babers' goal of making people feel "at home" in
the public gallery.[79] In part, these metaphors depended on more widespread in-
novations in the realm of art criticism and gallery design, such as the valoriza-
tion of domestic arts in the Aesthetic movement.[80] But the process of including
women in museum work in a range of capacities was neither a story of women
reinventing the museum as a "private" institution nor one of women being re-
crafted as "public" beings by means of their participation in the arts and sci-
ences. As Kali Israel has noted, the upsurge of women's art education in the mid-
to late nineteenth century was both authorized and marginalized by the dis-
courses of domesticity; Victorian women were receiving training in the arts
in unprecedented numbers but still found themselves sidelined in terms of in-
stitutional patronage.[81] Museums depended on the integration rather than the
differentiation of public culture and home. This process of unification was
particularly meaningful in Britain, where private donors were such a crucial
presence. Ultimately, professional debates about women's work in museums—
in particular, female curatorship—had taken the museum beyond the cate-

gories of "public" and "private." Domestic and feminized labor was paid for
and professionalized within museums, suggesting that the historical category
of "separate spheres" is of limited use for conceptualizing museology and cul-
tural property—both of which depend on exploiting the space between these
spheres.[82]

Women such as the Babers brought a certain measure of accessibility—
or, one might argue, commercialization—to the public gallery. Their stated
goals were not explicitly feminist. But in an age of institutional disenchantment
and insecurity, Jameson's earlier project of feminist critique and reform found
a new legislative life. After the triumph of Sunday opening legislation in 1896,
for example, longtime Sunday Society member Anna Parsons wrote to the *West-
minster Review*, "[I]t is the opening up of a new world." She continued, "[W]e
rejoice to think that women will participate in these advantages, and that many
a wife will find her home brighter and her life happier for the boon. May it
help to hasten the day when woman shall take her fitting place as the help-meet
for man."[83]

For Parsons, the link between the democratization of culture and the ex-
pansion of a new sphere for women was rational and teleological. From her point
of view, there was an obvious Liberal alliance between access to the arts and ac-
cess to the other rights and duties of citizenship. But the crafting of art institu-
tions specifically for British women proved to be a complicated and difficult pro-
cess. The opening of the art gallery at the Holloway College for Women, for
example, was met with controversy and derision. The patent medicine manu-
facturer and philanthropist Thomas Holloway had always been at great pains to
distinguish his university for middle-class women from a trade school or train-
ing institute for governesses. His art collection, reputedly worth £90,000, was
sufficiently lavish to differentiate the college from any dreary technical school.[84]
The Holloway College Art Gallery contained a splendid assortment of modern
British paintings, including works by Constable, Gainsborough, Landseer, Mil-
lais, Frith, and, of course, Turner. As a site of instruction and entertainment for
the female students, the gallery at Holloway College was the first British exhibi-
tion space designed specifically for women. On December 17, 1887, Princess
Christian officially opened the collection to the students, unveiling a statue of her
mother, Queen Victoria, as an exemplary object for women students to contem-
plate. The princess promised that this gallery would inspire its viewers to be as
beautiful as the art it contained, preserving their femininity despite their aca-
demic pursuits and ultimately giving "that refined elegance to their homes which
does not depend on wealth."[85] Thus far, the Holloway College Art Gallery was
depicted as an ideal home in which the fine arts invigorated the domestic arts.

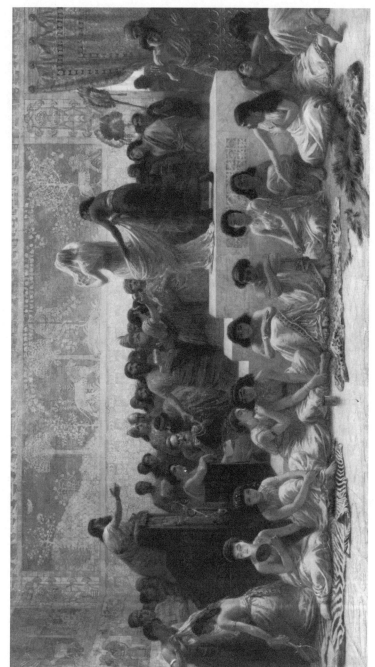

9. Edwin Long, *Babylonian Marriage Market*, 1875. Picture Collection of Royal Holloway, University of London.

But this same gallery immediately became a focus of public outrage and contempt. Holloway was viciously attacked for his immoderate expenditures on a "women's gallery,"[86] and paintings such as Edwin Long's *Babylonian Marriage Market* (fig. 9) were deemed morally inappropriate for female visitors.[87] The painting illustrated an auction of women described in Herodotus in which the extra funds raised by prettier women were put toward the dowries for the unattractive; everyone was thus successfully paired off in the end. Holloway's motives for selecting this painting are not known, but he paid the relatively high price of £6,615 for it. He paid this same price for Landseer's *Man Proposes, God Disposes*, which was a record price for a Landseer painting. His willingness to pay top prices for modern British works at auction instead of buying from the artist directly led to accusations that he was inflating the art market unnecessarily.[88] Holloway was also criticized for failing to consult with experts on women's education before embarking on his spending frenzy; if he had, the London *Times* suggested, he certainly would have been warned away from this immodest and strangely orientalist display.

Holloway was urged to deaccession the entire collection and to dismantle this depraved "art palace" for women that had called his whole educational project into question.[89] In many respects, the Holloway debacle prefigured the concerns of the Holbein controversy and highlighted the apparent incompatibility of women and artistic patrimony in Britain. The institutional context for the British paintings had altered their moral message beyond repair. What was instructive for a general audience in the National Gallery was clearly degenerative for the female students at Holloway College. But at the college, the key issue was the circumvention of established patterns of education and leisure in a "women's gallery" and the potential degradation of the female audience. These debates about the future of women's artistic education were primarily concerned with what women should see, not what women could own. During the Holbein debates, issues of property and ownership became absolutely central. The crisis of the aristocracy intersected with the rise of radical feminism to produce new anxieties about the destabilization of British patrimony. By 1909, the notion of a feminist gallery had become a much more viable and pressing concern.

Remaking the *Ennuyée:* Women, Art, and Property

Feminists hailed the Married Women's Property Act of 1882 as the Magna Carta of women's liberties: a social revolution.[90] According to the *Englishwoman's Review*, the act was clearly emancipatory in that it established a "broad and complete equality between men and women with regard to all rights of property and contract."[91] In short, married women were deemed capable of holding property

and entering into contracts as if they were unmarried. Whereas earlier laws per-
taining to married women's rights of ownership had limited their protection to
certain subcategories of property, the act of 1882 was broader in scope. Wives
still lacked full contractual rights, and the responsibilities for women's credit re-
mained confused.[92] But in undercutting the principle of coverture—the prin-
ciple that a married woman was under her husband's protection and was legally
represented by him—the act also made claims against women's suffrage more
difficult to sustain.[93]

After the passage of the act, British women often organized collectively to
offer works of art to the nation or municipality.[94] For example, a ladies' com-
mittee in Birmingham purchased tapestries by Burne-Jones depicting the quest
for the Holy Grail, which they presented with great ceremony to the Birming-
ham Museum and Art Gallery in 1906.[95] A 1909 Ruskin exhibition at Keswick
was composed entirely of contributions from women, including a gift of pottery
from Mrs. Mary Watts, the widow of artist George Frederick Watts, to illustrate
the cottage arts Ruskin had advocated.[96] Women's contributions to public art in-
stitutions were often understood in explicitly patriotic terms.[97] Trade journals
often opposed the heroic efforts of women to beautify the nation to the crassness
of their governors, depicting women art donors as Britain's truest and most taste-
ful citizens.

But despite the increased presence of women in public galleries—both as
donors and as laborers in various capacities—the museum remained a focal
point for larger concerns about women's relationship to property. After all, the
fictive Lord Prenderby's individualist defense of artistic property was an exclu-
sively male preserve; no Lady Prenderby accompanied him on his quest for the
truly private *objet d'art*.[98] Leonard Raven-Hill, the junior political cartoonist at
Punch, devised an illuminating sketch on this very theme of gender and owner-
ship in the British art world. His untitled cartoon, which I will call "The Rachel
Rembrandt," was published in March 1909, just a few months before the Hol-
bein crisis (fig. 10). The cartoon depicts two men in a private home, the guest
admiring his host's famous Rembrandt landscape. The guest notes with surprise
that the painting is actually signed "Rachel." The owner, presumably Jewish,
replies, "Dot is on account of mein greditors. Everyding vos in mein wife's
name." Here, the female owner has supplanted the artist as the primary source
of the painting's value and identification. Owner and artist are made one. The
levels of corruption in this sketch are many; patrimony is at risk from Jews, from
women, from speculation. The combination of male debt and female rights of
ownership is derided as alien or foreign. But what was spoofed in Raven-Hill's
cartoon as an outlandish or exotic mode of property relations would resurface in
the Holbein debates as a uniquely British concern. The Holbein crisis, much like

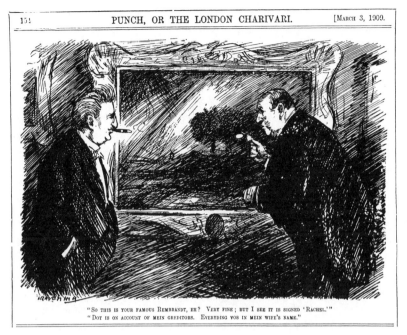

151 PUNCH, OR THE LONDON CHARIVARI. [March 3, 1909.

"So this is your famous Rembrandt, eh? Very fine; but I see it is signed 'Rachel.'"
"Dot is on account of mein greditors. Everyding vos in mein wife's name."

10. Leonard Raven-Hill, "The Rachel Rembrandt," *Punch*, March 3, 1909

a real-life "Rachel Rembrandt," threatened to allow a woman—offstage and in-visible to the public eye—to erase or corrupt the Old Master.

Literary scholars have traced the evolving connection between art and property in prewar British and American novels, focusing on the "collecting impulse" at the center of such works as Henry James's *The Spoils of Poynton* and John Galsworthy's *Man of Property*.[99] But lesser-known works, such as Jane Panton's *Having and Holding: A Story of Country Life* (1890), recast this model of art proprietorship in explicitly gendered terms. Panton was an interior decorator and the daughter of the Victorian panoramic painter W. P. Frith. She published a series of advice tracts about home design for women,[100] stressing the need to distinguish between appropriate aesthetic programs for museums and private homes. In the aftermath of the Married Women's Property Act of 1882, Panton took up the theme of exchange between art and property.[101] Her novel underscored the ways in which the ownership of art—with its universalist, anti-commercial, and transcendent associations—could function as a surrogate sphere of property ownership for women.[102] Panton's work makes a useful contrast to James's dystopic fantasy of women's property, in which a widowed mother vows to destroy her *objets d'art* rather than let them pass to her philistine son. Jeff Nunokawa has argued that Victorian novelists searched constantly for

new metaphors of ownership, striving to locate a form of possession that would transcend the instability of capital. For Panton, it would seem, art served this function—with the additional dimension of her particular concerns about women, commerce, and exchange.

The heroine of *Having and Holding*, Jacinth Merridew, is a beautiful orphan placed in straitened circumstances, first by her father's financial mismanagement and then by his suicide. She works as a secretary in an interior decorating firm until she marries the noble Sir William, a philanthropic Liberal socialist, who takes more interest in the designs of his convalescent home in the country than in Jacinth's schemes to beautify their own estate. Sir William also functions as the voice of political independence, declaring that he would be willing to vote for the Conservatives if they would "free the land, give Ireland justice and home rule," and interestingly, "throw open the museums on Sundays." He is contrasted with the evil Francis Seymour, Jacinth's former lover and a staunch Conservative who blames contemporary unrest on "education, and People's Palaces, and such like rot." Seymour continues to woo Jacinth in various picture galleries after her marriage, encouraging her to spy on her husband for the Conservatives.

At this point in the story, Jacinth is best described as apolitical. She has impeccable taste in the private realm, but no principles to dignify it. When her husband tries to divert her to philanthropic pursuits, she politely declines: "I have worlds to conquer and the morning room to decorate." Jacinth and her husband become increasingly estranged, as Sir William starts a china manufactory in his model village and Jacinth runs up enormous debts decking the halls of Windyholme. Panton's central problematic of women and property is manifested here as Sir William is faulted for keeping his wife in a condition of financial dependence. His plan to nationalize the land is widely admired, even by his Liberal colleagues, but Panton raises the question of how Jacinth is supposed to fit into this idyllic scheme of male collectivization. Crucially, Sir William opposes women's suffrage, and Panton leaves the reader in doubt as to whether this platform constitutes his greatest moral failing or further proof of his autonomy and incorruptibility.

Driven to distraction by high decorating costs, Jacinth eventually agrees to sell Sir William's Land Nationalization Bill to Francis for £1,000. Fortunately for England, Jacinth sells the wrong draft of the bill, and Sir William's political career is saved. But her scheme is uncovered and she spends several chapters in a state of penance, toiling alone in London. In a breathless conclusion, Jacinth and Sir William are reunited in the country, and Jacinth learns to recognize both the moral value of socialism and the aesthetic benefits of communalized production. The loveliness of Windyholme fades as Jacinth applies her considerable artistic talents to the common good—educating factory workers in ceramic de-

sign. Private land is exchanged for the realization of a unified, communal British aesthetic. Decorative art is both the foundation of the regenerated marriage and the bedrock of British labor.

In many ways, museums play a negative role in *Having and Holding*; they are the sites of Jacinth's sexualized downfall and political prostitution. But such institutions are not entirely cast out. Panton's vision of the artistic community and the productive marriage has an institutional element as well. Sir William conceives of his factory as a new brand of museum, opposed to the aristocratic home.[103] In his utopia, production and preservation are on a happy continuum—at least for the male laborer. By the end of the novel, Jacinth has become Panton's ideal female proprietor, rescuing property from its characteristic egotism and selfishness. The marriage, previously mired in a commercialized model of "having and holding," is transformed by the redemptive powers of art to a shared, emotive notion of possession in which Jacinth is equally included. In Panton's treatment, "having and holding" are made compatible with both collectivism and married women's rights of ownership. For Panton, a self-described "raging republican," the central question of the 1880s and 1890s was how to write women into a system of property relations that she perceived as fundamentally corrupt without sacrificing women's integrity. In *Having and Holding* and elsewhere, art becomes the cleansing agent in an otherwise unholy alliance of women and property.[104] It functions as a special form of property—potentially illicit in the institutional context of the museum, but sanctified in the socialist factory. Cultural property begins to transcend property itself. The gulf between art and other forms of wealth marks the divide between the only type of property that women can oversee without moral danger and the far more numerous types they cannot.

During this period, women's contributions to the National Gallery—the ultimate repository of artistic patriotism—increased dramatically. Commemorative gifts by women began to appear in the gallery reports,[105] women artists began making efforts to bequeath their own works,[106] women collectors developed networks of patronage for women artists,[107] and gallery administrators became more careful about distinguishing women's gifts as their own property.[108] The noted feminist Lady Wolseley gave a succession of gifts during the prewar period, and the social reformer and art critic Elizabeth Twining gave a series of watercolors in her own name to the Tate Gallery in 1898.[109] The letters from women donors to the trustees of the National Gallery drew heavily on the language of patriotism and national culture, regardless of whether the women involved were the collectors of the artworks in question or simply carrying out the wishes of a deceased male relative.[110] For example, Sarah Solly, the daughter of the art collector Edward Solly, donated five paintings from her father's collection

to the National Gallery in 1879. Although she had played no direct role in form-
ing the original collection,[111] she noted in her offer that the rest of the paintings
had been sold to Berlin; she and her sister Lavinia had "saved" five of the works
for England by buying them with their own inheritance.[112] Critics such as Flower
and Geddes might continue to understand the British collection of artworks and
artifacts as a peculiar triumph of male ownership. But the trajectory of acqui-
sitions at the major public galleries in Britain—especially after the passage of
the Married Women's Property Act of 1882—illustrates that the transmission or
cession of this property into the hands of the nation could also be overseen and
influenced by women.

Individual women donors tended to frame their gifts of artworks in civic
terms. Lady Charlotte Schreiber, an art collector and a major donor to the Vic-
toria and Albert Museum,[113] described her own public connoisseurship as a con-
junction of aesthetic appreciation and Liberal patriotism.[114] Schreiber's diaries
reflect the lively debates about politics and art that took place in her extended
family. Her Conservative son-in-law, Austen Henry Layard, was especially wary
of the potentially emboldening powers of female connoisseurship. He told the art
critic Lady Eastlake that he would be "very glad indeed to see women taking
a prominent and useful position in art—if it does not encourage yourself and
other advocates of 'feminine' rights (as *The Times* calls them) to claim for them
superiority in all depths of human genius and human manual labor."[115] Layard,
the great diplomat and archaeologist who undertook the massive excavations at
Nineveh, does not seem to have shared his views about women connoisseurs
with his mother-in-law. But it is fascinating to consider the ways in which the dif-
ferent members of this family might have understood the relation between wom-
en's donations to public galleries and other forms of social authority. Schreiber
sketched out the complexity of her family's political allegiances as her male rela-
tives tended to commit to different planks of Conservative and Liberal platforms.
She was keenly aware of the wide range of Liberal opinion, within her own fam-
ily and on the larger political stage.

About her own political views, Schreiber concluded, "For myself, I am dif-
ferent from them all. I hold on to my old Whig principles in domestic policy,
but I go with the Conservatives in their Eastern and other foreign policy."[116] In
her diaries, it is the "old Whig principles" that are most evident. In the 1880s,
Schreiber referred often to the franchise debates and to her hope that the Liber-
als would win the battle to extend suffrage to workingmen. She wrote:

> It is odd that I should care about this—but the love of the Old
> Country continues strong. . . . How curious that love of country is!
> On my way I called at Liberty's to learn how their Exhibition had

prospered, and at Kerridge's where I fell in love with a large
Worcester dessert basket of the old blue decoration—but so perfect
and so characteristic. Really I must stop these morning rambles into
curiosity shops—or I shall be ruined—another £5—but then it is
all going into South Kensington. Love of country again.[117]

It is not, of course, terribly surprising that a donor to a great national collection
should choose to describe her contribution in patriotic terms. But Schreiber's
rhetoric was not the generic language of patriotic fervor. Rather, she spoke to a
specific set of party concerns about workers' enfranchisement and education in
Britain. Schreiber framed her own acts of patronage in terms of the future of
Liberalism's class politics and the role of women in influencing that politics. She
addressed two key questions: How should women participate in Liberalism?
What role could they play in shaping Liberalism's agenda of rights?

Schreiber's own brand of participation in national life, her proposed dona-
tion of English china to the central storehouse of British decorative arts, is elided
with the state's extension of the franchise. Her personal "ruin" is an offering to
Britain's stock in art and successful industry. Schreiber self-consciously imagines
a democracy within the public gallery, a woman's collection of "perfect" and
"characteristic" pieces to instruct the new voting populace. This populace might
exclude women from the franchise, but its moral and visual education is crafted
by feminine judgment and sacrifice. Sir James Yoxall's 1908 guide for middle-
class art lovers, *The ABC About Collecting*, cited Schreiber as the first truly mod-
ern collector. Her lively interest in English china set her apart from the tradi-
tion of the fusty, pedantic classicism of traditional eighteenth-century collectors
such as Sir Hans Sloane.[118] Amateurs and professionals alike praised Schreiber's
collection for its representative qualities,[119] though *Connoisseur* noted (seem-
ingly in praise) that she had "ransacked the shops of Europe for curios like a
housewife."[120]

This conjunction of art and citizenship responded to familial and national
concerns about women's participation in Liberal affairs. Schreiber's claim that
her artistic donations paralleled a highly specific form of party patriotism was
echoed elsewhere in the prewar period, especially once women entered the fray
of party via local government.[121] The reception of two portraits—both given
as gifts from women to that quintessential Liberal icon, William Ewart Glad-
stone—illustrates this point. In 1889 the art dealer and devoted Liberal Sir Wil-
liam Agnew wrote to Gladstone to offer him a bequest.[122] The gift, presented on
behalf of "women of Great Britain and Ireland," was a painting by Sir John Mil-
lais, one of the most identifiably "British" of Victorian artists.[123] Agnew de-
scribed the picture as an "offering" to Mr. and Mrs. Gladstone from a collectiv-

ity of women "whose desire has been and *is* that their gift shall not be accompa-
nied by any announcement of their names." He assured the Gladstones that "the
sympathies of the humblest as well as of the highest have found loving and prac-
tical expression" in the donation of this particular work of art.[124] The painting
was thus presented as the outcome of cross-class female patriotism, and spe-
cifically Liberal patriotism: a visible show of support for Gladstone outside the
forbidden realm of suffrage.

But even in the realm of Liberal arts, women's participation was not always
welcome. In 1891 the evolutionary biologist and art critic Grant Allen wrote an
article for the *Contemporary Review* titled "Democracy and Diamonds."[125] The
piece, focusing on the exploitative nature of the diamond market, was intended
as a critique of excessive materialism among the British and American wealthier
classes. Allen pointed to a recent incident of putative civic connoisseurship in
which a band of Liberal women had given Gladstone a portrait of himself—set
entirely in South African diamonds.[126] According to Allen, no authentic Liberal
would have dreamed of such a gift, which managed to situate both Gladstone
and the fine arts in the degenerate realm of imperial exploitation. The women
donors had tainted the artwork with the most exploitative of individual posses-
sions instead of ceding the Gladstone portrait to the public domain. They had
given their leader an image of himself surrounded by markers of selfishness and
profit.[127] The true Liberal, Allen wrote, would not seek to monopolize artistic
treasures; he would ensure their proliferation in homes and galleries alike. To
this extent, Allen's views were reflective of the Arts and Crafts movement, which
advocated the love of Morris's calico prints rather than diamonds and furs that
were produced under immoral contracts between labor and capital. But Allen's
portrayal pointed to the ways in which the ongoing drama of female property
and citizenship could be played out in the world of art, warning against the dan-
gers of base material corruption that inevitably followed from the gifts of *faux*-
Liberal women.

The Case of the Disappearing Holbein: Feminism in the Gallery

Although women's gifts to the National Gallery and other institutions were im-
portant in shifting the gallery's perception of its audience and leadership, none
of these donations attracted any major public attention. But after the duke of
Norfolk threatened to take his *Duchess* away from the National Gallery in 1909,
the role of women in creating patrimony struck the British popular press as a
new and significant topic of debate. As national confidence about the educa-
tional mission of the public gallery continued to decline, the rise of radical fem-

inism and suffragettes' attacks on art provided a new social and institutional context for Jameson's vision of a feminist gallery.

As an episode in the cultural history of Liberalism, the Holbein case encompassed many of the key political questions of the prewar period, for example, how would Liberalism meet the challenges posed by an increasingly vocal audience of socialists and feminists? From the beginning of the Holbein debates, the duke of Norfolk claimed that he was forced to sell because of Lloyd George's "People's Budget" of 1909, a new set of Radical taxes that financially strained the aristocracy and prompted the sale of many country-house art collections to Continental and American buyers.[128] The London *Times* complained that the sale could not possibly have come at a worse time. The duke was in the same anxious position as every other English landowner in the wake of the Budget, and those who might ordinarily be expected to serve as patrons of the arts were now in need of financial assistance themselves.[129] The *Sheffield Independent* interpreted the duke's proposed sale of the Holbein as an indirect attack on the Budget, which he had planned to fight against in Parliament. The duke's withdrawal of his *Duchess* from the sphere of public art and education thus represented his effort to punish the Radicals for their assault on aristocratic privilege.[130]

The *Catholic Herald* pointed to the planned sale as proof that the British aristocracy should be abolished. If the peers, who were already in financial and political decline, were now relinquishing their traditional role as the protectors of British patrimony, then they had no other means to justify their continued existence.[131] This assault from a Catholic newspaper must have been a particularly crushing blow to the duke, who was described after his death as the most prominent Catholic layman since Sir Thomas More. In fact, years after the Holbein incident, the art critic and benefactor Isidore Spielmann speculated that Norfolk had been motivated purely by Catholic philanthropy; his intention, Spielmann suggested, was to use the funds from the Holbein sale to support Catholic schools that had lost their public funding.[132]

Within this framework, the intertwining of the Radicalization of British economics and the Holbein sale was taken as a sign of the changing political character of the British nation and the waning fortunes of Liberalism. The duke's proposal confirmed the curatorial fear that paintings in British galleries were always private property, to be reclaimed at any moment. The case thus seemed to underscore the failings of national art institutions, as well as the selfishness or venality of the British aristocracy.[133] In terms of the protection of patrimony, Britain had no leading class. Lionel Cust, the director of the National Portrait Gallery, acknowledged that he viewed the sale with "an element of tragedy . . .

coupled with a sense of deep humiliation."[134] British papers published a list of artworks that had made an "exodus" to America in the previous few years and lamented that Britain had become a nation of sellers rather than consumers of art.[135] Several journalists and politicians suggested that Britain should follow Italy's example and adopt a protective tax on art,[136] and others demanded a Parliamentary inquiry into the relations between private art collectors and the British government.[137] But such a tariff would clearly signal the death of free-trade principles and interfere with the sacred power of the male British subject to dispose of his property as he chose.[138] The *Evening Standard* argued that although no one cared about the portrait as a work of art—in itself a disputable claim—every British citizen must be concerned with the principles of trade and export that the potential sale of the painting involved.[139]

The rights of the duke to sell his *Duchess* were challenged and upheld with equal measures of vitriol. At stake was Britain's premium on the defense of property and free trade. On the basis of an Act of Parliament (1627) passed during the reign of Charles I that had expressly forbidden the sale of any items connected with Arundel Castle, the duke of Norfolk's estate, the *Morning Leader* insisted that the duke was legally bound not to sell the portrait.[140] If the Holbein painting were on the list of scheduled items, the duke's proposed sale would be illegal. But no one seemed certain whether this particular painting had been listed.[141] Even if it had, the *Globe* argued, the duke had been forced into alienating his private property by the Radicals, and therefore the historic demands of Charles I were no longer viable: "[W]hen [Radicals] discover that they cannot at one and the same time plunder the propertied classes and receive their accustomed gifts from them, the cry of joy is quickly changed to a shriek of pained indignation. One cannot have it both ways."[142] It was as disturbing to realize that the National Gallery still depended on aristocratic patronage as to acknowledge that these individual patrons could no longer function in their accepted roles.

The question of who really "owned" the *Duchess*—the duke, the National Gallery, or the nation at large—provoked an outpouring of antisocialist vitriol, a fervent apology for laissez-faire principles in the sphere of aesthetics and public art. As the *Globe* argued, the picture was the duke's property, to be taken away at will regardless of its sentimental value for the collective British public:

> The fact seems elementary enough; but your latter-day Radical is apt to be a little vague as to the distinction between *meum* and *tuum*. He has drunk so long from Socialist wells that it is perhaps not very surprising if he confuses private with national property, and pictures which are only lent with pictures that have been paid for.[143]

The portrait of a Danish widow thus became a litmus test for determining the boundaries between public and private property, between older loyalties to the freedom of the individual and the rising claims of the British nation-state. Exploding the principles of Liberalism as the Victorians had known them, the Holbein case presented the British public with new models of property, patronage, and heritage that it seemed ill-inclined to receive.

Colnaghi, the art dealers' firm that amassed an £800 profit from handling the duke's proposed sale, printed a letter in Britain's major newspapers blaming Victorian Liberal principles generally and free trade specifically for the downfall of art in England.[144] As Colnaghi himself wrote, "[I]f the English continue cherishing the exploded principles of Cobden and Bright to the detriment of home industries and agricultural interests, then they must be prepared to lose whatever their forefathers attained, whether property, prestige, or pictures."[145] The case of the disappearing Holbein had been reconstituted as both a meeting point and a critique for two different visions of Liberalism: a nineteenth-century version of free-trade Liberalism and the New or "newer" Liberalism of the Edwardians. The Holbein controversy thus took part in Liberalism's own epistemological shift from laissez-faire to state intervention, exposing the continued debate about which party "owned" free trade—historically and in the present. If traditional Liberal values were to be abandoned in the sphere of art and public culture, eradicating what one newspaper referred to as the "free trade in pictures," where else might Liberalism fail?[146]

As the dreaded sale of the Holbein drew closer, the controversy expanded beyond competing notions of property and party to encompass the gendered category of patriotism itself. The fact that such powerful political forces were being marshaled in defense of a woman's portrait caused dissent in the British press. Many newspapers and journals questioned whether foreign female portraiture could inspire the kind of nationalistic zeal that warranted large Treasury expenditures.[147] As Deborah Cherry has suggested, portraiture was par excellence an art of the individual, and female portraiture involved the fabrication of a subject that did not yet exist: the woman with full civil and legal rights.[148] In 1909, one British journalist argued against heroic measures to retain the *Duchess*: "It is not as though the picture speaks any lessons of patriotism, raises any historic memories of which we are proud, nor inspires any exaltation of morals. It is a portrait of a woman, executed by a foreigner long dead, and of no conceivable advantage to the nation except as a museum specimen of mastery in technical art."[149] This report opposed the portrait of an individual woman to national ethics, education, and history. Worst of all, the painted woman in question was not even visually alluring. The *Daily Graphic* published a letter from "A

Doubter" who wrote, "Henry VIII was an uncommonly good judge of female beauty. I much doubt whether he would have chosen the little Duchess as one of his types."[150] The portrait, after all, had not brought about a match between Henry and Christina. One newspaper published a series of unflattering comments by gallery visitors about the duchess's utter lack of physical charm, culminating in one man's remark, "Wot an ole puddin-face!"[151] As part of the nation's capital in beauty—real or painted—the *Duchess* was pronounced worthless.

Victorian and Edwardian exhibitions were frequently organized to highlight the theme of female beauty. In 1894, for example, the Ladies' Committee of the Grafton Galleries opened an exhibition called "Fair Women," devoted entirely to female loveliness. The displays included a survey of two hundred historical portraits of beautiful women, as well as the trinkets and treasures of women socialites: fans, lace, miniatures, and jewels. The exhibition also professed to be a celebration of the English school of portraiture; it juxtaposed paintings by Millais and Watts with a wide array of eighteenth-century portraits. This exhibition has been interpreted primarily as a nostalgic enterprise whose organizers sought to re-create the aesthetics of the eighteenth century as well as former constraints on women's public behavior.[152] But by the early twentieth century, the mania for collecting English School portraits of "pretty women" had only intensified. In 1903, C. J. Holmes, later the director of the National Portrait Gallery and National Gallery, termed the speculation in this field of art "insane."[153] He urged wise collectors to "sit serene above these fluctuating femininities" and consider creating collections of male portraiture instead.[154] He noted that galleries of men would be more interesting on historical grounds than galleries of women, "as men have always had the larger share in the world's work."[155] This expert devaluation of female portraiture was juxtaposed with Holmes's advice that a safe rule for wise investment in art was to buy pictures that women instinctively disliked. Thus, art lovers could be assured that their prize collections would be purged of sentiment and accrue their highest possible economic value.[156]

In 1909, the New Gallery hosted another exhibition titled "Fair Women," organized this time by the International Society of Sculptors, Painters, and Gravers and presided over by Mrs. Winston Churchill.[157] The exhibition included a painting of Aphrodite, miscellaneous portraits of aristocratic women from the Renaissance to the eighteenth century, and portraits of Queen Victoria. The exhibition catalogue offered a series of historical-cum-aesthetic exegeses; Lady Jane Grey was described as a "small and prettily-shaped heretic."[158] As many art historians have noted, Edwardian notions of female beauty were particularly complex: they comprised a "battleground" for juxtaposing images of an extravagant and monumentally sexualized femininity with images of feminism and its progress.[159] When the visitors to the National Gallery commented on

Christina's attractiveness (or lack thereof) in 1909, therefore, they took part in a broader exhibitionary culture of thematizing the history of female beauty. But the Holbein portrait could not easily be associated with a wistful nostalgia for prior standards of British women's appearance and behavior. The portrait of Christina clearly failed to evoke a historical vision of "fair women." As we will see, the problem with its proposed sale extended beyond the significance of female beauty as a source of national value and into the futuristic realm of international economies of culture.

The campaign to retain the *Duchess* rested less on the painting's aesthetic appeal than on the manufacturing of a sexualized American threat to Britain's cultural treasures.[160] The stereotype of the rapacious American millionaire who bought up England's patrimony was underscored by the *Duchess* case, highlighting the advent of "wealth—often Jewish, often foreign, often American—[that] engendered a real and justified sense of patrician anxiety."[161] The ultraconservative cartoonist Bernard Partridge created a remarkable cartoon about the Holbein crisis for *Punch* in May 1909 (fig. 11).[162] His sketch, called "Hans Across the Sea," depicted an evil, vaguely Semitic, money-bag-clasping Uncle Sam molesting the virtuous Duchess. As Uncle Sam grasps at Christina's hand, he declares, "Once aboard the liner, and the gyurl is mine!"[163] Christina clings in horror to the frame of her painting in the British gallery, even as the American villain drags her out of the sanctified realm of the art museum into the sullied, prostituting world of the international market. The cartoon also plays on the threat of an elision between museums and markets; Christina's body is both the boundary and the link between the National Gallery and the world of commerce and capital. The figure of capital is depicted as unmistakably American and clearly a foreign presence in the gallery, far more foreign than the Danish duchess captured in paint by the German artist. The alien qualities of the American buyer trumped any vestiges of continental foreignness that clung to the portrait.[164]

Next to Christina's head, a small placard in the style of a museum label reads, "Please Spare £70,000." The label evokes a visual connection between Britain's "fallen women"—who were at the mercy of individual and state philanthropy as well as unscrupulous male suitors—and Christina herself, now bereft of her virginal white gloves. The *Duchess* figured in the British press as a victim and a pawn, a symbol of the ways in which irresponsible aristocrats and nation-states traded in the most vulnerable members of their society. The ambiguities of ownership within the museum had placed Christina in a morally precarious position.[165] According to this cartoon, the Anglo-American trade in pictures was also a traffic in women.

Punch's invocation of the malevolent American was especially topical be-

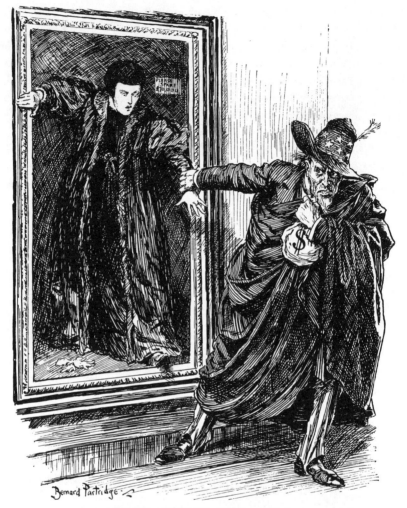

HANS ACROSS THE SEA ?

Stranger (U.S.A.) " ONCE ABOARD THE LINER, AND THE GYURL IS MINE!"

[The Duke of Norfolk has sold Hans Holbein's masterpiece, " Christina, Duchess of Milan," and there is a danger of its leaving the country.]

11. Bernard Partridge, "Hans Across the Sea?" *Punch*, May 12, 1909

cause much of the Holbein controversy focused on the counterexample of American protectionism, in particular, American tariffs on imported art that were intended to shield native artists from foreign competition. The *Punch* cartoon implied that there was nothing from which Britain needed so much protection as protectionism itself. America's withdrawal from the world of artistic free trade had reduced it to this sexualized act of kidnapping. Liberalism was the

virtuous woman who struggled to exist in Britain: Christina's counterpart in the world of international political thought. The collective possession of Christina's portrait—a painting "devoid" of patriotic feeling because of its foreign female subject—had come to symbolize the essence of what British Liberal patriotism must defend. The rumor of an American buyer for the painting raised the possibility that British art would be drawn not only out of Britain but also into protectionism, a disturbing ideological development. The minor poet Canon H. D. Rawnsley wrote an optimistic letter to the *Times* suggesting that perhaps an American donor would provide the necessary funds and leave the painting in Britain, avoiding the prohibitively high tax that he would have to pay to bring the Holbein into the United States.[166] In this framework, the National Gallery in London could function as a trustee for American property as well as for British patrimony, "protecting" American art lovers from their own government. The proposed sale thus constituted an attack on the property of a British individual and institution as well as an assault on the traditional Liberal conception of free trade: the right of British male citizens to participate in an open market, and especially a market of women. To export the Holbein might be the duke's right, but to export it to a country that had abandoned the principles of free trade was far more troubling.

Alongside this discursive masculinization of the struggle for the Holbein portrait, British women contributed heavily to the subscriptions campaign. By June 1909, women constituted approximately half of the donors to the Holbein Fund, some of them subscribing more than once. Their letters to the fund's administrators were explicit about the honor of participating in the retention of a national art treasure, echoing the sentiments of women donors earlier in the century. One donor, Dorothea Moore, wrote apologetically, "I should so much like to give something towards the subscription for buying the 'Duchess of Milan' for the nation. . . . I enclose a cheque for one Guinea with much regret that it is not for more—but most girls' bank balances may be reckoned in shillings—if they are not overdrawn!"[167] Similarly, the artist Beatrice Carpenter wrote, "I feel as if it were *too* absurd when I suppose it is thousands that are wanted but I should like to promise £100 if it could be of the least use. . . . I *love* that picture and copied it years ago and so got to know it as an old friend."[168]

The Holbein Fund's subscriptions proved insufficient to meet the duke's purchase price, and the press began to despair of rescuing the *Duchess* from foreign buyers. Suddenly, in early June, an eleventh-hour anonymous donor gave the remaining £40,000, and the nation cheered: The *Duchess* was saved. Rejoicing was not universal; some artists protested the fact that so large a sum had been spent on an Old Master when living artists were woefully underfunded.[169] But for the most part, the press depicted the retention of the *Duchess* as a triumph of

SOMETHING HAS TURNED UP.

THE HOLBEIN DUCHESS : *I ne-ver—will—desert—Mr. Bull!*
MR. MICAWBER BULL : *Something HAS turned up !*
[The anonymous gift of £40,000 at the last moment has saved the Holbein Duchess for the National Gallery.]

12. "Something Has Turned Up," *Westminster Gazette,* June 7, 1909

masculinized British patriotism. The *Westminster Gazette* published a cartoon of Christina clinging tenderly to John Bull (fig. 12), the embodiment of English manhood, as she declares, "I ne-ver—will—desert—Mr. Bull!" He flings one arm wide and announces gratefully to the reader and the nation, "Something HAS turned up!"[170] Similarly, a *Western Mail* cartoon titled "American Covetousness" pictured the donor as a faceless man climbing out of the Atlantic with the painting in hand; he then rushes to meet John Bull, who exclaims, "Saved!" Charles Holroyd, the National Gallery director who had been on the brink of nervous collapse from his efforts to rescue the painting, reportedly burst into tears when he heard the good news. [171]

The real donor, shrouded in mystery and intrigue, was initially reputed to be a "wealthy Bristol gentleman." But within a week after the retention of the *Duchess,* an astonishing fact was revealed to the British public: The anonymous donor was a woman. At first she was described simply as a "patriotic lady,"[172]

and the *Nation* reported that "on the whole, we think the Lady comes better out of this unpleasant business than the Duke [of Norfolk]."[173] The announcement about the donor's sex provoked a series of public debates about the gendered nexus of art, property, and patriotism. Whereas the Holbein episode had initially encapsulated contemporary concerns about fluctuating property relations among men—namely, from traditional Liberal to Radical frameworks of ownership—the discovery that the donor was a woman shifted the focus of the Holbein debates from the male ownership of female portraiture to the feminist ownership of British patrimony.

The revelation of the donor's sex clearly disconcerted the British press. Fears that Britain's public galleries might be converted into focal points of feminist protest and politics were often taken to comic extremes. Perhaps the most easily recognizable foe of women's suffrage, Mrs. Humphry Ward, received a reply to her request for special exhibition tickets from the Victoria and Albert Museum that sternly reminded her that "everyone who comes must solemnly undertake not to use the occasion for a demonstration about Votes for Women."[174] The writer acknowledged that these instructions might be "quaintly unnecessary" in Mrs. Ward's case, but anxieties about suffragists and suffragettes intruding into the public spaces of Britain's cities were clearly on the rise in the summer of 1909.[175] One women's newspaper, the *Lady*, reflected on the nation's ambivalence about accepting the gift of patrimony from a woman:

> But for her [the donor's] unparalleled generosity, the "Duchess" would have gone to America. The presence of women at the Chemistry Conference, and the appearance of this anonymous lady coincide, and emphasize the lesson that everywhere women are taking an active part in public work. Only the other day they received what is known as the 'commercial' vote in Italy. But this is dangerous ground.[176]

According to the *Lady*, the "patriotic lady" would inevitably metamorphose into a female citizen, effecting the risky transformation from civic sentiment to political participation. Given the earlier construction of the Holbein campaign as a project of Liberal masculine identity, the "discovery" of female leadership in this transaction was indeed dangerous ground. The locus of the threat to the old political order had shifted; Liberalism now needed to be rescued not only from the Radicals and the American protectionists but also from the encroachment of its own—possibly feminist—British women.[177] The feminization of public connoisseurship, regardless of the leanings of the individual donor, was now perceived as part of a feminist political agenda. Indeed, the assumption that the do-

nor was a feminist pervaded the Holbein press coverage even before individual women were presented as potential "suspects," and the trajectory from a public connoisseurship to women's suffrage seemed inexorable. The earliest reports of the Holbein sale had focused on the post-Budget failure of male aristocratic patronage. But during the summer of 1909, feminism had intervened as a new player in the Liberal contest of mine and yours—or *meum* and *tuum*, as the *Globe* had put it—positioning gender at the heart of the crisis in British property and politics.

Approximately a dozen different possibilities for the donor's identity were suggested in the press, including Lady Tate, the widow of the sugar manufacturer and gallery founder Henry Tate, and Lady Harriet Wantage, the daughter of art collector Lord Overstone.[178] These rumors and speculations about the donor's identity spawned irate letters of denial from Britain's wealthiest heiresses, satirized in *Punch* throughout the summer of 1909.[179] The journal included a fictive letter from the writer Marie Corelli that stated, "I could of course have given the £40,000 with the greatest ease—simply by writing a short story—but as a matter of fact I didn't. It is of no interest to me to provide the nation with pictures at which ignoramuses and toads are free to look."[180] This type of spoof of the unknown lady donor suggested to *Punch*'s readers that women's taste was incompatible with the patriotic goals of the National Gallery. The inclusion of Marie Corelli was a particularly sly move on *Punch*'s part. Corelli was a representative of middle-class suburban culture who marshaled considerable power in the world of print (as opposed to pictorial) commodities.[181] Her popularity was often taken as a sign of declining taste for "high" art in Britain.[182] In the pages of *Punch*, the fictive voice of Corelli opposed the worlds of stories and public portraits, suggesting that the Holbein suffered from the undiscerning gaze of an unscreened population. *Punch* drew on the Holbein episode to suggest that female self-importance, as well as women's financial independence in the arts and letters, had grown unchecked in Britain to a comical degree. When women entered public galleries as potential donors, *Punch* suggested, they brought the middlebrow and the philistine with them.

Although the predominantly male leaders of the Holbein campaign, in particular, Lord Balcarres of the National Art-Collections Fund, were praised for their public-spirited efforts on the *Duchess*'s behalf, the woman donor's intentions were challenged and censured. The high cost of the painting—the price for the Holbein was reported to have been as much as £200,000, although the National Art-Collections Fund claimed the amount was much lower—was cited repeatedly to show that the "lady" was no connoisseur or arbiter of taste, no deliberate savior of Britain's patrimony. She had simply paid a large sum of money to ensure her place in British society. The *American* published a report that the

donor was Consuelo Vanderbilt, the American heiress who had lately become the duchess of Marlborough, and that "the motive is said to have been to fortify her social position."[183]

According to this newspaper, at least, the Holbein gift was not the natural outcome of an individual Englishwoman's patriotism. Rather, it was sadly reflective of a larger social pattern of the British aristocracy's dependence on American millionairesses to buttress their fortunes by means of marriage.[184] If indeed the donor were an American heiress such as Consuelo Vanderbilt, her new "ownership" of the painting raised troubling questions about what was actually for sale in the Holbein case. Whereas the lecherous Uncle Sam of the *Punch* cartoon molested the painted duchess, the putative American donor shamelessly swapped the painting for her own duchessdom, a disturbing commodification of aristocratic privilege and Britishness itself.[185]

The elision of real and painted duchesses was a frequent theme in the coverage of the Holbein controversy. *Vanity Fair* suggested that major expenditures on this type of portraiture were wasted, because British citizens could "see our own live duchesses to-day free, and to any patriot they are quite as good. Why, then, pay £72,000 to see dead duchesses? It is all nonsense. Photograph or mezzotint the woman; don't buy her."[186] The special status of painting was devalued as both Christina and the genre that portrayed her were dismissed as eminently reproducible. The contested meaning of duchessdom within the context of an Americanized British upper class added another layer of complexity to the Holbein debates, as Christina came to symbolize an era of uncorrupted intermarriage between European nations: a Renaissance epoch of purified aristocracy in which foreign wives merged seamlessly into British "high" culture instead of contaminating it.

The *Ennuyée* and After: From Jameson to Carlisle

The identity of the Holbein donor remains a mystery to this day. But perhaps a more likely candidate than an American millionairess is a British aristocrat, staunch Liberal, and feminist: Rosalind Carlisle. Lady Carlisle, a distant relative of the duke of Norfolk, seems to have been the only one of the women suggested by the press as the Holbein donor who did not deny the rumor.[187] But my intention in proposing Lady Carlisle as a possibility is not to "solve" the Holbein case, because the evidence is clearly circumstantial. Rather, Lady Carlisle's complicated relationship to the National Gallery offers a useful conclusion to this discussion of art, gender, and property, taking us back to and beyond Jameson's embattled *ennuyée*.

Rosalind Carlisle, who had opposed her Unionist son and husband by be-

coming an influential figure in many Liberal platforms, had been associated in the public mind more often with politics than with art.[188] Until 1898, she was the president of the Women's Liberal Association and corresponded extensively with her son-in-law Gilbert Murray about the role and rights of women within the Liberal Party. Lady Carlisle was also well known in the art world, not only for her own collections at Castle Howard but for her efforts to train women in the field of art history.[189] She was responsible for several other major prewar gifts to the National Gallery after her husband's death in 1911 and was mentioned in a report on the retention of art in Britain as the National Gallery's only example of a "purely" patriotic and public-spirited donor.[190] She also continually vexed the gallery's trustees despite her generosity, insisting that she be included in curatorial decisions about her gifts.[191] To this extent, it is tempting to read Carlisle as the *ennuyée* cured and reborn: a victorious embodiment of Jameson's anticonnoisseur who remakes the National Gallery as a Liberal feminist enterprise.

But Lady Carlisle's participation in the National Gallery was far from a simple story of feminist teleology and progress. Her discourse of anticonnoisseurship was accepted, if not appreciated, by the gallery's trustees, but the problem of the gallery's debt to a woman who embodied both the principles of feminism and an outdated mode of Liberalism proved overwhelming to certain elements of the British press. As in Thomas Holloway's disturbing "art palace" for women, gender became a fault line in the public gallery. Jameson's earlier vision of a feminist gallery was now reframed in the context of women's property ownership and radical feminism as a viable political threat. Having so recently won the right to own property, at least within limited contexts, how could women exercise this right within the sphere of the public gallery, where everyone and no one was an owner? The trajectory from Holloway College to the National Gallery did not provide a triumphant answer to this question; the donor was vilified rather than ordained, the painting devalued rather than exalted.

In 1911, Carlisle sold the *Adoration of Kings,* painted by Jan Goessart or Mabuse and known as the Castle Howard Mabuse, to the National Gallery for £40,000, a high price but well below the painting's market value. The press reports concerning the Mabuse sale ranged from praise for the countess's "patriotic unselfishness as a vendor" and thanks for avoiding the "usual alternative" of purchase by an American millionaire to the very opposite.[192] One particularly irate letter to the right-wing *Morning Post* referred to the new acquisition as

> most deplorable from a Unionist as well as a National point of
> view. . . . The purchase of the picture is a fresh scandal which will
> have silent but far reaching effects on the fortunes of the Unionist
> party. It is just a Liberal job to buy off or pension a lady who, with

the best of intentions no doubt, had done much already to make her
own class thoroughly unpopular. And this not least by her strenu-
ous work for a man-made and sectarian Liberalism by which she
has for years disgusted all moderate-minded people both of her own
and the other sex.[193]

The author of the letter, Ralph Thicknesse, was the author of several tracts con-
cerning the legal rights of marriage and one of the more controversial members
of the Men and Women's Club in London.[194] He concluded that the English
aristocracy should give its art to the nation freely rather than sell it, even at low
prices. Generosity should not be tainted by filthy lucre, especially in the sacred
sphere of art. In the end, Thicknesse argued, the scandalously high price paid by
the government for the picture signaled "another nail in the Liberal coffin." The
only clear victor was the Labour Party, which had opposed the sale in the first
place.[195] According to this particular rant, Carlisle's gift had diminished the sta-
tus of the National Gallery, the reputation of womanhood, and the future of Lib-
eralism itself. In future years, suffragettes would seek to topple Liberal cabinets
by physically attacking the nation's artistic resources. But Thicknesse suggested
that the *preservation* of art—if derived from the wrong source—could be equally
dangerous or destructive.

Even critics who lacked Thicknesse's vitriol focused their discussion of the
Castle Howard Mabuse on Carlisle's feminist politics. The *Gloucester Journal*
took the Mabuse acquisition as an occasion to outline publicly the more "radi-
cal" components of Carlisle's political platform, including her belief that women
should be paid at the same rates as men.[196] Furthermore, the *Journal* reported,
Lady Carlisle believed that men had ousted women from their traditional forms
of employment. In accordance with these beliefs, the *Journal* noted with dismay,
Lady Carlisle's estate kept no footmen, no chef, and no butler. The article con-
cluded that Carlisle's philanthropy in the art world would inevitably lead to
greater attention for her political projects, particularly feminism. As in the Hol-
bein case, the highly public Mabuse sale crystallized British anxieties that the
National Gallery was changing hands. The salvation of British art from acquis-
itive foreign buyers seemed to involve an unhealthy reliance on donors such as
Lady Carlisle. If the duke of Norfolk had relinquished his aristocratic role as a
protector of patrimony, Lady Carlisle had stepped in to fill the void. The initial
cession of the Holbein portrait—and many other works housed in British gal-
leries and country houses—had prompted widespread contempt for aristocratic
failures. But whether the mysterious donor was Lady Carlisle or a woman of
lower birth, the "revelation" of a woman patron for the Holbein portrait pro-
voked an entirely new set of concerns. The solution to the crisis of the aristoc-

racy was not to be found in female patronage, at least not without a host of attendant crises to follow.

In the end, what had been saved and what had been lost in the "case of the disappearing Holbein"? The public perception of the portrait shifted now that the painting was acknowledged as "le tableau 'le plus cher du monde.'"[197] In December 1909, Henry James completed a play called *The Outcry* based on the Holbein affair. He converted the play into a novel the following year, after the death of King Edward VII forced the temporary closure of the British theaters and the collapse of his production plans. Key details of the Holbein story are altered in James's retelling. For example, the painting in danger is now indisputably British: a portrait of the duchess of Waterbridge by Sir Joshua Reynolds. Instead of being on display in a public gallery, the portrait is owned privately by an English aristocrat, Lord Theign, who is both impoverished and indifferent to the claims of his countrymen on his own possessions. He plans to sell the portrait to a wealthy American businessman. Theign's daughter, Grace, is the most fervent advocate for keeping the *Duchess* at home, even offering to forfeit her own happiness and marry the businessman who covets the portrait if her father will abandon the sale.

Interestingly, the "outcry" of James's title is not a reflection of British public opinion per se but the response of his patriotic peers; in contrast to the Holbein case, it is an outcry *of* the aristocracy rather than an outcry *against* it. Theign's friends are slow to see the error of his ways; even Grace notes that the international art market is not inherently bad: "Well, I suppose our art-wealth came in—save for those awkward Elgin Marbles!—mainly by purchase too, didn't it? We ourselves largely took it away from somewhere, didn't we? We didn't grow it all."[198] But soon, Grace and her friends are convinced of this portrait's special importance. At one point, a motley crew of aristocratic protestors surrounds the American buyer, yelling, "You can't have our Duchess!" Theign bows to this pressure; the offer to the American is withdrawn, and—as in the Holbein case—the *Duchess* is saved. The salvation comes from regenerated aristocrats, chastened at what they have already lost, who have learned to take up their burden as guardians of the nation's cultural objects with better grace than before.

This novel earned James impressive royalties and immediately ran to several editions, ensuring that the Holbein case would have some kind of afterlife among the reading public.[199] A series of articles appeared in the British, European, and American press about the personal history of this last Sforza duchess. Even Christina's physical appearance was reassessed, with one French journalist bravely claiming that although "ses traits ne sont pas réguliers," she had prob-

ably been considered quite a beauty in her own time. Others stressed the loveli-
ness of her slender white fingers and hands, which Catherine de' Medici had
called "the prettiest in the whole world."[200] More important, these articles
stressed Christina's independence in refusing to marry Henry VIII. Her rejec-
tion of the Tudor king was taken up alternately as a tale of international alliances
achieved by marriage and as a parable about protofeminist opposition to tyr-
anny. In the early twentieth century, the primary mode of such alliances was An-
glo-American rather than Anglo-Continental. But the tale of Christina's resist-
ance to a wealthy foreign power seemed all the more topical as a result.

The Holbein debates were spurred by larger concerns about the status of fe-
male portraiture, the status of property in national galleries, and the seemingly
inverse status of women and aristocrats as patriotic connoisseurs. The National
Gallery had retained its *faux*-British portrait, but much had shifted in the pro-
cess of retention. The institutional frameworks proposed by Jameson, Nord-
linger, Holloway, Panton, and Carlisle illustrated the use of patrimony as a cri-
tique of social and sexual norms, with varying degrees of success. For Jameson,
the National Gallery was both a site of resistance to feminism and a place where
feminism could be made visible. When she wrote in her *Companion* that she was
trying to tell her female compatriots "some things they do not know," she re-
ferred not only to artistic education but also to political identity, and to the bond
between the two. Clearly, professional and philanthropic expectations of pub-
lic galleries tended to work against a feminist agenda, and Jameson's successors
pointed to a range of projects rather than a single feminist politics. But follow-
ing the Holbein donation and the Mabuse sale, British curators were left with the
uncomfortable sensation that a feminist presence lurked in their galleries. In-
deed, one might say with regard to the politics of contemporary institutional cul-
ture that the presence of feminism is spectral still.

By the end of 1909, the National Gallery was compelled to confront the
possibility that feminism had played a role in preserving the British art historical
canon. But this experience of "canonization" or "integration" also destabilized
the prevailing terms of feminist discourse, signaling feminism's point of depar-
ture from Liberalism. The case of the disappearing Holbein revealed both the
potential successes and the limitations of a feminist model of cultural property.
In the 1840s, Jameson had assumed that feminists could remake the National
Gallery in their own image, relying on a uniquely British process of Liberal re-
form. By 1911, in the wake of the Holloway Gallery debacle and the Holbein
controversy, Jameson's project seemed less plausible. In the Holbein debates, the
central museological concept of property—individual and collective, patrimo-
nial and matrimonial, cultural and political—was called into question. Chris-

tina's portrait was placed at the center of the contemporary crisis of property rights and Liberal identity, raising important questions about the future of a demasculinized patrimony in Britain. The mysterious Holbein donor had not created the feminist gallery envisioned by Jameson, nor is it clear that this would have been her goal. But her actions spurred a larger debate about what role women could play in the rapidly changing world of property and patronage, revealing the depth of British anxiety about the gendered parameters of culture.

Civics and "Civi-otics" at the London Museum

When the London Museum opened its doors on March 5, 1912, the idea of the museum-going public—and, indeed, the idea of a museum itself—underwent a fundamental change. Originally housed in Kensington Palace, this museum was established in 1911 by Liberal M.P. Lewis ("Loulou") Harcourt and Reginald ("Regy") Brett, Viscount Esher, to memorialize the social, domestic, and public life of Londoners past and present. This definition encompassed items ranging from a Roman ship excavated by the London County Council and a collection of policemen's buttons to a theatrical museum of playbills and Queen Victoria's "funny little fat shoes."[1] But what really perturbed the journalists and politicians at the opening ceremony was not the range or content of the collections. It was this museum's "abnormal popularity" with the greater London public.[2] Although attendance statistics were strikingly absent, the belief that the London Museum embodied a new nexus between high and low culture —an unprecedented connection between the museological and the masses— was universal in the press during the museum's early years.

As Britain's first concerted attempt at a "folk" museum,[3] the London Museum elevated everyday objects—what James Deetz has referred to as "the small things forgotten" of household life—to prized museum artifacts.[4] As the leading Radical newspaper *The Star* reported, the London Museum "touches intimately [its visitors'] domestic relations, it conjures up vivid pictures of their homes."[5] The press reports about the London Museum described a new sphere of activity for museumgoers. In theory, every visitor to this civic institution—or, at least, every visitor who resided in London—was also a potential donor. Aristocratic and even middle-class patrons were to be displaced by armies of working-class or female Londoners who uncovered bits of pottery and fabric in their attics and backyards. The curatorial anxieties prompted by this experiment with

urban "folk" history speak to larger issues of authenticity, value, and ownership at the heart of museum studies past and present.

The domestication of this civic museum, in particular the emphasis on objects from ordinary London homes, also altered the prior museological framework of gender relations.[6] Within this institution devoted to the relics of domestic life, women had important roles to play as civic collectors, donors, and viewers. But this expanded role for women was neither easily nor universally accepted, as the case of the disappearing Holbein had recently illustrated. The London Museum's project of "feminizing" its collections and audience was complicated by the coincidence of the museum opening and a series of attacks by suffragettes on art. Certainly, attacks on public works of art operated as part of a larger program of feminist disruption and protest between 1912 and 1914.[7] But these incidents, in which fourteen pictures were slashed and nine women arrested, also reflected a highly specific response to the gender politics of the public gallery: its overvaluation of the female nude and its devaluation of real, as opposed to painted, women.[8] At the London Museum, women were credited with the paradoxical impulses of preservation and destruction. To a degree, both projects—preservation and destruction—were broadly perceived as feminist. In this context, women visitors to the London Museum were both envisioned as esteemed guardians of household treasures—or individual property—and heavily policed as potential destroyers of public goods.

The two most striking aspects of the London Museum's opening ceremony were the incredible popularity of the new exhibits and the precautions taken against militant suffragettes.[9] The juxtaposition of popularity and its dangers thus defined the London Museum from its inception. When it opened in 1912, an editorial in the *Town Planning Review* noted that this institution posed unique curatorial dangers and pitfalls. Owing to the new museum's emphasis on the odds and ends of everyday life, the utility of the exhibits would depend on their meaningful sequence and arrangement, not on the intrinsic value of the objects themselves.[10] The collections could easily veer into the haphazard, the sensationalistic, and the archaic.[11] As the guidebook author Ernest Law put it, this was a collection for citizens, not for connoisseurs.[12]

In exploring the discourse and practice of civics as it was deployed both by the supporters and the detractors of the London Museum, this chapter analyzes the redefinition of the relationship between citizenship and material culture in prewar London. Debates about ownership had a particular significance in London, where property disputes among tenants, builders, and landowners had played a major role in defining the prewar urban experience.[13] Furthermore, the founders of the London Museum confronted a long history of contention about how to govern London's civic museology, namely, the decades of struggle be-

tween the London County Council (LCC) and the Corporation of London to establish the ideal civic institution. The organizers of the London Museum witnessed a politically diverse set of antecedents in thinking about the role of objects in crafting new urban identities: the Corporation's involvement with the Guildhall Museum and Guildhall Art Gallery and, at the other end of the party spectrum, the LCC's administration of the Horniman Museum. Ultimately, the London Museum transformed the concept of civic education articulated by the Corporation and the LCC into what one donor memorably called "civi-otics," an amalgam of patriotism and civics that recast existing British notions of the ideal citizen. This conversion of civics to "civi-otics," continually shaped by contemporary debates about gender, radicalism, and popular culture, raised the fundamental question of whether "culture" and "property" could ever be fully reconciled in a British context.

Precedents: Songs and Skansen

Among the competing visions of ideal donors and visitors to the London Museum were the folklorist, the revolutionary socialist, and the wild suffragette. The London Museum's organization coincided with the rise of academic folklore studies in Britain. Scholarship dealing with the British folk revivals has focused overwhelmingly on the work of Cecil Sharp in collecting English folk songs and dances and on the complexities of Sharp's relationship to socialist philanthropy or on his appropriation of working-class culture.[14] But the history of the London Museum offers a different angle on both the folk revival and the processes of writing a radical history of folk culture. Nineteenth-century folklorists had often concentrated on music, oral tradition, and performance, omitting material or visual culture from their historical reconstructions.[15] The advent of the use of material artifacts in folklore studies was accompanied by a new preoccupation with the scientific "truth" of folklore, as the criteria of authenticity devolved from a Romantic moral notion of the original in the nineteenth century to more scholarly documentations in the twentieth.[16] The London Museum took part in this more general shift toward the material in folklore studies but also complicated existing notions of "the folk" in its emphasis on urban and industrial cultures.

The success of Artur Hazelius's open-air folk museum at Skansen, a pan-Scandinavian collection of costumes, tools, furniture, ancient timber houses, and living tableaux established in Stockholm in 1891, tantalized British curators.[17] In 1910 the *Museums Journal* reported a scheme to revamp the Crystal Palace as a national folk museum. The grounds would be converted into open-air galleries of domestic objects, offering a happy, anglicized counterpoint to the narrative of British inferiority that had ultimately characterized the Great Exhibition of

1851.[18] This plan was brought up again in January 1912, just before the open-
ing of the London Museum.[19] But this proposal was never implemented, in part
because its supporters failed to convince the Palace's commissioners that the
Great Exhibition of 1851 had been rooted in anything resembling "folk" culture;
the Palace was an inappropriate or inadequate analogue for Skansen.[20] In cer-
tain respects, the rejection of the Crystal Palace site represented a belated exposé
of the shortcomings of the Great Exhibition. Indeed, the London Museum num-
bered a season ticket to the Crystal Palace among its collections, relegating the
nineteenth-century "exhibitionary complex" to the material past of the city.[21]

The founders of the London Museum clearly felt that they were embarking
on an innovative experiment in folk culture, despite the project's local and inter-
national antecedents.[22] Skansen was established as an agrarian collection at an
early moment of urbanization and industrialization in Sweden. But the London
Museum's relationship to these historical processes was more complex. Over-
whelmingly, academic folklore studies in Scandinavia and elsewhere focused on
the rural and the preindustrial as sources of national and civic regeneration. In-
deed, part of the impetus for the folk revival in Britain was the assumption that
the common people had imperiled their heritage first by moving into towns and
subsequently by becoming derelict toward their own past in the adoption of ur-
ban popular songs and the music hall. Reformers such as Mary Neal and Grace
Kimmins brought folk performances to London in the early 1900s, Neal by
training girls in folk dance at the Espérance Club in northwest London and
Kimmins by restoring English folk games at the Bermondsey University Settle-
ment in south London.[23] But both were primarily concerned with rural tradi-
tions imported *to* the city, rather than the discovery of a traditional culture *of* or
within the city.[24] Indeed, Kimmins believed that rural games would prove uplift-
ing for children doomed to spend their lives in urban slums; the function of the
rural here was entirely palliative and not meant to be blended with existing ur-
ban cultural forms. The revival may have had a metropolitan base, but the his-
tory of London had as yet played little or no part in the reconstruction of folk
traditions.

But whereas Hazelius had relied primarily on rural peasants for his national
ethnographic collection,[25] Harcourt and Esher looked to urbanites for the débris
of domestic life in the city.[26] The London Museum would be more than a Brit-
ish Skansen; it was the institutionalization of the British "folk" inflected by par-
ticular conceptions of urban culture and municipal socialism.[27] By the 1890s,
modern artists had begun to construct a recognizable London "type," as in the
depictions of "Cockney" characters in William Nicholson's *London Types* wood-
cuts, William Orpen's *The Wash House*, and William Rothenstein's *Coster Girls*.[28]

In general, the London Museum's curators did not draw on what Gareth Sted-man Jones has called the "pseudo-ethnography" of the Cockney so popular in the jingoistic days of the fin-de-siècle.[29] The Liberal *Daily News*, referring to "20th-century Cockney" visitors at the new museum, suggested that they might feel some consciousness of a common citizenship "as they gazed into the eyeless sockets of a paleolithic Londoner."[30] But the editors concluded that this partic-ular "throng of moderns" would be unable to comprehend such unfamiliar ma-terial. As later debates about the London Museum's depiction of local neigh-borhoods and industries would suggest, the ethnography of the urban "folk" remained elusive. Cities were both centers of power and places where power might be challenged.[31] Patrick Joyce has argued that examination of the city is one productive means by which the history of Liberalism can be traced, in part because the Liberal Party was so deeply ambivalent about cities.[32] Although the city constituted the ultimate (and thus most beloved) object of Liberal reform, the anonymity and dissolution of social bonds in urban life heightened Liberal anxiety about the impact of cities on individual moral development. The city was routinely contrasted by Liberal politicians with the smallholding of the Scottish crofters or the town as the model of Athenian democracy. The governance of cities required Liberal thinkers to articulate the parameters of what they saw as good government. The establishment of the London Museum would prove that both the expression and the defiance of power posed special problems in Brit-ain's capital city.

The Gospel of Geddes and the Problem of London

Local history museums existed in Britain long before the London Museum, es-pecially in the northern provinces of Birmingham, Leeds, and Manchester. But according to the Scottish sociologist, biologist, and urban planner Patrick Ged-des, none of these institutions met his definition of a truly "civic" museum.[33] The Geddesian notion of civics focused on the efflorescence of individual tal-ents in a group context, namely, the ideal city. The Victorian city had degener-ated into a site of chaos that disrupted the Geddesian history of cities as carriers of civilization and human culture.[34] Note that Geddesian improvements were never intended to be anti-urban but were meant to rise to the challenge posed by the industrialized city.[35] Cities were central to human development, but they needed to be regenerated in order to fulfill this potential. Within this frame-work, all museums were key institutions for fostering civic consciousness.[36] Civic museums should inspire the visitor to create the perfect urban environment by showing him or her what the city had been in the past. More broadly, civic

museums should encourage interaction between individual and collective by
making the abstract principles of social life and political thought concrete for the
visitor.[37]

In 1892 Geddes had envisioned and partially constructed his own civic mu-
seum in Edinburgh's Outlook Tower, a five-story edifice near Edinburgh Castle
with each floor housing its own museum. The visitor was meant to enter and
proceed directly up to the fifth floor, or "Prospects," which held a camera ob-
scura reflecting a picture of the city in motion outside.[38] After being rooted in
the topography of modern Edinburgh, the visitor descended into a series of gal-
leries dealing with the history of Edinburgh, then Scotland, then Europe, and
finally the first-floor gallery, titled "The World." Each gallery was intended to
function as a self-contained, independent collection—with maps, photographs,
and other artifacts of the geopolitical unit at hand—and as an illustration of Ed-
inburgh's relationship to larger units of corporate life.[39] Contemporary critics
predicted that the tower would operate as a sociological laboratory as well as an
exhibition site:

> In the Outlook Tower, Geddes has written an epic concerning civic
> affairs. It is the modern story of Paradise Lost and Paradise Re-
> gained. Some day it will be called the Epic of Civic Gold. For it
> tells of the gold of man's enduring endeavours buried in cities.
> Moreover, it preaches the joy of life and prophesies the good time
> coming.[40]

The author of this comment proposed an "extractive" model of museums, in
which the artifacts housed at the Outlook Tower represented buried treasure
brought to light. The Outlook Tower was a self-conscious effort to rework the
biblical model of the Tower of Babel, bringing order and unity to urban life out
of a heterogeneous melee of action. Only in the city could the potential for hu-
man endeavor be fully realized, and only in museums could the city be fully un-
derstood as the pinnacle of human achievement. Without the tower, the civic self
would remain ever inarticulate.[41]

This Geddesian nexus of civics and education certainly influenced Har-
court and Esher. But the project of institutionalizing London civics posed a
special problem even in the burgeoning field of urban studies. London was not
simply another city but the recently and incompletely unified capital of the na-
tion and the center of empire.[42] It was perceived as an island of the anti-civic in
a nation of local sentiment—a "confused and anomalous wilderness" that de-
prived many Londoners of the benefits of citizenship.[43] The very personality of
the Londoner worked against the idea of civic virtue; one critic described the

typical Londoner as "self-centred, unsociable, phlegmatic, and narrow."[44] As J. Starkie Gardener wrote, Londoners had "no *esprit de corps* or bond of union."[45] Visually, too, London was in need of unification. The Arts and Crafts spokesman W. R. Lethaby noted that in artistic terms, London was "as structureless as one of its own fogs."[46]

The formation of the London County Council in 1889 was intended to rationalize and centralize London's government, creating a political unit from social and cultural heterogeneity. Having replaced the "effete and corrupt" Metropolitan Board of Works, the LCC was linked more broadly with the cause of reform. But the LCC never incorporated the wealthy, intractably Conservative section of London known as the City, and the City continues to maintain its own set of civic rituals and local government offices to the present day—standing, as one author put it, "churlishly aloof" in its own Conservatism.[47] As late as 1923, more than thirty years after its establishment, one London travelogue still referred to the LCC as that "entirely upstart and as yet unhistorical body."[48]

From 1889 to 1907, the LCC was dominated by Progressives—a loose coalition of Gladstonian and New Liberals, as well as socialists and trade unionists who supported a reorganization of society along collectivist lines.[49] In particular, the Progressives emphasized the role of the local authority in tackling social problems, along with the traditional elements of municipal socialism that had already developed elsewhere in Britain—for example, in Chamberlain's Birmingham.[50] Susan Pennybacker has suggested that the Progressive failure was due in part to the LCC's inability to negotiate between the two poles of individualism and collectivism, dramatizing the property issues at the heart of the Liberal crisis. Although the LCC's tendency to alienate working-class voters with puritanical campaigns against music halls and other "irrational" forms of leisure made the Progressives unattractive to many voters at both ends of the social spectrum,[51] the Progressivist philosophy of evangelical reformism persisted throughout the prewar period, particularly in terms of cultural policy.[52] As Chris Waters has argued, the Progressive effort to critique existing forms of popular culture was part of a larger socialist faith in the importance of individual character in shaping a collective morality.[53] The national Liberal Party was fascinated by the Progressivist experiment in London. Until 1907, when the Progressives suffered a major defeat and the LCC swung to the Conservatives (or Municipal Reformers), the LCC represented the focal point of socialist hopes in Britain.[54]

With this unique political history of total "ungovernability," as Donald Olsen has put it,[55] London was seen as both particularly in need of and particularly resistant to the concept and practices of civic museology. British museums were a profoundly urban phenomenon.[56] But the reformist mission of the public gallery was often countered (if also intensified) by curatorial fears that the

quotidian banalities of the city and the vagrant, fugitive pleasures of street life would find their way into London's art institutions.[57] As Paul Valéry was to argue in his 1923 essay "The Problem of the Museum," the city and the museum were analogical modern spaces. Both were characterized by abrupt claims on the viewer's attention and inexplicable juxtapositions that created a sense of unbalance.[58] Whereas British critics were less prone than their continental counterparts to describe the museum as an emblem of modernity, their sense that the chaos of the urban streets and the eclecticism of the public gallery often mirrored one another in disturbing ways was in keeping with Valéry's articulation of the urban museum problem.

Geddes himself stressed the urgent need for a civic museum in London, an institution to counter the pervasive "cockneyism" he found antithetical to true civic pride. For him, the "Cockney spirit" of so many Londoners was divisive, highlighting superficial differences of accent and dress at the expense of civic unity. The task of the urban civic museum was therefore espeically difficult in London.[59] Geddes's followers also devised plans for remaking London's artistic and scientific institutions such as Huntly Carter's 1906 "Sketch of a Civic Museum for London." Carter proposed the establishment of an Index Museum that would serve as a guide to the capital's vast institutional resources, organizing the "large masses of unorganized civic facts."[60] In addition to topographical and other galleries illustrating the relation of London to England, the empire, and Europe, Carter's civic museum emphasized the unique pathologies of London: the hazards "peculiar to London occupations" and the diseases brought about by the particular social and racial composition of the capital.[61]

Like the city itself, London's relics were decentralized.[62] Some municipal reformers looked to the London Museum as a centralizing force, recognizing that political reform movements were predicated on the notion of cultural interests common to Londoners.[63] But the notion of a single cultural authority for the capital was never universally embraced. Fragments of London history—its gravestones, pavement slabs, and so forth—were housed throughout the major national collections, as well as at the Guildhall and the LCC offices. Several newspapers suggested that all artifacts pertaining to London be consolidated in the new museum; the British Museum in particular would "have to be coaxed into yielding up [its] treasures."[64] But the London Museum was intended to do more than centralize the discrete artifacts of urban history. Public complaints about the relationship between historical narrative and the existing collections—especially the British Museum—ranged widely. The *Daily Chronicle* complained that visitors at Bloomsbury were offered no means of comparing the priceless collection of historical manuscripts, some of which pertained directly to London's past, with the equally valuable collection of artifacts, overwhelmingly of

imperial origin. Urban history was indeed imperial history, but the British Museum had failed to make this connection visually or textually explicit. Without this link between object and document, the visitor could not discern what the past meant to him- or herself and to future citizens.[65]

Liberals and Conservatives:
The Guildhall Art Gallery versus the Horminan Museum

Throughout the prewar period, the Corporation of London and the London County Council looked to the field of arts administration as one important means of defining civic power and identity. Their experiments with museum management—the Corporation's establishment of the Guildhall Art Gallery in 1886 and the LCC's takeover of the Horniman Museum in 1904—represented two different visions of London civics and two different views of the function of art, science, and ethnography within this civic paradigm. Ultimately, both of these visions would help shape the parameters of the London Museum. The case of the Guildhall Art Gallery is explored here because it stands as an atypical example of Conservative sponsorship of a public arts project; or rather, its Conservatism was atypically explicit. The political ideologies of the Guildhall Art Gallery and the Horniman Museum ranged from ultraconservatism to ultraprogressivism, demonstrating the malleability of civics in the capital city. In the aftermath of political upheaval in "reformed" London, these institutions operated as sources of division and disorder as much as sources of reconciliation or consolidation.

The Guildhall Art Gallery was founded in a year of particularly heated debate about the nature of London government and the elusive dream of a unified London. The Corporation already had charge of the Guildhall Museum, a peripatetic hodgepodge of Old London relics and portraits of deceased aldermen that had been open to the public since 1826. But this poorly funded and little-known collection was inadequate as a cultural resource in the political battles of the 1880s. While the Liberal Municipal Reform League denounced the present "chaos" of London government and advocated the abolition of a separate City administration,[66] the City responded in 1886 with that most unassailable institution of Liberal progress: the public art gallery. Threatened with the dismantling of the guilds and renewed attacks on the Corporation's extensive wealth and power, the City hid behind a shield of art in order to recast public perceptions of City government.[67]

At first, the "new" gallery consisted of little more than a rearrangement of pictures and busts from the old museum and the Guildhall offices. No new purchases were made, but the act of centralizing the Corporation's artistic resources

was symbolically meaningful. The first acquisitions came as gifts from the wealthy livery companies, the most despised targets of Liberal municipal reform. The Drapers' Company offered a portrait of the first Lord Mayor of London, and the Goldsmiths' Company presented G. A. Storey's *The Violinist* to the gallery in the summer of 1886.[68] The Barbers' Company offered their Holbein for £15,000, claiming that they would devote the proceeds from the sale of the painting to "charity and education," but only a fraction of the demanded sum was raised from the City community.[69]

The Guildhall Art Gallery's politics might be best described as defensive: an apology for élite privilege couched in terms of the City's communalization of art. In response to Liberal charges that the Corporation was "selfish and sleepy,"[70] the gallery's promotional literature stressed that it distributed proceeds from its exhibitions to the poor, casting itself as a Gallery Bountiful. Conservative politics, when embodied in a public art gallery, magically emerged as "liberal" in the broadest sense of the word. In redefining the livery companies and the Corporation as art owners and patrons, the City had shifted the terms of the debate about London's future. The opposing parties could no longer be polarized into the public-spirited, reform-minded Liberals and the privileged, cliquish City Conservatives.

The *City Press* optimistically suggested that the guilds pool their artistic resources in the Guildhall Art Gallery. A gallery composed of the amalgamated wealth of art from the City guilds and the Corporation would greatly improve the public standing of the "much misrepresented" guilds.[71] The class politics of this first major museum project for London civics diverged significantly from the Victorian model of art philanthropy.[72] The intended audience for this gallery, apparently, was not the ordinary disaffected Londoner—the "common" viewer who would later be embraced by the London Museum—but the educated Liberal M.P. who sought to eradicate the City as an independent political entity. Whereas the curators at the National Gallery and especially South Kensington often referred to the education of the British worker in their institutions, the *City Press* reported that the Guildhall Art Gallery offered a tranquil place of respite to the "weary City man who snatches a few minutes from the cares of business to gaze on the productions of the artist."[73] The relationship between labor, education, and the art gallery clearly had a unique resonance in the Guildhall.

The *City Press*'s coverage of the Guildhall Art Gallery's opening was framed by a narrative of oppression about Liberal municipal reform movements. Liberal governments had provided little central support for the arts, and London could ill afford to abolish institutions as rich in art treasures as the guilds. If there were no other reason to maintain the guilds, the *City Press* argued, art alone would suffice. The newspaper further suggested that the Corporation commis-

sion artists to paint scenes from Epping Forest, Burnham Breeches, and Coulsdon Common in order to record its role in preserving open spaces and more rural resorts within London for posterity.[74] Although the workings of the gallery bore very little relation to the vision of "City aesthetics" imagined here, the sense that this gallery should serve as a testament to the Corporation's philanthropic history was strongly felt by its organizers. Within the walls of the Guildhall Art Gallery, the Corporation was pictured as the ultramodern civic authority, matching the new London County Council painting for painting.

Under the auspices of the art collector and curator Alfred G. Temple, the Guildhall Art Gallery became a tremendous critical success. The permanent collections remained lackluster, but in 1890 Temple instituted an annual series of blockbuster loan exhibitions, winning acclaim for his installations of Spanish, Dutch, and eighteenth-century French art.[75] He was careful to connect his civic gallery to larger national concerns and patriotic endeavors. In 1904 Temple hosted an exhibition of Irish art that had the stated intention of "showing Parliament" how artistic the Irish people could be and proving that Dublin deserved its own municipal gallery of modern art.[76] The gallery also held an exhibition for the Artists' War Fund during the Boer War in 1900 and raised £12,000. When World War I broke out, Temple suggested an exhibition of French and British military painters to support recruitment. The Guildhall Art Gallery cast the defense of privilege as a civic endeavor, reimagining the Corporation as a "liberal" governing body.

At the same time, Temple reminded his audience that the Tate Gallery, the central institution of modern art in London, had initially discouraged his enterprise.[77] The Tate had refused to loan pictures to the Guildhall because "no one would think of coming to the City to see pictures, the West End was the place."[78] But Temple offered a new view of the urban geography of modernism, suggesting that the Guildhall could operate as a site of "resurrection" for Millais, Burne-Jones, Hunt, and Rossetti. From his point of view, the Guildhall Art Gallery was a major pre-Raphaelite outpost in London—despite the general perception that the City was the locale for antiquarian collections, not modernist art. Challenging the notion that the Tate was a more "national" institution than the Guildhall, Temple clashed several times with the Tate's administrators. When the National Art-Collections Fund refused to assist Temple in buying Burton's *Wounded Cavalier* from a private collector unless he agreed to cede the painting to the Tate, Temple argued that the art collection at the Guildhall ultimately formed a "national gallery."[79] As Brandon Taylor has noted, the Tate was finally situated at Millbank, a former penitentiary; in Taylor's view, the conversion of a prison into an art gallery represents the pinnacle of liberal reform.[80] But the City had originally staked a claim in the Tate Gallery as well, and while the LCC took over the

Tate construction project—inaugurating a block of Council housing on the out-skirts of the Tate site in which the apartments were named for British artists from Reynolds to Leighton—Temple's gallery made it difficult to locate modernist art outside the City completely.

The Guildhall Art Gallery was an education in City civics: the civics of os-tentation compelled into public service. This gallery constituted London's first overtly Conservative public museum project, organized in the name of consoli-dating and defending the privileges of culture rather than democratizing them. As such, it formed a significant institutional counterpoint to the National Gal-lery and South Kensington, both guided by the principles of Benthamite Liberal reform. As the London County Council would learn, the Guildhall Art Gallery also bore witness to the difficulties of defining a single civic ideology for Lon-don. Whereas the Corporation had opposed "the civic" and "the popular," the LCC would try to forge a liberalized civic museology in its dealings with the Horniman Museum. Throughout the prewar period, however, the Guildhall Art Gallery stood in silent opposition to the LCC's museum projects. It proposed the art of elitism as a viable philosophy of civics, even as the Council strove to conceive of London citizenship in Liberal-Labour terms.

When the London County Council was established in 1889, the provision of "culture" was perhaps an unlikely priority.[81] Embroiled in an endless series of debates about the nature of civic rights and responsibilities, its tripartite goal of centralization, rationalization, and unification of the metropolis met challenges from a variety of quarters. But the exploration of new definitions of government within the realm of art and artifacts became a conciliar mission within the first year of its existence. Although the LCC's reputation for artistic expertise was in-different at best,[82] proposals for handing over all London museums and galleries to it multiplied throughout the prewar period.[83] By the time the London Mu-seum opened to the public, every museum in London was potentially subject to "councilization"—even the National Gallery.[84] The LCC sought to develop its own theory and practice of museum civics in opposition to the Corporation's Guildhall Art Gallery project. In the realm of the music hall, the Council's cam-paigns to sanitize urban leisure earned it a reputation for puritanism and rigid-ity. Its involvement with artistic and scientific institutions during the prewar period does not necessarily contradict its image as an agent of social purity, be-cause museums could fall into the category of "appropriate" or "rational" leisure activity. But the LCC's cultural policy was complex, pointing to a range of agen-das in the reform and development of various London institutions. It aimed not only at the purification of urban leisure but also at the transformation of urban visual culture into something imperial and glorious: the remaking of the "local" as the "civic."

The LCC's first practical experiment with museum administration, its acquisition of the art and ethnographic collections at the Horniman Museum in 1901, catapulted it into a world of Japanese butterfly boxes, stuffed opossums, mummies, and ancient Celtic bells—in short, the universe of "curiosities" that typified earlier British collections such as the Ashmolean.[85] This museum originated in the private collections of Frederick J. Horniman, the owner of a tea-packing firm and staunchly Liberal M.P. for Falmouth and Penryn who traveled extensively in the 1870s. The museum first opened in 1891 at Surrey House, Horniman's private home in the Forest Hill suburb of London. Horniman made tireless efforts to establish personal contact with the public by means of receptions, lectures, and excursions. He also encouraged young visitors to bring in their own collections of shells, birds' eggs, and butterflies to be identified and named.[86] From its inception, his museum was open to the general public at no charge on specific days, and the catalogue was offered for free as well. By 1897 the annual number of visitors had risen to 90,383. The museum was quickly outgrowing the capacities of Horniman's residence, although he had removed his family to an adjoining estate to make room for the collections. Horniman continued to acquire freeholds to the adjacent properties, preparing an area totaling fifteen acres for his museum, library, and gardens.[87]

In contrast to other ethnographic collections, such as the British Museum, the Horniman Museum seemed concerned less with cementing the imperial identity of British visitors than with ensuring that visitors from other cultures acknowledged the "authenticity" of his collections.[88] In 1896 Horniman invited Burmese troops visiting London to his museum, noting that the soldiers were "astonished at seeing so much from their own country." He welcomed Burmese silversmiths, wood-carvers and cigar makers, a couple of Brahmins, and a Buddhist priest.[89] Horniman also entertained Japanese ministers and the Maharajah of Bhaunagai at the museum with good cheer, inviting his guests to comment on the genuineness of the artifacts and offering each visitor a box of exotic butterflies as a memento.[90] Indeed, the non-British were incorporated into his museum's history as collectors and donors as well as visitors, although they were rarely designated as individual connoisseurs. The annual report for 1895 listed the donors for some Ceylonese brass ear ornaments as "Two Little Tamil Girls."[91] Lest the ethnography of Britishness should suffer, Horniman organized a special exhibition of Nelson relics for Trafalgar Day in 1896, arranging a miniature ivory painting of the admiral, a model of the *Victory*, Spanish daggers, and Nelson jugs on top of a table covered with the Union Jack.[92]

Surrey House was demolished in 1898, and the collections were reestablished in a new art nouveau building with a white Doulton stone front designed by C. Harrison Townsend on the same site (fig. 13). The façade of Townsend's

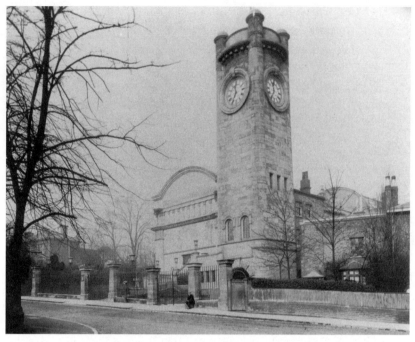

13. Exterior of the Horniman Museum before 1912. Courtesy of
the Horniman Museum and Gardens, London.

building was dominated by Robert Anning Bell's enormous decorative mosaic panel, one of the few instances of an exterior mosaic in English architecture and one of the most remarkable examples of mural decoration in the metropolis (fig. 14).[93] The panel, which was thirty-two feet long and ten feet high, depicted an allegory of the different stages of human existence: the limitations of circumstance (birth, education, and surroundings) were represented along with the eternal conditions of human nature. The new building thus engaged the visitor with the question of individual and collective character: What makes us as we are, and what role would this new institution play in improving our spirit? Bell anticipated some disappointment that the mosaic lacked the gold backgrounds and stronger colors of Byzantine designs, and he stressed that the tesserae for his panel were all of British manufacture—prioritizing native artistic production over aesthetic appeal.[94] The annual report for the Horniman Museum took this occasion to offer a history of the site itself, which had previously been known as Westwood Common. The authors evoked the area's history of being inhabited by gypsies and fortune-tellers, noting that although the original rights of commons such as pasture and recreation had disappeared, Horniman had provided

14. The Bell mosaic at the Horniman Museum as illustrated in C. Harrison Townsend's *Description of the Museum.* Courtesy of the Horniman Museum and Gardens, London.

nearly the same rights of collective pleasure with his private munificence.[95] The site for this museum had thus followed a complex path from corporate to private space and back again—although Horniman had clearly compromised the earlier communal function of the site.

In 1901 Frederick Horniman ceded the new museum, library, and gardens to the London County Council. The gift—estimated to be worth at least £50,000, and possibly as much as £100,000—was announced to the Council by Frederick's son Emslie because Frederick was on another jaunt in the Far East. Emslie was also a keen collector and an equally staunch believer in the tenets of liberal education; he was the Liberal M.P. for Chelsea and the chairman of the LCC's Historical Records and Library Subcommittee, the branch that dealt with museums. The transfer of ownership from the Horniman family to the LCC was never fully explained to the public, although the press suggested that the Hornimans had simply grown weary of their vast curatorial responsibilities and wished to retreat into private life. Emslie himself said that he believed the collections would be more useful if they were vested in a public body, although the Council's record in artistic matters was less than impressive.[96] Thus far, its cultural endeavors—for example, its policing of the music-hall industry—had resulted in the alienation of the populace from the municipal government.[97] The takeover of the Horniman Museum represented an opportunity to launch the LCC in a new direction of policy-making in which Progressive culture could be made popular.

Emslie arranged for a grand ceremony at the Horniman Museum to mark this new era of Council ownership. On June 9, 1901, the duke of Fife and A. M. Torrance, the chairman of the Council, presided over a fireworks display and a public promenade of Townsend's building and the surrounding gardens. A deputation representing the trade, benefit, and friendly societies of South London presented the Horniman family with an illuminated manuscript to express their thanks for this gift.[98] The duke concluded that although the LCC could have created such a museum itself, it was immensely more gratifying that the collections had originated with a private citizen: a Liberal and a Londoner.[99] The crowd was addressed at length by Sir George Laurence Gomme, clerk of the LCC, renowned folklorist and ethnohistorian and prolific writer on Londoniana.[100] Gomme was also known for his historico-legal writings concerning the history of property rights in England, in which he argued that the Domesday Book showed evidence of group holdings rather than individual ownership exclusively. For Gomme, then, property rights in England were originally founded in a *collective* notion of ownership, not an individual one.[101] Gomme's work at the LCC embodied the New Liberal ideals of civil service and community. Whereas

traditional liberal anthropologists had envisioned society as a voluntary compact of atomistic individuals, Gomme argued that the state had to assume paternalistic powers in order to protect ordinary persons from the hazards of modern society. This particular brand of collectivism, as Henrika Kuklick has noted, did not entail the subordination of individual interests to those of the state but retained the stamp of traditional liberalism. Collectivism was believed to advance the cause of progressive evolution, which would ultimately result in the development of altruistic individuals and a regenerated community.[102]

For Gomme, the LCC's work at the Horniman Museum was an opportunity to express these values of government action at the level of the city. It was, in other words, an opportunity to create a New Liberal museum. The Horniman played a pivotal role in the Council's redefinition of citizenship as a phenomenon of the city, not the nation-state. In Gomme's view, British cities had already begun to transcend their previously limited existence, taking municipalism beyond what he perceived as the finite capabilities of nationalism. As he put it, the new world empire would be governed as Rome had been—by its cities.[103] The centralization of government was to be carried out by the consolidation of London government. This centralization of authority would elevate the rationality of government services and, ultimately, serve as a palliative for divisive party politics. In his efforts to make sense of the new Council property, Gomme spoke with great zeal about a new coalescence of civics and museology, particularly for this entity London, which was "something more than a city without a city's organization and unity."[104] He heralded the takeover of the Horniman Museum as "an important development in the municipal history of London" that would mark the "first step of the London County Council in a new path."[105] He expressed some trepidation about the LCC's taking on this new field and regretted that London had come so late to the sphere of cultural patronage. For the LCC, this acquisition had provoked an equal amount of self-doubt and self-congratulation. But the Horniman Museum also provided a perfect site for the Council to challenge the elite civic ideology promoted by the Guildhall. Although the Guildhall contained a magnificent collection of antiquities, Gomme argued, its visitors were limited by a narrow conception of "London" as a locality rather than a national and imperial center:

> But the needs of London, now the centre of our newly-created educational interests, cannot rest here. As the capital city of our vast Empire, its interests extend to almost every branch of man's handiwork, whether it be savage, barbarian, or civilised, or whether it includes artistic, industrial, or technical objects.[106]

As the LCC and the Corporation vied for control of London's art, Gomme carefully delineated the sphere of civic virtue outside of the City and beyond the Guildhall—squarely within the province of conciliar power at the Horniman Museum. He sidestepped the question of why the LCC had been chosen to inherit the Horniman since its collections had little to do with the history of London. Gomme admitted that this museum's origins as an eclectic private collection made it difficult to classify but suggested that it could be redefined as part of the "Modern English School of Decorative and Applied Arts." Under the auspices of the LCC, the Horniman had been reimagined as an institution of London history and a seat of civic identity. In Gomme's terms, the very inclusivity and comprehensiveness of the Horniman Museum made it Londonesque—an appropriate institutional expression of the city that was said to have more Scotchmen than Edinburgh, more Irishmen than Dublin, more Jews than Palestine, and more Catholics than Rome.[107] London and the Horniman Museum both composed the civic universe as Gomme saw it: one in the diversity of its citizens, and the other in the variety of its material objects.

During the first year of the Council's tenure at the Horniman, attendance nearly doubled; 177,312 people visited the museum in 1901. Flyers publicizing the museum were distributed at schools, libraries, and railway stations. During the summer of 1902, the LCC arranged a series of grants from the Technical Education Board to hold lectures for teachers at the Horniman, including a special set of lectures on the role of museology in general education. Lectures were now accompanied by bibliographies so that the lessons of the Horniman could be integrated into London school curricula. The Council also entertained a proposal to convert the museum into a warehouse that would distribute art and natural history objects throughout London's schools.[108] The Horniman would thus operate as an extension of the classroom, or as a clearinghouse for "ideas worked out in the schools themselves."[109]

Although the warehousing proposal was never implemented, the impulse toward centralization in the world of art and artifacts mirrored the Council's own political interests. The Education Act of 1902 had already inaugurated a closer connection between schools and public museums, allowing teachers to count time spent in museums as school hours.[110] The notion that children learned to reason abstractly by means of "object lessons"—training in the observation, naming, and classification of objects—had long been a mainstay of British missionary schools.[111] But at the turn of the twentieth century, the pedagogical technique of the object lesson was increasingly secularized. It shared with the public museum the faith that learning to perceive the kinships and differences between objects would instill in children the ability to recognize patterns of relationship among peoples and nations. Schools and museums were therefore linked by the

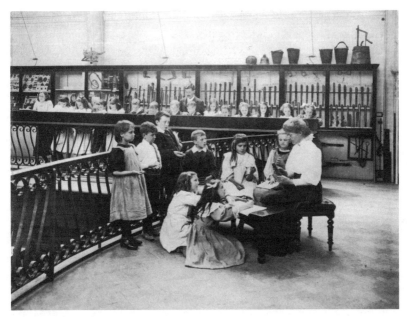

15. Children from the Birley House Open Air School studying stone-age implements at the Horniman Museum. Courtesy of the London Metropolitan Archives.

belief that particular objects could instruct people in abstract concepts. As the provisions of the Education Act of 1902 would suggest, the instructional value of objects was well recognized in official circles. But the management of the Horniman reflected a special facet of this more general emphasis on the centrality of objects in education. The LCC sought not only to bring London schoolchildren into the Horniman but also to redirect the educational aims of the Horniman itself. The student visitor was supposed to be uplifted by the objects on display, in keeping with earlier Ruskinian notions of moral viewing, but the process of visual education was made effective by a vast teaching apparatus that linked public museums to the Technical Board Schools and other state offices. Under the auspices of the Council, the Horniman had been converted from an educational museum to a creature of the London Board of Education—a subtle but profound distinction.[112] The spirit of these reforms is reflected in a photograph taken at the Horniman Museum in 1908 (fig. 15) that shows a group of ragamuffins from a Council school studying the museum's stone-age implements. The Horniman had been transformed into an official branch of the state education office. It was a new museum for the incipient welfare state.

The LCC took an active role in overseeing the Horniman's collections, visiting the museum en masse and then with ladies in October 1902.[113] Gomme

continued to oversee new acquisitions himself, but the Council interviewed po-
tential curators together. They brought in A. C. Haddon, the famed Cambridge
ethnologist, as their advisory curator, confident that he would help transform
this museum into a center of "objective" (object-oriented) education.[114] The
Horniman was acquired during a period of major housing development in Lon-
don, and the LCC made contributions to the collections from its own excava-
tion projects. The Horniman Museum and the London Museum were atypical
in that they stressed the contributions of LCC workers and were established at
a time when such labor was exceptionally visible in the capital city. The work-
ers frequently discovered objects of archaeological and historical interest during
their digs. A report from the LCC's Museums Subcommittee in July 1904 stated
that the Council had given the Horniman "seven pieces of pottery and seven
wooden water-pipes" discovered during the formation of the new tramway.[115]
The report recommended that ten shillings be distributed to each of the work-
men who had unearthed these objects.[116] The LCC's contributions to the Horni-
man demonstrated that objects of institutional value could be derived from more
subterranean regions than the country estate or the urban home. The street and
its workers were new sources of prized hoards. In 1904 the Local Government
and Taxation Committee was reconstituted as the Local Government, Records,
and Museums Committee to reflect the LCC's new sphere of cultural action and
responsibility. Museum business was integrated into the typical Council agenda
of property assessment, street naming, and taxation of land values.[117] The up-
keep of the Horniman proved expensive for the Council, but the committee in-
sisted—despite one grumpy dissenter—that the money was well spent.[118]

The Council was anxious to receive instruction in its new role, and it invited
Patrick Geddes to give a series of lectures titled "Great Cities" at the LCC be-
tween 1901 and 1904.[119] It is interesting to speculate about how Geddes's vision
of the "ideal city" might have influenced the Council's cultural practices. But its
education in these matters was not limited to Geddes. It compiled a library full
of advice texts from private donors who considered it to be in need of artistic tui-
tion. It was presented with a gift of Francis Arthur Bather's *The Museum and the
Citizen* amid a host of more typical though no less eclectic donations, including
a report from the Mines Department of New South Wales, a Board of Education
report from New York, and the quarterly publications of the American Statisti-
cal Association.[120] It also received a catalogue of the antiquities in the Guildhall
Museum. Given the strained relations between the Council and the Corporation
of London, this gift must have rankled some of the councilors. In 1905, the
Council purchased a brand-new copy of David Murray's recent survey *Muse-
ums: Their History and Use.*[121] This study of museums from ancient Rome to the
present must have been a deeply discouraging text for the readers at the LCC.

Murray's treatise emphasized that art institutions must be administered by scientific professionals and not by political bodies. He concluded that museums were of supreme importance to the "well-being of the State" and should be entrusted only to governing bodies of a "stable and non-fluctuating character, independent of party and of the ballot-box."[122] Despite its best efforts, there was perhaps no single body less apt to meet Murray's description of an ideal organization than the London County Council.

By the time the idea of a "London Museum," an institution devoted specifically to London history and artifacts, had gained popularity in official circles, Gomme had proposed a complete identification of the Council and the civic museums of the capital. Emslie Horniman himself had proposed a similar plan for a Council Museum of London as early as 1905, although his own vision of a London Museum was decidedly more antiquarian and thus at odds with Gomme's hypermodern image of the city.[123] Early discussions of a new museum for London had pointed toward a gallery of Gomme's dreams: an institution entirely dependent on support of the Council. Gomme entered into extensive correspondence with the London Museum's organizers, hoping to convince Harcourt and Esher to house it in the projected County Hall complex across from Parliament. The London Museum would thus be tied visually and ideologically to the new LCC offices, promoting Gomme's efforts to make the London Museum into an entirely conciliar endeavor.

In terms of competing notions of the urban "folk," the transfer of objects from the LCC to the London Museum proved to be particularly complicated. From Harcourt and Esher's point of view, the Council was no longer a politically appropriate sponsor for the London Museum. The 1907 defeat of the Progressives at the LCC had opened up a new disjunction not only between national Liberal success and municipal Liberal failure but also between the newly Conservative LCC and the dashing Liberal organizer of the new museum. Loulou Harcourt, who was well-known for his interest in art and archaeology, combined his activities as First Commissioner of Works with the founding of the Free Trade Union and the support of socialist free-trade M.P.s. As the devoted only son of William Harcourt, the great Liberal statesman who had introduced the London Government Bill in 1884 before narrowly missing the prime ministership, Loulou had a proud history of local and national Liberal reform behind him, an equally distinguished career in arts administration, and an impeccable pedigree as a Whig grandee. Esher, who diverged from his friend Loulou in his support for imperialistic expansion, had been strongly influenced by the Radical Sir Charles Dilke in his political training, though his chief activities consisted in mediating between the royal family and the prime minister.[124]

The London Museum represented an effort to transpose the glories of Lib-

eralism to the municipal level, where they seemed to have miscarried. As a result, Harcourt and Esher were wary of Gomme's interest in co-opting this new museum for the LCC, and they rejected Gomme's site proposal.[125] Relations between the Council and the museum officials worsened when Gomme refused to offer the Council's extensive collection of London prints and drawings to the new museum, concluding that these artifacts were vital to the "social work" of the LCC and could not be spared.[126] The Council did demonstrate major support for the London Museum. It placed a number of artifacts from Council excavations on permanent loan and struggled unsuccessfully with the Port of London Authority to acquire its collections for the new museum.[127] But the project of centralization in urban government was not accompanied by artistic centralization. Thousands of relics of London's past were still scattered throughout the metropolitan government offices when the museum opened to the public.[128] The London Museum was not to be a Council museum after all.

Gomme wrote privately to Guy Laking, the ambitious young curator of the London Museum, to express his enthusiasm for Laking's new exhibits. But his approval was tempered by his own elevated, even grandiose vision of London history. He said, "I was much interested in the museum and have nothing but praise for it, except that I am not greatly impressed with the rather garish pictures of London life!"[129] In particular, the folklorist expressed disappointment that the new museum had not given sufficient prominence to artifacts from Roman London (such as the LCC's Roman boat)[130] and suggested that these objects of late antiquity could shore up flagging imperial sentiments in contemporary Britons.[131] For Gomme, who had perceived all museums as engines of empire, Laking's focus on domestic artifacts—on Britain "at home"—was disillusioning. This account of Roman artifacts as a source of imperial pride was clearly at odds with the portrayal of ancient Rome in the Gold Ornaments trial in Ireland.[132] From the Irish point of view, "Rome" had signified a period of English denigration at the hands of foreign invaders. But in Gomme's historicist view of empire, the Romans and their crafts functioned primarily as exemplars: object lessons in imperial rule.

The source of Gomme's disagreement with Harcourt and Esher therefore extended beyond the location of the new museum.[133] If they had accepted the Council's site, the organizers would have associated their collections with Gomme's own view of the function of the "folk" in a modern imperial city. Gomme had been a zealous proponent of expanding academic folklore studies from oral tradition to material culture and written documents; he was thus vitally interested in a collection of artifacts that could support his own theories of historical change. Within the field of academic folklore in Britain, Gomme was noted for his focus on early British man rather than prehistoric "savage" com-

munities.[134] As Richard Dorson has noted, Gomme (unlike his fellow folklorists Edward Tylor and Andrew Lang) found his savages in early Britain rather than abroad.[135] Gomme's notion of London "folk"—and his ensuing vision for the new London Museum, which focused on both prehistoric and imperial artifacts—were grounded in his efforts to situate folklore in a definite ethnographic area with a local archaeological base. His correspondence with the museum's organizers reflects shared enthusiasm for a public collection of Londoniana but also points to a larger set of divisions about the perceived historical significance of London artifacts. Ultimately, while Gomme praised the new London Museum, he also portrayed the Council offices as an alternative, even competitive exhibition site.[136]

The City Corporation's relationship to the new London Museum was considerably more distant. Although Harcourt initially hoped to incorporate the City galleries into the London Museum scheme,[137] he acknowledged that the City seemed entirely uninterested in his project. The Corporation remained aloof from the proceedings, and the individual guilds proved less than forthcoming with their artistic treasures. The London Museum sent more than ninety requests for loans or gifts to the guilds and received only eight acceptances. One newspaper noted that the City had always been purposeful about the preservation of its historic glories, whereas Greater London had not; the opening of the London Museum thus represented a "step towards the realisation of self-consciousness" on a path the City had long since traveled.[138]

In 1911, London was a city riven by fantasy as well as political leadership. As the capital climbed toward the peak of plutocratic splendor, "tales of ballrooms banked high with the loot of hot-houses, of champagne flowing like a sea, of bare backs and jeweled bosoms and fabulous expenditure would fly—with the impetus of fact and the wings of fantasy—out of the West and into the East End."[139] During the early years of the London Museum, the challenge posed by London's warring governing bodies and the competitive experiments at the Guildhall and the Horniman Museum proved difficult to overcome. Although the London Museum was intended to embody the best of the reconstituted capital, its legacy of ambivalence about its own parameters continually frustrated its organizers and the museum-going public. The museum's founders inherited a quagmire of controversy about the goals of civic identity and the fluid relationship between local and national definitions of citizenship. The ongoing "problem" of London produced its own vision of relations between visitors, institutions, and individual and collective ownership. In the end, the London Museum's presentation of urban civics took the museum farther away from the models of civic curatorship inherited from the LCC and the Corporation and placed it in an international context of radical, socialist, and feminist politics in flux.

Urban Revolutions: Making "Civi-otic" History

The Outlook Tower and Geddesian civics were inadequate to London's needs, as was the romanticized pastoralism of Skansen. Ultimately, the London Museum's organizers turned away from the Geddesian model of civic virtue and looked instead to France—an appealing alternative to the impasse between the LCC and the Corporation. Specifically, they turned for inspiration to the Musée Carnavalet, the institution established by the city of Paris in 1869 to illustrate the past fifteen hundred years of its history. The Carnavalet has been described as the supreme example of the genre of city museums, an inspiration of Haussmann's broader project of urban renewal and reform.[140] As depicted by the *Sheffield Telegraph*, the Musée Carnavalet aimed at "the presentation of anything that recorded or embodied the passing history of the city, such as pictures, plans, souvenirs of war, objects relating to civil sociology and progress and so on." The *Telegraph* added, "[A]pply this enterprise to London, the modern Babylon, and its magnificent possibilities are obvious."[141] The London Museum's organizers took the Carnavalet model seriously and competitively.[142] The curator, Guy Laking, wrote to Harcourt, "[A]las they [the Carnavalet] have got a long way ahead of us, and I fear it shall be some years before we shall catch them up. But we will."[143]

Earlier critiques of the Guildhall Art Gallery had rested in part on its failure to live up to the example of the Carnavalet; the gallery at the Guildhall was unable to express the spirit of "municipal patriotism." As the leading English positivist and ardent Ruskinian Frederic Harrison wrote in 1894, the Carnavalet was "a serious attempt to raise a historic monument to the memory of the actors in the fierce communal life of Paris. Our Guildhall reeks only of Jingoism and turtle-soup."[144] But although the Musée Carnavalet was presented as an ideal civic museum in many respects, it was also a politically troubling prototype for Londoners. The British press described the Carnavalet as an institution composed primarily of objects from the French Revolution and other periods of revolt in France's past.[145] The original collections were lost in the destruction that followed the end of the Commune in 1871; this posed important questions about how museums should treat episodes of social conflict and distress.[146] French models of art and political communalization were satirized in the *Daily Citizen*, which reported that "the régime of Republican liberty is nowhere better illustrated than in the French treatment of museum exhibits. . . . If a man wishes to take a famous picture home to contemplate it at his leisure, hardly any obstacle is put in his way."[147] The barrier between individual and institutional property rights was erased in the Parisian collection, and the threat of reappropriation by the enterprising viewer (shades of Wallace Collins) was ever present.

Early critiques of the LCC had focused on the specter of the Commune of 1871,[148] producing a host of apocalyptic British fantasies about French municipal dystopia and local government radicalism.[149] The curator of the Guildhall Art Gallery, A. G. Temple, approached Henri Rochefort—who had been associated with the Commune—to discuss a loan of Rochefort's fine Dutch paintings to the Guildhall but had a crisis of civic faith at Rochefort's doorstep. He described Rochefort as an individual whose ardent energies had been given up to anarchy and whose hands were stained with the blood of innocent persons. He concluded that to ask such an individual to lend his assistance "to an ancient and honoured Corporation, which had for centuries been renowned for its upholding of order and authority," simply "would not do."[150] But the London Museum was more closely modeled on the Carnavalet than the Guildhall Art Gallery had ever thought to be, and the tension between authority and rebellion was built into the institution itself; it was not merely a function of an individual donor.[151] In the context of a London Carnavalet, popularity could never be fully divorced from anarchy, nor the civic from the riotous.

The London Museum was now a testament to a revolution that had never happened in Britain, and the burden of remaking revolutionary civics in a nonrevolutionary setting created a vacuum at the heart of the London Museum project. The archetypal act of regicide that had collectivized France's art treasures was absent, although the impulse toward replicating French civic pride was not. The British were all too aware that the fruits of revolution were public art and culture. As the English journalist W. T. Arnold wrote, French museums were founded on the twin legacies of revolutionary confiscation and Napoleonic pillage:

> Suppose that in our civil war, the noble houses of Knowsley and
> Chatsworth had taken the losing side, that all their goods and chat-
> tels had consequently been confiscated, that the State had set apart
> all the works of art they contained. . . . That is exactly analogous to
> what happened in France. It is more than doubtful whether the
> State in France would have given itself the trouble if it had not so
> magnificent a foundation to work upon, and that foundation was
> secured by robbery, pure and simple.[152]

The price of the nonrevolutionary Liberal British state was an impoverished museum culture. If the founders of the new museum wished to tamper with this pact, they had a politically risky task at hand.

Whereas the Parisian civic museum was perceived as being built to house artifacts of conflict and strife, the London Museum rejected the visual presen-

tation of discord. The museum contained, for example, no relic of Charles I's quarrel with the City or of what one guidebook termed the London "commune"—most likely a reference to the revolution that took place in City government in the 1640s, when the royalist Lord Mayor was replaced by a Common Council.[153] The museum's collections obscured the fundamental divide between the City and Greater London, excising the quasi-independent City from London's "official" civic museum. British newspapers and journals addressed the ambiguities of a "London Carnavalet" either by denying the revolutionary and communard legacy of the Parisian museum or by stressing the different political contexts for the two institutions. Remarking on the Carnavalet's exhibition of communard artifacts, the *Times* drew on long-standing national stereotypes to distinguish French and British modes of citizenship:

> Happily the history of London during the last 250 years has no
> such political tragedies to record; but if the public life to be com-
> memorated in the London Museum is less sanguinary it does not
> follow that it will be much less interesting. In the first place, its be-
> ginnings are immensely ancient; in the second, the continuity of its
> history has proceeded without a break, through centuries of unex-
> ampled growth and unresting change.[154]

French civic history, the *Times* implied, was inherently antimuseological, characterized by gory disruptions. The curator must impose a false sense of continuity or progress on what was in fact a disjointed account of violence. At the London Museum, English constitutionalism had produced the unexpected benefits of aesthetic unity and visual purity: an unbroken line of artifacts, history, and property.

Initially, the London Museum's collections were housed in Kensington Palace, spatially cimcumscribing the Carnavalet's revolutionary associations.[155] French museums were founded on royalty's destruction, but their London counterpart nestled in the set of kingly pomp: a folk museum in a regal setting.[156] The history of the British Crown was differentiated from that of the luckless French monarchy at every point in the London Museum's history; "London is happy in being able to bestow this new collection of relics in a palace which is no mere survival of feudal rapacity or civil war."[157] Carnavalet civics had been re-monarchized and de-revolutionized for British use. The *Irish Times* focused on the Carnavalet's history as the private residence of Mme de Sévigné, the late seventeenth-century *salonnière*.[158] The personal history of the original female owner was foregrounded instead of the national and local annals of revolution,

and the Carnavalet was reinterpreted as a domestic, aristocratic, and fundamentally feminine institution.

But revolution was not an easy element to expel from the London Museum. The sheer number of visitors that this museum brought to the palace constituted its own form of social friction, and some observers worried that the palace would be destroyed by overuse.[159] *Reynold's Newspaper* reported that the opening events had "so annoyed some of the ladies occupying apartments in the Palace that they have asked their relatives to remove them. They cannot endure the prospect of being brought into close contact with the proletariat."[160] The museum's opening coincided with a coal strike, and some newspapers suggested that the enormous popularity of the new collections was due to the fact that the trains weren't running out of London.[161] Londoners had been compelled into civic virtue and duty by the circumstances of national unrest—a retreat into the local and the municipal in the face of larger patterns of cooperative agitation. But Ethel McKenna, a writer for *Connoisseur* magazine, suggested that the museum also functioned as an antidote to collectivization: "[E]ven if politically we tend towards socialism, the individual personality, as expressed by personal belongings, is of overwhelming interest."[162] The objects of households past, McKenna suggested, would bind Britons together in defense of that ancient bulwark of British political liberty: free expression of the will for individual ownership rather than socialist collaboration.

The projected number of donors to the London Museum was so high that the *Evening News* felt bound to remind its readers of the continued importance of private property and individual collections. The editor argued that certain owners of London treasures should *not* give them to the new museum, because "the spirit of the individual collector is valuable to the State" and outweighs the enrichment of the public galleries.[163] The ideal donors were those who had inherited objects that were of no interest to them or those who were sufficiently altruistic to sacrifice "their own pride of possession."[164] Potential donors were grouped into true connoisseurs, who were tied to their property by the individual taste that had led them to acquire it, and "ordinary citizens," who made their property meaningful only by ceding it to the municipality. The state, then, was equally well served by those who kept and those who gave.[165] The potential tension between communalizing artistic property and protecting the status of the individual British collector—in effect, the incipient conflict between personal property and civic sentiment—was salved by this careful categorization of donors into givers and keepers. Civic enthusiasm within the London Museum was measured not simply in terms of attendance but in the redistribution of private property, a sign of the collector's willingness to disrupt the process of inheri-

tance. Within the framework of this "populist" and popular institution, the defense of private property seemed as vital to the *Evening News* as the promotion of a national collection.

The London Museum's organizers quickly found that "popularity" posed certain problems of its own. The curators were continually accused in the local and national newspapers of pandering to visitors' baser desires for ostentation and gore. The miniature panorama of old London, which contained a wax model of a hairy Roman Briton in his canoe, was termed "a concession to the popular almost unexampled" among public collections.[166] In particular, exhibits relating to the old Newgate prisons were professionally perceived as "gruesome."[167] The mayoress of Kensington, I. Blanche Thompson, objected to the prison relics on the ground that they soiled children's imaginations, and the *Kensington News* denounced the reconstructed prison cells as catering "to the cravings of the morbid."[168] Instead of producing a citizenry of moral, rational museum visitors, some observers feared, the London Museum would inspire criminal behavior and a sociopathic spirit.[169]

In the depiction of civic history, the London Museum had two choices: male crime and female virtue. The new museum's "chamber of horrors" was contrasted unfavorably with other provincial civic institutions, even those that did not conventionally serve as exhibition spaces. The highly popular *Illustrated London News*, for example, invoked the stained glass display at Liverpool Cathedral's Lady Chapel in direct contrast to the London Museum because of the chapel's depiction of " 'Catherine Gladstone and all good wives; Angela Burdett-Coutts and all almoners of Heaven; Grace Darling and all brave women,'—and so on."[170] This opposition of masculine and feminine historical narratives—cast here in terms of degeneration and progress—provided the basis for a moral critique of Laking and his colleagues. This concern prefigured the gender debates that would later envelop the London Museum as the female "vice" of radical suffrage became easier to see.

The press also complained that this museum's presentation of London was insufficiently lofty, even downtrodden. Visitor loyalties, secured by the inclusion of the everyday and the mundane, were gained at the expense of London's grand Whig history. The *Times* feared that civics could not survive in this context of the inglorious. The museum's depiction of social history had erased any vision of London's role in larger historical narratives and undermined the central Geddesian tenet of the civic museum—namely, that it must connect the city to larger units of collective life.[171]

Printed satires pictured the new museum as a potential storehouse of recent political memorabilia, in which Radical and feminist challenges to Liberal orthodoxy might be consigned to the realm of institutionalized nostalgia. These

satires raised important questions about what could safely be labeled "past" or "present" in the rapidly changing political and material landscape of London. The museum undertook the first publicized act of contemporary collecting in its 1912 acquisition of a Hansom cab, displayed while there were still a thousand Hansoms at work on the London streets.[172] The comprehensiveness of the collections led the editors at *Punch* to deride the museum's founders for leaving out such key relics as "the first 'H' dropped by the first Cockney . . . and bottles containing samples of London fogs."[173] The *Graphic* satirically listed among the museum's oversights an Independent M.P. and the last London chaperone.[174] Most strikingly, *John Bull* questioned Laking's ability to represent the "real" London; he had omitted such important artifacts of conflict in contemporary civic life as the cells occupied by suffragettes, feeding tubes used on Mrs. Pankhurst at the prison at Holloway, and David Lloyd George's Insurance Bill.[175]

Other newspapers criticized the more sensationalistic aspects of the London Museum, arguing that it functioned as a government-sanctioned shrine to Gothic melodrama.[176] Catherine Ross has recently described this model of curatorship as a "pageant paradigm," in which theatrical display techniques took precedence over more traditional conventions of installation.[177] As one editor of the *Westminster Gazette* lamented,

> Sentimentalism is part of the British constitution. But it is surely a new thing to see this sentimentalism formally and officially organized by those in authority, passed and approved by our governors as an item in the national curriculum. . . . I can imagine an impressionable retired Army officer weeping in the London Museum. I picture to myself a girls' school positively drowned in tears, each member of the band passing out into the Broad Walk of Kensington Gardens with red eyes, her right hand grasping a little wet ball of saturated handkerchief.[178]

For this editor, object-centered observation had not resulted in the nation of abstract and rational thinkers that Geddes and Horniman might have envisioned. Rather, the London Museum had taken the native British weakness for the mawkish and the maudlin and, unforgivably, given it institutional life.

Laking's public appeal to London residents for artifacts and artworks prompted an outpouring of offerings to the museum, and labor and services were volunteered along with material objects.[179] The scope of the new museum seems to have been poorly understood even by its donors, and Laking often had to remind Londoners that this museum had a local purpose.[180] He was given a collection of paintings produced using the occult powers of a psychic, drawings

of India, and a gun owned by Robinson Crusoe (also known as Alexander Sal-kirk), none of which could be said to pertain directly to London history. The would-be donor of the gun, Randolph Berens, stressed the imperial rather than the local relevance of his artifact. He claimed that he had already received an of-fer from the Edinburgh Museum, but "What I should *like* to do would be to leave it to the children of the British Empire so that they might flatten their little noses against the glass case and see the actual gun that Robinson Crusoe had with him on the Island."[181] Berens seemed motivated solely by the location of the new museum, not by the scope of its collections—although his offer did reflect in part the infinitude of what people considered "London" artifacts. The royal con-nection was similarly confusing; many donors presented royal memorabilia that had little import for London history specifically.[182]

Those who donated objects to the London Museum expressed a range of motivation for their gifts, including financial gain and the desire for status. When Berens offered Laking the Crusoe gun, for example, he added that an American buyer—always the bugbear of the Edwardian art market—might pay two thou-sand pounds for it, "so its fate lies in the lap of the market.[183] But most also men-tioned the desire to contribute to the glorification of London. One potential benefactor characterized this sentiment as "civi-otic." Offering Voltaire's letter of eulogy to England as the land of philosophers, this donor continued, "it is the duty of every civi-otic Londoner to support you in your efforts—so far won-derfully achieved—to make the London Museum a thing of increasing beauty and interest."[184] "Civi-otics," a neologism describing the union of patriotism and civics, was thus developed within the context of the museum itself—a cul-tural solution to the political problem of London's overlapping local and national identities. The museum was credited in the press with the invention and suste-nance of "London patriotism," that is, the patriotism of the city.[185]

The *Manchester Courier* acknowledged that the new museum was unlikely to "lead to an explanation of the Home Rule question or of syndicalism," but it provided the breadth of outlook, the sense of historical sweep, in which the pres-ent generation was thought to be so woefully lacking.[186] This museum would do more than provide an education in the history of London; it would change the visitor's perception of social history itself. On the brink of World War I, the Lon-don Museum was a final hope for resolving the problem of London civics, a last resort for bringing Londoners not only to the worlds of art and history but also to the much-needed joys of common feeling. The museum was indeed a prod-uct of unification and reform, but mainly as a preemptive measure to counter the cultural hazards of centralization—impressing the Londoner with the unity and dignity of his city despite the haphazardness of its government.[187] The London Museum compensated for the "civi-otic" sentiment then lacking in the Lon-

doner, and the visitor was entirely dependent on the reeducation it offered for his "civi-otism." As one guidebook suggested,

> The galleries of the London Museum tell the story of centuries; but every street of London is built upon the centuries, and speaks with their voice, if we could but hear it. The Museum interprets for us their speech, lights up their life, gives resonance and pomp and inspiration to their language that is not dead, but only sleepeth. He is a bad Londoner who has not learnt that mother tongue.[188]

The use of the phrase "mother tongue" conflated the languages of national and civic sentiment, illustrating the localization of British identity within the new museum.

But was it really a "London" museum? From its first days, the royal relics were by far the most popular collection in the museum.[189] Laking was professionally attacked on this front; other curators suggested that he had sacrificed the parameters of local history to the visual thrill of state regalia.[190] The problem of defining and procuring "London" objects, given that London no longer functioned as a major center of industry, posed another dilemma for Laking. Responding to Laking's call for donations of London pottery, the *Times* asked, "how many of the pots are merely naturalized citizens and not London-born? For the collections are as cosmopolitan in origin as the population of London herself."[191] This museum was, the *Times* implied, a graveyard of London's consumer history, and a graveyard of questionable local specificity. Although the curators called for Chelsea and Bow porcelain, Battersea enamel, Lambeth pottery, and Spitalfields silk, these items were all presented as relics of an industrial past.[192] Some of these industries, such as Spitalfields silk-weaving, had already been described in detail in Henry Mayhew's *London Labour and the London Poor* and were thus familiar to British readers in a very different context.[193] But now London no longer produced objects; it only institutionalized them.[194] When Laking sought to promote native artistic productions, he was compelled to turn back to medieval faience for lack of more contemporary urban industry.[195]

This curatorial analysis of decaying industry in London marked an important departure from the Continental folk ideal promoted at Skansen. Whereas Hazelius's objective was to memorialize the objects of peasant craft production before they could be entirely erased by industrialization, Laking was confronted with the task of trying to memorialize industry itself—or integrating certain kinds of industry into the history of the urban folk. To this extent, London itself was the real museum; the London Museum was only the "lying in state of dead London."[196] The institutional perception of the death of London industry was

perhaps exaggerated. As Helen Douglas-Irvine noted in her 1912 history of the city, London still served as a center for the production of cheap furniture, ready-made clothing, rubber, fur, envelopes, cardboard boxes, and wholesale boots and shoes—as well as supplying material for the manufacture of soap and glue.[197] But these industries drew little interest from Laking and Harcourt. Whereas Geddes's camera obscura at the apex of the Outlook Tower had attempted to unite the civic museum with the living city, the London Museum had no such material marker of economic action and contemporaneity.

Unifying London within the museum proved as difficult as without, and the problem of circumscribing London's boundaries plagued the museum's directors. Visitors and donors often wrote to Laking to question his definition of "London" as it was revealed in the museum's collections. One E. E. Newton, for example, argued that the new museum failed to correspond to the political de-lineation of London laid out so recently by the LCC. The London Museum, Newton concluded, had placed itself at odds with the conciliar view of the city.[198] Steering between the various conceptions of London offered by the LCC, the Corporation, and Londoners themselves, this museum sought inclusivity in-stead of narrowness in its own definition of the capital. Only a year after the Lon-don Museum opened to the public, the *Globe* suggested dispersing the collec-tion into different districts in order to stimulate "neighborhood" patriotism.[199] The *Chiswick Times* also proposed establishing an array of smaller "London" museums, each dedicated to one of the vast variety of neighborhoods that com-posed greater London.[200] Even when London's identity was made concrete with relics and guidebooks, it subdivided before the viewer's eyes into smaller and more discrete units until the notion of a coherent "civic London" disintegrated altogether.

In 1913 the London Museum moved from Kensington Palace to Stafford House, a historic residence near Saint James's Palace that had served as an im-portant site of Victorian social and political life. The building was donated by Sir William Lever, later Lord Leverhulme, the great soap magnate, art collector, and founder of the model village at Port Sunlight. Lever had originally wanted to use the residence for a gallery of British art but was convinced by Harcourt that an ur-ban history museum would ultimately be of greater philanthropic import.[201] At Stafford House, the collections were reorganized according to strict chronologi-cal principles as opposed to type of object. The visitor ascended through the var-ious eras and epochs of London history and then descended to the basement, where the remains of the Roman boat discovered by the London County Coun-cil were housed in a specially made pit. A picture gallery, theatrical artifacts, crime relics, and royal memorabilia were placed in separate rooms. The London *Times* initially objected to the move, arguing that Stafford House served as a sign

of the "aristocratic exclusiveness" of London's geography.[202] The *Freeman's Journal* offered a different interpretation, arguing that the move brought the London Museum even closer to the Carnavalet model: Both institutions were housed in magnificent old estates that had lost their aristocratic bearings, and both had become fatefully subject to the will of the people.[203]

"Civi-otic" Women: Mothers and Suffragettes in the London Museum

The tensions between the museum's industrial and proto-socialist elements were matched by growing anxieties about the museum-going audience—in particular, anxieties about female visitors.[204] Professionally innovative in its focus on domestic objects, the London Museum reinterpreted its female audience according to the institutional context of the folk museum and the political context of radical feminism. The same officials and administrators who had presented their idea of a museum as a feminized space, a seeming union of domestic goods and womanly pride, were confronted with an unforeseen revolutionary element of the museum-going public: the "wild" suffragette who destroyed the museum, rather than the housewife who created it. The Geddesian notion of the ideal city had delineated an important role for women in the promotion of civic values.[205] But the London Museum's reformulation of modes of citizenship, in particular its amalgamation of civics and patriotism into "civi-otics," offered new fields of possibility for conceptualizing female participation in the related realms of art, property, and politics.[206]

The public perception of the London Museum as an institution of disproportionate interest to women was in part grounded in the reality of unprecedented numbers of female donors. Art collecting by women had been growing in status and strength since the passage in 1882 of the Married Women's Property Act, which allowed married women to hold property and enter into contract as if they were *feme sole*.[207] But this museum's revaluation of household objects as worthy of preservation within its walls, regardless of aesthetic worth, broadened the socioeconomic basis of womens' collecting and located the primary site of civic connoisseurship within the home.[208] The London Museum also benefited from the increased visibility of women in the late Victorian and Edwardian capital, from the shopper to the journalist to the social investigator. The notion that women were observing urban spaces in new ways during this period gave credence to the new museum's philosophy that women were particularly important collectors of urban history, in the streets and at home.[209]

Women were a crucial link between museums and the world of domestic goods. To this extent they were key members of the "civi-otic" community. Writers such as Grace Vallois offered guides such as *Antiques and Curios in Our*

Homes (1912) and *First Steps in Collecting* (1913) to interest owners of "home" treasures in their own possessions. Similarly, Frederick Burgess's guide for collectors noted that "conservative" English housewives were largely responsible for the excellent condition of the trivial *objets d'art* now in high demand by professional curators.[210] Vallois did acknowledge that art collections were often formed out of the personal tragedy of another collector, highlighting the gap between "legitimate" inherited collections and an artificial art market that interfered with the prototypically British system of inherited property—now under siege in the wake of the People's Budget.[211]

Other institutions, such as the Pitt Rivers Museum at Farnham, had also crafted historical displays dealing with women's labor. These displays were part of a larger curatorial argument about evolutionary progress. That is, modern-day female visitors could examine the objects over which their predecessors had toiled and be grateful that they so little resembled the "beasts of burden" they might have been in another time and place.[212] At the London Museum, the topic of women's labor had a more sharply contemporary focus. Women donors wrote to Laking to offer their household collections, to critique his curatorial practices, and to present their own handiwork.[213] The embroideress Florence Canfield submitted her "beautiful robe, embroidered and woman's work" and a cape stitched with fifty-two different flora; both were her original designs.[214] She cited the years she had spent collecting the specimens of flora in their natural state as well as her recent exhibition at the Ritz Hotel, intended to encourage women's paid labor, clearly believing that such a résumé would impress Laking. Indeed, Canfield's robe was one of the few items purchased for the museum rather than donated. The London Museum seems to have become a receptacle not only for domestic relics but also specifically for women's work.

The correspondence between Laking and female donors presented this museum as a site of valorized domestic property. At the same time, the press was telling another story, one in which the London Museum functioned as a displaced site of conflict about the meaning and value of domesticity itself. Fashionable "society" periodicals for women, such as *Queen, Lady, Ladies' Field,* and *Lady's Pictorial* offered extensive coverage of the museum's collections. But even apart from the "women's press," this museum was treated as fodder for a female readership; reports about it were carried on the ladies' pages.[215] The *Liverpool Courier* printed a series of editorials titled "From London Town: A Woman's Letter," which exhorted all British women to visit the London Museum as soon as possible.[216] But the press seemed fearful about defining women as public-spirited property owners in an age of feminist discontent. Coverage of the London Museum carefully occluded female ownership of art, allowing readers to ignore the gendered basis of these collections and dispelling anxieties about

women's changing relationship to property. As the *Ladies' Field* put it, the new museum was a repository "of the lost," bringing together the "trifling objects of everyday existence. We cannot get on without them, yet we despise them."[217] This museum emerged as a project of recovery for domestic experience, while the objects of this experience were alternately cherished and degraded.

The press depicted the costume section and royal relics as the most "feminine" elements of the new museum; the supposed attraction of the royal galleries for women visitors was legendary.[218] The royal collection came to function as an education in motherhood and a paean to Victorian mother-child relations in particular. Referring to King Edward's baby shoes, the highly popular *Daily Sketch* predicted "how London mothers will press to see those souvenirs of babyhood so tenderly preserved by that most motherly of Queens, the great Victoria!"[219] These collections, then, provided object lessons in maternal virtue for a female audience. Victoria was constructed as the ideal female collector, who focused her energies on preserving the artifacts of male childhood rather than acquiring her own property or destroying the collective property of men. In this, at least, the press hoped that all women visitors would emulate her.[220]

The press characterized gifts from women to the new museum as a "national sacrifice," often with quasi-sexual overtones.[221] The *Christian Age* cautiously praised Queen Mary for displaying her bridal dress, although the editors believed that the gown should have been packed away in lavender rather than exposed "to the gaze of all visitors."[222] Yet apart from the royal collections, the London Museum was depicted as an exhortation to appropriate womanly behavior—an important outpost of Conservative education for domesticating New Women.[223] Similarly, press reports of female interest in this museum were taken as a promising sign of anti-suffragist public sentiment. For example, the fashionable society periodical *Queen* suggested that the London Museum's collection of cradles forged a cross-temporal connection among women throughout the ages. As the journalist Louise Gordon-Staples wrote, no matter in what age, clime, or station of life, "the same spirit animates the soul of the woman who is preparing a cradle for her child, the spirit that is strong to ensure that her jewel shall be given the most beautiful setting that it is within her power to secure."[224] Feminine property was recast in solely maternal terms, working against the social, political, and economic effects of the recent Property Acts.

While the press sought to undercut the notion of feminine patrimony by associating it with maternity and domesticity, it presented an equally powerful image of the female viewing audience as both covetous and consumerist.[225] Newspapers and journals concluded that women understood the London Museum as a shoppers' paradise rather than as a site of "civi-otic" feeling; they craved the depletion of the museum's goods as in any ordinary department store. In another

gendered division of civic museology, this museum was presented as a fantasy of "civi-otic" history for male audiences and a fantasy of conspicuous consumption for women. The London Museum apparently brought women no deeper understanding of their abstract political natures; rather, it situated them ever more firmly in the world of base material greed. The *Daily Graphic* noted that the museum's collection of London jewelry would "lead to much damaging of the Tenth Commandment . . . by ladies especially."[226] Another journal suggested that the museum might fund its expanding collections by hawking copies from the jewelry collection to its female audience. "Nearly every woman I heard discussing [the jewels] was suggesting getting some like them—replicas, of course. If the museum can copyright the design—it might easily secure a small income from the sale of reproductions of those pleasant seventeenth-century ornaments."[227] The museum experience of "civi-otic" education was incorporated, for the female viewer, into a larger consumer event. As the *Christian World* happily noted, ladies would be able to combine an hour at Stafford House with "a shopping expedition and tea in one of the fashionable tea-shops of the neighbourhood."[228] As in the case of the disappearing Holbein, women were placed at the heart of the evolving connection between the museum and the marketplace. The public focus was not primarily on women's consumer power but on the seemingly inevitable ill effects of this power on British heritage.

This depiction of the female viewer as inherently insatiable was certainly not unique to the London Museum.[229] *Punch* cartoons often satirized women's treatment of art exhibitions as a sort of fashion show or expensive shop.[230] But this representation of the female viewer was strangely at odds with the realities of the London Museum's collections. Somehow, the property-owning women who had donated their goods to this museum had been transformed by the press into pre-propertied consumers. Arguing that women often discarded high-quality collections as "rubbish,"[231] the *Evening News* described the London Museum as a refuge from women—a safe haven of collective masculine self-possession. One guidebook juxtaposed a paragraph about this museum's "domestic" collections with a satire of ladies' devotion to china, chronicling the tragicomic tale of a female collector who went mad when she broke her latest acquisition and then decorated her cell in Bethlehem Hospital with Chelsea urns.[232] Museological notions of value, public-spiritedness, and preservation simply went awry when they were applied to women. As an earlier guide had suggested, "most true women are vandals at heart."[233] Laking emerged as the savior of London relics, tastefully distinguishing between the rubbish and the artifactual. Laking's task was to purge the "folk" of the "feminine." But for him, the world of old London would be forfeited to indifferent or greedy female hands.

Early in the London Museum's history, the fashionable *Lady's Pictorial* had

praised the curators for depicting fully the role women had played in urban life. Although a museum containing London relics might not at first appear to have interest for women, it was "a place every woman should see, for it emphasizes in a quite extraordinary way the part that women have played in London's life from time almost before London may be said to have existed."[234] To this extent, the editors implied, the curators embraced a proto-feminist vision of social history or prehistory.

But this optimistic vision of the London Museum as an incipient site of women's history soon gave way to a more alarming image: the museum destroyed by "wild women" or suffragettes. The opening of the London Museum coincided exactly with a series of attacks by suffragettes on art, and this fact was central to the complex presentation of gender and politics in the new collections. In fact, Loulou Harcourt's home, Nuneham House, was the target of the first attempted suffragette attack on record.[235] As the Liberal *Daily News* put it, the London Museum and the science of "civi-otics" had both been founded during a state of siege imposed by suffragettes.[236]

The suffragettes' attacks tended to target established institutions such as the National Gallery and the National Portrait Gallery, necessitating an increased police presence (fig. 16).[237] In fact, in 1912 the Criminal Record Office issued photo charts of "known militant suffragettes" to the police at these galleries (fig. 17). It was a fascinating series of snapshots, in which feminists appeared in states ranging from high glamour to apparent dementia. Photographs such as these were among the first secret surveillance images taken in the United Kingdom. Because jailed suffragettes often refused to be photographed, some of the shots were taken covertly while the women walked around Holloway Prison's yards.[238] The aim of these photographs, which varied in style from the publicity still to the mug shot, was to identify the most dangerous women before they caused any damage to the treasures at these galleries.[239] But the London Museum was also a potential site of attack. Its collections were sponsored in part by an anti-suffrage politician, and its link to a revolutionary urban history in France was never entirely forgotten. Loulou Harcourt was a steadfast opponent of women's suffrage; indeed, his determined opposition was one reason the Liberal Party found it so difficult to sponsor suffrage legislation in the years before World War I.[240] The London Museum's inauguration at Kensington Palace was delayed in part because it was feared that "certain ladies, *not content with the opening of the Museum,* might endeavor to open the cases with a view to proving their fitness for the exercise of legislative functions."[241] The *Daily News* thus depicted the new museum as a possible compensation for the vote: a civic and cultural displacement of national political rights. But the suffragette was not, as the paper implied she should be, satisfied with what the state and the municipality had

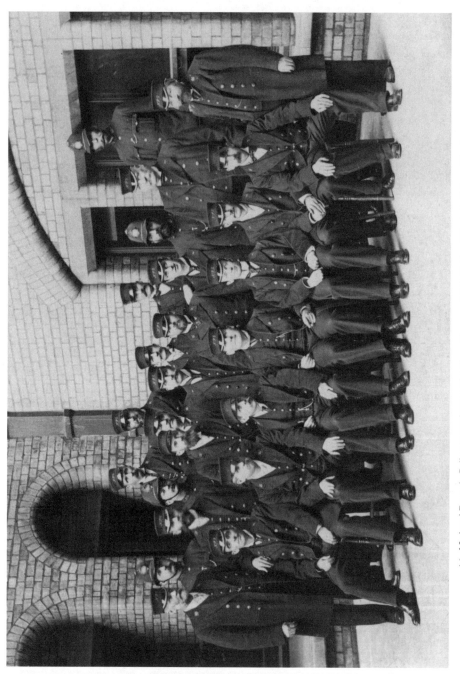

16. National Portrait Gallery attendants and police officers, c. 1900. National Portrait Gallery Muniments. Courtesy of the National Portrait Gallery, London.

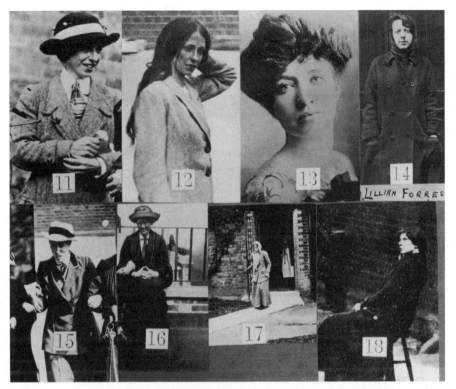

17. "Photographs of Known Militant Suffragettes," 1912, National Portrait Gallery
Muniments. Courtesy of the National Portrait Gallery, London.

jointly offered her: a public culture of preserved domesticity. Despite Laking's
curatorial efforts to purge women's property of its radical elements, the specter
of suffrage haunted the London Museum's organizers.

In Britain, the downfall of the museum had been predicted many times.
From the spontaneous threat of violence at the Collins march to the legal debates
about repatriation during the Gold Ornaments trial, the survival of museums
was a vital question for Edwardian curators, collectors, and politicians. In liter-
ary terms, even the women's angle on this process of deaccessioning had been
anticipated. In Edith Nesbit's *Story of the Amulet* (1906), the queen of Babylon
travels from the distant past to modern London. The magical property of time
travel is derived from the titular amulet, which, Nesbit implies, was wrongfully
brought to Europe by Napoleon.[242] The queen is appalled to find that her prized
possessions have been imprisoned in the British Museum. She announces im-
periously to the museum guards that all the jewels in the glass cases belong to
her, and she tries to smash the cases. The guards kick her out, calling her a "poor

demented thing." But when she wishes aloud that all the Babylonian artifacts in the museum would "come out," her wish is magically granted. Glass shatters; the objects fly out into the street in chaos. It is an amazing fictive episode of forceful repatriation, in which the foreign queen stakes her claim to "British" goods. A journalist mistakes the queen for the Theosophist Annie Besant and publishes an article about the "spiritualist" incident titled "Impertinent Miracle at the British Museum."

By the end of Nesbit's story, the objects are back in their "rightful" place at Bloomsbury.[243] But outside the realm of fiction, the theme of demolition—not by wayward queens or theosophists, but by radical feminists—became a persistent fear at the London Museum and elsewhere. The threat of broken glass was an increasingly frequent marker of urban feminist discontent. Anxieties about disturbances by suffragettes represented the culmination of several years of debate about the London Museum's alarming popularity. When the French Revolution did come to London, it seemed to have taken a feminist turn. After the London Museum opened at Stafford House, elaborate precautions were taken against suffragette attacks; women visitors were required to turn in their handbags and muffs for inspection, and their umbrellas and walking sticks were confiscated.[244] One journalist reported that he had recently conducted two "tame, sedate, and delightfully middle-aged ladies" to the museum and that

> It was as thrilling as a paper-backed detective novel. . . . At the turn-
> stiles a sergeant resolutely held us up until both ladies had nervously
> opened their hand satchels and each little feminine gewgaw inside
> had been ruthlessly fished up and exposed to view. . . . We felt quite
> desperate characters. A lady journalist who happened to be wearing
> green and mauve [the colors of the Women's Social and Political
> Union] assured me she had a regular posse of Scotland yard men
> after her all the time. She said she did not know whether she felt
> more like a Cabinet Minister or a ticket-of-leave man.[245]

As reports of feminist antimuseum plots intensified, the press established a complex relationship between the ideal female viewer—the responsible and sentimental collector of domestic objects—and the demonized suffragette, who posed a threat not only to the art heritage of Britain but to the corporate property of other women, the tools of home and hearth so recently elevated to museum status.[246]

As earlier chapters suggest, the organizers of the London Museum were not the first to be wary of urban crowds and protest politics. But owing to the timing of its opening, the hazards of the unruly public—especially a public of an-

gry urban women—seemed particularly immediate. In yet another account of the delayed opening, one journalist reported, "There is every sign that they (the wild women) are in the mood to be taught."[247] The London Museum was perceived as a retraining ground for the suffragette as well as a possible focus for her outrages; it was a site of reeducation in the powers, responsibilities, and limits of good citizenship.[248] It alone might succeed where other measures of Liberal education had failed, binding the suffragette to the government that had created this uniquely "feminine" institution.

Within this context of contemporary political discontent, the ideal of the female viewer that emerged at the London Museum was fundamentally backward-looking. Much of the press coverage of the museum that was intended for women readers focused on this notion of depoliticized nostalgia, associating women with the social and domestic life of London past rather than the uncomfortable political present. For example, the journal *Lady* published an exposition of the new museum in the form of a fictive letter to "My Dear Granny," who was supposed to be devoted to the study of London.[249] More strikingly, Leonard Raven-Hill's *Punch* cartoon for March 1912 depicted London itself as an aging and bespectacled woman (fig. 18).[250] In this image, Lady London peers over the display cases, exclaiming, "Bless My Soul, What a Life I Have Led!" Her life is invested with meaning by the museum experience alone, and her understanding of her past as being historically significant is a museum-induced revelation. She examines the Saxon and Norman tools and implements—what we might call the "hardware" of history rather than the theatrical or royal baubles and costumes that real-life women were thought to admire. The caption reads "A Lady with a Past," evoking the notion of a personal, sexualized history as well as the "objective" history of the relics before her. She wears a model of Saint Paul's Cathedral on her head, testifying visually to the geopolitical inclusivity of the new museum and incorporating the cathedral in the independent City into the museum history of Greater London. This deployment of women as abstract political symbols was nothing new; the depiction of Britannia as the embodiment of the nation-state, for example, had a long history in British visual culture.[251] But this cartoon of a feminized London was situated in a specific historical discussion of radical feminism and the public gallery, conflating the collector, the consumer, and London herself. The "civi-otic" history depicted in the London Museum turns out to be a chronicle of feminine experience, but the satirical characterization of London as literally near-sighted undercut a feminist reading of that experience.[252] London in the museum was always a lady, not a suffragette.

Suffragettes' attacks on works of art have received the most scholarly attention when they dealt explicitly with the female nude. Of these, Mary Richardson's 1903 attack on the *Rokeby Venus* is perhaps the best known—as much for

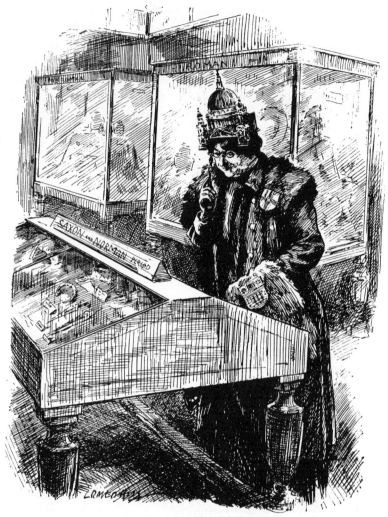

A LADY WITH A PAST.

LONDON (*in her new Museum at Kensington Palace*). "BLESS MY SOUL, WHAT A LIFE I HAVE LED!"

18. "A Lady with a Past," *Punch*, March 27, 1912

Richardson's statement that she sought to "rescue" the painting from the ogling eyes of male visitors as for the high status of the Velasquez canvas she attacked.[253] I wish to examine a lesser-known episode of feminist violence against a work of art: Annie Hunt's attack on Millais's portrait of Thomas Carlyle at the National Portrait Gallery (fig. 19). My aim is not to consider the Millais painting in terms of its fuller significance within the canon of British portraiture, but rather to fo-

cus briefly on Hunt's attack for what it says about patterns of feminist protest before the Great War.[254]

Although this attack took place at the Portrait Gallery rather than the London Museum (and thus also speaks to many of the questions set out in chapter 3), the press reports regarding Hunt's attack were primarily concerned with the same questions of value and valor that characterized debates about the London Museum. The attack took place on the morning of July 17, 1914. It was a students' day at the gallery, so attendance was relatively light compared to "free" days, and the other visitors were engaged in copying portraits. The guards saw a young woman walking from picture to picture, apparently engaged in admiring the various works. She stopped in front of the Millais portrait of Carlyle, took a butcher cleaver from the folds of her dress, and struck quickly and with shocking force. She smashed the glass and slashed the canvas in three places: from below Carlyle's right eye to just below his beard, from his lip to his left eye, and on the left side of his forehead.[255] After the first blow, an art student named Miss Payne tried to grab the attacker, but Hunt proved too strong and continued to strike at the portrait, her hand bleeding profusely from the shattered glass. A guard who later became head attendant at the gallery, Mr. Wilson, eventually subdued the attacker.[256]

As with the trial of Wallace Collins, the court proceedings for Annie Hunt proved to be an unruly affair. Hunt was disruptive throughout the session, mak-

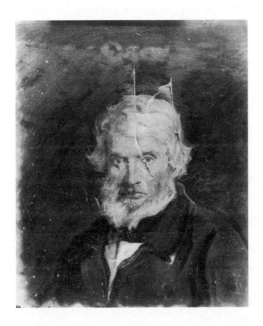

19. John Millais, *Thomas Carlyle* (National Portrait Gallery, London), after attack by Ann Hunt, 1914. Courtesy of the National Portrait Gallery, London.

ing a rush from the dock announcing that she did not recognize the court's right to try her. Like Mary Richardson, Hunt mentioned the compelling powers of Mrs. Pankhurst as a motivation for her attack.[257] She had attacked the portrait, she said, in order to draw attention to the rearrest of Mrs. Pankhurst as well as to protest the government's refusal to hear a deputation of suffragettes.[258] In this sense, Hunt's assault was entirely conventional within the rubric of radical feminism. She was sentenced to six months' imprisonment, though she was not made to pay for the damages.[259] The gallery's guards were instructed never to admit her again. The portrait, as the curators happily noted, could be restored. After it was whisked away for repairs, the frame and its broken glass were carefully preserved and replaced on the wall, a material testament to feminist anarchy in the realm of fine art.[260]

After sentence had been passed, Hunt addressed the court. She developed another rationale for her actions in which Mrs. Pankhurst played a less prominent role. The portrait of Carlyle, she suggested, would now take on a new historical meaning. She instructed the court that the painting would now "have an added value" and "be of great historical interest because it has been honored with the attentions of a militant."[261] Hunt's claims were grandiose, but the response at the Portrait Gallery was equally dramatic. In a letter to the director, Charles John Holmes, one observer noted that "the fact that people of good intent were standing by and unable to prevent the outrage shows how much we are really at the mercy of women who are determined."[262] A little more than a week before the Great War broke out in Serbia, and less than a month before Britain entered the war, Hunt's attack spoke to a late moment of radical feminist protest. In Hunt's terms, the portrait's true value was derived not from its original role in the canons of British portraiture—nor, indeed, from the significance of its subject—but rather from its intended destruction at feminist hands.

Suffragette attacks such as these abated after 1914. But the gender politics of the London Museum became increasingly complicated as Britain headed toward war. When museum officials contemplated closing for the duration because of diminished manpower, the *Manchester Guardian* countered that women would happily volunteer in this new sphere of museum work.[263] Women members of the Art Teachers' Guild quickly replaced official museum guides.[264] When the museum announced that it would shut its doors until it could guarantee the safety of the collections,[265] the *Globe* published an editorial titled "A Farewell Visit," offering readers a last look at this bastion of "civi-otics" before they faced the Hun. The final prewar image of the London Museum was one of the triumph of feminized knowledge within a "civi-otic" framework. This museum's lessons of civic education had been transposed into a scheme of collective curatorship for women. As the *Globe* concluded, "[W]herever one turned

there was practical knowledge and love of London going on. . . . One passed group after group in which an elder woman was instructing a younger upon some stage of the growth of London." [266] The journalist noted that whereas there had been many soldiers present on his last visit to the British Museum—that great repository of masculine imperialism—the air of general camaraderie produced by this outpouring of feminine enthusiasm at the London Museum was far more inspirational.

The political implications of incorporating a specific vision of femininity into "civi-otics" just as debates about women's inclusion in the national political process were intensifying were profound. Museum officials, the press, and the women who participated in the construction of "civi-otics" by their visits and donations to the London Museum vied for ownership not only of local history but also of femininity itself. The unruly suffragette, the caretaker of household property, the shopper, and Lady London coexisted as part of this museum's complex production of female political identity.

Conclusion: The Limits of the "Civi-otic"

The London Museum—beloved beyond its founders' expectations, tainted with the legacy of French revolt, and associated, against its leaders' intentions, with socialist and feminist discontent—was constantly confronting the dilemma of its own popularity. Forging new definitions of the folk, the feminine, the civic, and the "civi-otic," the London Museum continually faced its debt, both material and ideological, to its audience. The visitor was no longer simply a viewer; he or she was a collector, a donor, a curator. In short, he or she was a citizen of museum culture, a propertied participant in the "civi-otic" realms of art and history. The London Museum thus reimagined more than the history of London or its objects. In the new museum, the history of citizenship itself—both as a changing phenomenon in British society and as a more general Western principle of human development—was given visual form, and the categories of Londoner, Englishman, and Man were fused into one. [267] The historical narratives of this museum's collections ranged from the imperial glories of ancient Rome to the death of urban industry, with the urban collector as the only constant. The unique circumstances of the museum, in particular its perceived emphasis on a joint curatorial venture between the institution and its audience, encouraged Londoners to reconceive of the visitor as an active participant in the creation of local and national identities. In its final prewar incarnation, the London Museum embodied a new, anti-Victorian model of the British nation-state: a state that was, at least in the realm of culture, both creative and collectivist.

The story of the London Museum indicates that the coincidence of the

founding of "urban studies" as both an academic discipline and a practical political question with the formation of Geddesian "museum studies" as a branch of civics was not happenstance. It reflected a historically specific conception of the role of art in public life and the role of the artifact in educating the citizen. The London Museum represented the union of these two branches of early twentieth-century civic education, but with a number of caveats. The designation and material preservation of the "urban folk" in London required a departure from the models established at Skansen, the Outlook Tower, and the Carnavalet. The London Museum adapted the legacies of Corporation and Council civic culture in a variety of ways, producing a museum more truly "of the people" than either of those bodies or the museum's founders might have intended or desired. In remaking the local history museum as the Museum "Civi-otic," London Museum officials had negotiated the problem of creating a civic institution for a national and imperial capital. At the same time, they had engendered a new set of questions about the balance of power between professionals, politicians, and an imagined public of socialists and suffragettes—questions about the political wages of cultural popularity.

During the founding years of the London Museum, cultural objects were recast as part of an ongoing process of negotiation between the institution and its diversifying public, taking Britain's artistic patrimony outside the sphere of the museum and into the more diffuse realm of culture and property. The mediation of Liberal values was enacted in this museum's redefinition of the culture of property, as the concepts of individual protest and communal reform were incorporated into the new London collections. The museum may not have been entirely prepared for the new types of citizens that it encountered and manufactured, but the nation that turned from the London Museum to World War I was forged in part by this museum's own notion of "civi-otic" British identity: feminized, domestic, and intractably and disturbingly popular.

CONCLUSION

That is an old building built before the middle of the
twentieth century, and as you see, in a queer fantastic
style not over beautiful; but there are some fine things
inside it, too, mostly pictures, some very old. It is called
the National Gallery; I have sometimes puzzled as to
what the name means.

—William Morris, *News from Nowhere* (1890)

If a man's pictures are to be scheduled by a Government
department, why not his Louis Seize furniture or his
Dresden china? The end would seem to be that
everybody who owned an article of value, whether it
was a Velasquez or a Caxton, a commode signed by
Œben, or a blue de Roi vase, would hold it in trust for
the nation. . . . Free communities are neither built up
nor maintained upon such principles as these.

—*Guardian*, May 26, 1909

In William Morris's socialist utopian novel, *News from Nowhere*, the British
Museum has become obsolete. The utopia has abolished all ideals of empire,
and the preservation of imperial artifacts is thus an outmoded enterprise.[1] But
Morris's vision of the utopian museum is complex, mirroring and anticipating
many of the debates about culture and property discussed in this study. There is
no dismantling of the British Museum here; the artifacts and collections con-
tained therein do not revert to the people. Presumably, the happy workers of No-
where would not want them. The truism that public collections are based on pri-
vate property—both the mainstay and the paradox of British institutions—is
realized in its fullest form as this museum reverts to a private home, perhaps the
most extreme form of repatriation. In residence at the former museum is Mor-

ris's sympathetic antiquarian, a grandfather and himself a relic of an earlier age. Clearly, this is not where Wallace Collins got his inspiration to storm the British Museum in 1908. Morris's museum is not under siege; it is simply irrelevant.[2] Instead of English workers reclaiming the fruits of their labor, we apprehend museums as outposts of private ownership in a collectivized world. The things that are private, Morris suggests, are only those that no longer matter to the inhabitants of Nowhere.

Significantly, not all museums are banished from this utopia. South Kensington is absent, because the skilled workers of Nowhere no longer require the education in industrial and decorative arts that Morris's contemporaries seemed to need so desperately. But the National Gallery survives in Nowhere, in much the same condition as in Morris's day. As the protagonist William Guest's tour guide tells him, any place where pictures are kept is called a national gallery, and there are national galleries all over Britain. Yet Dick is puzzled by the term "national gallery," as are his fellow residents of Nowhere. The National Gallery thus has a peculiar status in the socialist universe. Its paintings and statues are intact, but we no longer know what history they signify. The fine arts have their place in Nowhere, but they have lost their national bearings. Individual works can no longer be interpreted with reference to a universal survey of national histories of art but, presumably, are viewed instead through the lens of the labor relations that produced them.

In 1910, the National Gallery in London published its *Memorandum Regarding the Registration of Pictures*, which advocated the cataloguing of all privately owned works of art that were of "national" interest. Under this new policy, the gallery would retain the first option of purchase if an owner wished to sell one of the listed works. Although the director, Sir Charles Holroyd, insisted that he wished to interfere as little as possible with the rights of individual art collectors, the public response to this type of proposal was extremely unfavorable. As the editors of the *Guardian* warned, artistic protectionism was antithetical to British notions of personal freedom and liberty. This process of valuation and assessment—an aestheticized modern regression to the medieval days of the Domesday Book—would inevitably extend outward from the limited category of "national art," because no single curator seemed able to define this troublesome term. Under this system, the *Guardian* predicted, Britons would stop collecting art altogether. Selfish extravagance and egoistic indulgence would spread through the land as potential connoisseurs would be confined to baser uses for their wealth. Britain's status as a moral nation seemed to depend on the preservation of free trade in art; state ownership of artistic resources merely deprived individual citizens of the opportunity for right action.

The *Memorandum* occurred against the backdrop of Lloyd George's on-

going efforts to assess the monetary worth of British land; in April 1910, the Commissioners of Inland Revenue were empowered to carry out a new valuation of all land in the United Kingdom. Again, the Domesday Book was the only comparable precedent. This enactment of a "New Domesday" crystallized the notion of a final judgment or reckoning in the Edwardian psyche.[3] At the heart of the "New Domesday" Survey was a broader question about the nature and future of the Liberal state as Lloyd George sought to raise revenue for social welfare programs from taxes on private property. As property taxes spiraled upwards, the central philosophical issue was clear: To what extent could an individual's property be subjected to the control of public policy in the name of the common weal?[4]

In response to the debate about art registration, G. K. Chesterton—the author of such comic paeans to public collectivism as *The Napoleon of Notting Hill* (1904) and *The Flying Inn* (1914)—criticized the British tendency to conceive of heritage solely within the realm of private property. According to Chesterton, this misinterpretation of patrimony as property was at the heart of Britain's political history of decentralization. He wrote, "England is individualist to excess; England is not England, but a cluster of principalities. People talk of going back to the Heptarchy; we have never properly come out of it."[5] Chesterton also referred to the private art collections scattered throughout the countryside as "Unnational Galleries," mocking the British aristocracy for thinking of the Elgin Marbles as if they were family portraits and the pyramids as if they were family tombs. He concluded that no man could own privately "that which is unique and the object of a public affection," offering Stonehenge and paintings by Raphael as examples. Chesterton concluded that the transgression of this ownership taboo was unique to Britain. He threatened that the "unnatural" British quality of property in the realm of art and aesthetics would lead to a collectivist triumph because the aristocracy's conception of national art as its own possession was so profoundly unappealing.

Chesterton located his analysis of art and property within his larger dual critique of capitalism and socialism, illustrating the extent to which debates about artistic patrimony negotiated between individualist and collectivist visions of the British nation. His assessment of the failed union of "culture" and "property" also reflected the significance of 1909 as a turning point in the history of Liberalism and in the history of cultural property. The passage of the "People's Budget" completed the process that had begun long before, taking British art out of the hands of aristocracy. The exodus of art from Britain was tremendous. One National Gallery trustee estimated that the value of art exported from Britain was £581,304 in 1909 and £595,829 in 1910.[6] By the end of the Edwardian period, the culture of property had been revamped according to socialist, feminist,

and Celtic nationalist visions of Britishness. The institutional representation of political difference—sexual, socioeconomic, racial, and national—was synthesized with the continued absence of full political rights for these groups.

For the most part, this book has not been about the production of alternative exhibition spaces—no feminist galleries or workers' museums were born of the episodes of conflict I have discussed here, at least not directly. The key institutions of this project have been those that were hoped to best embody a liberal ethos of education, from the Dublin Museum of Science and Art to the National Gallery itself. The episodes of conflict described in this study alternated between a collective desire to reform or create institutional culture and the threat of destroying those same institutions. These experiments were forged in the crisis (or crises) of Liberalism, and they were not always successful in the ways that had been anticipated. Often, as in the Celtic gold controversy, the redistribution of artifacts turned out to be just as complicated and troubling as their original "loss." Like literary texts, visual artifacts participated in the construction and also in the revision of canons of different kinds. The array of objects at stake in this book—the Celtic gold ornaments, the Scottish paintings in the National Gallery in Edinburgh, the Holbein portrait of Christina, the ordinary household objects and Roman boat of the London Museum—were of widely divergent economic value, and their place in an art historical or archaeological canon was not always well assured. But it was a peculiarity of British politics at the end of the nineteenth century and the beginning of the twentieth that these objects, taken together in a heap, mobilized such political energy, less for their connection to "national" heritages and histories than for what they symbolized about the twists and turns of the history of ownership itself.

The recent struggles related to peace treaties in Ireland—as well as the development of the European Community and devolution in Scotland—have brought a new dimension to the central concept of Union, now allowing for the possibility of a union that accommodates diversity. The Irish battle for Celtic gold was conceived outside the existing terms of national difference as a creative sphere of interaction between the English, the Irish, the Celtic, and the British. Within this current framework of reinventing "Irishness" so that it no longer stands explicitly or exclusively in opposition to "Englishness," we can look to earlier debates about the nature and limits of free trade in culture in order to illuminate these evolving models of British nationalism and postnationalism. But these are not all success stories, regardless of the fate of the objects.

In Ireland and Scotland, debates about culture and property functioned less as a demand for goods than as a forum for questioning the Liberal premise of British citizenship as a product of property, ownership, and possession. Within these disputes, the museum operated not simply as a means of upholding the

material relationship between "nation" and "culture" but as an institutional fo-
rum for exploring the boundary points of Scotland, Ireland, England, and Brit-
ain. The Irish struggle for Celtic gold and the Scottish campaign—both Home
Rule and Unionist—to "nationalize" the gallery at Edinburgh both challenged
and upheld Liberal frameworks of national culture. The Irish campaign to re-
claim Celtic gold from England placed art and artifact in a new model of ex-
change and surrogacy with land, which opens up another direction for future re-
search in the history of Celtic dispossession. This episode of repatriation within
an Anglo-Irish context suggests that the return of cultural objects cannot always
be read as a reversal of colonial relations. The success of the Celtic gold case
rested on its participants' willingness to speak what should have been an out-
moded language: that of medieval English kings. The protection of property—
that Liberal ideal that had always proved so difficult in Ireland—was derived
solely from the king of England.

In the Holbein case the National Gallery in London was confronted with a
new vision of the feminist museum that undermined prior conceptions of patri-
mony. The public revelation that Hans Holbein's *Christina, Duchess of Milan*
may have been saved for the nation by a noted feminist sparked anxieties that the
1909 Budget had prompted the feminization of Britishness as well as an eco-
nomic victory for Labour—both potentially more threatening than American
wealth and patronage. The Holbein controversy crystallized the interdepend-
ence of feminism and Liberalism as well as their points of divergence and spoke
to a host of contemporary concerns about what Liberal politics could tolerate:
Would women corrupt Liberalism by participating in it? And, if so, did Liberals
have a future without them? The possibility of reinventing the National Gallery
as a tribute to female property ownership drew on larger anxieties about the cir-
culation and redistribution of British "goods"—from Old Masters to the vote—
along gendered lines.

Arguably, it is the controversial founding and early years of the London
Museum that best illustrate this complex relationship between Liberalism and its
challengers. In the establishment of the first British "folk" museum, the practices
of exhibition and curatorship were reconstituted as a political, economic, and
social puzzle—a major problem of the modern city. The curators recast British
identity between two perceived poles of the international traffic in artifacts: the
fanatical republicanism of France and the excessive protectionism of the United
States. The London Museum emerged as the savior of both individualism and
collectivism, striving to reconcile these two models of Liberalism, not always
successfully. After the museological invention of "civi-otics," the new hybrid of
civics and patriotism, the varieties of British citizenship seemed endless. The
citizenship of the city dweller, of the laborer, and of the radical feminist all found

their institutional expression in the London Museum, reflecting the degree to which this museum had literally named new forms of political identity. It was an institution born of socialist and feminist critiques of existing cultural practices, a museum constructed of protest politics. Ultimately, the survival of museums in this age of Liberal crisis seemed to depend on the incorporation of political protest into the collections themselves.

World War I brought significant changes to British and European perceptions of the relationship between culture and property.[7] Museums were understood as important components of the peace process because they were thought to inspire respect for a variety of cultures.[8] At the same time, the international conflict led many critics to reconceptualize art beyond the bounds of national identity.[9] But despite these postwar innovations in the realm of national heritage, the prewar terms of the culture of property in Britain have continued to shape institutional philosophy in both Western and non-Western museums. The Department of Culture, Media, and Sport—the youngest department in Britain—published its Select Committee Report in July 2000, aimed at clarifying Britain's policy concerning cultural property. The report recommended that the Home Office make a public commitment to establishing a national database of stolen cultural property and that this database conform to international standards of export and import. The report did not recommend that Britain become a party to the 1970 UNESCO Convention, nor did it recommend new legislation that would allow public museums and galleries to deaccession their galleries more easily. The Glasgow City Council was commended for its effort to devise a repatriation policy, but no suggestions were made for other institutions seeking to clarify the government's position with respect to cultural return. The strongest provisions were made for provenance research relating to the period 1933 to 1945, again associating the problem of cultural property most strongly with the history of armed conflict. The report also noted that the merits of public access must always be subordinated to the interests and wishes of a rightful owner, but only with specific reference to wartime accessions; this was a limited and historically specific valorization of individual property rights to which even the British Museum could accede.

Mark O'Neill, the head of curatorial services at the Glasgow Museum, recently argued that art institutions would have to admit to the possibility that there may be other values that are more important than those of possession and even of preservation; "possession in itself cannot be an absolute value."[10] Yet without the principles of possession, what is the museum? Furthermore, what is British political identity? I have drawn on this history of the British invention of cultural property in the hope of illuminating the "strange death" of Liberal Britain and the rebirth of Liberal principles in current museum practices.[11] Cultural

property represented the meeting point of Liberalism's individualist past and its collectivist future. The history of culture and property in Britain was the history of Liberalism adapting to or transforming itself for the twentieth and twenty-first centuries, with highly varied degrees of success. This exploration of the genesis and development of these British debates suggests that such seeming dichotomies as institution/critique, high culture/mass politics, private property/patrimony, and perhaps even culture/anarchy are, along with the history of British Liberalism, due for reevaluation.

As the legal scholar Joseph William Singer has recently noted, property "is not given to us whole; it does not emerge fully formed like Athena from Zeus' head." Rather, property is to be collectively defined. Like music, he argues, property derives its sense of stability from the ongoing creation and resolution of various forms of tension.[12] Property leaves us in the land of judgment, charged with the responsibility of investing property and its paradoxes with social meaning. Its definition always entails moral frameworks as well as legal and historical ones.

Debates about cultural objects have been one way for people to define what they meant by property itself, that is, what they have meant historically by "mine" and "yours." In late nineteenth- and early twentieth-century Britain, the laws of property could not fully account for or encompass the life of cultural objects. Law was both a starting point for thinking about culture and a dead end. Arguably, the paradoxes of property were exacerbated in the realm of culture, thrown into sharp relief by the very groups whose rights to ownership were most contentious. Yet at the same time, art and artifact offered a new sphere in which to engage the riddles of property in Britain, positing an alternative to the seeming irreconcilability of individual and group ownership. The invocation of property rights within and outside the museum was not always a magic or regulatory spell of order. Rather, at times, the language and law of property made culture itself anarchic. Bringing Britain into the history of how culture came to be understood as a form of property illuminates the ways in which labor, gender, and colonialism have necessarily been at play in ongoing debates about cultural property today.

In 1916 the cartoonist Henry Mayo Bateman published a series of cartoons in *Punch* titled "The Boy Who Breathed on the Glass in the British Museum" (fig. 20).[13] Bateman's panels, later reprinted in a book, relayed the tragicomic tale of a young boy who visits the British Museum, breathes on a glass case that houses many mummies, and is promptly carted away by a vigilant guard. The boy goes through a high-profile trial, just as Wallace Collins had eight years earlier, and crowds of angry Britons demand his imprisonment. In Bateman's cautionary tale, it is the viewer who is under siege, rather than the British Museum, the National Gallery, or their Celtic counterparts. The errant boy is sent

THE BOY WHO BREATHED ON THE GLASS IN THE BRITISH MUSEUM.

AN ANTE-BELLUM TRAGEDY.

20. Henry Mayo Bateman, "The Boy Who Breathed on the Glass in the British Museum," *Punch*, October 4, 1916

to prison for many years' hard labor and emerges in his dotage, a wizened, hunched old man. He immediately proceeds to the British Museum, where he breathes once more on the same glass case, then keels over and dies.

At a historic moment of international armed conflict, Bateman's focus is on internal cultural division—the artifact versus the citizen, rather than their mutual dependence. The real threat to British individualism stems not from the Hun but from the irrational preservation of the foreign artifacts that compromise domestic freedom. Bateman chooses to end his story when the individual yields—ungracefully and unwillingly—to the institution; he can never outlast the mummy in the glass case. The episode illustrates the Liberal dilemma of the self-regarding action, picturing the Liberal crisis of faith in front of this pane of glass. But the final scene shows that the protestor has left his mark on the British Museum after all. The case is defaced; the guard looms angrily in the background. The drama of institution and audience is an ongoing one and, in this case as in the episodes detailed in this book, resolves with no clear winner. This study therefore aims beyond a new account of the strange death of Liberal Britain toward a more contemporary set of questions about what, both as individuals and as communities, we can own, what can be shared, and what falls outside or between the two.

NOTES

❦

The following abbreviations are used in the notes:

Bodleian Library	BOD
British Library	BL
Corporation of London Records Office	CLRO
Edinburgh City Archives	ECA
Greater London Record Office (now London Metropolitan Archives)	GLRO
Hansard's Parliamentary Debates	*Hansard*
Manchester Central Library	MCL
Museum of London Archives	MLA
National Archives of Ireland	NAI
National Gallery Archives, London	NGL
National Library of Ireland	NLI
National Library of Scotland	NLS
National Museum of Ireland	NMI
National Portrait Gallery	NPG
Public Record Office	PRO
Scottish Register Office	SRO
Strathclyde Regional Archives	SRA
Tate Gallery Archives	TGA

Introduction

1. The phrase is taken from Dangerfield, *Strange Death of Liberal England.*

2. Singer, *Entitlement*, p. 28. Also see Rose, *Property and Persuasion*; Waldron, *Right to Private Property.*

3. Hyde, *Gift.*

4. Quoted in Singer, *Entitlement*, p. 3. Similarly, see John Boyd Kinnear's 1914 account of the term "property," in which he notes that the word is derived from the Latin *proprius*: peculiar or proper to one person. Kinnear, *Principles of Property*, p. 1.

5. Palmer, *Museums and the Holocaust*, p. 5.

6. Sax, *Playing Darts with a Rembrandt*, p. 9.

7. On the idea of "culture" as a product of history, see Clifford, *Predicament of Culture*; Herbert, *Culture and Anomie*.

8. Dangerfield, *Strange Death*, pp. 65–66.

9. Ibid., pp. 14, 179.

10. On the dynamism of property in Britain, see Offer, *Property and Politics*.

11. Bellamy, *Victorian Liberalism*. For an illuminating contemporary source see Verax (Henry Dunckley), *I and My Property*.

12. Simpson, *Indigenous Heritage*.

13. Wilf, "What Is Property's Fourth Estate?"

14. Merryman, "Public Interest in Cultural Property."

15. Gerstenblith, "Identity and Cultural Property"; Hutt and McKeown, "Control of Cultural Property as Human Rights Law."

16. Weiner, *Inalienable Possessions*. On the extension of cultural property protection to ritual practices, see Prott and O'Keefe, "'Cultural Heritage.'"

17. On the history of cultural property legislation in western Europe, see O'Keefe and Prott, *Law and the Cultural Heritage*, 1:30–40.

18. Greenfield, *Return of Cultural Treasures*, p. 199.

19. Gerstenblith, "Public Interest in the Restitution of Cultural Objects."

20. Kaye, "Laws in Force at the Dawn of World War II," 100–105.

21. See Jonathan Petropoulos's excellent study of Nazi arts policy, *Art as Politics in the Third Reich*. Other useful sources are Feliciano, *Lost Museum*; Nicholas, *Rape of Europa*; and Petropoulos, *Faustian Bargain*.

22. Feliciano, *Lost Museum*.

23. Trevor-Roper, *Plunder of the Arts in the Seventeenth Century*.

24. Simpson, "To Have and to Hold." The traffic in illicit antiquities is frequently compared to the narcotics trade.

25. Gillis, *Commemorations*.

26. Benton, *Law and Colonial Cultures*.

27. Coombe, *Cultural Life of Intellectual Properties*; Messenger, *Ethics of Collecting Cultural Property*; Simpson, *Indigenous Heritage*.

28. Lawrence Kaye and Carla Mann have argued that the free-market analysis at work in these protective legislative measures removes the antiquities trade from the realm of ethics and history and wrongly places it in the world of supply and demand. Kaye and Mann, "Law, Ethics, and the Illicit Antiquities Trade."

29. Greenfield, *Return of Cultural Treasures*, p. 253.

30. Coombe, "Properties of Culture and the Possession of Identity"; see also Barsh, "How Do You Patent a Landscape?"

31. Barbara Kirshenblatt-Gimblett has argued that existing cultural property laws reflect a limited conception of modes of ownership because they assume the alienability of *all* forms of property. Kirshenblatt-Gimblett, *Destination Culture*, p. 165. Other scholars have suggested that the phrase "cultural property" be replaced by "cultural heritage,"

because the term "property" does not adequately express the concept of duty that cultural objects demand. See Prott and O'Keefe, "'Cultural Heritage'"; Simpson, *Indigenous Heritage*.

32. On the traffic in non-Western objects in the contemporary art world and the ways in which these objects are and are not defined as "cultural," see Marcus and Myers, *Traffic in Culture*.

Prelude

1. *Daily Telegraph* (London), October 20, 1908. For the estimated size of the crowd, see *Times* (London), October 20, 1908.

2. Collins was identified at his trial as the right-hand man of Alexander Stewart Grey, the leader of the Hunger Marchers. Grey described the aim of this group as the education of the urban community regarding social subjects such as the causes of unemployment and the unequal distribution of wealth. *Times* (London), October 20, 1908. For Collins's previous arrests, see *Times* (London), September 12, 1908 and October 3, 1908.

3. Wilde was imprisoned at Pentonville from 1895 to 1897.

4. Tony Bennett notes that when the Chartists marched to present the People's Charter to Parliament, the authorities (whose fears are described by Bennett as largely unwarranted) prepared to defend the British Museum "as vigilantly as if it had been a penitentiary." Bennett, *Birth of the Museum*, pp. 69–70.

5. *Annual Report of the National Sunday League* 22 (1876), p. 3.

6. Of the executive members of the Sunday Society who listed their party affiliation on the subscription list, 62 percent were Liberals, 33 percent were Radicals, and 5 percent were Conservatives. Malchow, *Agitators and Promoters*.

7. One peer suggested that the "mob" had threatened to destroy the National Gallery, but his was a minority opinion. *Hansard* 245 (3d ser.), May 5, 1879.

8. The first petition for Sunday opening was introduced in Parliament by William Lovett in 1829; the movement gained strength in the 1880s as the Sabbatarian lobby weakened, and Sunday opening legislation was passed on March 10, 1896. Borzello, *Civilizing Caliban*. Borzello also discusses another important strand of the Sunday opening movement: its dedication to rational recreation, the provision of moral leisure pursuits for the working classes by the middle classes. On rational recreation, see Bailey, *Leisure and Class in Victorian England*; Maltz, "Lessons in Sensuous Discontent"; Meller, *Leisure and the Changing City*; Waters, *British Socialists and the Politics of Popular Culture*; Waterfield, *Art for the People*.

9. *Hansard* 249 (3d ser.), May 19, 1882. Similarly, the American abolitionist Moncure Conway drew an elaborate analogy between the public gallery and the working-class home, arguing that Sunday closing was equivalent to slavery. The people were "locked out of their own houses [the art institutions] and forced to beg for a little beauty at the doors of charitable collections and studios. So it is today; tomorrow a like oppression of freedom, in a political or social matter, might cause a revolution." Conway, "Civilizing the Sabbath," p. 3496.

10. *Times* (London), February 19, 1896. On eighteenth-century precedents, see Goldgar, "British Museum."

11. Poulot, *Musée, Nation, Patrimoine*. Similarly, Joseph Sax locates the origins of modern preservationist thought in revolutionary France, specifically, in the cultural protection projects of the Abbé Grégoire. Sax, "Heritage Preservation as Public Duty."

12. Harris, *Private Lives, Public Spirit*, p. 253.

13. M. Fforde, *Conservatism and Collectivism*. On Edwardian land valuation, see Short, *Land and Society in Edwardian Britain*.

14. For a contemporary source concerning the relation between property and individual identity, see Gore, *Property*. Also see Bentley, *Climax of Liberal Politics*; Biagini, *Citizenship and Community*; Feske, *From Belloc to Churchill*; Mandler, *Fall and Rise*. Although she deals primarily with an American constitutionalist context, I find Jennifer Nedelsky's discussion of property very helpful. Nedelsky argues that property serves as an attempt to address the inevitable tension between individual and collective by marking what the state can touch and the sphere in which we can act unconstrained by collective demands. She sees this attempt as deeply flawed and argues for a reconceptualization of the collective as a source of autonomy, rather than a threat to it. Nedelsky, "Law, Boundaries, and the Bounded Self."

15. Waldron, *Right to Private Property*, p. 45.

16. M. Rose, *Authors and Owners*.

17. Offer, *Property and Politics*. On middle-class schemes for land reform, see Finn, *After Chartism*.

18. MacDonagh, "Ambiguity in Nationalism."

19. Offer, *Property and Politics*, p. 317.

20. Susan Pedersen and Peter Mandler have challenged the notion that the liberal intelligentsia of the 1880s rejected their Victorian forbears; they argue instead that this generation of New Liberals preserved the quintessentially Victorian tendency to link private behavior to public morality. Pedersen and Mandler, *After the Victorians*. On New Liberal conceptions of citizenship, see Finlayson, *Citizen, State, and Social Welfare*; Green and Whiting, *Boundaries of the State in Modern Britain*; Howe, *Free Trade and Liberal England*; Kuklick, *Savage Within*; Vincent and Plant, *Philosophy, Politics, and Citizenship*.

21. Searle, *Liberal Party*, p. 40.

22. For an illuminating discussion of the role of the individual home in English discourses of property ownership, see Marcus, *Apartment Stories*.

23. Dangerfield, *Strange Death*, p. 144.

24. Reeve, *Property*, p. 7. Also see Horne, *Property Rights and Poverty*.

25. Ryan, *Property and Political Theory*, p. 11.

26. Pocock, *Virtue, Commerce, and History*, p. 70.

27. Macpherson, *Political Theory of Possessive Individualism*, p. 215. Also see J. G. A. Pocock's important critique of Macpherson as insufficiently dialectical in Pocock, *Virtue*.

28. Jeff Nunokawa, *Afterlife of Property*, p. 83.

29. The problem of artistic property was often subsumed into the question of intellectual property, as in Robbins, *Practical Politics*. On intellectual property legislation in Britain, see Sherman and Bently, *Making of Modern Intellectual Property Law*.

30. Memorandum on Patent Museum (BT209/2, PRO), 1898; Purbrick, "Knowledge Is Property"; Richards, *Commodity Culture of Victorian England*, pp. 28, 64.

31. Copinger, *Law of Copyright*; Hunt, "Artistic Copyright"; Leighton and Wells, "Government and the Artists"; Routh, *Law of Artistic Copyright*; Scrutton, *Laws of Copyright*; Winslow, *Law of Artistic Copyright*.

32. Routh, *Law of Artistic Copyright*, p. 8.

33. *Art Journal* 41 (1879): 81.

34. *Report of the Proceedings of the Museums Association* 4 (1893), 67.

35. Mallock, "Conservatism and the Diffusion of Property."

36. Trodd, "Representing the Victorian Royal Academy."

37. Maleuvre, *Museum Memories*, p. 99.

38. Pointon, *Strategies for Showing*, p. 30.

39. Findlen, *Possessing Nature*; Smith and Findlen, *Merchants and Marvels*.

40. Küchler, "Sacrificial Economy and Its Objects."

41. Conway, *Sport of Collecting*.

42. Holmes, *Pictures and Picture Collecting*, p. 53.

43. Marie Stillman to Charles Fairfax Murray (Charles Fairfax Murray Collection MS 1278-83, MCL), n.d.

44. On the history of state support for the arts, or lack thereof, in Britain, see Minihan, *Nationalisation of Culture*; Pearson, *State and the Visual Arts*.

45. Haskell, *Ephemeral Museum*, p. 128.

46. On the National Art-Collections Fund, see Lago, *Christiana Herringham and the Edwardian Art Scene*. On the "intimate" relationship of private and public collections in Britain, see Goldgar, "British Museum."

47. For two particularly entertaining sources concerning "ordinary" collectors, see Holmes, *Pictures*; Yoxall, *ABC About Collecting*.

48. Fitzgerald, "Romance of the Museums." As Paula Findlen has suggested with reference to early modern Italy, there was historical precedent for collectors to demand greater publicity for their gifts to public institutions. But what Fitzgerald proposed was a much more elaborate history of ownership, far beyond the conventional scope of museum labeling in nineteenth- or twentieth-century Europe. Findlen, "Modern Muses."

49. Offer, *Property and Politics*; Nunokawa, *Afterlife of Property*.

50. On the equation of land and political power in Britain before the 1870s and the changes in this relationship thereafter, see Cannadine, *Decline and Fall of the British Aristocracy*, especially the prologue.

51. Macdonagh, *States of Mind*.

52. Williams, *Culture and Society*. This etymology is stressed again in Bray and Killion, *Reckoning with the Dead*.

53. Mandler, "Art, Death, and Taxes." On the changing fortunes of the English country house, see Mandler's excellent study *Fall and Rise of the Stately Home*.

54. Lubbock did succeed in aiding the passage of the Ancient Monuments Protection

Act in 1882, but landlord compliance with this legislation was voluntary, not compulsory, and the provisions did not extend to inhabited monuments. Mandler, *Fall and Rise*, pp. 157–58; Wright, "Trafficking in History."

55. Mandler notes that during the economic crisis of the aristocracy in the late nineteenth and early twentieth centuries, the Trust failed to fulfill its preservationist aims. On the history of preservation in Britain, also see Lowenthal, *Possessed by the Past*. Lowenthal concludes that the practice of preserving "heritage" was too complex to classify by political allegiance.

56. Waldron, *Right*, p. 43; Wolfe, "Land, Labor, and Difference."

57. Rodger, *Transformation of Edinburgh*, p. 10.

58. Thomas, *Possessions*. On the genre of colonial landscape, two particularly useful sources are Kriz, "Dido versus the Pirates," and Richards, "About Face."

59. *Times* (London), August 20, 1892.

60. *Times* (London), August 25, 1892.

61. On the structure of taxation in the People's Budget, see Murray, *People's Budget*.

62. Mandler, "Art, Death, and Taxes."

63. *Punch*, July 14, 1909.

64. Prenderby seems to be referring to the fact that Lloyd George had tried to broaden the definition of important works of art that would then be exempted from taxation, although the overall effect of the Budget was to prompt art sales. Mandler, "Art, Death, and Taxes"; Mandler, *Fall and Rise*, p. 182.

65. Prenderby also suggests that the state demand feudal service from everyone who owns land, rather than taxing landowners.

66. On the special status of land in British political theory, see Kinnear, *Principles of Property in Land*.

67. The narrator, in contrast to Prenderby, declares himself to be "a bit of a Socialist," stating that "land is the country itself; and the nation is its only rightful owner."

68. See, e.g., Jeffrey Auerbach's claim that "even before a Liberal party had been formed, the Great Exhibition gave coherence to the idea of Liberalism." Auerbach, *Great Exhibition*, p. 31. Carol Duncan argues that the establishment of the National Gallery in London was linked to the extension of the Benthamite reform movement in politics. Duncan, "Putting the 'Nation' in London's National Gallery."

69. Robinson, "Our Public Art Museums," 942. On the Great Exhibition itself, see Auerbach, *Great Exhibition*; Davis, *Great Exhibition*; Hoffenberg, *Empire on Display*; Purbrick, *Great Exhibition*; Richards, *Commodity Culture of Victorian England*.

70. Hoffenberg, *Empire on Display*, p. 24.

71. Cooper, "For the Public Good"; Alexander, *Museum Masters*, p. 144.

72. Henry Cole and J. F. D. Donnelly, "Memorandum on Remuneration by Fees," (ED23/629, PRO), February 1869.

73. Conforti, "Idealist Enterprise and the Applied Arts."

74. On the politics of the South Kensington collections, see Kriegel, "Britain by Design"; Taylor, *Art for the Nation*.

75. Anna Swanwick to W. E. Gladstone (Gladstone Papers, BL Add. MS 44403), August 6, 1864.

76. Greenhalgh, *Ephemeral Vistas.*

77. Peter Mandler has elaborated the connection between the crisis of the Liberal Party and the fragmentation of the British artistic community, noting that "the eclipse of political Liberalism between 1886 and 1906 deprived the aesthetically minded of a solid center." Mandler, "Against 'Englishness.'"

78. Note Martin Wiener's claim that the Great Exhibition marked the end, not the beginning, of Victorian enthusiasm for industrial capitalism. Wiener, *English Culture*, p. 28.

79. Cole, *Fifty Years of Public Work.*

80. *Times* (London), April 11, 1879. In a more personal account of disenchantment with the Crystal Palace, the social reformer Canon Samuel Barnett described his disappointment at attending a Handel concert there. He had hoped to be swept away by the power of the music, but instead he was conscious "only of the Crystal Palace, its flimsy structure and its frivolous associations." Samuel A. Barnett to F. G. Barnett (Barnett Papers F/BAR, GLRO), June 23, 1883.

81. *Times* (London), May 27, 1876.

82. Watson, *Art of the House*, p. 171.

83. *Punch*, December 8, 1909.

84. Similarly, Jim Sheehan has noted an intensification of criticism of the public gallery at the end of the nineteenth century in Germany. He stresses the crisis of moral didacticism associated with the rise of modernism as the concept of artistic autonomy became part of a radical critique of the nineteenth-century art world. Sheehan, *Museums in the German Art World.*

85. Memorandum on the Historical Purpose of the Art Museum (ED 34/311, PRO), January 1908; "The Collector on the Prowl," *Blackwoods Magazine*, May 1890, 677–87.

86. Ford Madox Brown exemplified the British tradition of damning with faint praise when he wrote of the National Gallery in London, "For a nation of shopkeepers our national collection of pictures is, I think, not so very, very bad." Brown, "Our National Gallery," *Magazine of Art* 13 (1890), 133. For other examples of attacks on British art institutions, see Harrison, "A Few Words About Picture Exhibitions"; Spielmann, "Faults of South Kensington."

87. *Truth*, September 4, 1890.

88. *Manchester Guardian*, July 6, 1892.

89. *Times* (London), November 29, 1892.

90. *Aberdeen Free Press*, July 14, 1903.

91. *Report of the Proceedings of the Museums Association* 4 (1893).

92. Wood, "Dulness of Museums."

93. On the role of Aestheticism at the Grosvenor Gallery, see Casteras and Denney, *Grosvenor Gallery*; Denney, *At the Temple of Art.* On the history of museum architecture in Britain, see Waterfield, *Palaces of Art.*

94. Taylor, *Art for the Nation.*

95. "English, You Know, Quite English," *Punch*, March 22, 1890, p. 137.

96. Memorandum of a Meeting at Scotland Yard (ED24/343, PRO), December 17, 1909; Board's Letter to Treasury (ED24/344, PRO), 1910.

97. *Sunday Review*, January 1880, p. 67.

98. Colvin, "Bethnal Green Museum."

99. Day, "How to Make the Most of a Museum."

100. Jevons, "Use and Abuse of Museums." Also see *Hansard* 296 (3d ser.), March 20, 1885.

101. The charge of indecency took two forms: first, that museums were being misused as romantic meeting-points by unsavory visitors, and second, that museums inspired illicit behavior with their tantalizing nudes. On the former, see "Museums After Dark," *Daily Telegraph*, August 22, 1885; *Artist's Record and Art Collectors' Guide* 4 (October 15, 1887), p. 73. On the latter, see Guy Pène du Bois's reminiscences of being taken to view a Rubens masterpiece behind locked doors at the National Gallery in London in 1905. Du Bois recalled that in order to see Rubens's "Descent of the Damned," he had had to tip a museum guard, who took him in "with a sly look, the knowing ingratiation of a pimp." Du Bois, *Artists Say the Silliest Things*, p. 96.

102. *Sunday Review*, April 1879, p. 195.

103. *Morning Post*, May 25, 1912. With respect to the museum-as-church, the antiquarian and Liberal M.P. Sir John Lubbock claimed that the British Museum was one of the finest Sunday schools in the country and that the Eastern artifacts readily accessible in many British collections would promote a better understanding of the Bible. *Hansard* 37 (4th ser.), March 10, 1896. Also see Borzello, *Civilizing Caliban*; Duncan, *Civilizing Rituals*.

104. Yoxall, *More About Collecting*, p. 88.

105. Of course, in 1876, the fact that the marchers could not gain access to the museum was the whole point of the protest. As Marcia Pointon has noted, nineteenth-century art institutions were characterized by a fundamental tension between access, or democratization, and control: what she calls inside and outside. Pointon, introduction to *Art Apart*, p. 2.

106. McClellan, *Inventing the Louvre*; Sherman, *Worthy Monuments*.

107. Duncan and Wallach, "Universal Survey Museum."

108. Quoted in Duncan, *Civilizing Rituals*, pp. 11–12.

109. Bazin, *Museum Age*; Bennett, "Exhibitionary Complex"; Harris, *Cultural Excursions*.

110. Bal, *Double Exposures*; Belk, *Collecting in a Consumer Society*; Bennett, *Birth of the Museum*; Hooper-Greenhill, *Museums and the Shaping of Knowledge*; Pearce, *Museums, Objects, and Collections*; Pearce, *On Collecting*; Wallach, *Exhibiting Contradiction*.

111. Barlow and Trodd, *Governing Cultures*; Conn, *Museums and American Intellectual Life*; Fyfe, *Art, Power, and Modernity*; Hoffenberg, *Empire on Display*; Yanni, *Nature's Museums*.

112. Farmer, *Martyred Village*; Gillis, *Commemorations*; Sherman, *Construction of Memory in Interwar France*; Winter, *Sites of Memory*.

113. Macleod, *Art and the Victorian Middle Class*.

114. The definitive work on this topic is Coombes, *Reinventing Africa*. Also see Bar-

ringer and Flynn, *Colonialism and the Object*. Breckenridge, "Aesthetics and Politics of Colonial Collecting"; Matnur, "Living Ethnological Exhibits"; Maxwell, *Colonial Photography and Exhibitions*.

115. Barringer, "Re-Presenting the Imperial Archive"; Coombes, "Museums and the Formation of National and Cultural Identities."

116. Huyssen, *Twilight Memories*; Maleuvre, *Museum Memories*; Sheehan, *Museums*; Sherman, "Quatremère/Benjamin/Marx."

117. On the use of images in historical argument, see Burke, *Eyewitnessing*.

118. Mastalir, "Proposal for Protecting the 'Cultural' and 'Property' Aspects."

119. Gerstenblith, "Identity and Cultural Property."

120. Merryman, "Public Interest," p. 351.

121. I am drawing primarily on Burton, *At the Heart of the Empire*; Hall, *Civilising Subjects*; Parsons, *King Khama*.

122. Gibbons, *Transformations in Irish Culture*, p. 149. Also see Ruane, "Colonialism and the Interpretation of Irish Historical Development." An account of the Irish in Victorian racial discourse that is widely cited but highly controversial is Curtis, *Apes and Angels*.

123. London, *Women and Property*.

124. I borrow this phrase from Poovey, *Uneven Developments*.

125. Burton, "Who Needs the Nation?" Other helpful meditations on the topic of critiquing "national" histories in a British context include Belchem, "Little Manx Nation"; Colley, "Britishness and Otherness"; Davies, *Isles*; Ellis, "Reconciling the Celt"; Pocock, "British History."

126. Alissandra Cummins of the Barbados Museum and Historical Society has pointed to the ways in which art institutions can be used to redefine the working terms of "national" history. Cummins reconstructs the concept of a "national" museum to accommodate postcolonial cultures by suggesting that we take the term *natio* in its ancient meaning, that is, to include family, local community, and a sense of belonging to a particular culture rather than the post-Enlightenment idea of "nation" as the autonomous nation-state. Cummins, "Embracing Ambiguity."

127. I should mention the absence of Wales in this project. An entire study could be devoted to the "folk" museum movement in Wales, which was ultimately the strongest in Britain. However, the development of folk institutions in Wales tends to fall outside the chronological parameters of this study because the study of Welsh folklore and material culture intensified in the 1920s. On the recent politics of Welsh museums, see chap. 4, n. 3, and John Williams-Davies's discussion of the Welsh Folk Museum at Saint Fagans, near Cardiff, which was founded in 1948. Williams-Davies, "Bigger Picture."

128. The phrase "social ether" is taken from a review of Joseph Sax's *Playing Darts with a Rembrandt* in Costonis, "Casting Light on Cultural Property."

Chapter One

1. Sir Robert Bannatyne Finlay was the solicitor general from 1895 to 1900, the lord rector of Edinburgh University from 1902 to 1903, and the attorney general for Ireland from 1900 to 1906. He served as Liberal M.P. for Inverness Burghs in 1885 and subse-

quently served as the Conservative M.P. for University of Edinburgh and Saint Andrew's Universities from 1910 to 1916 and as lord chancellor from 1916 to 1918.

2. Nicholl's obituary mentioned that he had been experimenting in 1896 with a new type of American plough that supposedly made deeper furrows when sub-soiling than a traditional Irish plough. *Northern Constitution*, February 15, 1964. Also see Neill, "Broighter Hoard," and Nicholl's own testimony in Statement of Thomas Nicholl, Glebe Finlagan (Celtic Ornaments File, TS18/603, PRO), n.d.

3. Evans, "On a Votive Deposit." The Irish attorneys viewed Gibson in a less favorable light, calling him "grasping" when he demanded large sums for excavations on his property. Opinion on Evidence. Celtic Ornaments Found in Ireland (Celtic Ornaments File, TS18/603, PRO), n.d.

4. On antiquarianism in Ireland, see Leerssen, *Remembrance and Imagination*. On the history of antiquarian research in Britain more generally, see Levine, *The Amateur and the Professional*.

5. Nicholas Whyte notes that the Royal Irish Academy was undergoing important changes during this period. Before 1900, it had been very much an Ascendancy body. But thereafter, the RIA began retiring one-fifth of its members annually. This rapid turnover ensured that the academy would be less of a Trinity clique. Whyte, "Science and Nationality."

6. The Celtic ornaments would be displayed in the Dublin Museum whether they were owned by the Royal Irish Academy or the museum, because the academy had ceded most of its antiquarian collections to the museum in 1890. I have not found any proposals to return the ornaments to Derry.

7. Merryman, "Public Interest."

8. Tunbridge and Ashworth, *Dissonant Heritage*, p. 51. Ellen Herscher discusses the political significance of the terms "repatriation," "restitution," and "cultural return" in Herscher, "Many Happy Returns?"

9. Primarily, the convention resulted in objects' being returned to nonnational entities such as tribal and religious groups rather than public institutions. Vincent, "Who Owns Art?"

10. Leach, "Owning Creativity."

11. Merryman, "Public Interest."

12. Tunbridge and Ashworth, *Dissonant Heritage*, p. 51.

13. Osman, "Occupiers' Title to Cultural Property."

14. Edgar and Paterson, "Introduction to Material Culture in Flux."

15. See, e.g., Bromilow, "Finders Keepers"; Jones, "Home Truths"; Kaplan, *Museums and the Making of "Ourselves"*; Karp and Lavine, *Exhibiting Cultures*; McBryde, *Who Owns the Past?*; Meighan, "Burying American Archaeology."

16. Nafziger and Dobkins, "NAGPRA in Its First Decade." An important exception to this history of repatriation as civil rights is the Kümmel Report, the vast repatriation project of Nazi Germany. The report offered an exhaustive list of German art objects held in foreign countries since the sixteenth century, legitimating repatriation campaigns as part of the more general program of Nazi conquest. Feliciano, *Lost Museum*; Petropoulos, *Faustian Bargain*.

17. Prott, "Repatriation of Cultural Property."

18. Bray, "Repatriation, Power Relations, and the Politics of the Past." Also see Fred, "Law and Identity." The literature on the uneven implementation and effectiveness of NAGPRA is now vast; one particularly useful collection of essays is Bray, *Future of the Past*.

19. Nason, "Traditional Property Rights and Modern Laws."

20. Leach, "Owning Creativity."

21. For an excellent discussion of the Benin bronzes and the tension between art and ethnography in debates about this collection, see Coombes, "Ethnography, Popular Culture, and Institutional Power."

22. See John Henry Merryman's influential though highly controversial account in *Thinking About the Elgin Marbles*.

23. David Wilson of the British Museum insists that the demand for the return of the marbles did not begin in earnest until the 1980s, adding that "what is pillage in the twentieth century was seen as a highly civilized and legal process in the eighteenth century." Wilson denies or ignores the history of dissent about the marbles and the terms of their acquisition, which began long before the twentieth century. Wilson, *British Museum*.

24. B. Butler, "British Museum Head Rebuts Calls for Return of Objects."

25. Declan Kiberd has argued that postcolonial culture actually begins in Ireland in the nineteenth century. He defines postcolonial culture as beginning not when the occupier withdraws but when the native author formulates texts committed to cultural resistance. Kiberd, *Inventing Ireland*, p. 5.

26. Anderson, "Repatriation of Cultural Property."

27. Murray Pittock, for example, characterizes the English attitude toward Ireland as "more proprietorial" than that shown toward its other colonies. Pittock, *Celtic Identity*.

28. For examples, see the essays in C. Fforde, Hubert, Turnbull, *Dead and Their Possessions*.

29. Gibbons, *Transformations in Irish Culture*; Graham and Kirkland, *Ireland and Cultural Theory*; Howe, *Ireland and Empire*; Jackson, *Ireland, 1789–1998*; Kiberd, *Inventing Ireland*; Lloyd, *Anomalous States*; Lloyd, *Ireland After History*; Pittock, *Celtic Identity*.

30. The phrase "internal colonialism" was originally deployed in the late nineteenth century by Russian populists and was later adopted by Lenin to characterize the persistent underdevelopment of key regions of Russia and Italy. Michael Hechter has controversially invoked this phrase to describe England's relationship to Ireland, Scotland, and Wales. Hechter, *Internal Colonialism*, p. xiii.

31. Colley, *Britons*.

32. On the relation between the Celtic fringe and Britain's overseas colonies, see Armitage, *Ideological Origins*; Canny, *Kingdom and Colony*; Canny, *Making Ireland British*; Jeffery, *An Irish Empire?*; Kestner, "Colonized in the Colonies"; Lowry, "'A fellowship of disaffection'"; Mansergh, *Prelude to Partition*; Silvestri, "'Sinn Féin of India.'"

33. Cook, *Imperial Affinities*.

34. Shaw, *John Bull's Other Island*, p. 8.

35. Ibid., p. 18.

36. *Hansard* 110 (4th ser.), June 12, 1902.

37. Quoted in Hutchinson, "Irish Nationalism."

38. O'Mahony and Delanty, *Rethinking Irish History.*

39. Nash, "Visionary Geographies." See also Graham Walker's discussion of Ulster Scots as disruptive to Irish nationalist narratives of unity in Walker, "Scotland and Ulster." The increased homogeneity of Catholic Ireland in the nineteenth century is discussed in Hoppen, "Nationalist Mobilisation and Governmental Attitudes."

40. Brett, *Construction of Heritage.* On the role of collective memory and commemoration in Ireland, see McBride, *History and Memory in Modern Ireland*, especially Gibbons, "'Where Wolfe Tone's Statue Was Not.'"

41. Tunbridge and Ashworth, *Dissonant Heritage*, p. 72. For a detailed account of the Broighter Hoard's impact on local history and archaeology, see Warner, "Broighter Hoard."

42. Graham, "'. . . Maybe That's Just Blarney.'"

43. Foster, *Modern Ireland*, p. 431.

44. Shaw, *John Bull's Other Island*, p. xxxvi.

45. McCaffrey, "From Province to Nation-State," p. 135.

46. Foster himself has argued that this earlier model of a "lull" in Irish political life after 1891 omits the important activities of the Irish Parliamentary Party and the agrarian mobilizing of the United Irish League. Foster, "Anglo-Irish Literature."

47. Maurice Goldring argues that many important Irish cultural movements predated the fall of Parnell and cannot be interpreted simply as a response to the "loss" of politics. More strikingly, Goldring suggests that Irish culture is historically inseparable from the Irish political nation and that the older model of alternating periods of political and cultural nationalism is therefore untenable. Goldring, *Pleasant the Scholar's Life*, pp. 20, 72; see also Curtin, "'Varieties of Irishness.'"

48. Eagleton, *Heathcliff and the Great Hunger*, p. 232.

49. Dominic Ware's 1907 attack on the condition of modern Irish art criticized the National Gallery of Ireland for embracing English aesthetics and ignoring the singularly Irish spirit of religious enthusiasm. Ware believed that exhibitions and galleries could play an important role in the reconstitution of Irish culture, but he suggested that the Gaelic League made a more promising host for this type of exhibition than the National Gallery of Ireland. The Gaelic League had no permanent exhibition building but funded and organized several exhibitions during this period in private galleries. Ware, "Shadow of a Flag," p. 159.

50. The celebrated Irish nationalist D. P. Moran expressed the commonly held view that uneducated peasants were the most authentically "Irish" part of the population. Moran, "Is the Irish Nation Dying?"

51. Netzer, "Picturing an Exhibition."

52. See, e.g., the analysis of culture and nationalism after 1891 in Boyce, *Nationalism in Ireland*, p. 246.

53. For a discussion of depictions of Irish peasant life in English international exhibitions, see Greenhalgh, *Ephemeral Vistas.* Also see Annie Coombes's brief discussion of the same in *Reinventing Africa*, pp. 208–10.

54. Foster, *The Story of Ireland*, quoted in Jackson, *Ireland.*

55. MacLochlainn, *Science and Art.*

56. *Irish Times* (Mayo Papers MS 11200, NLI). Press clipping, 1868.

57. W. H. Kerr to Lord Mayo (Mayo Papers MS 11200, NLI), November 25, 1867.

58. I am grateful to Felicity Devlin for calling my attention to this point. Alf Mac-Lochlainn notes that Irish stone was foregrounded in the construction of Dublin Museum. MacLochlainn, *Science and Art*, p. 3.

59. Cundall, "Dublin Museum of Science and Art."

60. *Hibernia* 1 (1882), p. 2.

61. *Weekly Irish Times*, November 25, 1882.

62. Ibid.

63. *Freeman's Journal*, November 27, 1882.

64. *Daily Express*, November 23, 1882.

65. See, e.g., von Herkomer, *Art Tuition*. Also see Kriegel, "Britain by Design"; Purbrick, "South Kensington Museum."

66. Memorandum by Henry Cole and W. D. Donnelly (Mayo Papers MS 11200, NLI), February 10, 1868.

67. See the discussion of the "Irish Kensington" in *Irish Times*, October 5, 1867.

68. One art historian noted that English leadership was "no blessing for the Dublin Museum." He described the English Department of Science and Art during the nineteenth and early twentieth centuries as a "dumping ground for gentlemen from other branches of the Civil Service and from the Army." Dr. Mahr to Thomas Bodkin (Bodkin Papers 6965, Trinity College, Dublin), January 23, 1931.

69. "The Maimed Science and Art Museum Scheme," *Irish Builder* 21 (March 1, 1879), 66.

70. "Our National Institutions and the Government Scheme," *Irish Builder* 18 (March 1, 1876), p. 57.

71. "Board of Visitors Report" (1890).

72. Sheehy, *Rediscovery of Ireland's Past*, p. 188.

73. Keane, "Lace-making in Ireland," *Women's World* (1888), p. 196. Similarly, an 1884 letter to the *Times* chastised Irish artists for confining their art to domestic terrain; "Ireland must learn that the multiplication of nationalist emblems will never make an Irish school." *Times* (London), January 30, 1884.

74. For a discussion of the denigration of Celtic design within British art history, see Vaughan, "Englishness of British Art."

75. For a brief discussion of Allen's aesthetic theories and his influence on the British intelligentsia in debunking Ruskin and Pater, see Gagnier, "Productive Bodies, Pleasured Bodies."

76. Allen, "Celt in English Art," p. 272.

77. On the history of Irish immigrants in London, see Lees, *Exiles of Erin*; MacRaild, *Irish Migrants in Modern Britain*; Swift and Gilley, *Irish in Victorian Britain*.

78. Hutchinson and O'Day, "Gaelic Revival in London."

79. Allen, "Celt in English Art," pp. 267, 272.

80. It was unclear whether Allen referred to the influence of individual politicians of Irish and Welsh descent or to what he called a "Celtic spirit" in politics.

81. On the status of the Celtic within nineteenth-century scholarship, see Vincent P. Pecora's useful article "Arnoldian Ethnology."

82. Allen, "Celt in English Art," p. 269.

83. According to Allen, the most "Celtic" (because the most "revolutionary") gallery was the Grosvenor Gallery in London. Ibid., p. 273. On the history of the Grosvenor Gallery, see Casteras and Denney, *Grosvenor Gallery*; Denney, *At the Temple of Art*.

84. *Times* (London), January 15, 1889.

85. The status of the Indian collections at South Kensington was a topic of particular interest at this time. The holdings of the India Museum were officially transferred to the Cross Gallery at South Kensington only in 1880, although many artifacts had already been moved unofficially. The collections attracted enormous crowds and produced a variety of scholarly debates about the hierarchies of international design. See Mitter, "Imperial Collections" and Mitter, *Much Maligned Monsters*.

86. *Daily Express*, August 5, 1898.

87. Second Report from the Select Committee on Museums of the Science and Art Department (London, 1898).

88. *Daily Express*, May 11, 1898.

89. Graves responded that he was only in favor of local self-government. Second Report from the Select Committee, p. 121.

90. *Irish Times*, May 23, 1899.

91. David Robert Plunket, Lord Rathmore was the solicitor-general for Ireland from 1875 to 1877, the M.P. for Dublin University from 1870 to 1895, and the first commissioner of works from 1885 to 1892. John Morley, a major Liberal spokesman, became chief secretary for Ireland in 1886 and aided Gladstone with the second Home Rule Bill. Although Morley was criticized for his failure to decentralize the administration of Dublin Castle, he also reduced the Protestant ascendancy among county justices and modified the Crimes Act. Sir John Lubbock, a scientist, banker, and Liberal Unionist M.P. for Maidstone, was a major figure behind the Act for the Preservation of Ancient Monuments (1882) and the Early Closing Act (1904). Sir John Evans, an archaeologist and numismatist, was a trustee of the British Museum from 1885 until his death in 1908. He owned extensive collections of medieval and other antiquities, including ancient British coins and Anglo-Saxon artifacts, many of which he bequeathed to the Ashmolean Museum in Oxford. He was at various times the president of the Anthropological Institute, the Society of Arts, and the British Association, and he was the only representative of the British Museum to serve on the Celtic Ornaments Commission. Sir Herbert Maxwell, the Conservative M.P. for Wigtownshire, wrote extensively about natural history, archaeology, and national history. From 1900 to 1913 he was the president for the Society of Antiquaries of Scotland. Sir Thomas Henry Grattan Esmonde was the M.P. for Dublin South (1885–91), West Kerry (1891–1900), and North Wexford (1900–19). He wrote a variety of articles about Irish folklore and Irish antiquities and became a senator of the Irish Free State in 1922.

92. *Celtic Ornaments Found in Ireland*, p. 3.

93. Ibid., p. 3.

94. The field of museology has been defined as dealing with anything pertaining to the technology of museums: their history and background, their role in public discussions of national culture, their systems of research, education, and conservation. More recently,

museology has been described as a specific branch of media studies concerned with culture as an expression of collective memory. Ernst, "Archi(ve)textures of Museology." Also see Vergo, *New Museology*. For a contemporary usage of the term "museologist," see "Circulating Museums," *Nation*, February 16, 1905, pp. 518–19.

95. *Celtic Ornaments Found in Ireland*, p. 27.

96. Ibid., p. 30.

97. George Coffey to George Noble Plunkett (Irish Antiquities Letters Files, NMI Education Department), January 12, 1899.

98. *Daily Express*, July 7, 1898.

99. Coffey's critique of imperial values may have gained force from the contemporary embarrassments of the Boer War. For a discussion of the negative effects of the Boer War on British imperial pride, see Davin, "Imperialism and Motherhood."

100. George Coffey, Memorandum on Gold Antiquities Found in the North of Ireland (Irish Antiquities Letters Files, NMI Education Department), January 11, 1901.

101. *Celtic Ornaments Found in Ireland*, p. 36.

102. *Irish Times*, June 16, 1900.

103. *Freeman's Journal*, July 14, 1900.

104. *Irish Times*, June 25, 1900; *Daily Express*, December 9, 1901.

105. Esmonde continued, "I suggest that your correspondent's 'nation' [i.e., the British Museum] has already possessed itself of so much of Ireland's national property that we have some reason for failing to acquiesce in its carrying off of such scattered fragments of our archaeological inheritance as yet remain to us." *Irish Times*, June 25, 1900.

106. *Irish Times*, June 13, 1902.

107. *Celtic Ornaments Found in Ireland*, p. 19.

108. Nash, "Visionary Geographies."

109. The experience of administering the Department of Agriculture and Technical Instruction eventually converted Plunkett to the cause of home rule. Edward Lysaght's 1918 biography of Plunkett refers to the department as "an instalment of Home Rule." Lysaght, *Sir Horace Plunkett*, p. 146.

110. Rempe, "Sir Horace Plunkett and Irish Politics."

111. Kearney, *Post-Nationalist Ireland*, p. 103.

112. "Report of the Department of Agriculture and Technical Instruction for Ireland" (1901–02), p. 692.

113. Ibid.

114. *Irish World*, May 21, 1904.

115. *Freeman's Journal*, January 27, 1900.

116. *Daily Nation*, January 29, 1900.

117. *Daily Express*, July 23, 1898.

118. *Evening Telegraph*, March 25, 1899.

119. The devolution to DATI in 1900 also prompted a series of discussions about the repatriation of scientific artifacts from England to Ireland. The British Museum's trustees briefly considered returning "Irish" crustaceans to Dublin, debating the broader question

of whether scientific artifacts could be said to have a national identity. Whyte, "Science and Nationality."

120. *Irish Figaro,* May 21, 1898. Similarly, Lord Mayo wrote to Sydney Cockerell, "You are of course quite right that Science and Art do not go hand in hand but what is one to do, one man has to organise a department for both under what is called technical education. . . . We have to meet the case as we find it . . . as by degrees the shadow of S[outh] Kensington will entirely disappear from Ireland." Lord Mayo to Sydney Cockerell (Cockerell Papers, BL Add. MS 52743), January 18, 1900.

121. Plunkett, *Ireland in the New Century,* p. 154.

122. Plunkett exhorted the Irish gentry to promote the rehabilitation of rural life by means of financial and intellectual support of cultural institutions in each parish. He suggested that every landowner contribute a library and magic lantern with slides to his district. Plunkett, *Noblesse Oblige,* p. 33.

123. Hugh A. Law to T. P. Gill (Horace Plunkett Papers MS 13482, NLI), April 5, 1900.

124. The exhibition was widely perceived as an enactment of DATI's principles of self-help and mutual aid. Evelyn Gleeson, who with Yeats's sisters founded the Dun Emer Guild to link Celtic Revivalism with the larger Arts and Crafts movement, wrote to the secretary of the department, "The Exhibition is wonderful and seems to have been a revelation to many people—It is indeed fine to see what self-help can do." Evelyn Gleeson to T. P. Gill (Horace Plunkett Papers MS 13483, NLI), July 1, 1903.

125. Quoted in Digby, *Horace Plunkett,* p. 95.

126. Memorandum from T. P. Gill (Horace Plunkett Papers MS 13483, NLI), 1903.

127. Gibbons, *Transformations,* p. 82.

128. *Daily Express,* May 9, 1898.

129. *Annual Report of the Board of Visitors* 23 (1902).

130. *Journal of the Proceedings of the Royal Society of Antiquaries Ireland* (March 1900): 19.

131. Soden-Smith, "Vicissitudes of Art Treasures," *Under the Crown* (March–April 1869): 402–8. This view of the Irish peasant's relationship to the antique can be contrasted with the London Museum's celebration of London County Council construction workers, who were publicly commended for preserving the objects turned up in Council excavations. For a discussion of the London Museum's employment of Council workers, see chapter 4.

132. *Freeman's Journal,* June 16, 1898.

133. *Freeman's Journal,* March 6, 1907.

134. Irving, "On Treasure Trove."

135. Rhind, *Law of Treasure-Trove,* p. 14.

136. Hill, *Treasure Trove in Law and Practice,* pp. 238–39.

137. Irving's proposed remedy was that public museums should attach notices of the finder and locality to their most prized objects; this would instill a sense of "pride and gratification" in working men. Irving, "On Treasure Trove," p. 90.

138. *Celtic Ornaments Found in Ireland,* p. 5.

139. *Hansard* 110 (4th ser.), June 12, 1902.

140. *Irish Times,* June 13, 1902.

141. Ibid.

142. Graham, "'. . . Maybe That's Just Blarney,'" p. 17. Also see the discussion of nineteenth-century British debates about originality, authenticity, and replicas in chapters 4 and 5 of Thomas, *Cultivating Victorians.*

143. Undated poem (Broighter Hoard File, Archaeology Department, NMI). I am grateful to Raghnall O'Floinn and Felicity Devlin for calling my attention to this file. The author of the poem had changed the location of the ornaments from Derry to the nearby county of Tyrone, presumably for the purposes of his rhyme. Thomas Farrell, mentioned in the second stanza of the poem, was a well-known Irish public sculptor of the nineteenth century. His statues of leading figures in Irish politics formed an important part of the landscape of Victorian Dublin.

144. Irish newspapers and journals cited this controversy as a turning point in Ireland's development as a preservationist nation. As the *Daily Express* admitted in 1898, "In the past, too little care has been taken of the treasures we possess. But now that we are fully alive to the value and importance of maintaining a representative national Museum no effort should be left untried to secure that it shall be as perfect as possible." *Daily Express,* July 23, 1898.

145. *Derry Journal,* June 24, 1903. Similarly, the *Daily Express* referred to the British Museum as the "receiver of unlawfully appropriated goods." *Daily Express,* July 23, 1898.

146. *Irish Times,* June 25, 1900.

147. John Atkinson and Dunbar Barton, "Law Officer's Opinion" (CSORP 4575, NAI), n.d.

148. *Evening Herald,* May 28, 1898.

149. *Daily Express,* December 9, 1901.

150. *Irish Times,* July 19, 1898.

151. *Irish Figaro,* December 14, 1901.

152. The term "repatriation" is used here to denote Ireland's status as a nation as well as a more limited reference to the process of cultural return.

153. *Celtic Ornaments Found in Ireland.*

154. *Museums Journal* 3 (1903–4): 81.

155. Harrison, "Give Back the Elgin Marbles," p. 981.

156. *Freeman's Journal,* July 14, 1900.

157. On the interrelationship of colonial history and discourses of "modernity," I have found these souces especially useful: Chatterjee, *Nation and Its Fragments*; Prakash, *Another Reason*; and G. Wright, *Politics of Design.*

158. *Freeman's Journal,* July 14, 1900.

159. Sir George Christopher Trout Bartley was the assistant director of the Science Division of the Science and Art Department in London until he resigned to stand for Parliament in 1885. He was the Conservative M.P. for North Islington from 1885 to 1906.

160. *Hansard* 110 (4th ser.), June 12, 1902.

161. Chief Justice Farwell was an additional judge of the Chancery Division from 1877 to his death in 1908. Haldane, a Liberal imperialist, was a specialist in the law relating

to real property and had also served on an advisory committee for the South Kensington complex. On Finlay, see n. 1.

162. In the High Court of Justice before Mr. Justice Farwell. The Attorney-General v. The Trustees of the British Museum (Royal Courts of Justice Records, NAI), 1903, p. 2.

163. Black, *On Exhibit,* and Coombes, *Reinventing Africa,* are particularly useful on this point.

164. The principal work concerning treasure trove in the twentieth century was authored by Sir George Hill, who was director of the British Museum from 1931 to 1936. See Hill, *Treasure Trove.*

165. Halfin, "Legal Protection of Cultural Property in Britain."

166. Gerstenblith, "Identity and Cultural Property."

167. Quoted in Martin, "Law of Treasure Trove" (1903), p. 55.

168. According to the British Treasure Act of 1996, the original restrictions on metal content were abandoned. The definition of treasure was expanded to include any object at least three hundred years old containing more than five percent precious metal. Also, the medieval law of *trover* was altered to remove the stipulation that the object must have been buried with the express intention of being found. Carleton, "Protecting the National Heritage"; Gerstenblith, "Public Interest."

169. Farwell drew his definition of treasure trove from Chitty's *Prerogatives of the Crown* (1820), which added the provision that the objects must be found either buried in the ground or concealed in a home or other private space. On Farwell's sources, see Martin, "Treasure Trove and the British Museum."

170. Blackstone, *Commentaries,* 1:285–86.

171. Martin, "Law of Treasure Trove" (1903), p. 145.

172. Irving referred to Blackstone's treatment of treasure trove law as "most unfortunate," presumably because of this point about the owner's intentions. He noted that Blackstone's definition did not account for situations such as that of Pompeii, in which objects were "concealed" by the hand of God rather than man. Irving, "On Treasure Trove," p. 86.

173. Antiquarian scholars also occasionally suggested biblical sources for the law of *trover,* such as Job 21: "Which long for death but it cometh not, and dig for it more than for hid treasures." Baylis, "Treasure Trove."

174. Martin, "Law of Treasure Trove" (1903), p. 56.

175. Blanchet and Grueber, "Treasure Trove"; Clarke, "Notes on the Roman and Early English Law of Treasure Trove."

176. Hill, *Treasure Trove,* p. 14.

177. Blackstone, *Commentaries,* 1:286.

178. Izuel, "Property Owners' Constructive Possession."

179. Clarke, "Notes," p. 355.

180. Blanchet and Grueber, "Treasure Trove," p. 159.

181. Murray, *Archaeological Survey,* p. 58.

182. Hill, *Treasure Trove,* p. vii.

183. Dobie, "Law of Treasure Trove."

184. Quoted in Irving, "On Treasure Trove," p. 89.

185. Martin, "Law of Treasure Trove" (1903), p. 56.

186. Dolley, "First Treasure Trove Inquest in Ireland?"

187. Anderson, "Treasure Trove"; Rhind, *Law of Treasure-Trove*, p. 8.

188. The English law generally prevailed in the colonies, although there were a few key exceptions. South Africa and British Guiana both retained the Roman-Dutch law, and Mauritius retained the French Code Civil. In the Sudan, ordinances regarding treasure trove applied only to hoards dated before 1783. Hill, *Treasure Trove*, p. 270.

189. On the Indian Treasure Trove Act (1878), see Biswas, *Protecting the Cultural Heritage*.

190. Patrick Coll to Undersecretary of Ireland (Celtic Ornaments File, TS18/603, PRO), February 7, 1900.

191. As a secondary claim, the British Museum attorneys argued that even if these articles were designated as treasure trove, the rights to *trover* in this particular district of Ireland had passed from the Crown to the Fishmongers' Company by the Charter of James I; the company had then passed their rights to the British Museum. Finlay successfully argued against this claim, noting that the Charter did not include the words "treasure trove" and that treasure could not pass from the Crown under the general terms of charters or franchises.

192. "Depositions" (Celtic Ornaments File, TS18/603, PRO), n.d.

193. Ibid.

194. Statement by S. Hanna (Celtic Ornaments File, TS18/603, PRO), February 12, 1900.

195. Statement of Thomas Nicholl (Celtic Ornaments File, TS18/603, PRO), n.d.

196. On the antiquarianism of the Anglo-Irish middle classes, see Foster, *Paddy and Mr. Punch*.

197. "Treasure Trove: Celtic Ornaments Found in Ireland. Case Submitted to the Attorney and Solicitor General for England and the Attorney and the Solicitor General for Ireland" (Celtic Ornaments File, TS18/603, PRO), December 28, 1899.

198. Martin, "Law of Treasure Trove" (1903), p. 280.

199. Clarke, "Notes," p. 356.

200. Faussett, "On the Present State of the Law of 'Treasure Trove.'"

201. Court Case *A.G. vs. British Museum* (NAI), 1903, p. 58.

202. Ibid., p. 55.

203. "Deposition: Robert Cochrane" (Celtic Ornaments File, TS18/603, PRO), n.d.

204. W. G. Towers to R. H. Lane (NAI), December 3, 1902.

205. W. G. Towers to Treasury Solicitor (NAI), May 7, 1903; "Instructions to Advise on Sufficiency of Evidence" (Celtic Ornaments File, TS18/603, PRO), n.d.

206. Collins, *Nationalism and Unionism*.

207. W. G. Towers to R. H. Lane (NAI), December 3, 1902.

208. "The Recent Case of Treasure Trove."

209. On the elusive history of the peasant in twentieth-century Ireland, see Kinmonth, "Rags and Rushes."

210. *Irish Times,* July 21, 1898.

211. *Celtic Ornaments Found in Ireland,* p. 8.

212. *Daily Express,* December 9, 1901.

213. *Times* (London), July 31, 1900.

214. W. G. Towers to J. R. Kilroe (NAI), May 29, 1903.

215. G. N. Plunkett to Crown Solicitor (Broighter Hoard File, Archaeology Department, NMI), February 24, 1903.

216. "Depositions" (Celtic Ornaments File, TS18/603, PRO), n.d.

217. Pecora, "Arnoldian Ethnologies," p. 356.

218. *Irish Times,* July 8, 1924.

219. *Evening Herald,* December 8, 1897. The paper also referred to early English workmanship as a "bastard variety of the Roman and Byzantine style." *Evening Herald,* August 25, 1898.

220. Compton, "Treasure Trove," p. 126.

221. "In the High Court of Justice before Mr. Justice Farwell. *The Attorney-General v. The Trustees of the British Museum*" (Celtic Ornaments File, TS18/603, PRO) [1903].

222. "In the High Court of Justice before Mr. Justice Farwell. *The Attorney-General v. The Trustees of the British Museum*" (Royal Courts of Justice Records, NAI), June 15, 1903, p. 74.

223. The argument that conquest establishes per se ownership rights has been debated by many legal scholars; Osman elaborates Merryman's views concerning this point and presents counterarguments in Osman, "Occupiers' Title."

224. "In the High Court of Justice before Mr. Justice Farwell. *The Attorney-General v. The Trustees of the British Museum* (Royal Courts of Justice Records, NAI)., June 15 1903, p. 74.

225. Gibbons, *Transformations in Irish Culture,* p. 159.

226. The *Irish Times* commented that judges rarely had such a "romantic, poetic, and interesting subject upon which to deliver argument in Chancery." *Irish Times,* June 22, 1903.

227. Praeger, *The Way That I Went,* p. 69.

228. *Hansard* 126 (4th ser.), July 28, 1903.

229. As the *Irish Times* concluded, the ancient Irish kings were "always imaginative," but oceans and mermaids held little place in their mythology. *Irish Times,* June 22, 1903.

230. "In the High Court of Justice before Mr. Justice Farwell. *The Attorney-General v. The Trustees of the British Museum*," (Royal Courts of Justice Records, NAI), June 15 1903, p. 173.

231. *Hansard* 125 (4th ser.), July 8, 1903.

232. Faussett, "'Treasure Trove.'" I am grateful to David Armitage for encouraging me to consider the implications of the law of *trover* further.

233. Carlyon-Britton, "Treasure-Trove."

234. *Minutes of the Royal Irish Academy* 7 (March 16, 1904), p. 211.

235. The name change was initiated by the Department of Agriculture, with the concurrence of Treasury and the Lord Lieutenant. As this chapter suggests, however, the phrase "national museum" was used with reference to the Dublin Museum long before 1908, with special reference to the Celtic gold ornaments controversy. *Irish Times*, July 1, 1908.

236. Jephson, "Valuation of Property in Ireland."

237. Foster argues that the land question remained central to Irish politics in this period, despite the fact that the land war has been "curiously written out of Irish history." Foster, "Anglo-Irish Literature," p. 64. The Wyndham Act of 1903 is discussed in detail in Bull, *Land, Politics, and Nationalism*, pp. 153–58.

238. Although the act was hailed as a centerpiece of conciliationist achievement, it was also attacked by radical agrarians in Ireland for the prices they imposed on land buyers and for sluggish operations in crisis areas, such as the west of Ireland. Jackson, *Ireland*, p. 151.

239. Campbell, "Irish Popular Politics."

240. The notion that Irish nationalism contained many characteristically "English" elements—such as the political centrality of property—is discussed in Hoppen, "Nationalist Mobilisation." Tadhg Foley and Séan Ryder have also noted the ways in which nineteenth-century Ireland functioned as a testing ground for ideologies utilized by imperial metropolitan cultures of Great Britain such as classicist aesthetics and laissez-faire economics. Foley and Ryder, *Ideology and Ireland in the 19th Century*.

241. On differing perceptions of land in England and Ireland, see Eagleton, *Heathcliff and the Great Hunger*.

242. On the centrality of the land wars in politicizing the Irish peasantry, see Boyce and O'Day, *Making of Modern Irish History*.

243. On the magical symbolism of the plough in Irish nationalist geographies, see Nash, "Visionary Geographies."

244. See the conflation of the Celtic ornaments case with the Irish land rights struggle in "National Gallery (Purchase of Adjacent Land)," *Hansard* 97 (4th ser.), July 22, 1901.

245. "Recent Case," p. 276.

246. Ibid.

247. This objection was cited by William Martin, one of the leading scholars of the law of *trover*. Martin himself did not share this objection because he believed that treasure trove was rarely indigenous to the place of its discovery. He maintained that the Celtic gold ornaments discovered in Broighter were probably stolen from England. Martin, "Law of Treasure Trove" (1908), p. 352.

248. Compton, "Treasure Trove."

249. This proposal is noted in Martin, "British Museum."

250. Compton, "Can Votive Offerings be Treasure Trove?"

251. The landowner had no legal compulsion to reward the finder and was subject only to moral suasion. But a Treasury Minute of 1886 outlined the rewards that were promised by the Crown if the treasure were voluntarily ceded. The key difficulty, according

to most scholars of treasure trove, was in communicating the fact of these incentives to peasants in remote districts. Martin, "Law of Treasure Trove" (1908), p. 351.

252. Anderson, "Treasure Trove," p. 79. After the conclusion of the Gold Ornaments case, William Martin suggested that remuneration for finders should be placed on a statutory basis and that the law of treasure trove should be extended to include objects other than precious metals. Martin, "Law of Treasure Trove" (1905).

253. This estimate of the bullion value of the ornaments was based on their weight, which exceeded twelve ounces. Anderson, "Treasure Trove," p. 75.

254. Martin, "Law of Treasure Trove" (1908), p. 352.

255. Hill, *Treasure Trove*, p. 241.

256. Martin, "Law of Treasure Trove" (1903), p. 281.

257. Martin, "Law of Treasure Trove" (1908), p. 358.

258. Carlyon-Britton, "Treasure Trove," p. 123.

259. Dobie, "Law of Treasure Trove," p. 308. See also "Treasure Trove," *British Museum Quarterly* 6 (1931): 28–29.

260. Elliott, *Art and Ireland*, p. 139. Irish dependence with respect to English design was perceived to be particularly strong in the field of domestic architecture. Dominic Ware wrote of Irish homes, "[I]f one does not quite look for Parnellite porches or Healyite flamboyancies, at least one might expect something indicative of independent thought. But there are many days' marches between such natural outcrops." Ware, "Shadow of a Flag," p. 156.

261. Elliott, *Art in Ireland*, p. 72.

262. Ibid., p. 46.

263. *Freeman's Journal*, March 15, 1911.

264. *Irish Times*, March 15, 1911.

265. *Evening Telegraph*, July 10, 1912.

266. The Museums Association had met once previously in Dublin, in 1894.

267. *Freeman's Journal*, January 10, 1912.

268. *Irish Monthly*, November 1912, pp. 608–12.

269. *Annual Report of the Board of Visitors to the National Museum of Ireland* (1913), p. 7.

270. *Irish Monthly*, November 1912, 608–12.

271. Elizabeth Bowen's more famous version of this aphorism, in which she said that she wished the English would keep history in mind more, and the Irish less, is quoted in Foster, *Paddy and Mr. Punch*, p. 1.

272. Hackett, *Ireland*, p. 158.

273. Praeger, *The Way That I Went*, p. 30.

274. Ibid., p. 32.

275. Thomas Bodkin, "Report on Art in Ireland" (Bodkin Papers 6965, Trinity College, Dublin), October 1, 1949.

276. Bodkin excised this paragraph about the Fascist Museum from his final draft of the report.

277. Bodkin, "Report on Art," p. 15.

278. Ibid., p. 82.

279. This interpretation would seem to support the earlier historiography concerning the incompatibility of political and cultural nationalisms in Ireland. See n. 47.

280. Crossman, *Politics, Law, and Order.*

281. Greenfield, *Return of Cultural Treasures*, p. 137.

282. Daley, "Pheidias Albion"; Thomas, "Theory of Devolution."

283. King, "Labour History at the People's Palace."

284. Jones, "Bones of Contention."

285. The main collection of Benin bronzes still resides in the British Museum. Daley, "Pheidias Albion."

286. Taylor, "Alternative to Art and Culture," p. 11.

287. Simpson, *Making Representations.*

288. Recent voluntary repatriation offers from the United Kingdom are outlined in Palmer, *Museums and the Holocaust.*

289. Falconer, "Finders Keepers?"

290. Garrett Stokes, pers. comm., June 30, 2000. Stokes's comments are particularly interesting in light of Luke Gibbons's analysis of the union between information technology and neotraditionalism in Ireland today. Gibbons, *Transformations in Irish Culture*, p. 89.

291. Press release from the Central Bank of Ireland, November 29, 1999.

292. Lloyd, *Ireland After History*, p. 4.

293. Nail, "Treasured Bones." My primary concern has been with the history of repatriating artifacts rather than human remains. But one case of the latter is significant, namely, the lobby in Zimbawe to exhume the mortal remains of the imperialist Cecil John Rhodes from the Matapos National Park in Zimbawe and return them to Britain. Although this case would seem to constitute a reversal of most repatriation claims, in that the demand is to return the remains to the colonizing country rather than the colonized, the process of striving to reverse colonial history is fundamentally similar. See Muringaniza, "Heritage That Hurts."

294. Leach, "Owning Creativity."

295. Irish Antiquities Letter Files (Education Department, NMI), 1899–1900.

Chapter Two

1. Campbell, *Portfolio.*

2. On the "Grecianizing" influence of W. E. Playfair's building program in Edinburgh, including the National Gallery of Scotland, see Devine, *Scottish Nation*, p. 329.

3. *Scotsman*, January 13, 1903.

4. See the prelude.

5. Duncan and Wallach, "Universal Survey Museum."

6. *Scotsman*, January 30, 1883.

7. One letter to the *Scotsman* complained that the National Gallery of Scotland housed an "offensive collection of diploma pictures." *Scotsman*, January 29, 1883.

8. Kidd, "Strange Death of Scottish History." 99.

9. Morris and Morton, "Where Was Nineteenth-Century Scotland?"; Morton, "Scottish Rights and 'Centralization.'"

10. Kidd, *Subverting Scotland's Past*, pp. 267–70.

11. Campbell, *Portfolio*.

12. The bill was written in the plural because its intended reforms would apply to the National Gallery of Scotland and to the National Portrait Gallery of Scotland. The chief complaints, however, were directed against the National Gallery.

13. I take the phrase from McCrone, *Understanding Scotland: The Sociology of a Stateless Nation.*

14. On the Liberal Party's vision of Celtic identity, see Ellis, "Reconciling the Celt."

15. The *Scotsman* supported the Unionists during the 1880s and broke with the Gladstonian Liberals, outraging many of its readers. Magnusson et al., *Glorious Privilege*, p. 70.

16. On the hegemony of Liberalism in Scotland and Wales from 1832 to 1914, see Brooks, "Gladstone and Midlothian"; S. Brown, "'Echoes of Midlothian'"; Devine, *Scottish Nation*; Jones, "Beyond Identity?"; Packer, "Land Issue."

17. Brown, McCrone, and Paterson, *Politics and Society in Scotland*, p. 25.

18. T. M. Devine argues that "Highlandism answered the need for the maintenance of a distinctive Scottish identity without in any way compromising the Union. Indeed the indissoluble link between tartanry, the Highland soldier, patriotism and imperial service bestowed a new cultural and emotional cohesion on the Union relationship." Devine, *Clanship to Crofters' War*, p. 98.

19. Rosey, "Museumry and the Heritage Industry." The collections policy of the new Museum of Scotland is analyzed in Taylor, "What Is in a 'National' Museum?" Taylor suggests that a viable collections policy would adopt a "territorial" definition of the Scottish nation and would illuminate the histories of the Scottish diaspora, overseas trade, and military history.

20. Trevor-Roper, "Invention of Tradition." For more recent critical responses to this piece, see Macdonald, *Reimagining Culture*; Pittock, *Myth of the Jacobite Clans*.

21. Watson, "Twee and the Tweed." Similarly, Murray Pittock argues that the Scottish have always lacked the nascent Irish suspicion of kitsch. Pittock, *Celtic Identity*, p. 93.

22. Donnachie and Whatley, *Manufacture of Scottish History*.

23. Mather, "Government Agencies and Land Development."

24. Shaw, "Land, People, and Nation."

25. "Crofters, Past and Present," *Blackwoods Magazine*, August 1906, pp. 264–74.

26. Devine, *Exploring the Scottish Past*, p. 133.

27. Cameron, "Politics, Ideology, and the Highlands Land Issue."

28. MacCuish, "Crofting Legislation Since 1886."

29. Campbell, *Scotland as It Was and as It Is*. Also see Mason, "Duke of Argyll."

30. Devine, *Exploring the Scottish Past*, p. 140.

31. Rodger, *Transformation of Edinburgh*, p. 269.

32. Ibid., p. 390.

33. Ibid., p. 412.

34. Alice Brown et al. have recently suggested that other institutions, such as the Scottish Office and the mass media, have also played a critical role in Scottish civil society. Brown, McCrone, and Paterson, *Politics and Society in Scotland.*

35. Cohen, "Nationalism and Social Identity"; Harvie, "Nineteenth-Century Scotland"; Kidd, "Teutonist Ethnology."

36. Kidd, "Sentiment, Race, and Revival."

37. Wolfe, *Government and Nationalism in Scotland*, p. 186. Also see Tom Nairn's discussion of the neurosis of Scottish "sub-nationalism," which Nairn sees as motivated by "vulgar tartanry." Nairn, *Break-Up of Britain*, p. 156.

38. Pittock, *Scottish Nationality*, p. 44.

39. Lindsay Paterson has argued that the Union was always partial; it was an amalgamation of Parliaments that left Scotland's institutions of civic life largely intact. The Union, in her view, thus allowed a distinctive Scottish civic ethic to flourish, and this ethic created the socially responsible character of Victorian Liberalism. Paterson, "Scottish Democracy and Scottish Utopias."

40. On narratives of British unity, see Colley, *Britons*; Colley, "Britishness and Otherness." For a critical overview of the scholarship produced in response to Colley, see Harvie, "Folly of Our Fable"; Mandler, "England, Which England?"

41. Gibson, *Thistle and the Crown.*

42. See, e.g., Hanham, *Scottish Nationalism*; and Morton, "Civil Society."

43. Gibson, *Thistle and the Crown.*

44. Hanham, "Development of the Scottish Office,"p. 51.

45. Ibid., p. 52.

46. Morris and Morton, "Where Was Nineteenth-Century Scotland?"; Morton, "What If?"

47. Morton, *Unionist Nationalism.*

48. Keating, *Nations Against the State.*

49. Prior, "Edinburgh, Romanticism, and the National Gallery of Scotland."

50. *Hansard* 95 (4th ser.), June 21, 1901.

51. Ibid.

52. *Glasgow Herald*, August 10, 1904.

53. Campbell, *Portfolio.*

54. Caw, *Scottish Painting Past and Present*, p. 94.

55. Caw, *Catalogue of the Scottish National Portrait Gallery.*

56. Caw, *Pictures and How to Enjoy Them*, p. 36.

57. Ibid., p. 44.

58. Billcliffe, *Glasgow Boys*; Jacobs and Warner, *Art in Scotland.*

59. Guthrie claimed that "while Scottish painting invades England it is seldom that things begun in England ripen in Scotland." James Guthrie to Reginald Hallward (ACC 8833, NLS), 1904.

60. John Murray to Austen Henry Layard (Layard Papers, BL Add. MS 39041), May 10, 1887.

61. In 1905 a deputation from the South of Scotland Chamber of Commerce visited the secretary of Scotland to demand that the Board of Manufactures increase its efforts in the promotion of woolens. The deputation argued that the board, in its apparent devotion to painting and sculpture, had "driven a coach-and-four through the [original] Act of Parliament." "Scottish Board of Manufactures: Claim for Restoration of Fund to Original Purpose" (Stirling-Maxwell Papers T-PM 122, Mitchell Library Manuscripts, SRA), 1905.

62. See the correspondence between Charles Cooper, editor of the *Scotsman*, and the earl of Rosebery. Charles Cooper to Archibald Philip Primrose, Earl of Rosebery (MS 10010, NLS), March 17, 1882 and May 13, 1883.

63. *Museums Journal* 1 (1901): 67.

64. Similarly, see the discussion of South Kensington's controversial ministrations in Ireland in chapter 1.

65. *Scotsman*, January 22, 1886.

66. The president of the Royal Scottish Academy demanded in 1884 that they should "get a little more Home Rule—not such as would injure Imperial interests, but sufficient to benefit them considerably at home." Unlabeled press cutting (National Gallery of Scotland Press Cuttings Archive, NG.1/68/1, SRO), January 16, 1884.

67. *Hansard* 271 (3d ser.), July 10, 1882.

68. Ibid.

69. *Scotsman*, June 27, 1902.

70. *Scotsman*, May 11, 1905.

71. Aytoun, "Scotland Since the Union," *Blackwood's Magazine*, September 1853 (repr., 1891), 263; Davidson, *Scotia Rediviva*.

72. *Scotsman*, June 20, 1882; Armstrong, "National Gallery of Scotland."

73. *Scotsman*, January 30, 1883.

74. The Scottish Society of Antiquaries did undertake its own repatriation campaign for a different purpose, which was to return the Glenlyon brooch to Scotland.

75. The *Scotsman* suggested that the greater expenditure on art in Ireland was due to the fact that Ireland had its own independent Office of Works. Scotland was under English control in this matter, and thus "every penny spent on Scotland by the English Office of Works was grudged." *Scotsman*, December 12, 1881.

76. X., *On the Neglect of Scotland*.

77. Davidson, *Scotia Rediviva*.

78. *Fiery Cross*, July 1904.

79. *Hansard* 95 (4th ser.), June 21, 1901.

80. *Scotsman*, January 29, 1883.

81. *Scotsman*, January 13, 1885.

82. Gibson, *Thistle and the Crown*.

83. *Scotsman*, November 18, 1885.

84. *Hansard* 110 (4th ser.), June 26, 1902.

85. On concentric loyalties, see Crick, "Essay on Britishness."

86. Annual reports to the secretary for Scotland by the commissioners and trustees of the Board of Manufactures in Scotland (London: H.M.S.O., 1894–1908).

87. Ibid.

88. James Guthrie to John Stirling-Maxwell (Stirling-Maxwell Papers T-PM 122, Mitchell Library Manuscripts, SRA), 1904.

89. *Scotsman*, June 28, 1902.

90. *Scotsman*, November 18, 1903.

91. *Hansard* 110 (4th ser.), June 26 1902.

92. Ibid.

93. Jenkins, *Chancellors*, pp. 91–93.

94. *Scotsman*, July 2, 1902.

95. The *Scotsman* later backpedaled regarding this point, acknowledging that artistic matters sometimes fell outside the parameters of the Scottish Office. *Scotsman*, July 18, 1902.

96. *Scotsman*, July 2, 1902.

97. *Scotsman*, June 8, 1885.

98. *Scotsman*, April 1, 1890.

99. *Hansard* 162 (4th ser.), July 28, 1906.

100. *Scotsman*, June 27, 1902.

101. On the Scottish fear that Irish nationalism was taken more seriously by British political elites, see Kidd, "Sentiment, Race, and Revival."

102. *Scotsman*, July 2, 1902.

103. *Scotsman*, January 13, 1903.

104. *Hansard* 145 (4th ser.), May 10, 1903.

105. Colin Kidd's comparative analysis of Scottish and Irish preoccupations with the past is particularly instructive. Kidd argues that the Scots have had a more profound sense of the gulf between antiquity and the present than the Irish; this perception of a rupture with the past tended to have a negative effect on Scottish ethnocultural identity and nationalism in the nineteenth century. Kidd, "Gaelic Antiquity and National Identity."

106. *Edinburgh Evening Dispatch*, July 1, 1902.

107. X., *On the Neglect of Scotland*.

108. *Hansard* 110 (4th ser.), June 26, 1902.

109. Scotland's own participation in imperial history was entirely overlooked in this debate. On more recent efforts to emphasize Scotland's radical democratic past instead of its imperial affairs, see Pittock, *Myth of the Jacobite Clans*.

110. *Hansard* 110 (4th ser.), June 26, 1902.

111. *Dundee Advertiser*, June 27, 1902.

112. *Scotsman*, July 11, 1902.

113. *Scotsman*, November 12, 1903.

114. *Glasgow Herald*, November 12, 1903.

115. James Guthrie to John Stirling-Maxwell (Stirling-Maxwell Papers T-PM 122, Mitchell Library Manuscripts, SRA), 1903.

116. *Scotsman*, November 18, 1903.

117. *Scotsman*, January 27, 1906.

118. Ibid.

119. *Hansard* 110 (4th ser.), June 26, 1902.

120. Pittock, *Myth of the Jacobite Clans*, p. 115.

121. *Glasgow News*, December 14, 1905.

122. Stirlingshire was a historic county in central Scotland that incorporated a section of the Highlands. Dumfries Burghs, in southwestern Scotland, was best known as a frequent target of English raids during the Scottish wars of independence. Smeaton and Gulland's amendments sought to shift the focus of the galleries bill debates away from the southeastern sector of Scotland and away from Edinburgh in particular.

123. *Scotsman*, November 17, 1906.

124. *Glasgow Herald*, August 10, 1904.

125. Fiona Watson notes that Glasgow remains exceptional in the Scottish heritage industry for its local and working-class support of museums. Watson, "Twee and the Tweed."

126. Best, "Scottish Victorian City."

127. Dickson and Paton, *Present Position*.

128. Maver, "Glasgow's Public Parks and the Community."

129. Maver, "Glasgow's Civic Government."

130. Fisher, "Glasgow – A Model Municipality."

131. Maver, "Politics and Power in the Scottish City."

132. Fraser, "Municipal Socialism and Social Policy."

133. "The Present Position of the Museum and Art Galleries of Glasgow," presented to the Parks Committee of the Town Council (Mitchell Library Manuscripts MP 14/688, SRA), February 5 1885; Parks Committee, Minutes as to the Proposed Exhibition in Glasgow in 1888 (Mitchell Library Manuscripts MP 15/129 and D-TC 7/16/1, SRA), n.d.

134. James Guthrie to Reginald Hallward (ACC 8833, NLS), July 19, 1904.

135. *Glasgow Herald*, February 6, 1903.

136. Rodger, *Transformation*, p. 491.

137. *Hansard* 139 (4th ser.), August 9, 1904.

138. *Scottish Patriot*, October 1904, p. 33.

139. *Glasgow Herald*, December 10, 1906.

140. *Scotsman*, July 30, 1906.

141. *Scottish Review and Christian Leader*, August 9, 1906.

142. *Hansard* 162 (4th ser.), July 28, 1906.

143. *Glasgow Herald*, July 30, 1906.

144. *Hansard* 162 (4th ser.), July 28, 1906.

145. On the centrality of democracy to Scottish identity, see Cohen, "Personal Nationalism."

146. *Bailie*, June 14, 1905; *Glasgow Times*, June 14, 1905.

147. *Hansard* 162 (4th ser.), July 28, 1906.

148. *Glasgow Herald*, July 30, 1906.

149. *Hansard* 162 (4th ser.), July 28, 1906. The *Glasgow Herald* also reported this speech, although it quoted Gulland as saying, "[S]urely Scotland was not going to be degraded to the level of England." *Glasgow Herald*, July 30, 1906.

150. *Glasgow Herald*, September 25, 1906.

151. Regarding this point, Gulland and Stirling-Maxwell agreed. As Stirling-Maxwell wrote to the art patron David Alexander, earl of Balcarres, Sinclair "has been a most complete failure this Session, and the Scottish Members appear to be somewhat irritated with his weakness and general conduct of Scottish business." John Stirling-Maxwell to David Alexander, Earl of Crawford and Balcarres (National Art-Collections Fund Papers 97/18-35, NLS), July 26, 1906.

152. *Hansard* 167 (4th ser.), December 14, 1906.

153. Ibid.

154. *Scotsman*, July 30, 1906.

155. *Glasgow Herald*, July 30, 1906.

156. *Glasgow Herald*, September 25, 1906.

157. *Scotsman*, October 10, 1906.

158. Hanham, "Scottish Office," pp. 54–55.

159. *Hansard* 167 (4th ser.), December 14, 1906.

160. *Glasgow Herald*, December 12, 1906.

161. *Scottish Review and Christian Leader*, January 10, 1907.

162. *Hansard* 167 (4th ser.), December 18, 1906.

163. *Scotsman*, December 12, 1906.

164. *Scotsman*, December 15, 1906.

165. *Hansard* 162 (4th ser.), July 28, 1906.

166. The amendments were referred to as the "compromised" portion of the bill; *Glasgow Herald*, December 15, 1906; *Scottish Review and Christian Leader*, December 20, 1906.

167. James Guthrie to John Stirling-Maxwell (Stirling-Maxwell Collection T-PM 122, Mitchell Library Manuscripts, SRA), August 19, 1905.

168. *Scotsman*, April 1, 1907.

169. *Scottish Patriot*, February 1904.

170. On the complex politics of commemoration, see Gillis, *Commemorations*; Sherman, *Construction of Memory*.

171. *Scotsman*, May 4, 1907.

172. Sir James Guthrie, "Report on the Present Composition and Suggestions as to the Desirable Development of the National Gallery" (National Gallery of Scotland Archives, SRO), November 29, 1907.

173. "First Report of the Scottish Modern Arts Association" (ED 003/2/1, ECA), 1908.

174. *Speaker*, November 3, 1906. Also see *Scotsman*, October 26, 1906.

175. The National Art-Collections Fund was overseen by the Scottish art patron David Alexander, the earl of Crawford and Balcarres. Isidore Spielmann to David Alexander, earl of Crawford and Balcarres (National Art-Collections Fund Papers, 97/18-35, NLS), March 9, 1906.

176. Unlabeled news clipping (National Gallery of Scotland Archives NG5/2/6, SRO), 1908.

177. *Scotsman*, March 3, 1909.

178. *Thistle*, May 1909.

179. *Scotsman*, March 5, 1909.

180. *Scotsman*, June 4, 1912.

181. *Scotsman*, June 6, 1912.

182. *Scotsman*, October 16, 1912.

183. *Thistle*, July 1911.

184. The Museum of Scotland, established in 1998 on the eve of Scottish devolution, did not include any mention of Wallace. Nationalist politicians had urged the inclusion of the Wallace legend, but the curators had no relics of Wallace and insisted that the historical narrative of the museum be entirely object-driven. *New York Times*, July 29, 1999.

185. *Thistle*, February 1911.

186. *Dispatch*, March 7, 1913.

187. *Connoisseur* 34 (1912): 34.

188. Nairn, *Break-Up of Britain*, p. 170.

Chapter Three

1. The National Gallery had apparently considered the duke's loan to be a permanent one. Many journalists were surprised to learn that the gallery did not own the painting outright. *Western Mail*, May 3, 1909.

2. Several art critics objected to this classification of Holbein as a British painter. One editor commented, "I always thought Holbein was a Bavarian. Ought not the picture to go back to the Bavarians?" *Bystander*, May 12, 1909. Similarly, the *Scotsman* reported that some visitors to the National Gallery did not care if the picture left the country, since it was "not as if an Englishwoman were going away." *Scotsman*, June 4, 1909.

3. *Daily Graphic*, May 4, 1909.

4. *Daily Graphic*, May 6, 1909.

5. The original sale price was £62,000, but the art dealers who handled the transaction at Colnaghi raised the price to £72,000. *Times* (London), May 10, 1909.

6. On the history of gender and portraiture in Britain, see Cherry, *Beyond the Frame*; Maynard, "'A Dream of Fair Women'"; Perry, "Looking Like a Woman"; Pointon, *Hanging the Head*.

7. Geddes, *World Without and the World Within*, p. 27.

8. Barbara Black's discussion of Victorian literary representations of museum culture notes that in Charlotte Brontë's *Villette*, "the museum represents for Lucy the space of the cultural, the other or non-self, the masculine. The museum is the arena of male prerogative and desire." Black, "Fragments Shored Against Their Ruin." Similarly, see Duncan, "MoMA's Hot Mamas"; Duncan, *Civilising Rituals*.

9. See the discussion of women art collectors, artists, and gallery directors at London's Grosvenor Gallery in Denney, *At the Temple of Art.*

10. See, e.g., Glaser and Zenetou, *Gender Perspectives*, which is focused entirely on the mid- to late twentieth century. The same time period is covered in Carnegie, "Trying to Be an Honest Woman" and Porter, "Seeing Through Solidity."

11. Koshar, "Building Pasts." Important exceptions dealing with individual collectors are Eatwell, "Private Pleasure, Public Beneficence"; Macleod, "Eliza Bowen Jumel"; West, "Gender Politics."

12. As Susan Pearce has suggested, "gender is itself constructed through collection and collections . . . for material culture has here, as everywhere, an active as well as a passive stance." Pearce, *Museums, Objects, and Collections*, p. 63.

13. The Guerrilla Girls designate the right to exhibit art in public spaces as a civil right and attribute the underrepresentation of women artists to women's lack of economic clout in the art market and in the larger society. *Confessions of the Guerrilla Girls*; Gablik, "'We Spell It Like the Freedom Fighters'"; O'Grady, "Dada Meets Mama."

14. Fowler, "Why Did Suffragettes Attack Works of Art?" See also Lynda Nead's insightful analysis of Mary Richardson's 1903 attack on the National Gallery's *Rokeby Venus* in Nead, *Female Nude.*

15. Anne Higonnet has described the National Museum of Women in the Arts as a failed institutionalization of feminism, arguing that the museum depoliticizes feminism by relegating it to the nostalgic sphere of the museum. She refers to this museum as an institution that "makes painfully aware the discrepancy between feminist ideals and the concrete possibilities for acting on them." Higonnet, "New Center."

16. The Guerrilla Girls, for example, have focused in particular on critiques of the Metropolitan Museum of Art, which was founded in 1870 and opened to the public in 1880. Noting that although 85 percent of the Met's nudes were female, only 5 percent of the artists represented at the museum were women, one of the most famous Guerrilla Girl posters asks the viewer, "Do women need to be naked to get into the Met?"

17. See Tim Dolin's discussion of Elizabeth Gaskell's *Cranford* as an atypical and not entirely successful disruption of this model. Dolin, *Mistress of the House.* On precedents for women's art collections, see Teixera, "Portuguese Art Treasures," and more recently, Gee, *Women, Art, and Patronage.*

18. Flower, *Essays on Museums*, p. 67.

19. Deane's three-volume treatise, *The Collector*, was originally published as a series of articles in *Queen Magazine.* Deane, *The Collector* (1903–7), 3:236.

20. Pearce, *On Collecting.*

21. The 1882 act involved more sweeping measures than its predecessors in 1857 and 1870. For a discussion of this legislation, see Holcombe, *Wives and Property*; Shanley, *Feminism, Marriage, and the Law.* For contemporary sources, see Baker, *Husband and Wife*; Hamilton, *Law of Husband and Wife*; Elmy, "Married Women's Property Act."

22. Dianne Sachko Macleod has noted that women art collectors occasionally prospered in Britain even before the passage of the 1882 act, although usually in conjunction with their husbands. Macleod shows an important network of British women art collectors providing a system of "matronage" for the Pre-Raphaelite Brotherhood. Macleod, "Pre-Raphaelite Women Collectors."

23. Butler, "Early Liberal Roots of Feminism"; Gerson, "Liberal Feminism"; Hekman, "John Stuart Mill's *The Subjection of Women*." For a wider historiographical debate, see Offen, "Defining Feminism"; Scott, *Only Paradoxes to Offer*.

24. Levine, *Feminist Lives*, pp. 116–17.

25. Hollis, *Ladies Elect*; Prochaska, *Women and Philanthropy*; Turnbull, "'So Extremely Like Parliament.'"

26. On the relationship between institutions and critiques, see Douglas, *How Institutions Think*.

27. Macpherson, *Memoirs of Anna Jameson*, p. 332. For a discussion of more recent scholarship on Jameson, see Booth, "Lessons of the Medusa"; Johnston, *Anna Jameson*.

28. Holcomb and Sherman, *Women as Interpreters of the Visual Arts*, p. 116.

29. According to Mary Lyndon Shanley, Jameson referred to Leigh Smith and her circle as her "adopted nieces." Shanley suggests that Leigh Smith's goals of legal reform in married women's property were in part shaped by witnessing Jameson's negative experiences with her husband, as well as the much more high-profile case of Caroline Norton. Shanley, *Feminism, Marriage, and the Law*, pp. 30–33. On Caroline Norton, see Poovey, *Uneven Developments*, pp. 51–88.

30. Jameson was involved in a campaign to ensure that women artists were given access to the Royal Academy, and many of the other campaigners were feminist activists. Cherry, *Beyond the Frame*, p. 16.

31. For an overview of recent scholarship on Victorian women art critics, see Flint, *Victorians and the Visual Imagination*; Fraser, "Women and the Ends of Art History"; Nunn, "Critically Speaking." On Emilia Dilke, see Kali Israel's excellent *Names and Stories*.

32. *Dictionary of National Biography* 29 (London, 1903), p. 230. On the "Grand Tour" in nineteenth-century Britain, see Buzard, *Beaten Track*.

33. Macpherson, *Memoirs of Anna Jameson*, p. 44.

34. Jameson, *Diary of an Ennuyée*, p. vi.

35. Ibid., p. 298.

36. On gender and connoisseurship in the late Victorian period, see Schaffer, *Forgotten Female Aesthetes*.

37. Ann Bermingham notes that the contemporary trope of women as mercenary and uncritical consumers was deployed to exclude women art collectors from the professions of art history and criticism. Bermingham, "Aesthetics of Ignorance."

38. This "re-classing" of taste in Jameson's writings is particularly interesting as a historical challenge to current theories about the sociology of taste, such as Pierre Bourdieu and Alain Darbel's argument that museums inevitably produce anxiety in working-class visitors by compelling them to rely on bourgeois technologies of information: captions, guides, and catalogues. Bourdieu and Darbel, *Love of Art*.

39. Bermingham, "Aesthetics of Ignorance."

40. Jameson's rejection of the *Diary* stemmed as much from the professionalization of the art historical discipline as from her personal desire to move away from the scandal surrounding the *Diary*'s publication. Her decision in the 1830s to define herself primarily as an art historian put the *Diary* in a new light. Although the *Diary* addressed aesthetic issues,

its fictional frame distinguished it from Jameson's later, more conventionally art historical works. On the professionalization of art history in Britain, see Israel, *Names and Stories.*

41. Jameson, *Letters of Anna Jameson to Ottilie von Goethe,* p. 101.

42. On gender and amateur art collecting, see Eatwell, "Collector's or Fine Arts Club"; Macleod, "Elizabeth Bowen Jumel."

43. Jameson, *Handbook,* p. 156.

44. Ibid., p. 286.

45. Alda deems connoisseurship inferior to "philosophical observation" and places herself in the camp of "observers." In another interesting connection to the *Diary,* Alda declares herself *"ennuyée* to death" at the Städel Museum. Jameson, *Sketches of Germany,* pp. 257, 71.

46. Jameson, *Sketches,* p. 131.

47. Similarly, see Helen Keer Brown's "English or Dutch? A Holiday Story," in which an initially xenophobic Englishwoman abandons suitors from her own country for a dashing Dutchman. He takes her on a whirlwind tour of Holland's art galleries, where she falls in love with him and accepts his marriage proposal. The "Dutchman" announces that he is actually English after all. Their mutual good taste—romantic and artistic—is revealed to have been English all along. H. Brown, "English or Dutch?" Also see Howitt, *Art-Student in Munich.*

48. Cherry, *Beyond the Frame,* p. 24.

49. Ruskin wrote, "[I]t was but yesterday my own womankind were in much wholesome and sweet excitement delighted to behold, in the practice of some new device of remedy for rents." *Art Journal* 62 (1880): 226.

50. Similarly, Charles Eastlake's classic treatise about home decoration, *Hints on Household Taste,* had encouraged women to study at museums, especially South Kensington—but only to rectify their natural tendency toward overdecoration. Eastlake, *Hints on Household Taste,* p. 97. On Eastlake and women's crafts, see Schaffer, *Forgotten Female Aesthetes.*

51. D. Nevill, *Under Five Reigns,* p. 250.

52. When Nevill died, *Connoisseur* published a lengthy obituary focused on her collection and placed a portrait of her by G. F. Watts on its cover. *Connoisseur* 35 (1913).

53. Charles Jerningham's guide to art collecting, *The Bargain Book,* was dedicated to Nevill, and noted that women played a particularly prominent role in the hunt for artistic bargains. Jerningham and Bettany, *Bargain Book,* p. 53.

54. Nevill's son Ralph wrote of her that "she took the greatest interest in the 'South Kensington Museum'—now the Victoria and Albert—to which up to the very end of her life she was a constant visitor. From her earliest years my mother was a great frequenter of museums, in the educational value of which she was a convinced believer." R. Nevill, *Life and Letters of Lady Dorothy Nevill,* p. 276. Dorothy Nevill also wrote several articles stressing the importance of country sales for private collectors, such as "The Small Collector."

55. Lady Dorothy Nevill to Elizabeth Haldane (MS 6020, NLS), [1907?].

56. Nevill to Haldane (MS 6040, NLS), n.d.

57. Koven, "Whitechapel Picture Exhibitions."On the feminization of philanthropy

in the Victorian era, I have found the following texts particularly helpful. Koven and Michel, *Mothers of a New World*; Koven, "Henrietta Barnett"; McCarthy, *Lady Bountiful Revisited*; Prochaska, *Women and Philanthropy*; Ross, *Love and Toil*.

58. Similarly, see the duchess of Sutherland's catalogue of metalware made by her Cripples' Guild. The object of the guild was "to teach cripples artistic handicrafts and thus fit them to become self-supporting." The catalogue further noted that designs by Old Masters were copied with great success and that the guild members also produced much "original work." *Connoisseur* 28 (1910), p. 321.

59. Baroness Burdett-Coutts and the duchess of Teck were also publicly praised for establishing a home for ladies attending art schools in London, providing "all the advantages of a home and family life" for artistically inclined women from the provinces. *Times* (London), April 11, 1879. For a more extended account of Burdett-Coutts's philanthropic activism and her personal art collections, see Edna Healey, *Lady Unknown*, and the unpublished biography by her secretary (Osborne Papers, BL Add. MS 46405 and 46406B).

60. Enid Layard was the third daughter of Lady Charlotte Schreiber and the wife of Austen Henry Layard, the art collector, excavator of Nineveh and prominent Conservative M.P.

61. Burdett-Coutts, *Turkish Compassionate Fund*, p. 227.

62. Ibid., p. 229.

63. For an overview of the historical relationship between museums and department stores, see Harris, *Cultural Excursions*. More recently, see Rappaport, *Shopping for Pleasure*.

64. For a discussion of women's philanthropic participation in the South London Art Gallery, see Waterfield, *Art for the People*. Waterfield notes that this gallery attracted the support of women interested in women's rights, such as Anna Swanwick. By 1890, one-quarter of the gallery's councilors were women. Waterfield, "Art for the People."

65. Hutchinson, "Parish School Dinners and Museums."

66. Annual reports of the Manchester Art Museum (1899–1900).

67. Horsfall, "Methods of Disseminating Knowledge and Love of Art," p. 98.

68. Annual reports of the Manchester Art Museum (1895–1900).

69. Horsfall appointed a "young lady curator" to the Manchester Art Museum, noting that she had been trained at the Manchester School of Art.

70. Horsfall, *Study of Beauty and Art*, p. 45.

71. On the Barnetts, see Koven, "Whitechapel Picture Exhibitions"; Koven, "Henrietta Barnett."

72. Cook, *Highways and Byways in London*.

73. On gallery tours led by women, see Maltz, "'Engaging Delicate Brains.'"

74. *Museums Journal* 3 (1903–4): p. 270.

75. Nordlinger's paper was delivered by E. W. Hoyle of the Manchester Museum. Several other women had previously presented papers at the association meetings, so it is likely that Nordlinger was simply unable to attend the conference rather than that she was not allowed to read her own paper.

76. *Glasgow Herald*, July 25, 1896.

77. *Museums Association Report of Proceedings* 9 (1898), p. 110.

78. *Connoisseur* 26 (January–April 1910). The final installment of the series stressed the additions to the collection that Lady Wantage had overseen personally, focusing on modern artists such as Watts, Alma Tadema, and Dicksee. *Connoisseur* 29 (January–April 1911).

79. Undated press clipping (Phythian Papers, MCL). Similarly, an application from Constance Heimpel and Eleanor Bedford to the Tate Gallery for permission to open a refreshment stall stressed that the stall would be managed and staffed entirely by female labor. Constance Heimpel and Eleanor Bedford to the Trustees of the National Gallery (NGL), June 22, 1898.

80. Casteras and Denney, *Grosvenor Gallery*; Reed, *Not at Home*; Schaffer, *Women and British Aestheticism*; Waterfield, *Palaces of Art*.

81. Israel, *Names and Stories*, p. 52.

82. I am arguing against a tradition of perceiving museums as markers or bastions of separate spheres ideology, a tradition that ranges from scholarly analyses (see n. 10) to the Guerrilla Girls. The Guerrilla Girls contend that museums reify the divide between undervalued female labor and male labor, which is classified as "art." For a useful overview and discussion of the "separate spheres" model of historical scholarship, see Vickery, "Golden Age to Separate Spheres?"

83. Parsons, "Present Situation of Sunday Opening." See the discussion of Sunday opening legislation in the prelude.

84. *Times* (London), June 16, 1887.

85. *Times* (London), December 17, 1887.

86. *New York Times*, July 19, 1886.

87. *Times* (London), January 7, 1887.

88. Bingham, *History of Royal Holloway College*.

89. *Times* (London), June 16, 1887.

90. Shanley, *Feminism, Marriage, and the Law*, pp. 103–30. For accounts of women's property in earlier periods, see Berg, "Women's Property and the Industrial Revolution"; Erickson, *Women and Property*; Staves, *Married Women's Separate Property*.

91. Elmy, "Married Women's Property Act," p. 390.

92. Rappaport, *Shopping for Pleasure*. An article in the *Englishwoman's Review* noted one of the less salutary effects of the act, namely, that married women were now responsible for all liabilities for the maintenance of their parents. "The Married Women's Property Act," *Englishwoman's Review*, October 15 1908, 264.

93. Shanley, *Feminism, Marriage, and the Law*, p. 104.

94. This pattern of collective organization for women can be contrasted with the model of individual male connoisseurship described in Galsworthy's *Man of Property*. The protagonist is knighted for his public gifts of art, even as his obsession with possessing beautiful artworks becomes a substitute for his wife's private affections and fidelity.

95. "A Graceful Gift," *Museums Journal* 6 (1906–7): 288. Similarly, the catalogue for the Dublin Municipal Gallery of Modern Art lists the "Women's Picture League" among its subscribers, along with noted individual contributors such as Lady Gregory and Lady Shaw. *Catalogue for the Dublin Municipal Gallery of Modern Art*.

96. *Museums Journal* 9 (1909–10): 94.

97. For example, a group of "loyal and patriotic" ladies in Wolverhampton sub-scribed together to purchase a bust of Queen Victoria for their local art gallery in 1901. The corporation rejected the bust sight unseen because it considered modern sculpture generally unsuccessful. The *Museums Journal* mocked the corporation for its lack of artistic judgment and praised the ladies' committee for its efforts to overcome the shortcomings of the local government. *Museums Journal* 1 (1901): 135, 275.

98. Lord Prenderby is discussed in the prelude.

99. Black, *On Exhibit.*

100. Panton, *Gentlewoman's Home*; Panton, *From Kitchen to Garret*; Panton, *Nooks and Corners*; Panton, *Suburban Residences.*

101. Although the following novels do not deal directly with the circulation of cul-tural objects, I also found Whitby, *Part of the Property*, and Scott, *Treasure Trove*, very use-ful for their treatments of gender and inheritance after the passage of the Married Women's Property Act of 1882. For a discussion of the relationship between women and property in a wider chronological range of texts, see Parker, *Literary Fat Ladies.*

102. Nunokawa, *Afterlife of Property.* On gender and property in Victorian literature, see Dolin, *Mistress of the House.*

103. On the relationship between museums and factories, see Hoffenberg, *Empire on Display*; Purbrick, *Great Exhibition*, pp. 1–25.

104. In her fictional works, Panton often concerned herself with female characters who interrupted the line of patrimonial inheritance—stealing a ruby ring from an Indian prince, for example. Often, these characters paid for their possessions with their virtue or their lives. Heroines who collected cultural objects tended to fare much better than those who cultivated land or chattel. See, e.g., Panton, *Dear Life.*

105. One potential donor, Mrs. Cheale, instructed her husband to write to the Na-tional Gallery's trustees on several occasions to promote the Lawrence painting she had in-herited from her mother. Her husband was unconvinced of the work's value but claimed that his wife would not rest until she had made this public gift in her mother's memory. Her dying wish was to accomplish "the great scheme of getting her mother's picture into [the] National Gallery." Mr. Cheale to W. M. Sturt (NGL), February 4, 1885. Similarly, see Clare Atwood to the Trustees of the National Gallery (NGL), December 26, 1906.

106. Douglas Hall to the Trustees of the National Gallery (NGL), December 1910.

107. Christiana Herringham, one of the founding members of the National Art-Collections Fund, wrote to the National Gallery to offer her services as "mediator" in the negotiations concerning Annie Swynnerton's painting *Ocean.* Both the painting and the of-fer were refused, though Herringham wrote again to indicate that she would bear all ex-penses of the transaction herself. Christiana Herringham to the Trustees of the National Gallery (NGL), July 17, 1906. Similarly, see Honoria M. Thompson to the Trustees of the National Gallery (NGL), July 8, 1905.

108. Edward Ricketts to the Trustees of the National Gallery (NGL), February 4, 1885.

109. Annual reports of the National Gallery (1899–1914).

110. Widowhood provided a particularly important opportunity for women to partic-ipate in museum practices, either by carrying out their late husband's explicit wishes or by

making gifts to commemorate the deceased. Mary Watts, the widow of the artist George Frederick Watts, was intimately involved with the museum arrangements for her late husband's works. She wrote frequently to the National Gallery's trustees to ensure that Watts's paintings were displayed to their best advantage and contributed her own terra cotta flower pots to decorate the central hall at the Tate Gallery. Mrs. George Frederick Watts to the Trustees of the National Gallery (NGL), July 14, 1902. Similarly, see Mrs. Charles Gassiot to the Trustees of the National Gallery (NGL), February 9, 1903; Inez Pringle to the Trustees of the National Gallery (NGL), July 19, 1908.

111. William Shaen, the executor of the Solly estate, noted that one of the pictures offered by Sarah Solly was not listed as part of the original Solly collection. Possibly Sarah Solly bought this picture, an interior of a Dutch church, after her father's death.

112. Sarah Solly gave explicit instructions for the plaque to accompany the pictures. She wished it to read, "From the collections of Edward Solly, presented by his daughters." Sarah Solly to the Trustees of the National Gallery (NGL), March 21, 1879. Similarly, see Miss Trevennen to the Trustees of the National Gallery (NGL), May 1, 1884.

113. In 1884, following the death of her husband, Lady Charlotte donated her collection of English china and enamels to the Victoria and Albert Museum. She wrote in her journal, "[T]he idea [of donating to the South Kensington Museum] is not a new one with me. Indeed, years ago, C[harles] S[chreiber] used to say what a pleasure it would be to collect national objects for the benefit of our country." Ostensibly, the gift was a tribute to her husband's memory, but her journal entries regarding the museum gift reveal a range of motivations. Guest, *Lady Charlotte Schreiber's Journals*, p. 422.

114. For a more extensive discussion of Schreiber's art collection, see Eatwell, "Private Pleasure." I am indebted to Ann Eatwell for directing me to Lady Charlotte's journals.

115. Austen Henry Layard to Elizabeth Eastlake (BL Add. MS 38972), May 18, 1874.

116. Guest, *Lady Charlotte Schreiber's Journals*, p. 263.

117. Ibid., p. 457.

118. Yoxall, *ABC About Collecting*, p. 119.

119. *Times* (London), January 8, 1886.

120. *Connoisseur* 32 (1912), p. 192.

121. Hollis, *Ladies Elect*, p. 464.

122. On Gladstone's own art collections, see Pointon, "W. E. Gladstone as an Art Patron and Collector."

123. Unfortunately, the painting was not specified in Agnew's letter, and I have not been able to trace it.

124. Sir William Agnew to William Ewart Gladstone (Gladstone Papers, BL Add. MS 44507), July 25, 1889.

125. Allen's writings about Celtic style and English politics are discussed in chapter 1.

126. Allen, "Democracy and Diamonds."

127. Ibid.

128. Note that Lloyd George stated publicly that he fully recognized the importance of the Holbein portrait, and the government offered a £10,000 gift for the painting. *Daily Graphic*, May 6, 1909.

129. *Times* (London), May 5, 1909.

130. *Sheffield Independent*, June 2, 1909.

131. *Catholic Herald*, June 12, 1909.

132. Spielmann, "Holbein's 'Duchess of Milan.'"

133. On the changing fortunes of the aristocracy during this period, see Cannadine, *Decline and Fall*; Mandler, *Fall and Rise*.

134. *Times* (London), May 5, 1909.

135. *Morning Post*, May 15, 1909.

136. The Italian protectionist legislation concerning art is discussed in Roberts, "Cattaneo Van Dycks." Roberts attacks Italian protective legislation because it is "contrary to all principles of political and freedom for a government to interfere and dictate terms to a private owner as to what steps he shall take, and to whom he shall sell his pictures or works of art." The title refers to the successful circumvention of the Italian law with reference to the Cattaneo Van Dycks, which were sold by an Italian noble family to a Chicago buyer against the wishes of the government.

137. *Irish Times*, May 15, 1909.

138. *Observer*, May 16, 1909.

139. *Evening Standard*, June 3, 1909.

140. *Morning Leader*, May 10, 1909.

141. "Who Will Have the Holbein?" *Literary Digest*, May 22, 1909: 889–90.

142. *Globe*, May 11, 1909.

143. *Globe*, May 11, 1911.

144. One potential donor to the Holbein Fund, Evelyn Manners, declined to contribute to the National Art Collections Fund after Colnaghi intervened in the campaign. She wrote to the fund's leaders that Colnaghi had succeeded in "interfering between the Nation and the vendor of a desirable picture." Manners concluded that the whole affair had soured her opinion of the fund, which she had joined to ensure that Britain would buy a number of pictures at reasonable prices rather than throwing away a fortune on one painting. Evelyn Manners to the National Art-Collections Fund (9328, TGA), May 1, 1909; May 12, 1909.

145. *Times* (London), June 7, 1909.

146. *Yorkshire Daily Observer*, June 8, 1909.

147. On the politics of female portraiture, see n. 6.

148. Cherry, *Beyond the Frame*, p. 188.

149. *Hospital*, May 15, 1909.

150. *Daily Graphic*, May 13, 1909.

151. *Sheffield Independent*, June 2, 1909.

152. Maynard, "'Dream of Fair Women.'"

153. Charles John Holmes served as director of the National Portrait Gallery from 1909 to 1916, and as director of the National Gallery from 1916 to 1928.

154. Holmes, *Pictures and Picture Collecting*, p. 19.

155. Ibid., p. 21.

156. Ibid., p. 55.

157. *Times* (London), February 22, 1909.

158. *Fair Women*. On the tradition of conceptualizing female viewers as works of art, see Kriz, "'Stare Cases'"; Psomiades, *Beauty's Body*.

159. Buckley and Fawcett, *Fashioning the Feminine*.

160. James Yoxall's 1908 guide for middle-class collectors devoted one section to fakes designed expressly for entrapping American buyers. In particular, he mentioned knock-off reproductions of jugs and punch bowls expressing British sympathy for the American Revolution, which were sure to attract interest from visitors across the Atlantic. Yoxall, *ABC About Collecting*, p. 69.

161. Cannadine, *Decline and Fall*, p. 91.

162. Partridge, who took over from Tenniel as chief cartoonist for *Punch* in 1901, was particularly harsh in his treatment of the trade union movement and the Women's Social and Political Union.

163. *Punch*, May 12, 1909, p. 326.

164. On the commodification of British culture, in particular *objets d'art*, see Richards, *Commodity Culture of Victorian England*. On the specific role of the museum in commodity culture, see Maleuvre, *Museum Memories*, p. 197.

165. British artists such as Philip Burne-Jones expressed concern about the painting's physical safety as well, arguing that the climate of American homes and museums was inevitably damaging. *Times* (London), May 3, 1909.

166. *Times* (London), May 14, 1909.

167. Dorothea Moore to David Alexander, Lord Balcarres (National Art-Collections Fund Papers, 97/18-35, NLS), May 5, 1909.

168. After the *Duchess* was "saved" for the British nation, Carpenter wrote to Lord Balcarres again to express her pleasure at having contributed toward the painting's rescue. Beatrice Carpenter to David Alexander, Lord Balcarres (National Art-Collections Fund Papers, 97/18-35, NLS), May 27, 1909; June 7, 1909.

169. *Daily News*, May 6, 1909.

170. *Westminster Gazette*, June 7, 1909.

171. Spielmann, "Holbein's 'Duchess of Milan.'"

172. *Observer*, June 6, 1909.

173. *Nation*, June 5, 1909.

174. Unsigned letter to Mr. and Mrs. Humphry Ward (ED 24/327, PRO), June 17, 1909.

175. On the "visibility" of suffragists and suffragettes during this period, see Tickner, *Spectacle of Women*.

176. *Lady*, June 10, 1909.

177. On the masculine culture of Liberalism, see Collini, *Public Moralists*.

178. Lady Wantage, a strenuous opponent of women's suffrage and a major contributor to the National Art-Collections Fund (the pet project of her nephew, the earl of Balcarres), was cited in at least one obituary as the Holbein donor. *North Wiltshire Herald*, August 13, 1920.

179. The *Daily Mail* reported that Lady Tate, Lady Wantage, Viscountess Hambleden, Lady Wills, and several others had denied being the donor. *Daily Mail*, June 7, 1909.

180. *Punch*, June 16, 1909.

181. I am grateful to Seth Koven for suggesting this point to me.

182. Federico, "Marie Corelli."

183. *American*, June 6, 1909. In New York, the *Sun* published a similar report on the duchess of Marlborough but attributed the duchess's alleged actions to her love of art. *Sun*, June 5, 1909.

184. See the overview of the transatlantic marriage market in Cannadine, *Decline and Fall*, esp. pp. 397–400; Montgomery, *Gilded Prostitution*.

185. *Punch* also printed a "Picture Collector's Guide" in the summer of 1909 that sought to advise parents who were training their sons to be wealthy collectors. The concluding exhortation was to "keep a photograph of the Holbein Duchess on your wall. Let that be your star. Some day, say to yourself, I too will sell a picture to the nation." *Punch*, July 21, 1909.

186. *Vanity Fair*, May 19, 1909.

187. I am indebted to Peter Stansky for pointing out the connection between Lady Carlisle and the duke of Norfolk to me.

188. Lord Carlisle, a major patron of the arts and a close friend of William Morris, joined the Unionists after the Home Rule split in 1886. His son, Charles James Stanley Howard, was the Unionist M.P. for South Birmingham from 1904 to 1911 and the Parliamentary whip.

189. Gilbert Murray wrote to Lady Carlisle that he had recently toured the European art galleries without his wife Mary, Rosalind's daughter, and that Mary's absence had greatly detracted from his appreciation of the paintings. Writing of Mary, he said, "She did things so thoroughly, looked at everything as if she meant to remember it (your training!) and things meant more to me when I saw them with her." Gilbert Murray to Rosalind Francis Howard, Countess of Carlisle (MSS Gilbert Murray 476, BOD), April 30, 1894.

190. Charles Fairfax Murray, a trustee of the National Gallery, stated that Lady Carlisle had often put her patriotism before her claims of personal possession. The chair responded, "That is rather an exceptional case of a lady who has public spirit on one hand . . . and has not perhaps need for very large sums of money on the other hand." *Report of the Committee of Trustees of the National Gallery to Enquire into the Retention of Pictures in This Country* (London, 1913), p. 121.

191. Rosalind Carlisle to Charles Holroyd (NGL), August 11, 1912 and August 14, 1912.

192. *Standard*, September 1, 1911; *Athenaeum*, September 2, 1911.

193. *Morning Post*, September 2, 1911.

194. Ralph Thicknesse is discussed briefly in chapter 5 of Judith Walkowitz, *City of Dreadful Delight*.

195. Thicknesse later acknowledged that his letter to the *Post* had been "intemperately expressed," though he did not apologize to Lady Carlisle directly. Ralph Thicknesse to Lord Balcarres (TGA), September 14, 1911.

196. *Gloucester Journal*, November 9, 1911.

197. "Le Portrait de Christine de Danemark par Holbein."

198. James, *The Outcry*, p. 53.

199. Edel, "Henry James and 'The Outcry.'"

200. Cartwright, "Christina of Denmark, Duchess of Milan"; Spielmann, "Holbein;" Stanton, "Christina, Duchess of Milan"; "Le Portrait de Christine de Danemark par Holbein"; "Who Will Have the Holbein?" *Literary Digest*, May 22, 1909, pp. 889–90.

Chapter Four

1. *Times* (London), March 21, 1912; *Morning Leader*, March 20, 1912.

2. *Evening Standard*, March 4, 1914.

3. The continental model of "open air" folk museums did not emerge in Britain until the 1930s and was concentrated overwhelmingly in Wales. Belchem, "Little Manx Nation"; Harrison, *100 Years of Heritage*.

4. Deetz, *In Small Things Forgotten*.

5. *Star*, February 3, 1912.

6. See chapter 3 for the antecedents of this debate.

7. Tickner, *Spectacle of Women*.

8. Bailkin, "Picturing Feminism, Selling Liberalism"; Black, "Empire's Great Expectations." Fowler, "Why Did Suffragettes Attack Works of Art?"; Nead, *Female Nude*.

9. *Morning Advertiser* (MLA), 1914.

10. "The London Museum," *Town Planning Review* 1 (April 1912): 1. Unlike the Victoria and Albert Museum, the London Museum did not maintain "rigid" standards of craftsmanship. *Review of Reviews*, December 1911.

11. One reviewer for the *Museums Journal* commented that he could not discern the guiding principle of the London Museum's collections because they were too eclectic. Quoted in Cumming, Merriman, and Ross, *Museum of London*, p. 12.

12. Law, *London Museum at Kensington Palace*, p. 45.

13. Morris and Rodger, *Victorian City*.

14. Although the political inheritance of the folk revival in Britain clearly departs from the "Herder to Hitler" model of scholarship concerning German folklore, Sharp's legacy has rarely been seen as benign. See, e.g., Bearman, "Who Were the Folk?"; Boyes, *Imagined Village*; Gammon, "Folk Song Collecting"; Watson, *Song and Democratic Culture*.

15. The absence of material culture studies in early British folklore scholarship has led to a number of serious misconceptions about the civilizations under investigation, for example, that Ireland has no indigenous visual tradition. Ballard, "Out of the Abstract."

16. Bendix, *In Search of Authenticity*.

17. Brüchner, "Open Air Museums for London." On the establishment of Skansen, see Baehrendtz et al., "Skansen—A Stock Taking at 90"; Burke, "Popular Culture in Norway and Sweden"; Chappell, "Open-Air Museums"; de Jong and Skougaard, "Early Open-Air Museums"; Sandberg, "Effigy and Narrative"; Shafernich, "Open-Air Museums in Denmark and Sweden." Also see the brief discussion of Hazelius in Kavanagh, *Dream Spaces*.

18. On the Great Exhibition, see n. 69 in the prelude.

19. *Manchester Guardian*, January 5, 1912.

20. *Museums Journal* 10 (1910–11): 249–53. Another proposal for converting the Crystal Palace to a folk arts museum included provisions for a performance space, although the author noted that English citizens lacked the Swedish delight in old dances. *Manchester Guardian*, January 5, 1912.

21. Darton, *London Museum*, p. 175. The phrase "exhibitionary complex" is from Bennett, "Exhibitionary Complex."

22. *Spectator*, December 21, 1912.

23. Bloomfield, "Quickening of the National Spirit."

24. Boyes mentions that Neal's Espérance Club sought to give "urban vigor" and a new element of "cockney humor" to rural songs. Boyes, *Imagined Village*; Gammon, "Folk Song Collecting."

25. Alexander, *Museum Masters*, p. 243. Alexander notes that Hazelius's open-air museum was bitterly attacked in the press by Norwegians who believed that Hazelius had misappropriated their patrimony and undermined Scandinavian regional diversity. Francis Arthur Bather, a prominent British museologist, was greatly impressed by Skansen and hoped that the Swedish example would prompt a material culture renaissance and the creation of a national folk museum in England as well.

26. Kirshenblatt-Gimblett, *Destination Culture*, pp. 40–41.

27. Mary Bronson Hartt, an American visitor to Skansen, drew a sharp distinction between the peasants at Skansen and other Victorian and Edwardian "living exhibits." The South Sea Islanders at the Chicago Fair, for example, had felt degraded by being exhibited in front of foreigners. But Hartt claimed that the Swedish peasants at Skansen took great pride in helping their compatriots to understand their history better. They were Swedes exhibited for the benefit of other Swedes, and rather than "masquerading" as non-Westerners would have been compelled to do, they were living "virtually their own lives" within a museum setting. Hartt, "Skansen Idea."

28. Holt, "London Types."

29. Jones, "The 'Cockney' and the 'Nation.'"

30. *Daily News*, April 9, 1912.

31. Gaynor Kavanagh explicates Braudel and Lewis Mumford on this point in Kavanagh and Frostick, *Making City Histories in Museums*.

32. Joyce, *Rule of Freedom*.

33. Geddes, *Every Man His Own Art Critic*.

34. Morris and Rodger, *Victorian City*.

35. Meller, "Patrick Geddes." More broadly, see Meller, "Urban Renewal and Citizenship."

36. On the extension of civic rights and responsibilities into the realm of culture and the role of museums in popular education, see Malden, *Rights and Duties of a Citizen*; Newland, *Short History of Citizenship*; Wyatt, *English Citizen*.

37. Geddes, "Suggested Plan for a Civic Museum"; Geddes, *Cities in Evolution*, p. 253.

38. The Outlook Tower still stands in Edinburgh today, although only the *camera obscura* remains true to Geddes's original idea.

39. Meller, "Patrick Geddes."

40. *New Age*, August 5, 1909.

41. Geddes, *Cities in Evolution*, p. 2

42. For a discussion of the changing practices of London government in the Victorian and Edwardian eras, see Davis, *Reforming London*; Young and Garside, *Metropolitan London*.

43. Owen, *Government of Victorian London*, p. 194. Also see Eades, *London*, p. 322.

44. Cook, *Highways and Byways in London*, p. 444.

45. *Builder*, April 5, 1912.

46. Lethaby, "Of Beautiful Cities," p. 444.

47. Corner, *London*, p. vi.

48. Harper, *Queer Things About London*.

49. Waters, "Progressives, Puritans, and the Cultural Politics of the Council."

50. Davis, "Progressive Council."

51. Pennybacker, *Vision for London*, p. 18. Objections to the LCC's cultural activities were not limited to workers but extended to high-minded critics such as Grant Allen, who mocked the Council's lackluster concerts in the public parks and its limited view of aesthetic education. Allen, "Beautiful London."

52. Pennybacker, *Vision for London*, p. 5; Clifton, "Members and Officers of the LCC," pp. 1–26.

53. Waters, *British Socialists and the Politics of Popular Culture*.

54. Pennybacker, *Vision for London*, p. 154.

55. See Olsen's comment that the metropolis was not merely ungoverned but ungovernable in his introduction to Owen, *Government of Victorian London*, p. 2.

56. Kavanagh and Frostick, *Making City Histories*; Lorente, *Cathedrals of Urban Modernity*.

57. Trodd, "Paths to the National Gallery."

58. Siegel, *Desire and Excess*.

59. Geddes, "Civic Museum," pp. 233–34.

60. Carter, "Sketch Plan of a Civic Museum for London."

61. Ibid., p. 240.

62. The relationship between the London Museum and other local institutions is discussed in Francis Sheppard's masterful study, *Treasury of London's Past*.

63. Hobhouse, *Some Reasons for a Single Government of London*, p. 2.

64. *Evening Standard*, March, 25, 1911. The *Sheffield Daily Register* complained shortly thereafter that the British Museum had not cooperated by ceding all the relevant treasures to the London Museum. *Sheffield Daily Register*, August 28, 1911. Frederick Kenyon of the British Museum referred to a potential bidding war between his institution and the London Museum for the Dimsdale seals. Kenyon warned that many more such disagreements would ensue if the London Museum intended to pursue objects connected with the Court. He concluded, "[O]ur interests will be liable to conflict over the whole range of the British Empire, and the London Museum will lose its local character." The

London Museum promptly withdrew from bidding for the seals. Frederick Kenyon to Guy Laking (In-Letters Box 2/3, MLA), June 17, 1913.

65. *Daily Chronicle*, March 25, 1911.

66. *City Press*, January 2, 1886.

67. For a discussion of the City's use of "invented traditions," such as the Lord Mayor's Show, for defensive political purposes, see Smith, "In Defence of Privilege."

68. Library Committee Minutes (CLRO), June 16, 1886.

69. *Times* (London), January 2, 1897.

70. *Times* (London), April 7, 1897.

71. *City Press*, February 6, 1886.

72. Koven, "Politics of Seeing."

73. *City Press*, September 11, 1886.

74. *City Press*, May 26, 1886. Also see Blackham, *London For Ever*, p. 269.

75. Attendance at the Guildhall Art Gallery's loan exhibitions ranged from two hundred thousand to three hundred thousand. *Times* (London), August 23, 1901.

76. *Times* (London), May 30, 1904.

77. On the development of the Tate Gallery, see Taylor, *Art for the Nation*.

78. Temple, *Guildhall Memories*, p. 89.

79. Ibid., p. 315.

80. Taylor, *Art for the Nation*.

81. Studies of the Council have tended to neglect its efforts to develop cultural institutions. Susan Pennybacker and Chris Waters have both analyzed its control of music hall culture during the prewar period, and Waters has also discussed the Council's provision of parks and public spaces, but a more general history of Council arts administration is still needed. For a discussion of the Council and the visual arts in the latter half of the twentieth century, see Garlake, "'War of Taste.'"

82. *Times* (London), March 29, 1898.

83. *British Weekly*, March 19, 1892.

84. George Scharf to Austen Henry Layard (Layard Papers, BL Add. MS 39044), November 25, 1889.

85. Impey and Macgregor, *The Origins of Museums*.

86. *Annual Report of the Frederick J. Horniman Museum* (1893).

87. *Times* (London), March 18, 1898.

88. On the major ethnographic collections in London, see Coombes, *Reinventing Africa*.

89. Horniman added that the Burnese visitors went off to the Crystal Palace looking "the very picture of contented happiness." *Annual Report of the Frederick J. Horniman Museum* (1896).

90. While the Japanese minister was visiting, Horniman hung the Union Jack and the Japanese flag together "in friendly company." *Annual Report of the Frederick J. Horniman Museum* (1894).

91. *Annual Report of the Frederick J. Horniman Museum* (1895).

92. *Annual Report of the Frederick J. Horniman Museum* (1896).

93. The mural was proudly discussed in W. W. Hutchings, *London Town Past and Present*, p. 1068.

94. *First London County Council Annual Report of the Horniman Museum* (1901–2).

95. Ibid.

96. *Times* (London), February 6, 1901.

97. Pennybacker, "'Millennium by Return of Post.'"

98. *First London County Council Annual Report of the Horniman Museum* (1901–2).

99. *Times* (London), July 1, 1901. Campbell-Bannerman and Gladstone discussed the creation of a baronetcy for Horniman in 1905, to be implemented when the Liberals returned to power. Horniman died before this took place. On the abortive Horniman baronetcy, see Cannadine, *Decline and Fall*, p. 312.

100. The clerk's office was the secretariat to the entire Council, and the clerk was the LCC's chief administrative officer. Pennybacker, *Vision for London*, p. 38. Gomme was particularly interested in the relationship between history and anthropology and in establishing the ancient origins of British institutions such as Parliament. Gomme, "Status of the County Council"; Gomme, *Lectures on the Principles of Local Government*; Gomme, *London in the Reign of Victoria*; Gomme, *Making of London* (Oxford, 1912). On Gomme's work as a folklorist, see De Caro, "G. L. Gomme."

101. Gomme, "On Archaic Conceptions of Property."

102. Kuklick, *Savage Within*, p. 111.

103. Gomme, *London*, p. 338.

104. Ibid., p. 1.

105. *Annual Report of the Frederick J. Horniman Museum* (1901).

106. Gomme, *London*.

107. Francis, *London, Historic and Social*, 2:323.

108. Minutes of the Proceedings of the Local Government, Records, and Museums Committee (LCC/MIN/8148, GLRO), October 15, 1904.

109. Markham, *Museums and Art Galleries*, p. 118.

110. Coombes, "Museums and the Formation of National and Cultural Identities."

111. Sengupta, "An Object Lesson in Colonial Pedagogy."

112. The London School Board was abolished in 1902 and was taken over by the LCC in 1904. Pennybacker, *Vision for London*, p. 14.

113. *Second Annual Council Report of the Horniman Museum* (1902–3).

114. *Times* (London), January 31, 1902.

115. Agendas of the London County Council (LCC/MIN, GLRO), July 8, 1904.

116. Ibid. In his 1925 survey *The Industrial Museum*, Charles Richards explores the idea that industry is actually more visible in non-Western countries such as India than in the West. He argues that in the West, labor is hidden away in factories. Thus, the museum becomes necessary to memorialize Western labor and make it visible once more. Richards, *Industrial Museum*; King, "Labour History."

117. Agendas of the London County Council (LCC/MIN, GLRO), March 23, 1904.

118. The Horniman cost £725 of the Museums Committee's total expenditure of £3,840 in 1903. *Times* (London), April 8, 1903.

119. Agendas of the London County Council (LCC/MIN, GLRO), March 31, 1905.

120. Minutes of the Proceedings of the Local Government Records and Museums Committee (LCC/MIN/8148, GLRO), January, 1906.

121. Minutes of the Proceedings of the Local Government Records and Museums Committee (LCC/MIN/8148, GLRO), March 3, 1905.

122. Murray, *Museums*, p. 284.

123. *Times* (London), June 22, 1905.

124. Lord Esher was the deputy governor, later governor, of Windsor Castle from 1901 to 1930 and thus served as the confidant of Victoria, Edward VII, and George V. He had extensive access to Victoria's papers and edited her correspondence with A. C. Benson.

125. *Daily Mail*, April 3, 1911.

126. G. L. Gomme to Guy Laking (Letter Box One, MLA), March 27, 1911. Gomme most likely was referring to the LCC's massive building and excavation projects, which might require the use of historical prints and the like. On these building projects, see Sheppard, *Treasury*.

127. *Daily Telegraph*, August 3, 1911.

128. *Daily Express*, March 25, 1911.

129. G. L. Gomme to Guy Laking (In-Letters, MLA), March 24, 1914.

130. The boat was excavated from a Council site near Westminster Bridge and paraded with great pomp to Kensington. *Cardiff Daily Express*, August 23, 1911; *Daily Express*, August 23, 1911; *Graphic*, September 2, 1911; *Illustrated London News*, September 2, 1911; *Manchester Courier*, August 25, 1911. For a discussion of the political significance of the Roman artifacts at the Museum of London, see Beard and Henderson, "Rule(d) Britannia."

131. On the deployment of folklore studies in the British Empire, see Maskiell, "Embroidering the Past."

132. See chapter 1.

133. Gomme also debated with Laking about the Roman elements of Old London and the importance of London in Roman and Saxon times. *Manchester Guardian*, January 5, 1912.

134. For Gomme's analysis of early London institutions, see Gomme, *Village Community*.

135. Gomme served as the president of the Folk-Lore Society from 1890 to 1894. On his role in academic folklore, see De Caro, "G.L. Gomme"; Dorson, *British Folklorists*. Gomme's relationship to Tylorian anthropology is set out in Gomme, *Ethnology in Folklore*.

136. On the design and building of the Council offices, see Port, "Government and the Metropolitan Image."

137. Guy Laking to Lewis Harcourt (Letter-Book 1, MLA), April 4 and 6, 1911.

138. Stead, "Museum of London."

139. Dangerfield, *Strange Death*, p. 212.

140. Hebditch, "Approaches."

141. *Sheffield Telegraph*, March 25, 1911.

142. "A real start has been made in connection with the new Museum for London, which is to be to London what the Carnavalet Musée is to Paris." *Irish Times*, March 25, 1911. Also see Laking, "Acquisitions for the London Museum."

143. Guy Laking to Lewis Harcourt (Letter-Book 1, MLA), June 14, 1911.

144. Harrison, "Municipal Museums of Paris," 461.

145. For an analysis of the role played by French revolutionary politics in Parisian museum culture, see Duncan, *Civilizing Rituals*; McClellan, *Inventing the Louvre*. On the strength of the revolutionary collections at the Carnavalet, donated primarily by M. Alfred de Lièsville in 1881, see Harrison, "Municipal Museums of Paris"; Mitchell, "Art and the French Revolution."

146. Hebditch, "Approaches," p. 108.

147. *Daily Citizen*, Mary 24, 1914.

148. The association between the LCC and the "Commune" was more positively expressed in Burns, "The LCC," and Burns, "Let London Live!"

149. In 1882 a pseudonymous author named GRIP published a dystopian pamphlet called "The Monster Municipality, Or Gog and Magog Reformed." In this fictional prediction of London life under the Council, GRIP depicted the abolition of the Stock Exchange, the City Halls handed over to the London School Board and their plate sold for tracing paper, and the conversion of the royal parks to "civic" use. The "monster" LCC was congratulated by the Parisian municipality and linked to foreign radicalism of all kinds. The pamphlet is discussed in Kellett, "The 'Commune' in London."

150. Temple, *Guildhall Memories*, p. 151.

151. The journal *Country Life* noted that the London Museum was primarily of antiquarian interest, in contrast to the more vitally "political" Carnavelet. Because the London curators were deeply concerned that their museum portray a sense of "living" history, this assessment was not professionally flattering. *Country Life*, April 1, 1911.

152. Arnold, *Possibilities of an Art Gallery*, pp. 6–7.

153. Darton, *London Museum*.

154. *Times* (London), March 25, 1911. Gomme evoked a similar contrast between Parisian and London civics when he wrote, "It was revolutionary Paris in a sea of blood which helped to form the modern state of France; but it is constitutional London acting continuously and not tumultuously which has performed this service for modern England." Gomme, *London*, p. 334.

155. Esher's strong connection to the royal family (see n. 124) enabled him to encourage certain royals to donate a variety of mementos to the new museum. For a discussion of Esher's relationships with Queen Victoria, King Edward, and Queen Mary, see Lees-Milne, *Enigmatic Edwardian*.

156. For a more extensive discussion of the role of particular royals in the founding of the London Museum, in particular Queen Mary, see Sheppard, *Treasury of London's Past*.

157. *Pall Mall Gazette*, March 21, 1912.

158. *Irish Times*, March 25, 1911.

159. Sir Schomberg MacDonnell to Guy Laking (In-Letters 2/3, MLA), November 17, 1911. Also see *Glasgow Record*, September 17, 1912.

160. *Reynold's Newspaper*, March 31, 1912.

161. *Glasgow Herald*, April 9, 1912.

162. *Connoisseur* 33 (1912), p. 104.

163. *Evening News*, March 25, 1912.

164. Similarly, the *Architects' and Builders' Journal* referred to the gifts of collectors who "have placed their civic pride before their private instinct to possess." *Architects' and Builders' Journal*, April 1, 1914.

165. I have borrowed this phrase from Weiner, *Inalienable Possessions: The Paradox of Keeping-While-Giving*.

166. *Manchester Guardian*, March 21, 1912.

167. *Huddersfield Examiner*, March 21, 1912.

168. The newspaper suggested that these prison relics be relocated to the Black Museum at Scotland Yard or to Madame Tussaud's. *Kensington News*, October 14, 1911.

169. The London Museum's organizers continued to negotiate the spheres of education and entertainment after World War I. In 1920, Lewis Harcourt presented a proposal for the London Museum to house a collection of artifacts pertaining to assassins and was advised by another trustee that the "horrors" he described were insufficiently London-centric to merit inclusion. Lewis Harcourt to Lionel Earle (Harcourt MS Dep. 519, BOD), March 15, 1920.

170. *Illustrated London News*, September 16, 1911.

171. *Times* (London), January 3, 1912.

172. Ross, "Collections and Collecting."

173. *Punch*, March 27, 1912.

174. *Graphic*, March 28, 1914.

175. *John Bull*, November 4, 1911.

176. On the relationship between contrived or faked representations of "the real" and museum culture in late nineteenth-century Paris, see Schwartz, *Spectacular Realities*.

177. Ross, "Collections," p. 119.

178. *Westminster Gazette*, April 10, 1912.

179. Laking had a heated exchange with E. E. Newton, a museum visitor who offered his services as a "great enthusiast" in London topography. Laking responded as if Newton had applied for a paid position and curtly informed Newton that he lacked the qualifications for such a position. Newton was outraged and replied that "it is the man with a hobby who sometimes knows more about it than the mere professional one." E. E. Newton to Guy Laking (Letter Box 1, MLA), March 25, 1911. On the professionalization of curatorship, see chapter 3.

180. Francis Howard to Lewis Harcourt (Harcourt MS Dep. 519, BOD), May 24–28, 1913.

181. Randolph Berens to Guy Laking (Letter Box 1, MLA), December 3, 1911.

182. Leonard Nober to Guy Laking (Letter Box 2/3, MLA), March 22, 1912.

183. Randolph Berens to Guy Laking (Letter Box 1, MLA), December 3, 1911.

184. H. Forbes [last name illegible] to Guy Laking (Letter Box 2/3, MLA), March 28, 1912.

185. For a slightly later exposition of the phenomenon of "civic" or "local" patriotism, see Begbie, *The Proud Citizen*. Begbie argued that this new gospel of English idealism was rooted in an antimaterialistic conception of the government as spiritual guide to its citizens.

186. *Manchester Courier*, March 22, 1912.

187. *Standard*, March 23, 1914.

188. Darton, *London Museum*, p. 245.

189. *Daily Mail*, March 21, 1912.

190. *Suffolk Chronicle*, March 29, 1912.

191. *Times* (London), August 20, 1912.

192. *Evening Standard*, March 25, 1911; *Westminster Gazette*, March 25, 1911; *Morning Post*, March 27, 1911; *Nottingham Guardian*, January 4, 1912; *Times* (London), September 27, 1912.

193. Kriegel, "Britain by Design."

194. On the decline of industry in London, see Schneer, *London 1900*, p. 6.

195. Laking, "Acquisitions," p. 417.

196. *Daily News*, April 9, 1912. Similarly, the art critic Charles Jerningham wrote with regard to the London County Council excavations that "it has been said that London is paved with gold. More truly might it be contended that its soil is a museum." Jerningham and Jerningham, *Bargain Book*, p. 195.

197. Douglas-Irvine, *History of London*, p. 324.

198. E. E. Newton to Guy Laking (Letter Box 1, MLA), March 25, 1911.

199. *Globe*, May 5, 1913.

200. *Chiswick Times*, June 18, 1912.

201. Sir William Lever changed the name of the building to Lancaster House in 1914, in reference to his Lancashire connections. The particular circumstances of the gift, as well as the Conservative opposition to Lever's involvement, are detailed in Sheppard, *Treasury*.

202. *Times* (London), April 18, 1914.

203. *Freeman's Journal*, March 24, 1914.

204. For discussions of "the crowd" in museum history, see Fyfe, *Art, Power, and Modernity*; Goldgar, "British Museum"; Kriz, "'Stare Cases'"; Maleuvre, *Museum Memories*; Trodd, "Paths."

205. Geddes, *Cities*, p. 143.

206. The coining of the term "civi-otics" removed the masculine part of the word "patriotism"—i.e., the father. I am grateful to Alison Matthews David for pointing this out to me.

207. See chapter 3.

208. Tim Dolin has argued that collecting by women was virtually invisible as a Victorian cultural pursuit and that public displays of women's collections were often deemed trivial or offensive. Dolin, *Mistress of the House*, p. 40.

209. On the gender and the new urban scene, see Nead, *Victorian Babylon*; Nord,

Walking the Victorian Streets; Rappaport, *Shopping for Pleasure*; Ross, *Love and Toil*; Walkowitz, *City of Dreadful Delight*; Walkowitz, "Going Public."

210. Burgess, *Chats on Household Curios.*

211. Vallois, *First Steps in Collecting.*

212. Pitt Rivers, quoted in Bennett, *Birth of the Museum*, p. 201.

213. Geraldine Mayo to Guy Laking (Letter Box 1, MLA), July 19, 1912; Hope Grant to Guy Laking (In-Letters 2/3, MLA), May 8, 1914. Similarly, Isabella Holmes, the author of a guidebook to London burial grounds and a general expert in Londoniana, chastised Laking for his lack of initiative in pursuing the Harben map collection and offered some of her own maps to the museum. Isabella Holmes to Guy Laking (In-Letters 1, MLA), March 22, 1912.

214. Florence Canfield to Guy Laking (In-Letters 2/3, MLA). March 19, 1912; March 28, 1912. Canfield also organized an exhibition of South African art in London in 1911, which included her own "needle-paintings" of South African flora. The proceeds from the event were to be used for a nursery in Johannesburg or Pretoria. *Times* (London), December 8, 1911.

215. See, e.g., *Illustrated London News*, April 18 1914. For an account of the politics of the different British women's magazines, see Beetham, *Magazine of Her Own.*

216. *Liverpool Courier*, April 21, 1914.

217. *Ladies' Field*, March 30, 1912.

218. "The objects of Royal interest are sure of a welcome from lady visitors." *Huddersfield Examiner*, March 21, 1912.

219. *Daily Sketch*, March 21, 1912.

220. *Mrs. Bull*, August 10, 1912.

221. On the sexualization of exhibition spaces, see Kriz, "'Stare Cases'"; Solkin, "'This Great Mart of Genius,'" pp. 1–8.

222. *Christian Age and Sunday Pictures*, June 14, 1912.

223. Debora Silverman has suggested an important link between the rise of domestic crafts movements and the effort to "domesticate" the unruly New Woman in *fin-de-siècle* France, in which the domesticated *femme feconde* was posited as a challenge to the joint menaces of feminism and collectivism. But the connection between feminism, collectivism, and domesticity proved more difficult to sever in the British case. If women donors might be readily described as "domesticated," women visitors were often feared to be the very opposite. Silverman, "'New Woman.'"

224. *Queen*, February 1, 1913.

225. On the prewar association of women and commodity culture, see Bowlby, *Just Looking*; Rappaport, *Shopping for Pleasure*; Walkowitz, *City of Dreadful Delight.*

226. *Daily Graphic*, March 9, 1914.

227. *Daily Mirror*, March 24, 1914.

228. *Christian World*, March 26, 1914.

229. For a fascinating analysis of men's consumer history that suggests that the feminization of the consumer market in the eighteenth century has been overemphasized, see Finn, "Men's Things."

230. Denney, *At the Temple of Art*; Gillett, "Art Audiences at the Grosvenor Gallery"; Lago, *Christiana Herringham*; Orr, *Women in the Victorian Art World.*

231. *Evening News*, March 25, 1912.

232. Darton, *London Museum*, p. 156. There are numerous other sources that discuss "bric-a-brac mania." For a contemporary source, see Hall, *Adventures of a Bric-a-Brac Hunter.* For a recent work see Eatwell, "Private Pleasure."

233. This notion of women as destructive to property was emphasized earlier in Rosamund Watson's interior decorating guide, which focused on precisely the kinds of artifacts that Laking was interested in collecting. She criticized women decorators, especially amateurs, for their "ruthless demoralization of old furniture, the defacement of what can ill be spared and may not be restored." The female decorator emerges as a vampire, destroying the remnants of the past rather than preserving and donating them. Watson, *Art in the House*, p. 150.

234. *Ladies' Pictorial*, March 30, 1912.

235. This episode is described in Dangerfield, *Strange Death*, p. 152.

236. *Daily News*, March 6, 1912. The British Museum was occasionally closed because of the suffragette threat, and museum closings were cited as a popular grievance against feminists. The *Southern Daily Echo* reported that "Londoners will not thank the ladies of Clement's Inn [the headquarters of the WSPU] for this delay in gaining access to what is in many ways the most interesting exhibition in London." *Southern Daily Echo*, March 22, 1912.

237. C. J. Holmes, the director of the National Portrait Gallery, recounted his own colorful adventures preventing suffragette attacks at the gallery. He reported that he had closed his galleries for a fortnight following Mary Richardson's infamous hatchet job on the Rokeby *Venus* in 1914. Holmes, *Self and Partners*, pp. 304–5.

238. On the history of these "most-wanted" photographs of suffragettes, see the BBC News report on the "March of the Women" exhibition at the National Archives in Kew (October–December 2003), which marks the centenary of the founding of the WSPU: http://news.bbc.co.uk/2/hi/magazine/3153024.stm.

239. The photographs were culled from sources such as surveillance photographs taken in the prison exercise yard and society portrait studies. Hamilton and Hargreaves, *Beautiful and the Damned*, p. 53.

240. Searle, *Liberal Party*, 110.

241. *Evening News*, March 25, 1912 (emphasis added).

242. Bland, *Story of the Amulet.*

243. Barbara J. Black has suggested that Nesbit's story initially promotes a Fabian utopia of deaccessioning in which all goods are released from their institutional "captivity." But ultimately, the story confirms the sanctity of museums and the Babylonian objects are once more safely contained in an exoticist narrative of British colonial acquisitions. Black, "An Empire's Great Expectations," p. 249.

244. *Evening Standard*, March 23, 1914.

245. *Liverpool Courier*, April 5, 1914.

246. *Morning Leader*, March 20, 1912.

247. *Evening News*, March 22, 1912.

248. The potential "museumification" of the suffragette was exemplified by Madame Tussaud's 1912 installation of a "realistic suffragette group" including Mrs. Pankhurst and her daughter. *Standard*, April 9, 1912. See also Mayhall, "Domesticating Emmeline."

249. *Lady*, March 28, 1912.

250. *Punch*, March 27, 1912.

251. Warner, *Monuments and Maidens*.

252. Lady London's *pince-nez* may also be a sign of her elderly distinction. I am grateful to Peter Stansky for suggesting this to me.

253. Fowler, "Why Did Suffragettes Attack Works of Art?"; Nead, *Female Nude*.

254. On the Millais portrait, see Paul Barlow's excellent essay "Imagined Hero as Incarnate Sign."

255. *Times* (London), July 18, 1914; *New York Times*, July 18, 1914.

256. The episode is recounted in the memoirs of the gallery's director, C. J. Holmes. Holmes, *Self and Partners*, p. 305.

257. Richardson had commented that she attacked the portrait of one of the most beautiful women in the world in order to protest, among other things, the government's attack on one of the most beautiful individuals: Mrs. Pankhurst. Nead, *Female Nude*.

258. *Times* (London), July 18, 1914.

259. *Times* (London), July 22, 1914.

260. Memorandum likely by Charles John Holmes (968, Heinz Archives, NPG), July 18, 1914. Also see *Times* (London), July 18, 1914.

261. *Times* (London), July 22, 1914.

262. Letter [signature illegible] to Charles John Holmes (968, Heinz Archives, NPG), July 18, 1914. I am indebted to Lara Perry for helping me track down this citation at the Portrait Gallery.

263. *Manchester Guardian*, January 16, 1916.

264. *Liverpool Courier*, March 30, 1916.

265. During the war effort, the National Gallery was revamped as a recreation center for wounded soldiers, the Royal Academy was used as a Red Cross center, and the London Museum housed the Government Clerk's offices. Kavanagh, *Museums and the First World War*.

266. *Globe*, February 1, 1916.

267. *Daily Mail*, April 9, 1912. Similarly, the *Morning Post* advised its readers to visit the London Museum often, because "in learning in pleasant fashion the history of London they will be acquiring in essence the history of the world." *Morning Post*, March 19, 1914.

Conclusion

1. Black, *On Display*.

2. Windsor Castle, interestingly, has become both a residence and a museum, although it has a less "private" aspect than the British Museum and many families live there together. Morris, *News from Nowhere*, p. 167.

3. Short, *Land and Society*.

4. Rodger, *Transformation*, p. 11.

5. *Illustrated London News*, June 12, 1909.

6. Witt, *Nation and Its Art Treasures.*

7. For an analysis of the impact of war on museum studies, see Malvern, "War, Memory, and Museums." Also see Sherman, *Construction of Memory.*

8. *Museums Journal* 15 (1914–15): 307, 309.

9. Kavanagh, *Museums and the First World War.*

10. Harvey, "Letting Go."

11. As Peter Mandler has noted, the heritage mania of the 1980s and 1990s—both in the scholarly arena and in political debate—already seems dated. The participants in the cases discussed here were concerned less with "heritage" than with their own relationship to ongoing Liberal values and frameworks of property, perhaps pointing to a reason for the continued relevance of these debates even after the heritage craze abated. Mandler, "England, Which England?" On the aftermath of the heritage debates, see Hall's essay "Whose Heritage?"

12. Singer, *Entitlement*, p. 13.

13. *Punch*, October 4, 1916. The series was reprinted in book form in *A Book of Drawings* (London: Methuen, 1921).

WORKS CITED

Major Manuscript Collections

Balcarres Papers, National Library of Scotland, Edinburgh

Barnett Papers, Greater London Record Office, London

Thomas Bodkin Papers, Trinity College, Dublin

Angela Burdett-Coutts Papers, British Library, London

Celtic Ornaments File, Public Record Office, Kew

Cockerell Papers, British Library, London

Sir Martin Conway Papers, University Library, Cambridge

Department of Education and Science Records, Public Record Office, Kew

Eastlake Papers, British Library, London

Patrick Geddes Papers, National Library of Scotland, Edinburgh

Gladstone Papers, British Library, London

Haldane Papers, National Library of Scotland, Edinburgh

Harcourt Papers, Bodleian Library, Oxford

Thomas Horsfall Papers, Manchester Central Library, Manchester

John Knowles Papers, City of Westminster Archives Centre, London

Austen Henry Layard Papers, British Library, London

D. S. MacColl Papers, Glasgow University Library, Glasgow

Mayo Papers, National Library of Ireland, Dublin

Charles Fairfax Murray Papers, John Rylands Library, Manchester

National Art-Collections Fund Papers, National Library of Scotland, Edinburgh

Osborne Papers, British Library, London

Phythian Papers, Manchester Central Library, Manchester

Horace Plunkett Papers, National Library of Ireland, Dublin

Rosebery Papers, National Library of Scotland, Edinburgh

Royal Courts of Justice Records, National Archives of Ireland, Dublin

Stirling-Maxwell Papers, Mitchell Library, Glasgow

Strathclyde Regional Archives

Eugenie Strong Papers, Girton College, Cambridge

George Frederick Watts Papers, National Portrait Gallery, London

Primary Sources

Annual reports and press-clippings books were consulted in the following institutions:

Archives of Art and Design, London

Guildhall Art Gallery, London

Horniman Museum, London

Hugh Lane Gallery of Modern Art, Dublin

Museum of London (formerly the London Museum)

Museums Association, London

National Gallery, Dublin

National Gallery, London

National Gallery of Scotland, Edinburgh

National Museum of Ireland, Dublin

National Portrait Gallery, London

Royal Academy, London

Royal Irish Academy, Dublin

Tate Gallery, London

Wallace Collection, London

Adams, Eve, ed. *Mrs. J. Comyns Carr's Reminscences*. London: Hutchinson, 1926.

Addison, Julia de Wolf. *The Art of the National Gallery: A Critical Survey of the Schools and Painters as Represented in the British Collection*. London: George Bell and Sons, 1905.

Allen, Grant. "The Celt in English Art." *Fortnightly Review* 55 (July–December 1891): 267–79.

———. "Democracy and Diamonds." *Contemporary Review* 59 (1891): 666–77.

———. "Beautiful London." *Fortnightly Review* 54 (July–December 1893): 42–54.

Anderson, Joseph. "Treasure Trove." *Scottish Historical Review* 1 (1903–4): 74–80.

Armstrong, Walter. "Pictures at Edinburgh." *National Review* 8 (October 1886): 179–88.

———. *Notes on the National Gallery*. London: W. Odhams, 1887.

———. *Scottish Painters: A Critical Study*. London: Seeley, 1888.

———. *Art in Great Britain and Ireland*. London: William Heineman, 1909.

Arnold, Matthew. *Culture and Anarchy*. Cambridge: Cambridge University Press, 1932.

Arnold, W. T. *The Possibilities of an Art Gallery in Manchester. By a Manchester Man*. Manchester: J. E. Cornish, 1889.

Arnold-Foster, Rt. Hon. H. O. *Our Great City, or London, the Heart of the Empire*. London: Cassell, 1900.

Art and Life, and the Building and Decoration of Cities: A Series of Lectures by Members of the

Arts and Crafts Exhibition Society, Delivered at the Fifth Exhibition of the Society in 1896. London: Rivington, Percival, 1897.

Art in Ireland. Dublin: McGlashen and Gill, 1875.

Artistic Homes; or How to Furnish with Taste; A Handbook for All Housekeepers. London: Ward, Lock, 1880.

Art Property in the Possession of the Royal Scottish Academy. Edinburgh: privately printed, 1883.

Ashbee, Charles Robert, ed. *The Survey of London: Being the First Volume of the Register of the Committee for the Survey of the Memorials of Greater London*. London: P. S. King, 1900.

———. *Should We Stop Teaching Art?* London: B. T. Batsford, 1911.

Baker, Charles E. *Husband and Wife and the MWPA, 1882*. London: Frederick Warne, 1882.

Balfour, Henry. *The Evolution of Decorative Art: An Essay upon Its Origin and Development as Illustrated by the Art of Modern Races of Mankind*. London: Rivington, Percival, 1893.

Barnett, Henrietta. "Women as Philanthropists." In *The Woman Question in Europe*, ed. Theodore Stanton. London: G. P. Putnam's Sons, 1884.

———. *The Making of the Home*. London: Cassell, 1885.

Barnett, Samuel, and Henrietta Barnett. *Practicable Socialism: Essays on Social Reform*. London: Longmans, 1894.

———. *Towards Social Reform*. London: T. Fisher Unwin, 1909.

Barrington, Emilie Isabel. "Is a Great School of Art Possible in the Present Day?" *Nineteenth Century* 5 (April 1879): 714–732.

———. *Essays on the Purpose of Art: Past and Present Creeds of English Painters*. London: Longmans, Green, 1911.

Bather, F. A. "The Functions of Museums—A Re-Survey," *Popular Science Monthly*, 1903–4, 210–18.

Battersea, Lady Constance. *Waifs and Strays*. London: Arthur L. Humphreys, 1921.

———. *Reminiscences*. London: Macmillan, 1922.

Baylis, T. H. "Treasure Trove." *Archaeological Journal* 43 (1886): 341–49.

Bayliss, Wyke. "The Fine Arts in Relation to the Sanitary Condition of Our Great Cities." *Society of Arts Journal* 41 (1892): 196–204.

Begbie, Harold. *The Proud Citizen*. London: Hodder and Stoughton, 1917.

Besant, Sir Walter. *London in the Nineteenth Century*. London: Adam and Charles Black, 1909.

Blackham, Col. Robert J. *London for ever the Sovereign City—Its Romance, Its Reality*. London: Sampson Low, 1932.

Blackstone, William. *Commentaries on the Law of England*, vol. 1. Chicago: University of Chicago Press, 1979.

Blanchet, J., and H. A. Grueber. "Treasure Trove: Its Ancient and Modern Laws." *Numismatic Chronicle* (1902): 148–75.

Bland, Edith Nesbit. *The Story of the Amulet*. New York: Coward-McCann, 1906.

Bodkin, Thomas. *Hugh Lane and His Pictures*. Dublin: Pegasus Press for the Government of the Irish Free State, 1932.

———. *The Importance of Art to Ireland*. Dublin: At the Sign of the Three Candles, 1935.

Boland, J. P. "The Future of Irish Art." *New Ireland Review* 26 (January 1907): 293–301.

Bradshaw, George Butler. *Condemned for Their Country, or "No Irish Need Apply": An Authentic, but Startling Exposé of the Delinquencies of South Kensington Museum and a Plea for the Projected Royal Irish Institute*. Dublin: W. B. Kelly, 1868.

Brown, Ford Madox. "Our National Gallery." *Magazine of Art* 13 (1890): 133.

Brown, Helen Keer. "English or Dutch? A Holiday Story." *Arts and Letters* 2 (1882): 325–31.

Brüchner, Georg. "Open Air Museums for London: A Suggestion." *International Studio* 12 (January 1901): 158–71.

Burdett-Coutts, W., ed. *The Turkish Compassionate Fund*. London: Remington, 1883.

Burgess, Frederick W. *Chats on Household Curios*. London: T. Fisher Unwin, 1914.

Burns, John. "The LCC: Towards a Commune." *Nineteenth Century* 31 (March 1892): 496–514.

———. "Let London Live!" *Nineteenth Century* 31 (April 1892): 674.

Caffin, Charles. *How to Study Pictures*. New York: Century, 1905.

Campbell, John Douglas Sutherland, duke of Argyll. *Scotland as It Was and as It Is*. Edinburgh: David Douglas, 1887.

———. *Portfolio of the National Gallery of Scotland*. London: Edward Arnold, 1903.

Campbell-Bannerman, Sir Henry. *The Past and Future of Government: A Speech Delivered at Manchester*. London: Liberal Publication Department, 1907.

Carey, C. W. *Royal Holloway College: Catalogue of Pictures*. London: Simpkin, Marshall, Hamilton, Kent, 1896.

Carlyon-Britton, P. W. P. "Treasure Trove, the Treasury, and the Trustees of the British Museum." *Reliquary* 13 (April 1908): 115–23.

Carr, Alice. *Mrs. J. Comyns Carr's Reminiscences*. London: Hutchinson, 1926.

Carr, Joseph Comyns. *Essays on Art*. London: Smith, Elder, 1879.

———. *Art in Provincial France: Letters Written, During the Summer of 1882, to the Manchester Guardian*. London: Remington, 1883.

———. *Some Eminent Victorians: Personal Recollections in the World of Art and Letters*. London: Duckworth, 1908.

Carrick, Alice van Leer. *Collector's Luck in England*. Boston: Little, Brown, 1926.

Cartwright, Julia. "Christina of Denmark, Duchess of Milan." *Century Illustrated Monthly Magazine*, March 1912, 707–17.

Catalogue for the Dublin Municipal Gallery of Modern Art (London, 1905).

Catalogue of the Collection of London Antiquities in the Guildhall Museum. London: Corporation of the City of London, 1903.

Catalogue of the Pictures and Drawings in the National Loan Exhibition in Aid of National Gallery Funds, Held in the Grafton Galleries, London. London: William Heinemann, 1909.

Caw, Sir James L. *Catalogue of the Scottish National Portrait Gallery.* Edinburgh: National Portrait Gallery of Scotland, 1895.

———. *Scottish Painting Past and Present, 1620–1908.* Edinburgh: T. C. and E. C. Jack, 1908.

———. *The Pictures and How to Enjoy Them: A Popular Guide to the National Gallery of Scotland.* Edinburgh: H.M.S.O., 1926.

———. *Hours in the Scottish National Gallery (Edinburgh).* London: Duckworth, 1927.

Celtic Gold Ornaments Found in Ireland. London: H.M.S.O., 1899.

Chambers, George F. *The Law Relating to Public Libraries and Museums.* London: Knight, 1899.

City of Manchester Art Gallery Committee. *Report to the City Council of a Visit to Certain Art Galleries and Museums in Belgium, Holland, Germany and in Great Britain.* Manchester: n.p., 1905.

Clarke, E. C. "Notes on the Roman and Early English Law of Treasure Trove." *Archaeological Journal* 43 (1886): 350–57.

Clayton, Ellen C. *English Female Artists.* London: Tinsley Brothers, 1876.

Cole, Alan Summerly. *Two Lectures on the Art of Lace Making.* Dublin: Alex Thom, 1884.

Cole, Sir Henry. *Notes for a Universal Art Inventory.* London: Eyre and Spottiswoode, 1867.

———. *The Duty of Governments Towards Education, Science, and Art.* London: n.p., 1875.

———. *What Is Art Culture? Report on the Manchester School of Art.* Manchester: G. Falkner and Son, 1877.

———. *Fifty Years of Public Work of Sir Henry Cole, K.C.B., Accounted for in His Deeds, Speeches and Writings.* London: George Bell and Sons, 1884.

"The Collector on the Prowl." *Blackwoods Magazine*, May 1890, 677–87.

Collingwood, William Gershom. *The Art Teaching of John Ruskin.* London: Percival, 1891.

Colvin, Sidney. "The Bethnal Green Museum." *Fortnightly Review* 12 (October 1872): 458–473.

Compton, C. H. "Treasure Trove. With Reference to the Case of the Attorney-General v. The Trustees of the British Museum." *Journal of the Archaeological Association* 10 (1904): 118–29.

———. "Can Votive Offerings Be Treasure Trove?" *Journal of the British Archaeological Association* 11 (1905): 109–17.

Conway, Moncure. *Travels in South Kensington.* New York: Harper and Brothers, 1882.

———. "Civilizing the Sabbath." *Open Court*, December 22, 1892, p. 3496.

Conway, Sir W. Martin. *The Domain of Art.* London: John Murray, 1901.

———. *The Sport of Collecting.* London: T. Fisher Unwin, 1914.

Cook, Edward Tyas. *A Popular Handbook to the National Gallery.* London: Macmillan, 1888.

———. *Studies in Ruskin: Some Aspects of the Work and Teaching of John Ruskin.* London: Kennikat, 1890.

Cook, Emily. T. *Highways and Byways in London.* London: Macmillan, 1903.

Copinger, Walter Arthur. *The Law of Copyright in Works of Literature, Art, Architecture, Photography, Music and the Drama.* London: Stevens and Haynes, 1915.

Corner, Herbert George. *London.* London: Longmans, Green, 1932.

Cornish, Charles. *Sir William Henry Flower: A Personal Memoir.* London: Macmillan, 1904.

Craik, Henry. *The State in Relation to Education.* London: Macmillan, 1896.

Crane, Lucy. *Art and the Formation of Taste.* London: Macmillan, 1882.

Crane, Walter. *An Artist's Reminiscences.* London: Methuen, 1907.

Cundall, H. M. "Dublin Museum of Science and Art." *Art Journal* 54 (February 1892): 49–52.

Darton, F. J. Harvey. *The London Museum.* The Treasure-House Series. London: Wells Gardner, Darton, 1914.

Davidson, J. Morrison. *Scotia Rediviva: Home Rule for Scotland.* London: William Reeves, 1893.

Day, Lewis Foreman. "How to Make the Most of a Museum." *Journal of the Society of Arts* 56 (January 1908): 146–55.

Deane, Ethel, ed. *The Collector: Articles and Illustrations, Reprinted from* The Queen *Newspaper, of Interest to the Great Body of Collectors.* London: Horace Cox, 1903.

Dewhurst, Wynford. *Wanted: A Ministry of Fine Arts.* London: Hugh Rees, 1913.

Dickson, J. H., and James Paton. *The Present Position of the Museum and Art Galleries of Glasgow.* Glasgow: Robert Anderson, 1886.

Dobie, William Jardine. "The Law of Treasure Trove." *Juridical Review* 43 (1931): 300–310.

Douglas-Irvine, Helen. *History of London.* London: Constable, 1912.

Doyle, Henry. *Catalogue of the Works of Art in the National Gallery of Ireland.* Dublin: Alex Thom, 1890.

Dyall, Charles. *First Decade of the Walker Art Gallery: A Report of Its Operations from 1877 to 1887.* Liverpool: Corporation of Liverpool, 1888.

Eades, George E. *London: The Romance of Its Development.* London: Mitchell Hughes and Clarke, 1927.

Eastlake, Charles. *Hints on Household Taste.* New York: Dover, 1869.

Edwards, John William, and William Frederick Hamilton. *The Law of Husband and Wife.* London, 1883.

Elliott, Robert. *Art and Ireland.* Dublin: Sealy, Bryers, and Walker, 1906.

Elmy, E. C. W. "The Married Women's Property Act, 1882." *Englishwoman's Review,* September 15, 1882, 386–93.

Emmett, John T. *The Basis of Municipal Reform: A Project and Review.* London: Simpkin, Marshall, Hamilton, Kent, 1895.

Erskine, Beatrice Caroline. [Mrs. Steuart.] *London as an Art City.* The Langham Series of Art Monographs. London: A. Siegle, 1904.

Evans, Arthur. "On a Votive Deposit of Gold Objects." *Archaeologia* 55 (1900): 55.

Fair Women: An Exhibition Arranged by the International Society of Sculptors, Painters, and Gravers, Held in the New Gallery. London: Ballantyne, 1909.

Fausset, Thomas Godfrey. "On the Present State of the Law of 'Treasure Trove.'" *Archaeological Journal* 22 (1865): 15–32.

Fawcett, Henry. *Art in Everything.* London: Houlston and Sons, 1882.

———. *State Socialism and the Nationalisation of the Land.* London: Macmillan, 1883.

Firth, J. B. F. *A Practical Scheme of London Municipal Reform.* London: London Municipal Reform League, 1881.

———. *London Government, and How to Reform It.* London: London Municipal Reform League, 1882.

Fisher, Garret. "Glasgow—A Model Municipality." *Fortnightly Review* 63 (1895): 607–22.

Fitzgerald, William G. "The Romance of the Museums." *Strand,* January–June 1896, 62–71.

Flower, William Henry. *Essays on Museums and Other Subjects Connected with Natural History.* London: Macmillan, 1898.

Francis, Claude de la Roche. *London, Historic and Social.* 2 vols. Philadelphia: Henry T. Coates, 1902.

Galsworthy, John. *Man of Property.* London: G. P Putnam, 1906.

Gardiner, A. G. *The Life of Sir William Harcourt.* London: Constable, 1923.

Geddes, Patrick. *Every Man His Own Art Critic at the Manchester Exhibition, 1887.* London: John Heywood, 1887.

———. *Every Man His Own Art Critic: An Introduction to the Study of Pictures (Glasgow Exhibition, 1888).* Edinburgh: William Brown, 1888.

———. *A Study in City Development: Park, Gardens, and Culture-Institutes—A Report to the Carnegie Dunfermline Trust.* Dunfermline: 1904.

———. *The World Without and the World Within: Sunday Talks with My Children.* Bournville: Saint George, 1905.

———. "A Suggested Plan for a Civic Museum." *Sociological Papers* 3 (1907): 233–34.

———. *Cities in Evolution: An Introduction to the Town Planning Movement and to the Study of Civics.* London: Ernest Been, 1915.

Glasgow Green Branch Museum and Art Gallery, People's Palace: Catalogue of the Inaugural Art Exhibition. Glasgow: William Hodge, 1898.

Goddard, Ethel. "A Plea for a Native Art." *New Ireland Review* 20 (November 1903): 147–51.

Gomme, Sir George Laurence. "On Archaic Conceptions of Property in Relation to the Laws of Succession; and Their Survival in England." *Archaeologia* 50 (1887): 195–214.

———. "The Status of the County Council." *Journal of the Society of Arts* 37 (1888): 195–208.

———. *The Village Community.* New York: Scribner, 1890.

———. *Ethnology in Folklore.* London: Kegan Paul, 1892.

———. *Lectures on the Principles of Local Government.* Westminster: Archibald Constable, 1897.

———. *London in the Reign of Victoria, 1837–1897.* London: Blackie and Son, 1898.

———. *The Governance of London.* London: Clarendon, 1908.

———. *The Making of London*. Oxford: Clarendon, 1912.

———. *London*. London: Williams and Norgate, 1914.

Gore, Charles, [Bishop of Oxford], ed. *Property: Its Duties and Rights*. London: Macmillan, 1913.

Gosse, Edmund. *Lady Dorothy Nevill: An Open Letter*. London: Chiswick, 1913.

Grant, Clara. *Farthing Bundles*. London: E. C. Grant, 1931.

Graves, Algernon. *A Century of Loan Exhibitions, 1813–1912*. London: Algernon Graves, 1913–1915.

Gray, J. M. *The Scottish National Portrait Gallery: The Building and Its Contents. Also a Report of the Opening Ceremony*. Edinburgh: n.p., 1891.

Greenwood, Thomas. *Museums and Art Galleries*. London: Simpkin, Marshall, 1888.

Gregory, Lady Isabella. *Hugh Lane's Life and Achievement, with Some Account of the Dublin Galleries*. London: John Murray, 1921.

———. *Case for the Return of Sir Hugh Lane's Pictures to Dublin*. Dublin: Talbot, 1926.

Guest, Montague J., ed. *Lady Charlotte Schreiber's Journals: Confidences of a Collector of Ceramics and Antiques Throughout Britain France Holland Belgium Spain Portugal Turkey Austria and Germany from the Year 1869 to 1885*. London: John Lane, 1911.

Hackett, Francis. *Ireland: A Study in Nationalism*. New York: B. W. Huebsch, 1918.

Hall, Major H. Byng. *The Adventures of a Bric-a-Brac Hunter*. London: Tinsley Brothers, 1868.

Hallé, Charles. *Notes on a Painter's Life, Including the Founding of Two Galleries*. London: John Murray, 1909.

Hamerton, P. G. *Thoughts About Art*. London: Macmillan, 1889.

Harcourt, William V. *The London Government Bill: Speech of Sir William V. Harcourt, on the Introduction of the Bill, April 8, 1884*. Municipal Reform Pamphlets, no. 12, London: London Municipal Reform League, 1884.

Harley, A. Ernest. *Old Pictures, and How to Collect Them*. Edinburgh: Otto Schulze, 1911.

Harper, Charles G. *Queer Things About London*. London: Cecil Palmer, 1926.

Harrison, Frederic. "A Few Words About Picture Exhibitions." *Nineteenth Century* 24 (July 1888): 30–44.

———. "Give Back the Elgin Marbles," *Nineteenth Century* 28 (December 1890): 980–87.

———. "The Municipal Museums of Paris." *Fortnightly Review* 62 (September 1894): 458–67.

Hartt, Mary Bronson. "The Skansen Idea." *Century* 83 (November 1911): 916–20.

Haweis, Mary Eliza. *The Art of Beauty*. London: Chatto and Windus, 1878.

———. *Beautiful Houses*. London: Sampson Low, Marston, Searle and Rivington, 1882.

———. *The Art of Decoration*. London: Chatto and Windus, 1889.

———. *The Art of Housekeeping: A Bridal Garland*. London: Sampson Low, Marston, Searle and Rivington, 1889.

Heaton, Alda. *Beauty and Art*. London: William Heinemann, 1897.

Herkomer, Hubert von. *Art Tuition*. n.p., 1895.

Hill, Sir George. *Treasure Trove in Law and Practice, from the Earliest Time to the Present Day*. Oxford: Clarendon, 1936.

Hill, Octavia. *Address at the Annual Meeting of the Manchester Art Museum*. Manchester: H. Rawson, 1897.

Hobhouse, Sir Arthur. *Some Reasons for a Single Government of London*. London: London Municipal Reform League, 1884.

Hodgkin, Thomas. *Think It Out: A Lecture on the Question of Home Rule for Ireland*. London: Walter Scott, 1887.

Holloway, Thomas. *Some Small Memories as to the Origin of Holloway College for Women*. London: G. Stahl, 1886.

Holmes, C. J. *Pictures and Picture Collecting*. London:Anthony Treherne, 1903.

———. *Self and Partners (Mostly Self): Being the Reminiscences of C. J. Holmes*. New York: Macmillan, 1936.

Horsfall, Thomas Coglan. *An Art Museum for Manchester*. Manchester: The Art Museum, 1878.

———. "Methods of Disseminating Knowledge and Love of Art." *Third International Art Congress* (1908): 97–106.

———. *The Study of Beauty and Art in Large Towns*. London: Macmillan, 1883.

———. *The Need for Art in Manchester: An Address, Given May 2nd, 1910, at the Annual Meeting of the Governors of the Manchester Royal Institution*. Manchester: Charles H. Barber, 1910.

Horsley, John Calcott. *Recollections of a Royal Academician*. London: John Murray, 1903.

Howitt, Anna Mary. *An Art-Student in Munich*. Boston: Ticknor, Reed, and Fields, 1854.

Hulme, F. Edward. *Art Instruction in England*. London: Longmans, Green, 1882.

Hunt, William Holman. "Artistic Copyright." *Nineteenth Century* 5 (March 1879): 418–24.

Hutchings, W. W. *London Town Past and Present*. London: Cassell, 1909.

Hutchinson, Jonathan. "Parish School Dinners and Museums." *Nineteenth Century* 57 (December 1905): 324–30.

Irving, George Vere. "On Treasure Trove." *Journal of the Archaeological Association* (1859): 81–104.

James, Henry. *The Outcry*. London: Methuen, 1911.

Jameson, Anna. *Sketches of Germany: Art, Literature, Character*. Frankfurt: Charles Jugel, 1837.

———. *Letters of Anna Jameson to Ottilie von Goethe*. London: Oxford University Press, 1939.

———. *Handbook to the Public Galleries of Art in and Near London*. London: John Murray, 1842.

———. *Sacred and Legendary Art*. London: Longman, Brown, Green, and Longmans, 1850.

———. *Communion of Labour: A Second Lecture in the Social Employments of Women*. London: Longman, Brown, Green, Longman, and Roberts, 1856.

———. *Diary of an Ennuyée*. Boston: Houghton Mifflin, 1885.

Jephson, Henry L. "The Valuation of Property in Ireland." Paper read at the meeting of the British Association for the Advancement of Science (Glasgow, 1876).

Jerningham, Charles Edward (Marmaduke), and Lewis Bettany. *The Bargain Book*. London: Chatto and Windus, 1911.

Jevons, W. S. "The Use and Abuse of Museums." In W. S. Jevons, *Methods of Social Reform*. London: Macmillan, 1883.

Jonas, Maurice. *Notes of an Art Collector*. London: George Routledge and Sons, 1907.

Kingsley, John. *Irish Nationalism: Its Origin, Growth, and Destiny*. London: P. S. King and Son, 1887.

Kinnear, John Boyd. *Principles of Property in Land*. London: Smith, Elder, 1880.

———. *Principles of Property*. London: Smith, Elder, 1914.

Krout, Mary. *A Looker on in London*. New York: Dodd, Mead, 1899.

Law, Ernest. *The London Museum at Kensington Palace*. London: Hugh Rees, 1912.

Leatham, James. *The Deep Fact of Nationalism: The Cases of Scotland and Ireland Contrasted*. Cottingham: Cottingham, 1914.

Leighton, Frederic and H. T. Wells. "Government and the Artists." *Nineteenth Century* 6 (December 1879): 968–84.

Lever, Sir William H. *Art and Beauty and the City*. London: Oldham Art Gallery, 1915.

Loftie, W. J. *A Plea for Art in the House*. London: Macmillan, 1876.

———. *London City: Its History, Streets, Traffic, Buildings, People*. London: Leadenhall, 1891.

London Government Reform. Municipal Reform Pamphlets No. 10, London: London Municipal Reform League, 1884.

"The London Museum." *Town Planning Review* 1 (April 1912): 1.

London Past and Present: A Reading-Book for Schools. London: Blackie and Son, 1894.

Lucas, Edward Verrall. *The Visit to London*. London: Methuen, 1902.

———. *A Wanderer in London*. London: Methuen, 1907.

Lysaght, Edward E. *Sir Horace Plunkett and His Place in the Irish Nation*. Dublin, 1918.

MacColl, D. S. *The Administration of the Chantrey Bequest*. London: Grant Richards, 1904.

———. *The Uses of an Art Gallery: An Address at the Royal Manchester Institution*. Manchester: Maclehose, 1912.

———, ed. *Twenty-Five Years of the National Art-Collections Fund, 1903–28*. Glasgow: The University Press, 1928.

———. *What Is Art?* Middlesex: Penguin, 1931.

Mackenzie, B. D. *Home Rule for Scotland, or Why Should Scotland Wait?* Edinburgh: Scottish Home Rule Association, 1900.

Mackenzie, Tessa. *The Art Schools of London: A Description of the Principal Art Schools in the London District*. London: Chapman and Hall, 1895.

Macpherson, Geraldine. *Memoirs of Anna Jameson*. Boston: Roberts Brothers, 1878.

"The Maimed Science and Art Museum Scheme." *Irish Builder* 21 (March 1879): 66.

Malden, Henry Elliot. *The Rights and Duties of a Citizen*. London: Methuen, 1894.

Mallock, W. H. "Conservatism and the Diffusion of Property." *National Review* 11 (1888): 383–404.

"The Manchester Art Museum: The Story of an Educational Experiment." *The Beacon* 3 (October 1923): 41–52.

Martin, William. "The Law of Treasure Trove." *Antiquary* 39 (1903): 54–57, 101–5, 142–46, 279–82.

———. "Treasure Trove and the British Museum." *Law Quarterly Review* 20 (January 1904): 27–40.

———. "The Law of Treasure Trove as It Affects Archaeological Research." *South-eastern Naturalist* (1905): 26–32.

———. "The Law of Treasure Trove." *Journal of the Society of Arts* 56 (February 1908): 348–59.

McKenna, Rev. J. E. *Irish Art.* Dublin: Catholic Truth Society of Ireland, 1910.

Merritt, Henry. *Art Criticism and Romance, with Recollections, and 23 Etchings by Anna Lea Merritt.* London: C. Kegan Paul, 1879.

Mitchell, W. *Home Rule for Scotland and Imperial Federation.* Edinburgh: Scottish Home Rule Association, 1892.

Moore, Frank Frankfort. *The Commonsense Collector: A Handbook of Hints on the Collecting and the Housing of Antique Furniture.* London: Hodder and Stoughton, 1910.

Moran, D. P. "Is the Irish Nation Dying?" *New Ireland Review* 10 (September 1898): 208–14.

Morris, William. *News from Nowhere.* Cambridge: Cambridge University Press, 1995.

Murray, David. *Museums: Their History and Their Use.* Glasgow: James MacLehose and Sons, 1904.

The National Gallery Difficulties Solved. Tracts upon National Promotion of Art and Science, no. 1, London: Longman, Brown, Green, Longman, and Roberts, 1857.

"The National Museum Again." *Hibernia* 1 (1882): 177.

The Nation's Pictures: A Selection from the Finest Modern Paintings in the Public Picture Galleries of Great Britain. London: Cassell, 1901.

Nesbit, Edith. *See* Bland, Edith Nesbit

Nevill, Lady Dorothy. *My Own Times.* London: Methuen, 1912.

———. *Under Five Reigns.* London: Methuen, 1914.

Nevill, Ralph. *The Life and Letters of Lady Dorothy Nevill.* London: Methuen, 1919.

Newland, H. Osman. *A Short History of Citizenship.* London: Elliot Stock, 1904.

Nisbet, Hume. *Where Art Begins.* London: Chatto and Windus, 1892.

Noble, J. Ashcroft. "Collecting Manias." *Victorian Magazine,* October 1867, 481–87.

Odgers, William Blake. *Local Government.* London: Macmillan, 1907.

Orrock, James. "The Claims of the British School of Painting to a Thorough Representation in the National Gallery." *Society of Arts Journal* 38 (1889): 384–93.

"Our National Institutions and the Government Scheme." *Irish Builder* 18 (March 1876): 57.

Panton, Jane Ellen. *From Kitchen to Garret: Hints for Young Householders.* London: Ward and Downey, 1888.

———. *Nooks and Corners.* London: Ward and Downey, 1889.

———. *Having and Holding: A Story of Country Life.* London: Trischler, 1890.

———. *Homes of Taste: Economical Hints.* London: Sampson Low, Marston, Searle, and Rivington, 1890.

———. *A Gentlewoman's Home: The Whole Art of Building, Furnishing, and Beautifying the Home.* London: The Gentlewoman's Offices, 1896.

———. *Suburban Residences, and How to Circumvent Them.* London: Ward and Downey, 1896.

———. *Leaves from a Life.* London: Eveleigh Nash, 1908.

———. *More Leaves from a Life.* London: Eveleigh Nash, 1911.

———. *Leaves from a Housekeeper's Book.* London: Eveleigh Nash, 1914.

Papworth, John. *Museums, Libraries, and Picture Galleries.* London: Chapman and Hall, 1853.

Parkes, Mary. *Art Monopoly. Deception in the Publication of Engravings. Being an Address to the Painters and Engravers of the United Kingdom together with Suggestions, by way of Remedy.* London: James Gilbert, 1850.

Parsons, Anna. "The Present Situation of Sunday Opening." *Westminster Review* 146 (1896): 14.

Paton, James. *The Fine Art Collection of Glasgow.* Glasgow: James Maclehose and Sons, 1906.

Phythian, John Ernest. *The Story of Art in the British Isles.* London: George Newnes, 1901.

———. *Half Hours at the Manchester City Art Gallery.* Manchester: Sherratt and Hughes, 1903.

Pitt-Rivers, A. H. L. F. *The Evolution of Culture and Other Essays.* Oxford: Clarendon, 1906.

Plunkett, Horace. *Ireland in the New Century.* London: John Murray, 1905.

———. *Noblesse Oblige: An Irish Rendering.* Dublin: Maunsel, 1908.

"Le Portrait de Christine de Danemark par Holbein." *La Revue de L'Art Ancien et Moderne* 26 (1909): 147–150.

Poynter, Sir Edward J. *Lectures on Art.* London: Chapman and Hill, 1897.

Price, John Edward. *A Descriptive Account of the Guildhall of the City of London: Its History and Associations.* London: Blades, East and Blades, 1886.

Quilter, Harry. "The Last Chanty of Chantrey." *Contemporary Review* 84 (August 1903): 253–64.

Rawnsley, H. D. "Our Industrial Art Experiment at Keswick," *Murray's Magazine*, 1887, 756–68.

"The Recent Case of Treasure Trove," *Juridical Review* 15 (1903): 268.

Reed, Charles. *Why Not? A Plea for a Free Public Library and Museum in the City of London, Established Without Taxation: A Letter to the Right Honourable the Lord Mayor.* London: Walton and Maberly, 1855.

"The Reflection of English Character in English Art." *Quarterly Review* (January 1879): 81–112.

Reid, Mark. "A Gallery of British Art," *Macmillan Magazine*, November 1890, 73–80.

Rhind, A. Henry. *The Law of Treasure Trove: How Can It Be Best Adapted to Accomplish Useful Results?* Edinburgh: n.p., 1858.

Richter, J. P. *The Mond Collection: An Appreciation.* London: John Murray, 1910.

Richter, Louise Marie. *Recollections of Dr. Ludwig Mond.* London: Eyre and Spottiswoode, 1910.

Robbins, Alfred F. *Practical Politics, or the Liberalism of To-Day.* London: T. Fisher Unwin, 1888.

Roberts, W. *Memorials of Christie's: A Record of Art Sales from 1766 to 1896.* London: George Bell and Sons, 1897.

———. "The Cattaneo Van Dycks." *Connoisseur* 18 (1908): 44–47.

Robinson, Sir John Charles. *The National Gallery, Considered in Reference to Other Public Collections.* London: James Toovey, 1867.

———. "Our Public Art Museums." *Nineteenth Century* 42 (December 1897): 940–64.

Ross, Estelle. *The Wallace Collection and the Tate Gallery.* The Treasure-House Series. London: Wells Gardner, Darton, 1908.

Routh, Martin. *The Law of Artistic Copyright.* London: Remington, 1881.

Ruskin, John. *General Statement Explaining the Nature and Purposes of St. George's Guild.* Kent: George Allen, 1882.

Ruskin Museum Committee. *The Ruskin Museum: A Popular Illustrated Handbook.* London: George Allen and Sons, 1911.

Sala, George Augustus. *London up to Date.* London: Adam and Charles Black, 1895.

Scott, Catherine Amy Dawson. *Treasure Trove.* London: William Heinemann, 1909.

Scottish Art and National Encouragement, Containing a View of Existing Controversies and Transactions During the Last Twenty-Seven Years Relative to Art in Scotland. Edinburgh: William Blackwood and Sons, 1846.

Scrutton, Thomas Edward. *The Laws of Copyright.* London: John Murray, 1883.

Shaw, George Bernard. *John Bull's Other Island.* New York: Brentano, 1907.

Soden-Smith, R. H. "Vicissitudes of Art Treasures." *Under the Crown,* March–April 1869, 402–8.

Sparkes, John. *Report of the Head Master of the National Art Training Schools on His Visit to the Art Schools of Belgium and Düsseldorf.* London: H.M.S.O., 1876.

Sparrow, Walter Shaw, ed. *The British Home of To-Day: A Book of Modern Domestic Architecture and the Applied Arts.* London: Hodder and Stoughton, 1904.

———, ed. *The Modern Home: A Book of British Domestic Architecture for Moderate Incomes.* London: Hodder and Stoughton, 1911.

Spielmann, Isidore. "Holbein's 'Duchess of Milan.'" *Nineteenth Century* 96 (October 1924): 580–86.

Spielmann, Marion Henry. "The Faults of South Kensington Exposed." *Magazine of Art,* October 1898, 666–69.

———. *John Ruskin.* London: Cassell, 1900.

———. "The National Gallery in 1900, and Its Present Arrangements." *Nineteenth Century* 48 (July 1900): 54–74.

"The State of Art in England." *Blackwood's Magazine,* May 1882, 609–22.

Stanton, W. "Christina, Duchess of Milan." *Harper's Magazine* 127 (July 1913): 292.

Stead, W. T. "A Museum of London." *Review of Reviews*, April 1912, 349–50.

Swanton, E. W. *A Country Museum: The Rise and Progress of Sir Jonathan Hutchinson's Educational Museum at Haslemere*. Haslemere: Educational Museum, 1947.

Taylor, Bernard Douglas. *Municipal Art Galleries and Art Museums: Their Scope and Value, with Special Reference to the Needs and Opportunities of Manchester*. Manchester: J. E. Cornish, 1912.

Temple, Alfred G. *Modern English Art*. London: Blades, East and Blades, 1895.

———. *Guildhall Memories*. London: John Murray, 1918.

Thompson, Kate. *A Handbook to the Public Picture Galleries of Europe with a Brief Sketch of the History of the Various Schools of Painting*. London: Macmillan, 1880.

Traill, H. D. *Central Government*. London: Macmillan, 1908.

Tremenheere, H. S. *How Good Government Grew up and How to Preserve it*. London: Liberal Unionist Association, 1893.

Trevor, John. *French Art and English Morals*. London: Swan Sonneschein, Le Bas and Lowrey, 1886.

Tuckwell, Rev. W., Godfrey Leland, and Walter Besant. *Art and Hand Work for the People: Being Three Papers Read Before the Social Science Congress*. Manchester: J. E. Cornish, 1884.

Twining, Elizabeth. *Leaves from the Notebook of Elizabeth Twining: Lady Visitor Among the Poor in London and Country*. London: W. Tweedie, 1877.

Tyskiewicz, Count Michael. *Memories of an Old Collector*. London: Longmans, Green, 1898.

The Union of 1707 Viewed Financially and Scotland and Home Rule. Edinburgh: Scottish Home Rule Association, 1887.

Usher, James Ward. *An Art Collector's Treasures*. London: Chiswick, 1916.

Vallois, Grace M. *Antiques and Curios in Our Homes*. London: T. Werner Laurie, 1912.

———. *First Steps in Collecting*. London: T. Werner Laurie, 1914.

Verax [Henry Dunckley]. *I and My Property*. London: Sampson Low, 1880.

Viccars, S. J. "British Art in the National Gallery." *New Review* 54 (November 1893): 536–43.

Von Falke, Jacob. *Art in the House: Historical, Critical, and Aesthetical Studies of the Decoration and Furnishing of the Dwelling*. Boston: L. Prang, 1879.

Waddie, Charles. *The Government and Scottish Home Rule*. Edinburgh: Scottish Home Rule Association, 1894.

———. *The Federation of Greater Britain*. Edinburgh: Waddie, 1895.

Wallace, Alfred Russel. *Land Nationalisation: Its Necessity and Aims*. London: Swan Sonnenschein, 1902.

Wallis, George. *British Art, Pictorial, Decorative, and Industrial: A Fifty Years' Retrospect, 1832–1882*. London: Chapman and Hall, 1882.

Wanliss, T. D. *Bars to British Unity, or a Plea for National Sentiment*. Edinburgh: Scottish Home Rule Association, 1895.

Ware, Dominic. "The Shadow of a Flag." *New Ireland Review* 28 (November 1907): 154–63.

Watson, Rosamund Marriott. *The Art of the House*. London: George Bell and Sons, 1897.

Whitby, Beatrice. *Part of the Property*. London: Hurst and Blackett, 1890.

White, Adam. *Four Short Letters . . . on the Subject of an Open Museum in the Scottish Capital*. Edinburgh: Edmonston and Douglas, [1850?]

White, William. *A Popular Handbook to the Ruskin Museum*. London: George Allen, 1891.

———. *Principles of Art, as Illustrated by Examples in the Ruskin Museum at Sheffield*. London: George Allen, 1895.

Whitehouse, John Howard, ed. *Saint George: The Journal of the Ruskin Society*, vols. 1–13 (1898–1910).

Wilkins, William Noy. *Letters on Connoisseurship, or The Anatomy of a Picture. With Some Remarks on National Galleries, and the Mission of the Modern Artist*. London: Chapman and Hall, 1857.

Winslow, Reginald. *The Law of Artistic Copyright*. London: William Clowes and Sons, 1889.

Wood, J. G. "The Dulness of Museums." *Nineteenth Century* 21 (March 1887): 384–96.

Wyatt, Charles Henry. *The English Citizen: His Life and Duty*. London: Macmillan, 1893.

X. *On the Neglect of Scotland and Her Interests by the Imperial Parliament and the Necessity for Local Government*. Edinburgh: Edmonston, 1878.

Yappe, George Wagstaffe. *Art-Education at Home and Abroad: The British Museum, the National Gallery, and the Proposed Industrial University*. London: Chapman and Hall, 1853.

Yoxall, Sir James. *The ABC About Collecting*. London: London Curio Club, 1908.

———. *More About Collecting*. London: Stanley Paul, 1913.

Secondary Sources

Alexander, Edward. *Museums in Motion: An Introduction to the History and Functions of Museums*. Nashville: American Association for State and Local History, 1979.

———. *Museum Masters: Their Museums and Influence*. Nashville: American Association for State and Local History, 1983.

Allen, Brian, ed. *Towards a Modern Art World*. New Haven: Yale University Press, 1995.

Ames, Michael. *Cannibal Tours and Glass Boxes: An Anthropology of Museums*. Vancouver: BBC Press, 1992.

Anderson, Benedict. *Imagined Communities: Reflections on the Origins and Spread of Nationalism*. London: Verso, 1983.

Anderson, Christopher. "Repatriation of Cultural Property: A Social Process." *Museum* 42 (1990): 54–55.

Appadurai, Arjun, ed. *The Social Life of Things: Commodities in Cultural Perspective*. Cambridge: Cambridge University Press, 1986.

Armitage, David. *The Ideological Origins of the British Empire*. Cambridge: Cambridge University Press, 2000.

Armstrong, Meg. "'A Jumble of Foreignness': The Sublime Musayums of Nineteenth-Century Fairs and Expositions." *Cultural Critique* 23 (1992–93): 199–250.

Asch, Ronald, ed. *Three Nations—a Common History? England, Scotland, Ireland and British History c. 1600–1920.* Bochum, Ger.: Brockmeyer, 1993.

Ash, M. *The Strange Death of Scottish History.* Edinburgh: Ramsay Head, 1980.

Ashworth, J. E., and G. J. Tunbridge. *Dissonant Heritage: The Management of the Past as a Resource in Conflict.* Chichester: John Wiley and Sons, 1996.

Auerbach, Jeffrey. *The Great Exhibition of 1851: A Nation on Display.* New Haven: Yale University Press, 1999.

Auslander, Leora. *Taste and Power: Furnishing Modern France.* Berkeley: University of California Press, 1996.

Baehrendtz, Erik Nils, et al. "Skansen—A Stock Taking at 90." *Museum* 34 (1982): 172–78.

Bailey, Peter. *Leisure and Class in Victorian England: Rational Recreation and the Quest for Control, 1830–1885.* London: Routledge and Kegan Paul, 1978.

Bailkin, Jordanna. "Picturing Feminism, Selling Liberalism: The Case of the Disappearing Holbein." *Gender and History* 11 (1999): 145–63.

———. "Radical Conservations: The Problem with the London Museum." *Radical History Review* 84 (2002): 43–76.

Baker, Malcolm, and Brenda Richardson, eds. *A Grand Design: The Art of the Victoria and Albert Museum.* Baltimore: Harry Abrams, 1997.

Bal, Mieke. *Double Exposures: The Subject of Cultural Analysis.* London: Routledge, 1996.

Ballard, Linda. "Out of the Abstract: The Development of the Study of Irish Folklore." *New York Folklore* 20 (1994): 1–13.

Barlow, Paul. "The Imagined Hero as Incarnate Sign: Thomas Carlyle and the Mythology of the 'National Portrait' in Victorian Britain." *Art History* 17 (December 1994): 517–45.

Barlow, Paul, and Colin Trodd, introduction to *Governing Cultures: Art Institutions in Victorian London,* ed. Paul Barlow and Colin Trodd, 1–25. Aldershot: Ashgate, 2000.

———, eds. *Governing Cultures: Art Institutions in Victorian London.* Aldershot: Ashgate, 2000.

Barrell, John. *The Political Theory of Painting from Reynolds to Hazlitt: The Body of the Public.* New Haven: Yale University Press, 1986.

Barringer, Tim. "Re-presenting the Imperial Archive: South Kensington and Its Museums." *Journal of Victorian Culture* 3 (1998): 357–73.

Barringer, Tim, and Tom Flynn, eds. *Colonialism and the Object: Empire, Material Culture, and the Museum.* London: Routledge, 1998.

Barsh, Russel Lawrence. "How Do You Patent a Landscape? The Perils of Dichotomizing Cultural and Intellectual Property." *International Journal of Cultural Property* 8 (1999): 14–47.

Baudrillard, Jean. *Le Système des objets.* Paris: Gallimard, 1968.

Baxandall, David. *A Brief History of the National Gallery of Scotland.* London: Pitkin Pictorials, 1961.

Bazin, Germain. *The Museum Age*. New York: Universal, 1967.

Beard, Mary, and John Henderson. "Rule(d) Britannia: Displaying Roman Britain in the Museum." In *Making Early Histories in the Museum*, ed. Nick Merriman, 44–73. London: Leicester University Press, 1999.

Bearman, C. J. "Who Were the Folk? The Demography of Cecil Sharp's Somerset Folk Singers." *Historical Journal* 43 (September 2000): 751–76.

Beetham, Margaret. *A Magazine of Her Own: Domesticity and Desire in the Woman's Magazine, 1800–1914*. London: Routledge, 1996.

Belchem, John. "The Little Manx Nation: Antiquarianism, Ethnic Identity, and Home Rule Politics in the Isle of Man, 1880–1918." *Journal of British Studies* 39 (April 2000): 217–40.

Belk, Russell. *Collecting in a Consumer Society*. London: Routledge, 1995.

Bellamy, Richard, ed. *Victorian Liberalism: Nineteenth-Century Political Thought and Practice*. London: Routledge, 1990.

Bendix, Regina. *In Search of Authenticity: The Formation of Folklore Studies*. Madison: University of Wisconsin Press, 1997.

Bennett, Tony. *The Birth of the Museum: History, Theory, Politics*. London: Routledge, 1995.

———. "The Exhibitionary Complex." *New Formations* 4 (1988): 73–102.

Benson, Susan Porter, Stephen Brier, and Roy Rosenzweig, eds. *Presenting the Past: Essays on History and the Public*. Philadelphia: Temple University Press, 1986.

Bentley, Michael. *The Climax of Liberal Politics: British Liberalism in Theory and Practice, 1868–1918*. London: Edward Arnold, 1987.

———, ed. *Public and Private Doctrine: Essays in British History Presented to Maurice Cowling*. Cambridge: Cambridge University Press, 1993.

Benton, Lauren. *Law and Colonial Cultures: Legal Regimes in World History, 1400–1900*. Cambridge: Cambridge University Press, 2002.

Berg, Maxine. "Women's Property and the Industrial Revolution." *Journal of Interdisciplinary History* 224 (1993): 233–50.

Bermingham, Ann. "The Aesthetics of Ignorance: The Accomplished Woman in the Culture of Connoisseurship." *Oxford Art Journal* 16 (1993): 3–20.

Bernstein, George L. *Liberalism and Liberal Politics in Edwardian England*. Boston: Allen and Unwin, 1986.

Best, Geoffrey. "The Scottish Victorian City." *Victorian Studies* 11 (1967–68): 329–58.

Beveridge, C., and R. Turnbull. *The Eclipse of Scottish Culture: Inferiorism and the Intellectuals*. Edinburgh: Polygon, 1989.

Bew, Paul. *Conflict and Conciliation in Ireland, 1890–1910: Parnellites and Radical Agrarians*. Oxford: Clarendon, 1987.

Bhaba, Homi, ed. *Nation and Narration*. New York: Routledge, 1990.

Biagini, Eugenio. *Liberty, Retrenchment, and Reform: Popular Liberalism in the Age of Gladstone*. Cambridge: Cambridge University Press, 1992.

———, ed. *Citizenship and Community: Liberals, Radicals and Collective Identities in the British Isles, 1865–1931*. Cambridge: Cambridge University Press, 1996.

Billcliffe, Roger. *The Glasgow Boys: The Glasgow School of Painting, 1875–1895.* Philadelphia: University of Pennsylvania Press, 1985.

Bingham, Caroline. *The History of Royal Holloway College, 1886–1986.* London: Constable. 1987.

———. *Beyond the Highland Line: Highland History and Culture.* London: Constable, 1991.

Biswas, Sachindra Sekhar. *Protecting the Cultural Heritage: National Legislations and International Conventions.* New Delhi: Aryan, 1999.

Black, Barbara J. "Fragments Shored Against Their Ruin." Ph.D. diss., University of Virginia, 1991.

———. "An Empire's Great Expectations: Museums in Imperialist Boy Fiction." *Nineteenth-Century Contexts* 21.2 (1999): 235–58.

———. *On Exhibit: Victorians and Their Museums.* Charlottesville: University Press of Virginia, 2000.

Bloomfield, Anne. "The Quickening of the National Spirit: Cecil Sharp and the Pioneers of the Folk-Dance Revival in English State Schools, 1900–1926." *History of Education* 30 (January 2001): 59–76.

Booth, Alison. "The Lessons of the Medusa: Anna Jameson and Collective Biographies of Victorian Women." *Victorian Studies* 42 (winter 1999–2000): 257–88.

Borzello, Frances. *Civilising Caliban: The Misuse of Art, 1875–1980.* London: Routledge, 1987.

Boswell, David, and Jessica Evans, eds. *Representing the Nation: A Reader. Histories, Heritage and Museums.* London: Routledge, 1999.

Bourdieu, Pierre. *Distinction: A Social Critique of the Judgment of Taste.* Trans. Richard Nice. London: Routledge and Kegan Paul, 1984.

Bourdieu, Pierre, and Alain Darbel. *The Love of Art: European Art Museums and Their Public.* Oxford: Polity, 1991.

Bowlby, Rachel. *Just Looking: Consumer Culture in Dreiser, Gissing, and Zola.* London: Methuen, 1985.

Boyce, D. George. *Nationalism in Ireland.* Baltimore: Johns Hopkins University Press, 1982.

———. *Nineteenth-Century Ireland: The Search for Stability.* Savage, Md.: Barnes and Noble, 1991.

Boyce, D. G., and A. O'Day, eds. *The Making of Modern Irish History: Revisionism and the Revisionist Controversy.* London: Routledge, 1996.

Boyes, Georgina. *The Imagined Village: Culture, Ideology, and the English Folk Revival.* Manchester: Manchester University Press, 1993.

Bradley, Ian. *The Strange Rebirth of Liberal Britain.* London: Chatto and Windus, 1985.

Brady, Ciaran, ed. *Interpreting Irish History: The Debate on Historical Revisionism, 1938–1994.* Dublin: Irish Academic Press, 1994.

Bray, Tamara. " Repatriation, Power Relations and the Politics of the Past." *Antiquity* 70 (1996): 440–44.

———, ed. *The Future of the Past: Archaeologists, Native Americans, and Repatriation.* London: Garland, 2001.

Bray, Tamara, and Thomas W. Killion, eds., *Reckoning with the Dead: The Larsen Bay Repatriation and the Smithsonian Institution.* Washington: Smithsonian Institution Press, 1994.

Breckenridge, Carol. "The Aesthetics and Politics of Colonial Collecting: India at World Fairs." *Comparative Studies in Society and History* 31 (1989): 195–216.

Brett, David. *The Construction of Heritage.* Cork: Cork University Press, 1996.

Breuilly, John. *Nationalism and the State.* Manchester: Manchester University Press, 1982.

Brockliss, Laurence, and David Eastwood. *A Union of Multiple Identities: The British Isles, c. 1750–1850.* Manchester: Manchester University Press, 1997.

Bromilow, Gavin. "Finders Keepers." *Museums Journal* 93 (March 1993): 31–34.

Brooks, David. "Gladstone and Midlothian: The Background to the First Campaign." *Scottish Historical Review* 64 (1985): 42–67.

Brown, Alice, David McCrone, and Lindsay Paterson. *Politics and Society in Scotland.* New York: St. Martin's, 1996.

Brown, Stewart J. "'Echoes of Midlothian': Scottish Liberalism and the South African War, 1899–1902." *Scottish Historical Review* 71 (1992): 156–83.

Buckley, Cheryl, and Hilary Fawcett. *Fashioning the Feminine: Representation and Women's Fashion from the Fin de Siècle to the Present.* London: I. B. Tauris, 2001.

Buck-Morss, Susan. *The Dialectics of Seeing: Walter Benjamin and the Arcades Project.* Cambridge: MIT Press, 1990.

Bull, Philip. *Land, Politics, and Nationalism: A Study of the Irish Land Question.* New York: St. Martin's, 1996.

Burke, Peter. "Popular Culture in Norway and Sweden." *History Workshop Journal* 3 (spring 1977): 143–47.

———. *Eyewitnessing: The Uses of Images as Historical Evidence.* Ithaca: Cornell University Press, 2001.

Burton, Antoinette. "Who Needs the Nation? Interrogating 'British' History." *Journal of Historical Sociology* 10 (1997): 227–48.

———. *At the Heart of the Empire: Indians and the Colonial Encounter in Late-Victorian Britain.* Berkeley: University of California Press, 1998.

Butler, Beverley. "British Museum Head Rebuts Calls for Return of Objects." *Museums Journal* 94 (May 1994): 10–11.

Butler, Melissa A. "Early Liberal Roots of Feminism: John Locke and the Attack on Patriarchy." *American Political Science Review* 72 (1978): 135–50.

Buzard, James. *The Beaten Track: European Tourism, Literature, and the Ways to Culture, 1800–1918.* Oxford: Clarendon, 1993.

Cairns, David, and Shaun Richards. *Writing Ireland: Colonialism, Nationalism, and Culture.* Manchester: Manchester University Press, 1988.

Cameron, Ewen A. "Politics, Ideology, and the Highlands Land Issue, 1886 to the 1920s." *Scottish Historical Review* 72 (1993): 60–79.

Campbell, Fergus. "Irish Popular Politics and the Making of the Wyndham Land Acts, 1901–1903." *Historical Journal* 45.4 (2002): 755–73.

Cannadine, David. *The Decline and Fall of the British Aristocracy*. New Haven: Yale University Press, 1990.

Canny, Nicholas. *Kingdom and Colony: Ireland in the Atlantic World, 1560–1800*. Baltimore: Johns Hopkins University Press, 1988.

———. *Making Ireland British, 1580–1650*. Oxford: Oxford University Press, 2001.

Carleton, James. "Protecting the National Heritage: The Implications of the British Treasure Act, 1996." *International Journal of Cultural Property* 6 (1997): 343–47.

Carnegie, Elizabeth. "Trying to Be an Honest Woman: Making Women's Histories." In *Making Histories in Museums*, ed. Gaynor Kavanagh, 54–65. London: Leicester University Press, 1996.

Chappell, Edward A. "Open-Air Museums: Architectural History for the Masses." *Journal of the Society of Architectural Historians* 58 (1999): 334–41.

Chatterjee, Partha. *The Nation and Its Fragments: Colonial and Postcolonial Histories*. Princeton: Princeton University Press, 1993.

Cherry, Deborah. *Beyond the Frame: Feminism and Visual Culture, Britain 1850–1900*. London: Routledge, 2000.

Clark, Samuel. *Social Origins of the Irish Land War*. Princeton: Princeton University Press, 1979.

Clark, T. J. *The Painting of Modern Life: Paris in the Age of Manet and His Followers*. Princeton: Princeton University Press, 1984.

Clarke, Peter. *Liberals and Social Democrats*. Cambridge: Cambridge University Press, 1978.

Clifford, James. *The Predicament of Culture: Twentieth-Century Ethnography, Literature, and Art*. Cambridge: Harvard University Press, 1988.

Clifton, Gloria. "Members and Officers of the LCC, 1889–1965." In *Politics and the People of London, 1889–1965*, ed. Andrew Saint, 1–26. London: Hambledon, 1989.

Cohen, Anthony P. "Nationalism and Social Identity: Who Owns the Interest of Scotland?" *Scottish Affairs* 18 (winter 1997): 995–1007.

Colley, Linda. "Britishness and Otherness: An Argument." *Journal of British Studies* 31 (1992): 309–29.

———. *Britons: Forging the Nation, 1707–1837*. New Haven: Yale University Press, 1992.

Collini, Stefan. *Liberalism and Sociology: L. T. Hobhouse and Political Argument in England, 1880–1914*. Cambridge: Cambridge University Press, 1979.

———. *Public Moralists: Political Thought and Intellectual Life in Britain, 1850–1930*. Oxford: Clarendon, 1991.

Collins, Peter, ed., *Nationalism and Unionism: Conflict in Ireland, 1885–1921*. Belfast: Institute of Irish Studies, 1994.

Colls, Robert and Philip Dodd, eds. *Englishness: Politics and Culture, 1880–1920*. London: Croom Helm, 1986.

Conforti, Michael. "The Idealist Enterprise and the Applied Arts." In *A Grand Design: The Art of the Victoria and Albert Museum*, ed. Malcolm Baker and Brenda Richardson, 23–47. Baltimore: Baltimore Museum of Art, 1997.

Conn, Steven. *Museums and American Intellectual Life, 1876–1926*. Chicago: University of Chicago Press, 1998.

Cook, S. B. *Imperial Affinities: Nineteenth-Century Analogies and Exchanges Between India and Ireland.* New Dehli: Sage, 1993.

Coombe, Rosemary. "The Properties of Culture and the Possession of Identity: Postcolonial Struggle and the Legal Imagination." In *Borrowed Power: Essays on Cultural Appropriation,* ed. Bruce Ziff and Pratima Rao, 74-96. New Brunswick, N.J.: Rutgers University Press, 1997.

———. *The Cultural Life of Intellectual Properties: Authorship, Appropriation, and the Law.* Durham: Duke University Press, 1998.

Coombes, Annie. "Museums and the Formation of National and Cultural Identities." *Oxford Art Journal* 11 (1988): 57–68.

———. "Ethnography, Popular Culture, and Institutional Power: Narratives of Benin Culture in the British Museum, 1897–1992." *Studies in the History of Art* 47 (1994): 143–57.

———. *Reinventing Africa: Museums, Material Culture, and Popular Imagination in Late Victorian and Edwardian England.* New Haven: Yale University Press, 1994.

Cooper, Ann. "For the Public Good: Henry Cole, His Circle, and the Development of the South Kensington Estate." Ph.D. diss., Open University, 1992.

Corbett, David Peters, and Lara Perry, eds. *English Art, 1860–1914.* New Brunswick, N.J.: Rutgers University Press, 2001.

Corrigan, Philip, and Derek Sayer. *The Great Arch: English State Formation as Cultural Revolution.* Oxford: Basil Blackwell, 1985.

Costonis, John. "Casting Light on Cultural Property." *Michigan Law Review* 98 (May 2000): 1837–62.

Crane, Susan A., ed. *Museums and Memory.* Stanford: Stanford University Press, 2000.

Crick, Bernard. "Essay on Britishness." *Scottish Affairs* 2 (winter 1993): 71–83.

Crimp, Douglas. *On the Museum's Ruins.* Cambridge: MIT Press, 1993.

Crossman, Virginia. *Politics, Law, and Order in Nineteenth-Century Ireland.* New York: St. Martin's, 1996.

Crow, Thomas E. *Painters and Public Life in Eighteenth-Century Paris.* New Haven: Yale University Press, 1985.

Cumming, Valerie, Nick Merriman, and Catherine Ross. *Museum of London.* London: Museum of London/Scala Publications, 1996.

Cummins, Allisandra. "Embracing Ambiguity: Changing Definitions and Notions of National Museums of History," Panel Discussion at the American Historical Association (Seattle, 1998).

Curtin, Nancy J. " 'Varieties of Irishness': Historical Revisionism, Irish Style." *Journal of British Studies* 35 (April 1996): 195–219.

Curtis, L. Perry. *Apes and Angels: The Irishmen in Victorian Caricature.* Washington, D.C.: Smithsonian Institution Press, 1997.

Daley, Michael. "Pheidias Albion." *Art Review* 52 (February 2000): 34–35.

Dalsimer, Adele, ed. *Visualizing Ireland: National Identity and the Pictorial Tradition.* Boston: Faber and Faber, 1993.

Dangerfield, George. *The Strange Death of Liberal England.* Stanford: Stanford University Press, 1997.

Danto, Arthur C. *Beyond the Brillo Box: The Visual Arts in Post-Historical Perspective.* New York: Farrar, Straus and Giroux, 1992.

———. *After the End of Art: Contemporary Art and the Pale of History.* Princeton: Princeton University Press, 1997.

Davidoff, Leonore, and Catherine Hall. *Family Fortunes: Men and Women of the English Middle Class.* Chicago: University of Chicago Press, 1987.

Davin, Anna. "Imperialism and Motherhood." *History Workshop* 5 (spring 1978): 9–63.

Davis, John H.. *Reforming London: The London Government Problem, 1855–1900.* Oxford Historical Monographs, Oxford: Clarendon, 1988.

———. "The Progressive Council, 1889–1907." In *Politics and the People of London, 1889–1965,* ed. Andrew Saint, 27–48. London: Hambledon, 1989.

Davis, John R. *The Great Exhibition.* Stroud: Sutton, 1999.

De Caro, Francis. "G. L. Gomme: The Victorian Folklorist as Ethnohistorian." *Journal of the Folklore Institute* 19 (1982): 107–17.

Deetz, James. *In Small Things Forgotten.* Garden City, N.Y.: Doubleday Natural History Press, 1977.

De Grazia, Victoria, with Ellen Furlough, eds. *The Sex of Things: Gender and Consumption in Historical Perspective.* Berkeley: University of California Press, 1996.

De Jong, Adriaan, and Matta Skougaard. "Early Open-Air Museums: Traditions of Museums About Traditions." *Museum* 44 (1992): 151–57.

Denney, Colleen. *At the Temple of Art: The Grosvenor Gallery, 1877–1890.* Madison, N.J.: Fairleigh Dickinson University Press, 2000.

Denney, Colleen, and Susan Casteras, eds. *The Grosvenor Gallery: A Palace of Art in Victorian England.* New Haven: Yale University Press, 1996.

Devine, T. M. *Clanship to Crofters' War: The Social Transformation of the Scottish Highlands.* Manchester: Manchester University Press, 1994.

———. "Whither Scottish History? Preface." *Scottish Historical Review* 73 (1994): 1–3.

———. *Exploring the Scottish Past: Themes in the History of Scottish Society.* East Lothian: Tuckwell, 1995.

———. *The Scottish Nation: A History, 1700–2000.* New York: Viking, 1999.

Digby, Margaret. *Horace Plunkett: An Anglo-American Irishman.* Oxford: Blackwell, 1949.

Dolin, Tim. *Mistress of the House: Women of Property in the Victorian Novel.* Aldershot: Ashgate, 1997.

Dolley, Michael. "The First Treasure Trove Inquest in Ireland?" *Northern Ireland Legal Quarterly* 182 (June 1968): 182–88.

Donnachie, Ian, and Christopher Whatley, eds. *The Manufacture of Scottish History.* Edinburgh: Polygon, 1992.

Dorson, Richard M. *The British Folklorists: A History.* London: Routledge, 1968.

Douglas, Mary. *How Institutions Think.* Syracuse: Syracuse University Press, 1986.

Douzinas, Costas, and Lynda Nead, eds. *Law and the Image: The Authority of Art and the Aesthetics of Law.* Chicago: University of Chicago Press, 1999.

Du Bois, Guy Pène. *Artists Say the Silliest Things*. New York: American Artists Group, 1940.

Duncan, Carol. "The MoMA's Hot Mamas." *Art Journal* 48 (summer 1989): 171–78.

———. "Putting the 'Nation' in London's National Gallery." *Studies in the History of Art* 47 (1994): 101–9.

———. *Civilizing Rituals: Inside Public Art Museums*. London: Routledge, 1995.

Duncan, Carol, and Alan Wallach. "The Universal Survey Museum." *Art History* 3 (1980): 448–69.

Eagleton, Terry. *Heathcliff and the Great Hunger: Studies in Irish Culture*. London: Verso, 1995.

Eatwell, Ann. "The Collector's or Fine Arts Club, 1857–74: The First Society for Collectors of the Decorative Arts." *Decorative Arts Society Journal* 18 (1994): 25–30.

———. "Private Pleasure, Public Beneficence: Lady Charlotte Schreiber and Ceramic Collecting." In *Women in the Victorian Art World*, ed. Clarissa Campbell Orr, 125–45. Manchester: Manchester University Press, 1995.

Edel, Leon. "Henry James and 'The Outcry.'" *University of Toronto Quarterly* 18 (July 1949): 340–46.

Edelstein, Teri J., ed. *Imagining an Irish Past: The Celtic Revival, 1840–1940*. Chicago: David and Alfred Smart Museum of Art, University of Chicago, 1992.

Edgar, Darcy N., and Robert K. Paterson. "Introduction to Material Culture in Flux: Law and Policy of Repatriation of Cultural Property." *University of British Columbia Law Review* 29 (1995): 1–2.

Ellis, John S. "Reconciling the Celt: British National Identity, Empire, and the 1911 Investiture of the Prince of Wales." *Journal of British Studies* 37.4 (October 1998): 391–418.

Elsner, John, and Roger Cardinal, eds. *The Cultures of Collecting*. Cambridge: Harvard University Press, 1994.

Erickson, Amy Louise. *Women and Property in Early Modern England*. London: Routledge, 1993.

Ernst, Wolfgang. "Archi(ve)textures of Museology." In *Museums and Memory*, ed. Susan A. Crane, 17–34. Stanford: Stanford University Press, 2000.

Falconer, Heather. "Finders Keepers?" *Museums Journal* 98 (August 1998): 30–31.

Farmer, Sarah. *Martyred Village: Commemorating the 1944 Massacre at Oradour-sur-Glane*. Berkeley: University of California Press, 2000.

Federico, Annette. "Marie Corelli: Aestheticism in Suburbia." In *Women and British Aestheticism*, ed. Talia Schaffer and Kathy Alexis Psomiades, 81–98. Charlottesville: University Press of Virginia, 1999.

Feldman, David, and Gareth Stedman Jones, eds. *Metropolis, London: Histories and Representations Since 1800*. London: Routledge, 1989.

Feliciano, Hector. *The Lost Museum: The Nazi Conspiracy to Steal the World's Greatest Works of Art*. New York: Basic, 1997.

Feske, Victor. *From Belloc to Churchill: Private Scholars, Public Culture, and the Crisis of British Liberalism, 1900–1939*. Chapel Hill: University of North Carolina Press, 1996.

Fforde, Cressida, Jane Hubert, and Paul Turnbull, eds. *The Dead and Their Possessions: Repatriation in Principle, Policy, and Practice*. London: Routledge, 2002.

Fforde, Matthew. *Conservatism and Collectivism, 1886–1914*. Edinburgh: Edinburgh University Press, 1990.

Findlen, Paula. *Possessing Nature: Museums, Collecting, and Scientific Culture in Early Modern Italy*. Berkeley: University of California Press, 1996.

———. "The Modern Muses: Renaissance Collecting and the Cult of Remembrance." In *Museums and Memory*, ed. Susan A. Crane, 161–78. Stanford: Stanford University Press, 2000.

Finlayson, Geoffrey. *Citizen, State, and Social Welfare in Britain*. Oxford: Oxford University Press, 1994.

Finn, Margot. *After Chartism: Class and Nation in English Radical Politics, 1848–1874*. Cambridge: Cambridge University Press, 1993.

———. "Men's Things: Masculine Possession in the Consumer Revolution." *Social History* 25.2 (2000): 133–55.

Flint, Kate. *The Victorians and the Visual Imagination*. Cambridge: Cambridge University Press, 2000.

Foley, Tadgh, and Séan Ryder, eds. *Ideology and Ireland in the 19th Century*. Dublin: Four Courts Press, 1998.

Foster, R. F. *Modern Ireland, 1600–1972*. London: A. Lane, 1988.

———. "Anglo-Irish Literature, Gaelic Nationalism, and Irish Politics in the 1890s." In *Ireland After the Union*, ed. Royal Irish Academy and British Academy, 61–82. Oxford: Oxford University Press, 1989.

———. *Paddy and Mr. Punch: Connections in Irish and English History*. London: Penguin, 1993.

———. *The Story of Ireland: An Inaugural Lecture Delivered Before the University of Oxford on 1 December 1994*. Oxford: Oxford University Press, 1995.

Fowler, Rowena. "Why Did Suffragettes Attack Works of Art?" *Journal of Women's History* 2 (1991): 109–25.

Fox, Daniel. *Engines of Culture: Philanthropy and Art Museums*. Madison: University of Wisconsin (Department of History), 1963.

Fraser, Derek. *Power and Authority in the Victorian City*. New York: St. Martin's, 1979.

Fraser, Hilary. "Women and the Ends of Art History: Vision and Corporeality in Nineteenth-Century Discourse." *Victorian Studies* 42 (1998–99): 77–100.

Fraser, Hamish. "Municipal Socialism and Social Policy." In *The Victorian City: A Reader in British Urban History, 1820–1914*, ed. R. J. Morris and Richard Rodger, 258–80. London: Longman, 1993.

Fraser, Hamish, and Irene Maver, eds., *Glasgow*. Manchester: Manchester University Press, 1996.

Fred, Morris A. "Law and Identity: Negotiating Meaning in the NAGPRA." *International Journal of Cultural Property* 6 (1997): 199–29.

Freedman, Jonathan. *Professions of Taste: Henry James, British Aestheticism, and Commodity Culture*. Stanford: Stanford University Press, 1990.

Fry, Michael. *Patronage and Principle: A Political History of Modern Scotland*. Aberdeen: Aberdeen University Press, 1987.

Fyfe, Gordon. *Art, Power, and Modernity: English Art Institutions, 1750–1950*. London: Leicester University Press, 2000.

Gablik, Suzi. "'We Spell It Like the Freedom Fighters': A Conversation with the Guerrilla Girls." *Art in America* 82 (1991): 43–47.

Gagnier, Regenia. "Productive Bodies, Pleasured Bodies: Victorian Aesthetics." In *Women and British Aestheticism*, ed. Talia Schaffer and Kathy Alexis Psomiades, 270–90. Charlottesville: University Press of Virginia, 1999.

Gammon, Vic. "Folk Song Collecting in Sussex and Surrey, 1843–1914." *History Workshop Journal* 10 (autumn 1980): 61–89.

Garlake, Margaret. "'A War of Taste': The LCC as Art Patron, 1948–1965." *London Journal* 18 (1993): 45–65.

Garvin, Tom. *Nationalist Revolutionaries in Ireland, 1858–1928*. Oxford: Clarendon, 1987.

Gee, Loveday Lewes. *Women, Art, and Patronage from Henry III to Edward III, 1216–1377*. Woodbridge: Boydell, 2002.

Gerson, Gal. "Liberal Feminism: Individuality and Oppositions in Wollstonecraft and Mill." *Political Studies* 50.4 (September 2002): 794–810.

Gerstenblith, Patty. "Identity and Cultural Property: The Protection of Cultural Property in the United States." *Boston University Law Review* 75 (May 1995): 559–688.

———. "The Public Interest in the Restitution of Cultural Objects." *Connecticut Journal of International Law* 16 (spring 2001): 197–246.

Gibbons, Luke. *Transformations in Irish Culture*. Cork: Cork University Press, in assocation with Field Day, 1996.

———. "'Where Wolfe Tone's Statue Was Not': Joyce, Monuments, and Memory." In *History and Memory in Modern Ireland*, ed. Ian McBride, 139–59. Cambridge: Cambridge University Press, 2001.

Gibson, John S. *The Thistle and the Crown: A History of the Scottish Office*. Edinburgh: H.M.S.O., 1985.

Gillett, Paula. *Worlds of Art: Painters in Victorian Society*. New Brunswick, N.J.: Rutgers University Press, 1990.

———. "Art Audiences at the Grosvenor Gallery." In *The Grosvenor Gallery: A Palace of Art in Victorian England*, ed. Susan Casteras and Colleen Denney, 39–58. New Haven: Yale University Press, 1996.

Gillis, John R. *Commemorations: The Politics of National Identity*. Princeton: Princeton University Press, 1994.

Glaser, Jane, and Artemis Zenetou, eds. *Gender Perspectives: Essays on Women in Museums*. Washington: Smithsonian Institution Press, 1994.

Goldgar, Anne. "The British Museum and the Virtual Representation of Culture in the Eighteenth Century," *Albion* 32 (summer 2000): 195–231.

Goldman, Lawrence. "The Social Science Association, 1857–1886: A Context for Mid-Victorian Liberalism." *English Historical Review* 101 (1986): 95–134.

———, ed. *The Blind Victorian: Henry Fawcett and British Liberalism*. Cambridge: Cambridge University Press, 1989.

Goldring, Maurice. *Pleasant the Scholar's Life: Irish Intellectuals and the Construction of the Nation State*. London: Serif, 1993.

Gow, Ian, and Timothy Clifford. *The National Gallery of Scotland: An Architectural and Decorative History*. Edinburgh: National Galleries of Scotland, 1988.

Graham, Colin. "'. . . Maybe That's Just Blarney': Irish Culture and the Persistence of Authenticity." In *Ireland and Cultural Theory: The Mechanics of Authenticity*, ed. Colin Graham and Richard Kirkland, 7–28. London: Macmillan, 1999.

Graham, Colin, and Richard Kirkland, eds. *Ireland and Cultural Theory: The Mechanics of Authenticity*. London: Macmillan, 1999.

Green, S. J. D., and R. C. Whiting, eds. *The Boundaries of the State in Modern Britain*. Cambridge: Cambridge University Press, 1996.

Greenfield, Jeanette. *The Return of Cultural Treasures*. 2d ed. Cambridge: Cambridge University Press, 1995.

Greenhalgh, Paul. *Ephemeral Vistas: The Expositions Universelles, Great Exhibitions, and World's Fairs, 1851–1939*. Manchester: Manchester University Press, 1988.

Guerrilla Girls. *Confessions of the Guerrilla Girls*. New York: Pandora, 1995.

Guest, Revel, and Angela V. John. *Lady Charlotte Guest: A Biography of the Nineteenth Century*. London: Weidenfield and Nicolson, 1989.

Habermas, Jürgen. *The Structural Transformation of the Public Sphere: An Inquiry into a Category of Bourgeois Society*. Cambridge: MIT Press, 1989.

Hachey, Thomas E., and Lawrence J. McCaffrey, eds. *Perspectives on Irish Nationalism*. Lexington: University of Kentucky Press, 1989.

Halfin, Simon. "The Legal Protection of Cultural Property in Britain: Past, Present, and Future." *Journal of Art and Entertainment Law* 6 (1995): 1–37.

Hall, Catherine. *Civilising Subjects: Metropole and Colony in the English Imagination, 1830–1867*. Chicago: University of Chicago Press, 2002.

Hall, Stuart. "Whose Heritage? Un-settling 'The Heritage,' Re-imagining the Post-Nation." *Third Text* 29 (winter 1999–2000): 3–13.

Hamilton, Peter, and Roger Hargreaves. *The Beautiful and the Damned: The Creation of Identity in Nineteenth-Century Photography*. Aldershot: Lund Humphries, 2001.

Hanham, H. J. *Scottish Nationalism*. London: Faber, 1969.

———. "The Development of the Scottish Office." In *Government and Nationalism in Scotland*, ed. J. N. Wolfe, 51–70. Edinburgh: Edinburgh University Press, 1969.

Haraway, Donna. *Primate Visions: Gender, Race, and Nature in the World of Modern Science*. London: Verso, 1992.

Harris, Jose. *Private Lives, Public Spirit: A Social History of Britain, 1870–1914*. Oxford: Oxford University Press, 1993.

Harris, Neil. *Cultural Excursions*. Chicago: University of Chicago Press, 1990.

Harrison, S., ed. *100 Years of Heritage: The Work of the Manx Museum and National Trust*. Isle of Man: Manx Museum and National Trust, 1986.

Harvey, Simon. "Letting Go." *Museums Journal* 99 (January 1999): 34–35.

Harvie, Christopher. *The Lights of Liberalism: University Liberals and the Challenge of Democracy, 1860–86*. London: Allen Lane, 1976.

———. "Nineteenth-Century Scotland: Political Unionism and Cultural Nationalism, 1843–1906." In *Three Nations—A Common History? England, Scotland, Ireland, and British History, c. 1600–1920*, ed. Ronald Asch, 191–228. Bochum, Ger.: Brockmeyer, 1993.

———. *Scotland and Nationalism: Scottish Society and Politics, 1707–1994*. London: Routledge, 1994.

———. "The Folly of Our Fable: Getting Scottish History Wrong." *Scottish Studies Review* 1 (winter 2000): 99–104.

Haskell, Francis. *The Ephemeral Museum: Old Master Paintings and the Rise of the Art Exhibition*. New Haven: Yale University Press, 2000.

Healey, Edna. *Lady Unknown: The Life of Angela Burdett-Coutts*. London: Sidgwick and Jackson, 1978.

Hearn, Jonathan. *Claiming Scotland: National Identity and Liberal Culture*. Edinburgh: Polygon, 2000.

Hebditch, Max. "Approaches to Portraying the City in European Museums." In *Making City Histories in Museums*, ed. Gaynor Kavanagh and Elizabeth Frostick, 102–13. London: Leicester University Press, 1998.

Hechter, Michael. *Internal Colonialism: The Celtic Fringe in British National Development, 1536–1966*. Berkeley: University of California Press, 1975.

Hekman, Susan. "John Stuart Mill's *The Subjection of Women:* The Foundations of Liberal Feminism." *History of European Ideas* 15 (1992): 681–86.

Hennock, E. P. *Fit and Proper Persons: Ideal and Reality in Nineteenth-Century Urban Government*. London: Edward Arnold, 1973.

Herbert, Christopher. *Culture and Anomie: Ethnographic Imagination in the Nineteenth Century*. Chicago: University of Chicago Press, 1991.

Herscher, Ellen. "Many Happy Returns? New Contributions to the Repatriation Debate." *American Journal of Archaeology* 102 (October 1998): 809–13.

Hewison, Robert. *The Heritage Industry: Britain in a Climate of Decline*. London: Methuen, 1987.

Higonnet, Anne. "A New Center: The National Museum of Women in the Arts." In *Museum Culture: Histories, Discourses, Spectacles*, ed. Daniel Sherman and Irit Rogoff, 250–64. Minneapolis: University of Minnesota Press.

Hobsbawm, Eric. *Nations and Nationalism Since 1780: Programs, Myth, Reality*. Cambridge: Cambridge University Press, 1990.

Hobsbawm, Eric, and Terence Ranger, eds. *The Invention of Tradition*. Cambridge: Cambridge University Press, 1983.

Hodge, P. S., ed. *Scotland and the Union*. Edinburgh: Edinburgh University Press, 1994.

Hoffenberg, Peter. *An Empire on Display: English, Indian, and Australian Exhibitions from the Crystal Palace to the Great War*. Berkeley: University of California Press, 2001.

Holcomb, Adele, and Claire Sherman, eds. *Women as Interpreters of the Visual Arts, 1820–1979*. Westport: Greenwood, 1981.

Holcombe, Lee. *Wives and Property: Reform of the Married Women's Property Law in Nineteenth-Century England*. Oxford: Martin Robertson, 1983.

Hollis, Patricia. *Ladies Elect: Women in English Local Government, 1870–1914.* Oxford: Clarendon, 1987.

Holt, Ysanne. "London Types." *London Journal* 25 (2000): 34–51.

Hooper-Greenhill, Eilean. *Museums and the Shaping of Knowledge.* London: Routledge, 1992.

———. ed. *Museum, Media, Message.* London: Routledge, 1995.

Hoppen, K. Theodore. *Ireland Since 1800: Conflict and Conformity.* London: Longmans, 1989.

Hoppen, K. Theodore. "Nationalist Mobilisation and Governmental Attitudes: Geography, Politics, and Nineteenth-Century Ireland." In *A Union of Multiple Identities: The British Isles, c. 1750–1850,* ed. Laurence Brockliss and David Eastwood, 162–78. New York: St. Martins, 1997.

Horne, Thomas A. *Property Rights and Poverty: Political Arguments in Britain, 1605–1834.* Chapel Hill: University of North Carolina Press, 1990.

Howe, Anthony. *Free Trade and Liberal England, 1846–1946.* Oxford: Clarendon, 1997.

Howe, Stephen. *Ireland and Empire: Colonial Legacies in Irish History and Culture.* Oxford: Oxford University Press, 2000.

Hudson, Kenneth. *Museums of Influence.* Cambridge: Cambridge University Press, 1987.

Hunter, James. *The Making of the Crofting Community.* Edinburgh: Donald, 1976.

Hutchinson, Ian. *A Political History of Scotland, 1832–1924.* Edinburgh: John Donald, 1986.

Hutchinson, John. *The Dynamics of Cultural Nationalism: The Gaelic Revival and the Creation of the Irish Nation State.* London: Allen and Unwin, 1987.

———. "Irish Nationalism." In *The Making of Modern Irish History: Revisionism and the Revisionist Controversy,* ed. D. G. Boyce and Alan O'Day, 100–119. Dublin: Routledge, 1996.

Hutchinson, John, and Alan O'Day. "The Gaelic Revival in London, 1900–1922: The Limits of Ethnic Identity." In *The Irish in Victorian Britain: The Local Dimension,* ed. Roger Swift and Sheridan Gilley, 254–76. Dublin: Four Courts Press, 1999.

Hutt, Sherry, and C. Timothy McKeown. "Control of Cultural Property as Human Rights Law." *Arizona State Law Journal* 31 (summer 1999): 363–89.

Huyssen, Andreas. *Twilight Memories: Marking Time in a Culture of Amnesia.* New York: Routledge, 1995.

Hyde, Lewis. *The Gift: Imagination and the Erotic Life of Property.* New York: Vintage, 1979.

Impey, Oliver, and Arthur MacGregor, eds. *The Origins of Museums: The Cabinet of Curiosities in Sixteenth- and Seventeenth-Century Europe.* Oxford: Clarendon, 1985.

Isar, Y. R., ed. *The Challenge to Our Cultural Heritage: Why Preserve the Past?* Washington: Smithsonian Institution Press, 1986.

Israel, Kali. *Names and Stories: Emilia Dilke and Victorian Culture.* Oxford: Oxford University Press, 1999.

Izuel, Leanna. "Property Owners' Constructive Possession of Treasure Trove: Rethinking the Finders Keepers Rule." *UCLA Law Review* 38 (August 1991): 1659–1702.

Jackson, Alvin. *Ireland, 1798–1998: Politics and War*. Oxford: Blackwell, 1999.

Jacobs, Michael, and Malcolm Warner. *Art in Scotland*. Norwich: Jarrold, 1980.

Jeffery, Keith, ed. *An Irish Empire? Aspects of Ireland and the British Empire*. Manchester: Manchester University Press, 1996.

Johnston, Judith. *Anna Jameson: Victorian, Feminist, Woman of Letters*. Aldershot: Scolar Press, 1997.

Jones, David. "Home Truths." *Museums Journal* 96 (1996): 20–21.

Jones, Gareth Stedman. "The 'Cockney' and the 'Nation,' 1780–1988." In *Metropolis—London: Histories and Representations Since 1800*, ed. David Feldman and Gareth Stedman Jones, 272–324. London: Routledge, 1989.

Jones, Jane Peirson. "Bones of Contention." *Museums Journal* 93 (March 1993): 24–25.

Jones, R. Merfyn. "Beyond Identity? The Reconstruction of the Welsh." *Journal of British Studies* 31.4 (October 1992): 330–57.

Joyce, Patrick. *The Rule of Freeedom: Liberalism and the Modern City*. London: Verso, 2003.

Kaplan, Flora E. S., ed. *Museums and the Making of "Ourselves": The Role of Objects in National Identity*. London: Leicester University Press, 1994.

Kavanagh, Gaynor. *Museums and the First World War: A Social History*. London: Leicester University Press, 1994.

———. *Dream Spaces: Memory and the Museum*. London: Leicester University Press, 2000.

———, ed. *Museum Languages: Objects and Texts*. Leicester: Leicester University Press, 1991.

Kavanagh, Gaynor, and Elizabeth Frostick, eds. *Making City Histories in Museums*. London: Leicester University Press, 1998.

Kaye, Lawrence M. "Laws in Force at the Dawn of World War II." In *The Spoils of War: World War II and Its Aftermath: The Loss, Reappearance and Recovery of Cultural Property*, ed. Elizabeth Simpson, 100–105. New York: Harry N. Abrams, in association with the Bard Graduate Center for Studies in the Decorative Arts, 1997.

Kaye, Lawrence, and Carla Mann. "Law, Ethics, and the Illicit Antiquities Trade." *Asian Art and Culture* 9 (winter 1996): 22–37.

Kearney, Richard. *Post-Nationalist Ireland: Politics, Culture, Philosophy*. London: Routledge, 1997.

Keating, Michael. *Nations Against the State: The New Politics of Nationalism in Quebec, Catalonia, and Scotland*. Houndmills: Macmillan, 1996.

Keating, Michael, and David Bleiman. *Labour and Scottish Nationalism*. London: Macmillan, 1979.

Kellett, John. "The 'Commune' in London: Trepidation About the LCC." *History Today* 33 (1983): 5–9.

Kestner, Joseph A. "The Colonized in the Colonies: Representations of Celts in Victorian Battle Painting." In *The Victorians and Race*, ed. Shearer West, 112–27. Aldershot: Ashgate, 1996.

Kiberd, Declan. *Inventing Ireland*. London: Jonathan Cape, 1995.

Kidd, Colin. *Subverting Scotland's Past: Scottish Whig Historians and the Creation of an Anglo-British Identity, 1689–c. 1830*. Cambridge: Cambridge University Press, 1993.

————. "Gaelic Antiquity and National Identity in Enlightenment Ireland and Scotland." *English Historical Review* 109 (1994): 1197–1214.

————. "Teutonist Ethnology and Scottish National Inhibition, 1780–1880." *Scottish Historical Review* 74 (1995): 45–74.

————. "Sentiment, Race, and Revival: Scottish Identities in the Aftermath of Enlightenment." In *A Union of Multiple Identities: The British Isles, c. 1750–1850*, ed. Laurence Brockliss and David Eastwood, 110–26. New York: St. Martin's, 1997.

————. "*The Strange Death of Scottish History* Revisited: Constructions of the Past in Scotland, c. 1790–1914." *Scottish Historical Review* 76 (1997): 86–102.

King, Elspeth. "Labour History at the People's Palace." Society for the Study of Labour History and Social History Curators' Group, Labour History in Museums. Papers from a Joint Seminar Held at Congress House, London, 18 October 1985, 11–16. Manchester: Cooperative Union, 1988.

Kinmonth, Claudia. "Rags and Rushes: Art and the Irish Artefact, c. 1900." *Journal of Design History* 14.3 (2001): 167–85.

Kirshenblatt-Gimblett, Barbara. *Destination Culture: Tourism, Museums, and Heritage.* Berkeley: University of California Press, 1998.

Knell, Simon J. ed. *Museums and the Future of Collecting.* Aldershot: Ashgate, 1999.

Koshar, Rudy. "Building Pasts: Historic Preservation and Identity in Twentieth-Century Germany." In *Commemorations: The Politics of National Identity*, ed. John Gillis, 215–38. Princeton: Princeton University Press, 1994.

Koven, Seth. "Henrietta Barnett: The (Auto)biography of a Late Victorian Marriage." In *After the Victorians: Private Conscience and Public Duty in Modern Britain: Essays in Memory of John Clive*, ed. Peter Mandler and Susan Pedersen, 31–53. London: Routledge, 1994.

————. "The Whitechapel Picture Exhibitions and the Politics of Seeing." In *Museum Culture: Histories, Discourses, Spectacles*, ed. Daniel Sherman and Irit Rogoff, 22–48. Minneapolis: University of Minnesota Press, 1994.

Koven, Seth, and Sonya Michel, eds. *Mothers of a New World: Maternalist Politics and the Origins of the Welfare State.* New York: Routledge, 1993.

Kriegel, Lara. "Britain by Design: Industrial Culture, Imperial Display, and the Making of South Kensington, 1835–1872." Ph.D. diss., Johns Hopkins University, 1999.

Kriz, Dian K. "Dido Versus the Pirates: Turner's Carthaginian Paintings and the Sublimation of Colonial Desire." *Oxford Art Journal* 18 (1995): 116–32.

————. "'Stare Cases': Engendering the Public's Two Bodies at the Royal Academy of Arts." In *Art on the Line: The Royal Academy Exhibitions at Somerset House, 1780–1836*, ed. David H. Solkin, 54–63. New Haven: Paul Mellon Centre for Studies in British Art and Courtauld Institute Gallery by Yale University Press, 2001

Küchler, Susanne. "Sacrificial Economy and Its Objects: Rethinking Colonial Economy in Oceania." *Journal of Material Culture* 2.1 (March 1997): 39–60.

Kuklick, Henrika. *The Savage Within: The Social History of British Anthropology, 1885–1945.* Cambridge: Cambridge University Press, 1991.

Kynaston, David. *The City of London.* London: Chatto and Windus, 1994.

Labour History in Museums: Papers from a Joint Seminar Held at Congress House, London, 18th October, 1985. Manchester: Cooperative Union, 1988.

Lago, Mary. *Christiana Herringham and the Edwardian Art Scene.* London: Lund Humphries, 1996.

Lavine, Steven, and Ivan Karp, eds. *Exhibiting Cultures: The Poetics and Politics of Museum Display.* Washington: Smithsonian Institution Press, 1991.

Lavine, Steven, Ivan Karp, and Christine Kreamer, eds. *Museums and Communities: The Politics of Public Culture.* Washington: Smithsonian Institution Press, 1992.

Leach, James. "Owning Creativity: Cultural Property and the Efficacy of Custom on the Rai Coast of Papua New Guinea." *Journal of Material Culture* 8.2 (July 2003): 123–43.

Leerssen, Joep. *Remembrance and Imagination: Patterns in the Historical and Literary Representation of Ireland in the Nineteenth Century.* Cork: Cork University Press, 1996.

Lees, Lynn Hollen. *Exiles of Erin: Irish Migrants in Victorian London.* Ithaca: Cornell University Press, 1979.

Lees-Milne, James. *The Enigmatic Victorian: The Life of Reginald, 2nd Viscount Esher.* London: Sidgwick and Jackson, 1986.

Lefebvre, Henri. *The Production of Space.* Oxford: Basil Blackwell, 1991.

Levine, Philippa. *The Amateur and the Professional: Antiquarians, Historians, and Archaeologists in Victorian England, 1838–1886.* Cambridge: Cambridge University Press, 1986.

———. *Feminist Lives in Victorian England: Private Roles, Public Commitment.* Oxford: Basil Blackwell, 1990.

Lloyd, David. *Anomalous States: Irish Writing and the Post-Colonial Moment.* Durham: Duke University Press, 1993.

———. *Ireland After History.* Notre Dame: University of Notre Dame Press, 1999.

Lloyd, David, and Paul Thomas. *Culture and the State.* London: Routledge, 1998.

London, April. *Women and Property in the Eighteenth-Century English Novel.* Cambridge: Cambridge University Press, 1999.

Lorente, J. Pedro. *Cathedrals of Urban Modernity: The First Museums of Contemporary Art, 1800–1930.* Aldershot: Ashgate, 1998.

Lowenthal, David. *Possessed by the Past: The Heritage Crusade and the Spoils of History.* New York: Free, 1996.

Lowry, Donal. "'A Fellowship of Disaffection': Irish-South African Relations from the Anglo-Boer War to the Pretoriastroika, 1902–1991." *Études Irlandaises* 17 (December 1992): 101–21.

Lynch, Michael, ed. *Scotland, 1850–1979: Society, Politics, and the Union.* London: Historical Association Committee for Scotland and The Historical Association, 1995.

Lyons, F. S. *Culture and Anarchy in Ireland, 1890–1939.* Oxford: Clarendon, 1979.

MacCuish, D. G. "Crofting Legislation Since 1886." *Scottish Geographical Magazine* 108 (1987): 90.

MacDonagh, Oliver. *States of Mind: A Study of Anglo-Irish Conflict, 1780–1980.* London: George Allen and Unwin, 1983.

————. "Ambiguity in Nationalism: The Case of Ireland." In *Interpreting Irish History: The Debate on Historical Revisionism, 1938–1994*, ed. Ciaran Brady, 105–21. Dublin: Irish Academic Press, 1994.

Macdonald, Sharon. *Reimagining Culture: Histories, Identities, and the Gaelic Renaissance.* Oxford: Berg, 1997.

Macdonald, Sharon, and Gordon Fyfe, *Theorizing Museums: Representing Identity and Diversity in a Changing World.* Oxford: Blackwell, 1996.

Maclean, Colin, ed. *The Crown and the Thistle: The Nature of Nationhood.* Edinburgh: Scottish Academic Press, 1979.

Macleod, Dianne Sachko. *Art and the Victorian Middle Class: Money and the Making of Cultural Identity.* New York: Cambridge University Press, 1996.

————. "Pre-Raphaelite Women Collectors and the Female Gaze." In *Collecting the Pre-Raphaelites: The Anglo-American Enchantment, Margaretta Frederick Watson, 109–20.* Aldershot: Ashgate, 1997.

————. "Eliza Bowen Jumel: Collecting and Cultural Politics in Early America." *Journal of the History of Collections* 13 (2001): 57–75.

MacLochlainn, Alf. *Science and Art, 1877–1977.* Dublin, 1978.

Macpherson, C. B. *The Political Theory of Possessive Individualism: Hobbes to Locke.* Oxford: Clarendon, 1962.

MacRaild, Donald M. *Irish Migrants in Victorian Britain, 1750–1922.* London: Macmillan, 1999.

Magnusson, Magnus, et al. *The Glorious Privilege: The History of "The Scotsman."* London: The Scotsman, 1967.

Malchow, H. L. *Agitators and Promoters in the Age of Gladstone and Disraeli.* New York: Garland, 1983.

Maleuvre, Didier. *Museum Memories: History, Technology, Art.* Stanford: Stanford University Press, 1999.

Maltz, Diana. *Lessons in Sensuous Discontent: The Aesthetic Mission to the British Working Classes, 1869–1914.* Ph.D. diss., Stanford University, 1997.

————. " 'Engaging Delicate Brains': From Working-Class Enculturation to Upper-Class Lesbian Liberation in Vernon Lee and Kit Anstruther-Thomson's Psychological Aesthetics." In *Women and British Aestheticism*, ed. Talia Schaffer and Kathy Alexis Psomiades, 211–29. Charlottesville: University Press of Virginia, 1999.

Malvern, Sue. "War, Memory, and Museums: Art and Artefact in the Imperial War Museum." *History Workshop Journal* 49 (spring 2000): 177–203.

Mandler, Peter. "Against 'Englishness': English Culture and the Limits to Rural Nostalgia, 1850–1940." *Transactions of the Royal Historical Society* 7 (1997): 155–75.

————. *The Fall and Rise of the Stately Home.* New Haven: Yale University Press, 1997.

————. "England, Which England?" *Contemporary British History* 13 (1999): 243–54.

————. "Art, Death, and Taxes: The Taxation of Works of Art in Britain," *Historical Research* 74 (August 2001): 271–97.

Mandler, Peter, and Susan Pedersen, eds. *After the Victorians: Private Conscience and Public Duty. Essays in Memory of John Clive.* London: Routledge, 1994.

Mansergh, Nicholas. *The Prelude to Partition: Concepts and Aims in Ireland and India.* Cambridge: Cambridge University Press, 1978.

Marcus, George E., and Fred R. Myers, eds. *The Traffic in Culture: Refiguring Art and Anthropology,* Berkeley: University of California Press, 1995.

Marcus, Sharon. *Apartment Stories: City and Home in Nineteenth-Century Paris and London.* Berkeley: University of California Press, 1999.

Markham, S. F. *The Museums and Art Galleries of the British Isles.* Dunfermline: Carnegie United Kingdom Trust, 1938.

Maskiell, Michelle. "Embroidering the Past: Phulkari Textiles and Gendered Work as 'Tradition' and 'Heritage' in Colonial and Contemporary Punjab." *Journal of Asian Studies* 58 (May 1999): 361–88.

Mason, John W. "The Duke of Argyll and the Land Question in Late Nineteenth-Century Britain." *Victorian Studies* 21 (1978): 149–78.

Mastalir, Roger. "A Proposal for Protecting the 'Cultural' and 'Property' Aspects of Cultural Property Under International Law." *Fordham International Law Journal* 16 (1993): 1033–93.

Mather, Alexander. "Government Agencies and Land Development in the Scottish Highlands: A Centenary Survey." *Northern Scotland* 8 (1998): 39–50.

Mathur, Saloni. "Living Ethnological Exhibits: The Case of 1886." *Cultural Anthropology* 15.4 (2000): 492–524.

Maver, Irene. "Politics and Power in the Scottish City: Glasgow Town Council in the Nineteenth Century." In *Scottish Elites: Proceedings of the Scottish Historical Studies Seminar, University of Strathclyde, 1991–1992,* ed. T. M. Devine, 98–130. Edinburgh: John Donald, 1994.

———. "Glasgow's Civic Government." In *Glasgow,* ed. W. Hamish Fraser and Irene Maver, 441–85. Manchester: Manchester University Press, 1996.

———. "Glasgow's Public Parks and the Community, 1850–1914: A Case Study in Scottish Civic Interventionism." *Urban History* 25 (December 1998): 323–47.

Maxwell, Anne. *Colonial Photography and Exhibitions: Representations of the "Native" and the Making of European Identities.* London: Leicester University Press, 1999.

Mayhall, Laura. "Domesticating Emmeline: Representing the Suffragette, 1930–1993." *NWSA Journal* 11 (2000): 1–24.

Maynard, Margaret. "'A Dream of Fair Women': Revival Dress and the Formation of Late Victorian Images of Femininity." *Art History* 12 (September 1989): 322–41.

McBride, Ian, ed. *History and Memory in Modern Ireland.* Cambridge: Cambridge University Press, 2001.

McBryde, Isabel, ed. *Who Owns the Past?* Melbourne: Oxford University Press, 1985.

McCaffrey, Lawrence J. "From Province to Nation-State." In *The Irish Experience,* ed. Thomas E. Hachey, Joseph M. Hernon, and Lawrence J. McCaffrey, 53–166. Englewood Cliffs, N.J.: Prentice-Hall, 1989.

McCarthy, Kathleen D., ed. *Lady Bountiful Revisited: Women, Philanthropy, and Power.* New Brunswick: Rutgers University Press, 1990.

McClellan, Andrew. *Inventing the Louvre: Art, Politics, and the Origins of the Modern Museum in Eighteenth-Century Paris.* Cambridge: Cambridge University Press, 1994.

McCrone, David. *Understanding Scotland: The Sociology of a Stateless Nation*. London: Routledge, 1992.

McCrone, David, Angela Morris, and Richard Kiely. *Scotland—The Brand: The Making of Scottish Heritage*. Edinburgh: Edinburgh University Press, 1995.

Meadowcroft, James. *Conceptualizing the State: Innovation and Dispute in British Political Thought, 1880–1914*. Oxford: Clarendon, 1995.

Meighan, Clement. "Burying American Archaeology." *Archaeology* 47 (1994): 64–67.

Meller, Helen. "Patrick Geddes: An Analysis of His Theory of Civics, 1880–1914." *Victorian Studies* 16 (1973): 291–315.

———. *Leisure and the Changing City, 1870–1914*. London: Routledge and Kegan Paul, 1976.

———. "Urban Renewal and Citizenship: The Quality of Life in British Cities, 1890–1990." *Urban History* 22 (May 1995): 63–84.

Merrill, Linda. *A Pot of Paint: Aesthetics on Trial in 'Whistler v. Ruskin'*. Washington, D.C.: Smithsonian Institution Press, 1992.

Merriman, Neil. *Beyond the Glass Case: The Past, the Heritage, and the Public in Britain*. Leicester: Leicester University Press, 1991.

Merryman, John Henry. "The Public Interest in Cultural Property." *California Law Review* 77 (1989): 339–64.

———. *Thinking About the Elgin Marbles: Critical Essays on Cultural Property, Art, and Law*. The Hague: Kluwer Law International, 2000.

Merryman, John Henry, and Albert E. Elsen. *Law, Ethics, and the Visual Arts*. Philadelphia: University of Pennsylvania Press, 1987.

Messenger, Phyllis Mauch, ed. *The Ethics of Collecting Cultural Property: Whose Culture? Whose Property?* Albuquerque: University of New Mexico Press, 1989.

Minihan, Janet. *The Nationalization of Culture: The Development of State Subsidies to the Arts in Great Britain*. New York: New York University Press, 1977.

Mitchell, Hannah. "Art and the French Revolution: An Exhibition at the Musée Carnavalet." *History Workshop Journal* 5 (spring 1978): 123–45.

Mitter, Partha. "The Imperial Collections: Indian Art." In *A Grand Design: The Art of the Victoria and Albert Museum*, ed. Malcolm Baker and Brenda Richardson, 222–29. Baltimore: Baltimore Museum of Art, 1997.

———. *Much Maligned Monsters: History of European Reactions to Indian Art*. Oxford: Clarendon, 1977.

Montgomery, Maureen E. *Gilded Prostitution: Status, Money, and Transatlantic Marriages, 1870–1914*. London: Routledge, 1989.

Moore, Kevin. *Museums and Popular Culture*. London: Cassell, 1997.

Morris, R. J., and Graeme Morton. "Where Was Nineteenth-Century Scotland?" *Scottish Historical Review* 72 (1994): 89–99.

Morris, R. J., and Richard Rodger, eds. *The Victorian City: A Reader in British Urban History, 1820–1914*. London: Longman, 1993.

Morton, Graeme. "Civil Society, Municipal Government, and the State: Enshrinement, Empowerment, and Legitimacy: Scotland 1800–1929." *Urban History* 25 (December 1998): 348–67.

―――. "What If? The Significance of Scotland's Missing Nationalism in the Nineteenth Century." In *Image and Identity: The Making and Remaking of Scotland Through the Ages*, ed. Dauvit Broun, R. J. Finlay, and Michael Lynch, 157–76. Edinburgh: John Donald, 1998.

―――. *Unionist Nationalism: Governing Urban Scotland, 1830–1860*. East Lothian: Tuckwell, 1999.

Muensterberger, Werner. *Collecting, an Unruly Passion: Psychological Perspectives*. Princeton: Princeton University Press, 1994.

Muringaniza, Svinurayi Joseph. "Heritage That Hurts: The Case of the Grave of Cecil John Rhodes in the Matapos National Park, Zimbawe." In *The Dead and Their Possessions: Repatriation in Principle, Policy, and Practice*, ed. Cressida Fforde, Jane Hubert, and Paul Turnbull, 317–25. London: Routledge, 2002.

Murray, Bruce K. *The People's Budget, 1909/10: Lloyd George and Liberal Politics*. Oxford: Clarendon, 1980.

Nafziger, James A. R., and Rebecca J. Dobkins. "The NAGPRA in Its First Decade." *International Journal of Cultural Property* 8 (1999): 77–107.

Nail, Norman. "Treasured Bones." *Museums Journal* 94 (1994): 32–34.

Nairn, Tom. *The Break-up of Britain: Crisis and Neo-Nationalism*. London: NLB, 1977.

Nash, Catherine. "Visionary Geographies: Designs for Developing Ireland." *History Workshop Journal* 45 (spring 1998): 49–78.

Nason, James D. "Traditional Property Rights and Modern Laws: The Need for Native American Community Property Rights Legislation." *Stanford Law and Policy Review* 12 (spring 2001): 255–66.

Nead, Lynda. *The Female Nude: Art, Obscenity, and Sexuality*. London: Routledge, 1992.

―――. *Victorian Babylon: People, Streets, and Images in Nineteenth-Century London*. New Haven: Yale University Press, 2000.

Nedelsky, Jennifer. "Law, Boundaries, and the Bounded Self." *Representations* 30 (1990): 162–89.

Neill, Ken. "The Broighter Hoard." *Archaeology Ireland* 24 (1993): 24–26.

Netzer, Nancy. "Picturing an Exhibition: James Mahony's Watercolors of the Irish Industrial Exhibition of 1853." In *Visualizing Ireland: National Identity and the Pictorial Tradition*, ed. Adele Dalsimer, 88–98. Boston: Faber and Faber, 1993.

Newman, Gerald. *The Rise of English Nationalism: A Cultural History, 1740–1830*. New York: St. Martin's, 1987.

Nicholas, Lynn H. *The Rape of Europa: The Fate of Europe's Treasures in the Third Reich and the Second World War*. New York: Knopf, 1994.

Nord, Deborah Epstein. *Walking the Victorian Streets: Women, Representation, and the City*. Ithaca: Cornell University Press, 1995.

Nunn, Pamela Gerrish. "Critically Speaking." In *Women in the Victorian Art World*, ed. Clarissa Campbell Orr, 107–24. Manchester: Manchester University Press, 1995.

Nunokawa, Jeff. *The Afterlife of Property: Domestic Security and the Victorian Novel*. Princeton: Princeton University Press, 1994.

Offen, Karen. "Defining Feminism: A Comparative Historical Approach." *Signs* 14 (1988): 119–57.

Offer, Avner. *Property and Politics, 1870–1914: Landownership, Law, Ideology, and Urban Development in England.* Cambridge: Cambridge University Press, 1981.

O'Grady, Lorraine. "Dada Meets Mama." *Artforum* 31 (1992): 11–12.

O'Keefe, Patrick J., and Lyndel Prott. *Law and the Cultural Heritage.* Abingdon, Oxon.: Professional Books, 1984.

O'Mahony, Patrick, and Delanty, Gerard. *Rethinking Irish History: Nationalism, Identity, and Ideology.* New York: St. Martin's, 1998.

Orr, Clarissa Campbell, ed. *Women in the Victorian Art World.* Manchester: Manchester University Press, 1995.

Osman, Dalia N. "Occupier's Title to Cultural Property: Nineteenth-Century Removal of Egyptian Artifacts." *Columbia Journal of Transnational Law* 37 (1999): 969–1002.

Owen, David. *The Government of Victorian London, 1855–1889: The Metropolitan Board of Works, the Vestries, and the City Corporation.* Ed. Roy Macleod. Cambridge: Harvard University Press, 1982.

Packer, Ian. "The Land Issue and the Future of Scottish Liberalism in 1914." *Scottish Historical Review* 75 (1996): 52–71.

———. *Lloyd George, Liberalism, and the Land: The Land Issue and Party Politics in England, 1906–1914.* Suffolk: Boydell, 2001.

Palmer, Norman. *Museums and the Holocaust: Law, Principles, and Practice.* London: Institute of Art and Law, 2000.

Parker, Patricia. *Literary Fat Ladies: Rhetoric, Gender, Property.* London: Methuen, 1987.

Parry, Jonathan. *The Rise and Fall of Liberal Government in Victorian Britain.* New Haven: Yale University Press, 1993.

Parsons, Neil. *King Khama, Emperor Joe, and the Great White Queen: Victorian Britain Through African Eyes.* Chicago: University of Chicago Press, 1998.

Paterson, Lindsay. *The Autonomy of Modern Scotland.* Edinburgh: Edinburgh University Press, 1994.

———. "Scottish Democracy and Scottish Utopias: The First Year of the Scottish Parliament." *Scottish Affairs* 33 (autumn 2000): 45–61.

Pearce, Susan. *Museums, Objects, and Collections: A Cultural Study.* Leicester: Leicester University Press, 1992.

———. *On Collecting: An Investigation into Collecting in the European Tradition.* London: Routledge, 1995.

———, ed. *Art in Museums.* New Research in Museum Studies, no. 5. London: Athlone, 1995.

Pearson, Nicholas. *The State and the Visual Arts: A Discussion of State Intervention in the Visual Arts in Britain, 1760–1981.* Milton Keynes: Open University Press, 1982.

Pecora, Vincent. "Arnoldian Ethnology." *Victorian Studies* 41.3 (spring 1998): 355–79.

Pennybacker, Susan D. *A Vision for London, 1889–1914: Labour, Everyday Life and the L.C.C. Experiment.* London: Routledge, 1995.

Pennybacker, Susan. "'The Millennium by Return of Post': Reconsidering London Progressivism, 1889–1907." In *Metropolis—London: Histories and Representations Since*

1800, ed. David Feldman and Gareth Stedman Jones, 129–62. London: Routledge, 1989.

Perry, Lara. "Facing Femininities: Women in the National Portrait Gallery, 1856–1899." D. Phil. thesis, University of York, 1998.

———. "Looking Like a Woman: Gender and Modernity in the Nineteenth-Century National Portrait Gallery." In *English Art 1860–1914*, ed. David Peters Corbett and Lara Perry, 116–32. New Brunswick, N.J.: Rutgers University Press, 2001.

Petropoulos, Jonathan. *Art as Politics in the Third Reich*. Chapel Hill: University of North Carolina Press, 1996.

———. *The Faustian Bargain: The Art World in Nazi Germany*. Oxford: Oxford University Press, 2000.

Pittock, Murray G. H. *The Invention of Scotland: The Stuart Myth and the Scottish Identity, 1638 to the present*. London: Routledge, 1991.

———. *The Myth of the Jacobite Clans*. Edinburgh: Edinburgh University Press, 1995.

———. *Celtic Identity and the British Image*. Manchester: Manchester University Press, 1999.

Plant, Raymond, and Andrew Vincent. *Philosophy, Politics, and Citizenship: The Life and Thought of the British Idealists*. Oxford: Basil Blackwell, 1984.

Plotz, John. *The Crowd: British Literature and Public Politics*. Berkeley: University of California Press, 2000.

Pocock, J. G. A. "British History: A Plea for a New Subject." *Journal of Modern History* 4 (1975): 601–21.

———. *The Machiavellian Moment: Florentine Political Thought and the Atlantic Republican Tradition*. Princeton: Princeton, 1975.

———. *Virtue, Commerce, and History: Essays on Political Thought and History*. Cambridge: Cambridge University Press, 1985.

Pointon, Marcia. "W. E. Gladstone as an Art Patron and Collector." *Victorian Studies* 19 (1975): 73–98.

———. *Strategies for Showing: Women, Possession, and Representation in English Visual Culture, 1665–1800*. Oxford: Oxford University Press, 1997.

———. *Hanging the Head: Portraiture and Social Formation in Eighteenth-Century England*. New Haven: Yale University Press, 1993.

———, ed. *Art Apart: Art Institutions and Ideology Across England and North America*. Manchester: Manchester University Press, 1994.

Poovey, Mary. *Uneven Developments: The Ideological Work of Gender in Mid-Victorian England*. Baltimore: Johns Hopkins University Press, 1988.

———. *Making a Social Body: British Cultural Formation, 1830–1864*. Chicago: University of Chicago Press, 1995.

Port, M. H. "Government and the Metropolitan Image: Ministers, Parliament, and the Concept of a Capital City, 1840–1915." In *The Metropolis and Its Images: Constructing Identities for London, c. 1750–1950*, ed. Dana Arnold, 101–26. Oxford: Blackwell, 1999.

Porter, Gaby. "Seeing Through Solidity: A Feminist Perspective on Museums." In *Theorizing Museums: Representing Identity and Diversity in a Changing World*, ed. Sharon Macdonald and Gordon Fyfe, 105–26. Oxford: Blackwell, 1996.

Praeger, Robert Lloyd. *The Way That I Went: An Irishman in Ireland.* Dublin: Hodges, Figgis, 1947.

Prakash, Gyan. *Another Reason: Science and the Imagination of Modern India.* Princeton: Princeton University Press, 1999.

Prior, Nick. "Edinburgh, Romanticism, and the National Gallery of Scotland." *Urban History* 22 (August 1995): 205–15.

Prochaska, F. K. *Women and Philanthropy in 19th-Century England.* Oxford: Clarendon, 1980.

Prott, Lyndel. "Repatriation of Cultural Property." *University of British Columbia Law Review* 29 (1995): 229–40.

Prott, Lyndel, and Patrick J. O'Keefe. "'Cultural Heritage' or 'Cultural Property.'" *International Journal of Cultural Property* 4 (1995): 241–354.

Psomiades, Kathy Alexis. *Beauty's Body: Femininity and Representation in British Aestheticism.* Stanford: Stanford University Press, 1997.

Pullan, Ann. "Conversations on the Arts: Writing a Space for the Female Viewer in the Repository of the Arts, 1809–1815." *Oxford Art Journal* 15 (1992): 15–26.

Purbrick, Louise. "South Kensington Museum: The Building of the House of Henry Cole." In *Art Apart: Art Institutions and Ideology Across England and North America,* ed. Marcia Pointon, 69–86. Manchester: Manchester University Press, 1994.

———. "Knowledge Is Property: Looking at Exhibits and Patents in 1851." *Oxford Art Journal* 20 (1997): 53–60.

———, ed. *The Great Exhibition of 1851: New Interdisciplinary Essays.* Manchester: Manchester University Press, 2001.

Radin, Margaret Jane. *Reinterpreting Property.* Chicago: University of Chicago Press, 1993.

Rappaport, Erika Diane. *Shopping for Pleasure: Women in the Making of London's West End.* Princeton: Princeton University Press, 2000.

Reed, Christopher. *Not at Home: The Suppression of Domesticity in Modern Art and Architecture.* New York: Thames and Hudson, 1996.

Reeve, Andrew. *Property.* Houndmills, Basingstoke: Macmillan, 1986.

Rempe, Paul L. "Sir Horace Plunkett and Irish Politics, 1890–1914." *Eire-Ireland* 13 (1978): 6–20.

Richards, Charles. *The Industrial Museum.* New York: Macmillan, 1925.

Richards, Colin. "About Face: Aspects of Art History and Identity in South African Visual Culture." In *Reading the Contemporary: African Art from Theory to the Marketplace,* ed. Olu Oguibe and Okwui Enwezor, 348–73. Cambridge: Harvard University Press, 1999.

Richards, Thomas. *The Commodity Culture of Victorian England: Advertising and Spectacle, 1851–1914.* Stanford: Stanford University Press, 1990.

Roberts, Mary Louise. *Civilization Without Sexes: Reconstructing Gender in Postwar France, 1917–1927.* Chicago: University of Chicago Press, 1994.

———. "Gender, Consumption, and Commodity Culture." *American Historical Review* 103 (June 1998): 817–44.

Robertson, John, ed. *A Union for Empire: Political Thought and the British Union of 1707*. Cambridge: Cambridge University Press, 1995.

Rodger, Richard. *The Transformation of Edinburgh: Land, Property and Trust in the Nineteenth Century*. Cambridge: Cambridge University Press, 2001.

Rose, Carol. *Property and Persuasion: Essays on the History, Theory, and Rhetoric of Ownership*. Boulder: Westview, 1994.

Rose, Mark. *Authors and Owners: The Invention of Copyright*. Cambridge: Harvard University Press, 1993.

Rosey, George. "Museumry and the Heritage Industry." In *The Manufacture of Scottish History*, ed. Ian Donnachie and Christopher Whatley, 157–70. Edinburgh: Polygon, 1992.

Ross, Ellen. *Love and Toil: Motherhood in Outcast London, 1870–1918*. New York: Oxford University Press, 1993.

Royal Irish Academy and British Academy, eds. *Ireland After the Union*. Oxford: Oxford University Press, 1989.

Ruane, Joseph. "Colonialism and the Interpretation of Irish Historical Development." In *Approaching the Past: Historical Development Through Irish Case Studies*, ed. Marilyn Silverman and P. H. Gulliver, 293–323. New York: Columbia University Press, 1992.

Ryan, Alan. *Property and Political Theory*. Oxford: Basil Blackwell, 1984.

Saint, Andrew, ed. *Politics and the People of London: The London County Council, 1889–1965*. London: Hambledon, 1989.

Saint-Amour, Paul K. *The Copywrights: Intellectual Property and the Literary Imagination*. Ithaca: Cornell University Press, 2003.

Saisselin, R. G. *Bricabracomania: The Bourgeois and the Bibelot*. London: Thames and Hudson, 1985.

Saler, Michael T. *The Avant-Garde in Interwar England: Medieval Modernism and the London Underground*. New York: Oxford University Press, 1999.

Samuel, Raphael, ed. *Patriotism: The Making and Unmaking of British National Identity*. London: Routledge, 1989.

———. *Theatres of Memory*. London: Verso, 1994.

Sandberg, Mark B. "Effigy and Narrative: Looking into the Nineteenth-Century Folk Museum." In *Cinema and the Invention of Modern Life*, ed. Leo Charney and Vanessa B. Schwartz, 320–61. Berkeley: University of California Press, 1995.

Sax, Joseph L. "Heritage Preservation as a Public Duty: The Abbé Grégoire and the Origins of an Idea." *Michigan Law Review* 88 (1990): 1142–69.

———. "Is Anyone Minding Stonehenge? The Origins of Cultural Property Protection in England." *California Law Review* 78 (1990): 1543–67.

———. *Playing Darts with a Rembrandt: Public and Private Rights in Cultural Treasures*. Ann Arbor: University of Michigan Press, 1999.

Schaffer, Talia. *The Forgotten Female Aesthetes: Literary Culture in Late-Victorian England*. Charlottesville: University Press of Virginia, 2000.

Schaffer, Talia, and Kathy Alexis Psomiades, eds. *Women and British Aestheticism.* Charlottesville: University Press of Virginia, 1999.

Schneer, Jonathan. *London 1900: The Imperial Metropolis.* New Haven: Yale University Press, 1999.

Schwartz, Vanessa R. *Spectacular Realities: Early Mass Culture in Fin-de-Siècle Paris.* Berkeley: University of California Press, 1997.

Scott, Joan. *Gender and the Politics of History.* New York: Columbia University Press, 1988.

———. *Only Paradoxes to Offer: French Feminists and the Rights of Man.* Cambridge: Harvard University Press, 1996.

Searle, G. R. *The Liberal Party: Triumph and Disintegration, 1886–1929.* Houndmills: Macmillan, 2001.

Sengupta, Parna. "An Object Lesson in Colonial Pedagogy." *Comparative Studies in Society and History* 45.1 (January 2003): 96–121.

Shafernich, Sandra Maria. "Open-Air Museums in Denmark and Sweden: A Critical Review." *Museum Management and Curatorship* 13 (March 1994): 9–37

Shanley, Mary Lyndon. *Feminism, Marriage, and the Law in Victorian England.* Princeton: Princeton University Press, 1989.

Shaw, John. "Land, People, and Nation: Historicist Voices in the Highland Land Campaign, c. 1850–1883." In *Citizenship and Community: Liberals, Radicals, and Collective Identities in the British Isles, 1865–1931,* ed. Eugenio Biagini, 305–24. Cambridge: Cambridge University Press, 1996.

Sheehan, James J. *Museums in the German Art World from the End of the Old Regime to the Rise of Modernism.* Oxford: Oxford University Press, 2000.

Sheehy, Jeanne. *The Rediscovery of Ireland's Past: The Celtic Revival, 1830–1930.* London: Thames and Hudson, 1980.

Sheppard, Francis. *The Treasury of London's Past: An Historical Account of the Museum of London and Its Predecessors, the Guildhall Museum and the London Museum.* London: The Museum of London, 1991.

Sherman, Brad, and Lionel Bently. *The Making of Modern Intellectual Property Law: The British Experience, 1760–1911.* Cambridge: Cambridge University Press, 1999.

Sherman, Daniel. *Worthy Monuments: Art Museums and the Politics of Culture in Nineteenth-Century France.* Cambridge: Harvard University Press, 1989.

———. "Quatremère/Benjamin/Marx: Art Museums, Aura, and Commodity Fetishism." In *Museum Culture: Histories, Discourses, Spectacles,* ed. Daniel Sherman and Irit Rogoff, 123–43. Minneapolis: University of Minnesota Press, 1994.

———. *The Construction of Memory in Interwar France.* Chicago: University of Chicago Press, 1999.

Sherman, Daniel, and Irit Rogoff, eds. *Museum Culture: Histories, Discourses, Spectacles.* Minneapolis: University of Minnesota Press, 1994.

Short, Brian. *Land and Society in Edwardian Britain.* Cambridge: Cambridge University Press, 1997.

Siegel, Jonah. *Desire and Excess: The Nineteenth-Century Culture of Art.* Princeton: Princeton University Press, 2000.

Silverman, Debora. *Art Nouveau in Fin-de-Siècle France: Politics, Psychology, and Style.* Berkeley: University of California Press, 1989.

———. "The 'New Woman,' Feminism and the Decorative Arts in Fin-de-Siècle France." In *Eroticism and the Body Politic*, ed. Lynn Hunt, 144–63. Baltimore: Johns Hopkins University Press, 1991.

Silvestri, Michael. "'The Sinn Fein of India': Irish Nationalism and the Policing of Revolutionary Terrorism in Bengal." *Journal of British Studies* 39 (October 2000): 454–86.

Simpson, Elizabeth, ed. *The Spoils of War: World War II and Its Aftermath: The Loss, Reappearance, and Recovery of Cultural Property.* New York: Harry N. Abrams, in association with The Bard Graduate Center for Studies in the Decorative Arts, 1997.

Simpson, Moira G. *Making Representations: Museums in the Post-Colonial Era.* London: Routledge, 1996.

———. "To Have and to Hold." *Museums Journal* 97 (October 1997): 29–30.

Simpson, Tony. *Indigenous Heritage and Self-Determination.* Copenhagen: Forest Peoples Program, 1997.

Singer, Joseph. *Entitlement: The Paradoxes of Property.* New Haven: Yale University Press, 2000.

Smailes, Helen. *A Portrait Gallery for Scotland: The Foundation, Architecture and Mural Decoration of the Scottish National Portrait Gallery, 1882–1906.* Edinburgh: Trustees of the National Gallery of Scotland, 1985.

Smith, Pamela H., and Paula Findlen, eds. *Merchants and Marvels: Commerce, Science, and Art in Early Modern Europe.* London: Routledge, 2002.

Smith, T. M. "In Defence of Privilege: The City of London and the Challenge of Municipal Reform, 1875–1890." *Journal of Social History* 27 (1993): 59–83.

Solkin, David. *Painting for Money: The Visual Arts and the Public Sphere in Eighteenth-Century England.* New Haven: Yale University Press, 1993.

———. "'This Great Mart of Genius': The Royal Academy Exhibitions at Somerset House, 1780–1836." In *Art on the Line: The Royal Academy Exhibitions at Somerset House, 1780–1836*, ed. David Solkin, 1–8. New Haven: Published for the Paul Mellon Centre for Studies in British Art and Courtauld Institute Gallery by Yale University Press, 2001.

———, ed. *Art on the Line: The Royal Academy Exhibitions at Somerset House, 1780–1836.* New Haven: Published for the Paul Mellon Centre for Studies in British Art and Courtauld Institute Gallery by Yale University Press, 2001.

Stansky, Peter. *Ambitions and Strategies: The Struggle for the Leadership of the Liberal Party in the 1890s.* Oxford: Clarendon, 1964.

———. *Redesigning the World: William Morris, the 1880s, and the Arts and Crafts.* Princeton: Princeton University Press, 1985.

Staves, Susan. *Married Women's Separate Property in England, 1660–1883.* Cambridge: Harvard University Press, 1993.

Stocking, George W. Jr., ed. *Objects and Others: Essays on Museums and Material Culture.* Madison: University of Wisconsin Press, 1985.

Swann, Marjorie. *Curiosities and Texts: The Culture of Collecting in Early Modern England.* Philadelphia: University of Pennsylvania Press, 2001.

Swift, Roger, and Sheridan Gilley, eds. *The Irish in Victorian Britain: The Local Dimension.* Dublin: Four Courts Press, 1999.

Taylor, Brandon. *Art for the Nation: Exhibitions and the London Public, 1747–2001.* Manchester: Manchester University Press, 1999.

Taylor, Michael. "What Is in a 'National' Museum? The Challenges of Collecting Policies at the National Museum of Scotland." In *Museums and the Future of Collecting,* ed. Simon J. Knell, 121–30. Aldershot: Ashgate, 1999.

Teixera, Madalena Braz. "Portuguese Art Treasures: Medieval Women and Early Museum Collections." In *Museums and the Making of "Ourselves,"* ed. Flora Kaplan, 291–313. London: Leicester University Press, 1994.

Thomas, David Wayne. *Cultivating Victorians: Liberal Culture and the Aesthetic.* Philadelphia: University of Pennsylvania Press, 2004.

Thomas, Nicholas. *Possessions: Indigenous Art/Colonial Culture.* London: Thames and Hudson, 1999.

Thomas, Rachel. "The Theory of Devolution." *Museums Journal* 97 (November 1997): 10–11.

Thompson, Colin. *Pictures for Scotland: The National Gallery of Scotland and Its Collection—A Study of the Changing Attitude to Painting Since 1820.* Edinburgh: Trustees of the National Galleries of Scotland, 1972.

Thompson, J. A. "The Historians and the Decline of the Liberal Party." *Albion* 22 (1990): 65–83.

Tickner, Lisa. *The Spectacle of Women: Imagery of the Suffrage Campaign, 1907–1914.* London: Chatto and Windus, 1987.

———. "Feminism, Art History, and Sexual Difference." *Genders* 3 (1988): 92–128.

———. *Modern Life and Modern Subjects: British Art in the Early 20th Century.* New Haven: Yale University Press, 2000.

Trevor-Roper, Hugh. *The Plunder of the Arts in the Seventeenth Century.* London: Thames and Hudson, 1970.

———. "The Invention of Tradition: The Highland Tradition of Scotland." In *The Invention of Tradition,* ed. Eric Hobsbawm and Terence Ranger, 15–41. Cambridge: Cambridge University Press, 1985.

Trodd, Colin. "The Paths to the National Gallery." In *Governing Cultures: Art Institutions in Victorian London,* ed. Paul Barlow and Colin Trodd, 29–43. Aldershot: Ashgate, 2000.

———. "Representing the Victorian Royal Academy: The Properties of Culture and the Promotion of Art." In *Governing Cultures: Art Institutions in Victorian London,* ed. Paul Barlow and Colin Trodd, 56–68. Aldershot: Ashgate, 2000.

Turnbull, Annmarie. "'So Extremely Like Parliament': The Work of the Women Members of the London School Board, 1870–1914." In London Feminist History Group, *Sexual Dynamics of History.* London: Pluto Press, 1983.

van Keuren, David K. "Museums and Ideology: Augustus Pitt-Rivers, Anthropological Museums, and Social Change in Later-Victorian Britain." *Victorian Studies* 28 (1984): 171–89.

Vaughan, William. "The Englishness of British Art." *Oxford Art Journal* 13 (1990): 11–24.

Vergo, Peter, ed. *The New Museology.* London: Reaktion, 1989.

Vickery, Amanda. "Golden Age to Separate Spheres? A Review of the Categories and Chronologies of Women's History." *Historical Journal* 36 (1993): 383–414.

———, ed. *Women, Privilege, and Power: British Politics, 1750 to the Present.* Stanford: Stanford University Press, 2001.

Vincent, Steven. "Who Owns Art?" *Art and Auction* 17 (January 1995): 84–87.

Wainwright, Clive. *The Romantic Interior: The British Collector at Home, 1750–1850,* ed. Paul Mellon Centre for Studies in British Art. New Haven: Published for the Paul Mellon Centre for Studies in British Art by Yale University Press, 1989.

Waldron, Jeremy. *The Right to Private Property.* Oxford: Clarendon, 1988.

Walker, Graham. "Scotland and Ulster: Political Interactions Since the Late Nineteenth Century and Possibilities of Contemporary Dialogue." In *Varieties of Scottishness: Exploring the Ulster-Scottish Connection,* ed. John Erskine and Gordon Lucy, 91–109. Belfast: Institute of Irish Studies, 1997.

Walkowitz, Judith R. *City of Dreadful Delight: Narratives of Sexual Danger in Late-Victorian London.* Chicago: University of Chicago Press, 1992.

———. "Going Public: Shopping, Street Walking, and Street Harrassment in Late-Victorian London." *Representations* 62 (spring 1998): 1–30.

Wallach, Alan. *Exhibiting Contradiction: Essays on the Art Museum in the United States.* Amherst: University of Massachusetts Press, 1998.

Walton, Whitney. *France at the Crystal Palace: Bourgeois Taste and Artisan Manufacture in the 19th Century.* Berkeley: University of California Press, 1992.

Warner, Marina. *Monuments and Maidens: The Allegory of the Female Form.* London: Weidenfeld and Nicolson, 1985.

Warner, Richard. "The Broighter Hoard." In *Derry and Londonderry: History and Society. Interdisciplinary Essays on the History of an Irish County,* ed. Gerard O'Brien, 69–90. Dublin: Geography Publications, 1999.

Waterfield, Giles, *Palaces of Art: Art Galleries in Britain, 1790–1990.* London: Dulwich Picture Gallery, 1991.

———, ed. *Art for the People: Culture in the Slums of Late Victorian Britain.* London: Dulwich Picture Gallery, 1994.

Waters, Chris. "Progressives, Puritans, and the Cultural Politics of the Council, 1889–1914." In *Politics and the People of London: The London County Council, 1889–1965,* ed. Andrew Saint, 49–70. London: Hambledon, 1989.

———. *British Socialists and the Politics of Popular Culture.* Stanford: Stanford University Press, 1990.

Watson, Fiona. "The Twee and the Tweed: Images of Scotland at Home and Abroad." Paper delivered at "'One Nation' Heritage? The Politics of Consensual Representations of the Past." York, 1998.

Watson, Ian. *Song and Democratic Culture in Britain.* London: Croom Helm, 1983.

Webb, Keith. *The Growth of Nationalism in Scotland.* London: Penguin, 1978.

Weil, Stephen. *Rethinking the Museum and Other Meditations.* Washington: Smithsonian Institution Press, 1990.

Weiler, Peter. *The New Liberalism: Liberal Social Theory in Great Britain 1889–1914*. New York: Garland, 1982.

Weiner, Annette B. *Inalienable Possessions: The Paradox of Keeping-While-Giving*. Berkeley: University of California Press, 1992.

Weiner, Deborah. *Architecture and Social Reform in Late-Victorian London*. Manchester: Manchester University Press, 1994.

Weiner, Martin. *English Culture and the Decline of the Industrial Spirit, 1850–1950*. Cambridge: Cambridge University Press, 1981.

West, Rebecca. "Gender Politics and the 'Invention of Tradition': The Museumization of Louisa May Alcott's Orchard House." *Gender and History* 6 (1994): 456–67.

Whyte, Nicholas. "Science and Nationality in Edwardian Ireland." In *Science and Society in Ireland: The Social Context of Science and Technology in Ireland, 1800–1950*, ed. Peter Bowler and Nicholas Whyte, 49–65. Belfast: Institute of Irish Studies, 1997.

Wilf, Steven. "What Is Property's Fourth Estate? Cultural Property and the Fiduciary Ideal." *Connecticut Journal of International Law* 16 (spring 2001): 177–82.

Williams, Raymond. *Culture and Society, 1780–1950*. London: Chatto and Windus, 1958.

Williams-Davies, John. "The Bigger Picture." *Museums Journal* 95 (1995): 28.

Wilson, David M. *The British Museum: Purpose and Politics*. London: British Museum, 1989.

Winter, J. M. *Sites of Memory, Sites of Mourning: The Great War in European Cultural History*. Cambridge: Cambridge University Press, 1995.

Withers, Josephine. "The Guerrilla Girls." *Feminist Studies* 14 (summer 1988): 285–300.

Wolfe, J. N., ed. *Government and Nationalism in Scotland*. Edinburgh: Edinburgh University Press, 1969.

Wolff, Janet, and John Seed eds. *The Culture of Capital: Art, Power, and the Nineteenth-Century Middle Class*. Manchester: Manchester University Press, 1988.

Wright, Gwendolyn. *The Politics of Design in French Colonial Urbanism*. Chicago: University of Chicago Press, 1991.

Wright, Patrick. "Trafficking in History." In *Representing the Nation: A Reader*, ed. David Boswell and Jessica Evans, 115–50. London: Routledge, 1999.

Yanni, Carla. *Nature's Museums: Victorian Science and the Architecture of Display*. London: Athlone, 1999.

Young, Ken, and Patricia L. Garside. *Metropolitan London: Politics and Urban Change 1837–1981*. New York: Holmes and Meier, 1982.

Ziff, Bruce, and Pratima Rao, eds. *Borrowed Power: Essays on Cultural Appropriation*. New Brunswick, N.J.: Rutgers University Press, 1997.

INDEX

Page numbers in italics refer to figures.

224n8, 224n16, 237n293, 240n74; in
Ireland, 23–24, 34, 36, 42, 45, 49,
53–54, 62–63, 67–73, 76–77, 197,
209, 231n152
Richardson, Mary, 199–200, 202
Robinson, John Charles, 44
Rochefort, Henri, 183
Rokeby Venus, The (Velázquez), 199–200
Roman artifacts, 159, 180, 186, 190, 208,
260n130
Roman conquest of Britain, 61, 175, 180
Roman law, 56
Rosebery, fifth earl of (Archibald Philip
Primrose), 10
Rossetti, Dante Gabriel, 169
Royal Academy, 13
Royal Irish Academy, 30, 37, 45–46, 48,
58, 65, 77, 224n5–6
Royal Scottish Academy, 91, 97–98, 102,
240n66
Ruskin, John, 2, 127–28, 136, 177; *Stones
of Venice,* 19
Ruskin Museum, 19

Sanitary Association (Manchester), 129
Schleswig-Holstein Museum, 130–31
Schreiber, Charlotte, 128, 140–41,
251n113
Science and Art Museum (Ireland) Act, 41
Scotland: art in, 85–86, land wars in,
82–83, 99, 109–10, 116; nationalism
in, 83–85, 98, 101, 105, 239n37,
241n105; radicalism in, 92, 99, 101,
103–9, 111, 113–14, 116, 241n109;
regionalism in, 99–111, 116, 242n122
(*see also* Highlands, Highlandism);
Unionists in, 24, 80, 88, 92, 96–97,
99, 103, 238nn14–16
Scottish Home Rule Association, 89. *See
also* Home Rule, in Scotland
Scottish Modern Arts Association
(SMAA), 113
Scottish Office, 84, 90, 104–7, 111, 114
Secretary for Scotland. *See* Scottish Office
Settled Land Acts (1882), 16
Sévigné, Marie de Rabutin-Chantal, mar-
quise de, 184

Sharp, Cecil, 161
Shaw, George Bernard, *John Bull's Other
Island,* 34
Shaw-Stewart, Michael, 99
Sinclair, John, 107, 111, 243n151. *See also*
Scottish Office
Skansen Museum, 161–62, 182, 189, 204,
256n25, 256n27
Sketches of Germany (Jameson), 126–27,
131
Smeaton, Donald, 100, 105
Smith, Adam, 18
Smith, Barbara Leigh, 122
socialism, 138, 181, 204, 207, 220n67; in
London, 162, 165, 179, 181; muse-
ums and, 15, 144, 205; in Scotland;
101
Soden-Smith, Robert Henry, 49
Solly, Sarah, 139
South Kensington Museum, 18–19, 38–
42, 47, 87, 206, 220n74, 228n85
Spielmann, Isidore, 143
Stafford House, 159, 190, 193–94, 198
Stirling-Maxwell, John, 80, 85, 87, 96–97,
99, 103, 107–8, 110–11, 114–15;
Scottish Office and, 90–91
Stonehenge, 207
Stone of Destiny, 73, 89
Stones of Venice, The (Ruskin), 19
Story of the Amulet, The (Bland), 197–98
suffragettes, 3, 186–87, 203–4, 266n248;
attacks in museums and, 20, 143, 155,
160, 191, 195, 198–99, 265nn236–
39
Sunday opening, 10, 21, 104, 133,
217nn6–9, 222n105
Surrey House, 171

Táin bó Cúalnge. See *Cattle Raid of Cooley,
The*
Tate, Amy, 152
Tate, Henry, 20, 152
Tate Gallery, 20, 113, 169–70
Temple, Alfred G., 169, 183
Thicknesse, Ralph, 155
Thomas Carlyle (Millais), 200–202, *200–
201*

DATE DUE			

GAYLORD No. 2333 PRINTED IN U.S.A.